PETER BURKE

The Italian Renaissance Culture and Society in Italy

Third Edition

Princeton University Press Princeton and Oxford Copyright © Peter Burke 1986, 1999, 2014

This revised third edition first published in North and South America and the Philippines in 2014 by Princeton University Press, 41 William Street, Princeton, New Jersey 08540

press.princeton.edu

Revised second edition first published 1999. Reprinted in 2000, 2003, 2004, 2005, 2006, 2010.

First edition 1972 by Batsford, UK. Scribner, US. Paperback edition published by Collins Fontana 1974. Revised edition first published 1987 by Polity Press in association with Blackwell Publishers Ltd. Reprinted in 1988, 1991, 1993, 1994

This revised third edition first published in Great Britain in 2014 by

Polity Press 65 Bridge Street Cambridge CB2 1UR, UK

All rights reserved. Except for the quotation of short passages for the purposes of criticism and review, no part of this publication may be reproduced, stored in a retrieval system, or transmitted, in any form or by any means, electronic, mechanical, photocopying, recording or otherwise, without the prior permission of the publisher.

Except in the United States of America, this book is sold subject to the condition that it shall not, by way of trade or otherwise, be lent, re-sold, hired out, or otherwise circulated without the publisher's prior consent in any form of binding or cover other than that in which it is published and without a similar condition including this condition being imposed on the subsequent purchaser.

Library of Congress Control Number 2013952036 ISBN 978-0-691-16240-9

Typeset in 10/12pt Sabon by Servis Filmsetting Ltd, Stockport, Cheshire Printed in Great Britain by T.J. International Ltd, Padstow, Cornwall

Image nos. 1–5, 8, 11–12, 16–22, 24–6, 29–32, 34–6 Wikimedia Commons; 6–7 by permission of Cambridge University Library; 9, Musei Vaticani; 10, Fabbrica di San Pietro in Vaticano; 13, Photgraph by James Austin; 14, St Bernard preaching, by Francesco di Giorgio e di Lorenzo known as the Elder (Vecchietta) (ca 1412–1480), Detail / De Agostini Picture Library / The Bridgeman Art Library; 15, Galleria Estense, Modena; 23, Musee Jacquemart-Andre, Paris (Photographie Bulloz); 27, Two studies of a man suspended by his left leg (red chalk on cream paper), Sarto, Andrea del (1486–1530) / Chatsworth House, Derbyshire, UK / © Devonshire Collection, Chatsworth / Reproduced by permission of Chatsworth Settlement Trustees / The Bridgeman Art Library; 28 & 33, Getty Images.

10987654321

THE ITALIAN RENAISSANCE

For Maria Lúcia

Contents

Illustrations		vii			
T T	INTRODUCTION The Theme The Approach A Revised Edition				
	PART I THE PROBLEM				
1	THE ARTS IN RENAISSANCE ITALY	17			
2	The Historians: The Discovery of Social and Cultural History	32			
	PART II THE ARTS IN THEIR MILIEU				
3	ARTISTS AND WRITERS Recruitment Training The Organization of the Arts The Status of the Arts Artists as Social Deviants	47 47 56 67 80 88			
4	Patrons and Clients Who are the Patrons? Patrons v. Artists Architecture, Music and Literature The Rise of the Market	94 95 107 118 125			
5	The Uses of Works of Art Magic and Religion Politics The Private Sphere Art for Pleasure	132 133 138 148 151			

CONTENTS

6	TASTE	152	
	The Visual Arts	153	
	Music	161	
	Literature	164	
	Varieties of Taste	166	
7	Iconography	171	
	D		
	PART III THE WIDER SOCIETY		
8	Worldviews: Some Dominant Traits	187	
	Views of the Cosmos	188	
	Views of Society	198	
	Views of Man	203	
	Towards the Mechanization of the World Picture	211	
9	THE SOCIAL FRAMEWORK	215	
	Religious Organization	215	
	Political Organization	220	
	The Social Structure	228	
	The Economy	234	
10	Cultural and Social Change	241	
	Generations	242	
	Structural Changes	249	
11	Comparisons and Conclusions	255	
	The Netherlands	256	
	Japan	259	
Apı	PENDIX: THE CREATIVE ELITE	264	
REI	References and Bibliography		
Index		266 314	

Illustrations

1.1	Carlo Crivelli: The Annunciation with Saint Emidius, 1486	24
1.2	Domenico Ghirlandaio: Adoration of the Shepherds, Santa	
	Trinità, Florence	26
1.3	The Colleoni Chapel in Bergamo	30
2.1	Gentile da Fabriano: Adoration of the Shepherds (detail),	
	Galleria Uffizi, Florence	40
3.1	A bust of Filippo Brunelleschi, Florence Cathedral	55
3.2	The training of a humanist at university, from C. Landino:	
	Formulario di lettere e di orationi volgari con la preposta,	
	Florence	59
3.3	Woodcut of Adriaan Willaert, from Musica Nova, 1559	63
3.4	Agostino Veneziano's engraving of Baccio Bandinelli's	
	'Academy' in Rome	65
3.5	Giovanni de Udine: Stucco relief showing Raphael's	
	workshop (detail), in the Vatican Loggia	69
3.6	The architect Filarete leading his apprentices, from the	
	doors of St Peter's, Rome	70, 71
3.7	Titian: Portrait of Giulio Romano	83
3.8	Palma Vecchio: Portrait of a Poet	91
3.9	Giulio Romano: The Palazzo del Te, Mantua, detail of a	
	frieze with slipped triglyphs	92
4.1	Lorenzo Vecchietta: San Bernadino da Siena (detail)	97
4.2	Battista Dossi: Madonna with Saints and the Confraternity	100
4.3	Andrea del Castagno: The Youthful David, tempera on	
	leather mounted on wood, c.1450	101
4.4	Leonardo da Vinci: Isabella d'Este	106
4.5	Agnolo Bronzino: Ugolino Martelli	108
4.6	Pietro Perugino: Battle of Love and Chastity	112
4.7	Raphael: Leo X	121
4.8	Titian: Pietro Aretino	125
5.1	Sandro Botticelli: The Punishment of Korah, Dathan and	
	Abiron, Sistine Chapel, Vatican	137

ILLUSTRATIONS

5.2	School of Piero della Francesca: Portrait of Alfonso of	
	Aragon	140
5.3	Donatello: Judith and Holofernes	142
5.4	Benvenuto Cellini: Cosimo I de'Medici	143
5.5	Massaccio: The Tribute Money (detail)	144
5.6	Andrea del Sarto: Two Men Suspended by their Feet (detail),	
	red chalk on cream paper	145
5.7	Vittore Carpaccio: The Reception of the English	
	Ambassadors and St Ursula Talking to her Father	150
6.1	Interior of the Pazzi Chapel in Florence	159
6.2	Raphael: Marriage of the Virgin	160
6.3	The interior of San Francesco della Vigna, Venice	163
7.1	Leonardo da Vinci: The Virgin, Child and Saint Anne	178
7.2	Giorgio Vasari: Portrait of Lorenzo de'Medici	179
8.1	Dosso Dossi: Circe	197
8.2	Pinturicchio: Self-Portrait (detail from The Annunciation)	207

Introduction

THE THEME

his book is a history of the culture of the Italian Renaissance in a period (roughly 1400–1550) in which contemporaries claimed that art and literature was 'reborn'. Paradoxical as it may seem, the Renaissance movement was a systematic attempt to go forward by going back – in other words, to break with medieval tradition by following an older model, that of the ancient Greeks and Romans.

Hundreds if not thousands of studies have been devoted to this topic. The most famous of them remains The Civilization of the Renaissance in Italy (1860) by the great Swiss historian Jacob Burckhardt. Writing over a hundred and fifty years ago, Burckhardt viewed the Renaissance as a modern culture created by a modern society. Today, it looks rather more archaic. This shift in attitude is due in part to scholarly research on continuities between the Renaissance and the Middle Ages, but even more to changes in conceptions of the 'modern'. Since 1860 the classical tradition has withered away, the tradition of representational art has been broken, and rural societies have become urban and industrial (if not post-industrial) on a scale that dwarfs fifteenth- and sixteenth-century cities and their handicrafts. Renaissance Italy now looks 'underdeveloped', in the sense that the majority of the population worked on the land, while many were illiterate and all of them were dependent on animate sources of power, especially horses and oxen. This perspective makes the many cultural innovations of the period even more remarkable than they seemed in Burckhardt's time. To understand and explain these innovations, which came in the course of time to constitute a new tradition, is the aim of this book.

The perspective

The aim of the present study is to write not only a cultural history but also a social history of the Renaissance movement, and in particular to

examine the relation between culture and society.¹ Neither of the key terms is easy to define. By 'culture' I mean essentially attitudes and values and their expressions and embodiments in artefacts (including texts) and practices (including performances). Culture is the realm of the imaginary and the symbolic, not distinct from everyday life but underlying it. As for 'society', the term is shorthand for economic, social and political structures, all of which reveal themselves in the social relationships characteristic of a particular place and time.

The central argument of this book is that we cannot understand the culture of the Italians in this period if we look only at the conscious intentions of the individuals who produced the painting, sculpture, architecture, music, literature and philosophy that we continue to admire today. Understanding these individual intentions, so far as this remains possible after five hundred years – hampered as we now are not only by gaps in the evidence but also by the differences between our categories, assumptions and values and theirs – is certainly necessary, but it is not sufficient for the understanding of the movement in which these individuals participated.

There are several different reasons why this approach is not sufficient in itself. In the first place, the power of the patron limited the freedom of artists and writers. Although Botticelli, for instance, expressed his individuality so clearly in paint that it is not difficult to recognize certain works five hundred years later as by his hand, he was not an entirely free agent. As we shall see (p. 117), it is likely that the conception or 'programme' for the *Primavera*, for example, was not the work of the artist himself. In the case of architects in particular, the constraints of space and money as well as the wishes of the patron were (and remain) apparent. Renaissance artists generally did more or less what they were told. The constraints on them are part of their history.

Yet it would be as much a caricature to portray a Botticelli forced to produce the *Primavera* against his will as it would be to describe the idea of its coming quite spontaneously into his head one morning. Romantic notions of the spontaneous expression of individuality were not available to him. The role of painter that he played was the one defined by (or, at any rate, in) his own culture. Even outstanding individuals such as Leonardo and Michelangelo were submerged in their culture and shared, for the most part at least, the assumptions or mentalities or worldviews current in their environment (a topic discussed in detail in chapter 8). Even when individuals succeeded, as did Machiavelli and Michelangelo for example, in modifying the political or the artistic language of their time, their success was due not only to their own gifts but also to the

¹ Williams, Culture and Society.

needs of their contemporaries, who accepted innovations only when they felt them to be appropriate. As the French historian Lucien Febvre used to say, it is not possible to think all thoughts at all times.

Febvre's colleague Fernand Braudel went even further and asserted that we are all 'imprisoned' by our mentalities. However, there are societies, and Renaissance Italy was one of them, where alternative definitions of the artist's role – and of much else – are available. This pluralism may well have been a precondition for the other achievements of the period. In any case, Braudel's metaphor of a prison is misleading. Without social experiences and cultural traditions (most obviously, languages) it would be impossible to think or imagine anything at all.

The problem for us in the twenty-first century is that the Renaissance has become, almost as much as the Middle Ages, an alien or, at the least, a 'half-alien' culture.2 The artists and writers studied in this book are becoming increasingly remote from us - or we from them. The Renaissance used to be studied as part of a 'grand narrative' of the rise of modern Western civilization, a triumphalist and elitist story that implicitly denigrated the achievements of other social groups and other cultures.³ Now that this narrative is largely rejected, along with the courses on 'Western Civilization' that were once customary in North American universities, the importance of studying the Renaissance has been called into question. On the other hand, Italian high culture of the fifteenth and sixteenth centuries has lost little if any of its appeal. Indeed, that appeal now extends well beyond Europe and the Americas. The Birth of Venus, the Mona Lisa and the frescoes by Michelangelo in the Sistine Chapel have never been so well known or so widely admired as they are in our age of global tourism and of the proliferation of images on television and the Internet.

What do these changes imply? The conclusion that virtually suggests itself at this point is that the Italian Renaissance should be studied from a perspective somewhat different from Burckhardt's. It should be reframed – in other words, detached from the idea of modernity – and studied in a 'decentred' fashion.⁴ The rise of new forms of culture need not be presented in terms of progress, as if building in the ancient Roman style, for example, was obviously superior to building in the Gothic or in the traditional Chinese manner. Such assumptions are unnecessary to the understanding of the movement or the appreciation of individual or group achievements in the period.

² Medcalf, 'On reading books'.

³ Bouwsma, 'The Renaissance and the drama'; Lyotard, Condition postmoderne.

⁴ Farago, Reframing the Renaissance; Warkentin and Podruchny, Decentring the Renaissance; Burke, 'Decentering the Renaissance'; Starn, 'Postmodern Renaissance'.'

Another way of decentring the Renaissance might be to note that the movement coexisted and interacted with other movements and other cultures in a process of unending exchange (below, p. 00).

THE APPROACH

The focus of this book is on a movement rather than the individuals who took part in it, although some of them, Michelangelo for example, never let us forget their individuality. Its concern will be not only with what linguists call the 'message', a particular act of communication (a poem, a building, a painting or a madrigal) but also with the 'code', the conventions or cultural rules that limit what can be said – but without which no message is possible. The central theme of this study is the break with one code, described at the time as 'barbaric', as 'Gothic' or as part of the 'Middle Ages' (a phrase coined by Renaissance humanists), and its replacement by another code, modelled more closely on ancient Greece and Rome but containing many new elements as well. The Florentines in particular developed in this period what may be called, with an element of paradox, a tradition of innovation.

The history of the arts at this time forms part of the general history of Italy in the fifteenth and sixteenth centuries – the history not only of changing attitudes and values but also, as we shall see, of economic booms and slumps, of political crises and changes in the balance of power, as well as the less dramatic and more gradual transformations of the social structure that will be discussed in detail in chapter 9 below. That the arts are related to the history of their time is obvious enough. The problem lies in specifying that relationship. My aim in this book is to avoid the weaknesses of two earlier approaches to the Renaissance, discussed in more detail in chapter 2. The first is *Geistesgeschichte* and the second is historical materialism, otherwise known as Marxism.

Geistesgeschichte, literally the 'history of spirit', was an approach to history that identified a 'spirit of the age' (Zeitgeist) that expressed itself in every form of activity, including the arts and above all philosophy. Historians of this persuasion, among them Jacob Burckhardt, still the greatest historian of the Renaissance, and the Dutchman Johan Huizinga, begin with ideas rather than with everyday life, stress consensus at the expense of cultural and social conflict, and assume rather vague connections between different activities. Historical materialists, on the other hand, begin with their feet on the ground of everyday life, stress conflict at the expense of consensus, and tend to assume that culture, an expression of what they call 'ideology', is determined, directly or indirectly, by the economic and social 'base'.

Despite my admiration on one side for Burckhardt and Huizinga

and on the other for certain Marxist scholars, from Walter Benjamin to Raymond Williams (whose *Culture and Society* inspired the original title of this study), this book attempts a third approach. It takes a middle position between Marxism and *Geistesgeschichte* in the sense that it is concerned with social influences on the arts, while viewing culture as much more than the expression of economic and social trends. This middle position is not unlike that of members of the French 'Annales School', notably Marc Bloch, Lucien Febvre and Fernand Braudel. My concern with the history of mentalities, in chapter 8, and with comparative history, in chapter 11, owes a good deal to their example. The discussion of the Netherlands, for instance, is an example of what Bloch called comparisons between neighbours, while that of culture and society in Japan illustrates his idea of distant comparisons.

My ideal in this book is an 'open' social history that explores connections between the arts and political, social and economic trends without assuming that the world of the imagination is determined by these trends or forces. When we try to explain the Florentine tradition of innovation, for example, it is worth bearing in mind that Florence was one of Europe's biggest cities, dominated by businessmen such as the Medici and fiercely competitive.

The open social history practised here makes use of the ideas of a number of social theorists, but without accepting any complete theoretical 'package'. Emile Durkheim's social explanations of self-consciousness and competition, for instance, Max Weber's concepts of bureaucracy and secularization, Karl Mannheim's concern with worldviews and generations, and more recently Pierre Bourdieu's interest in social distinction and symbolic capital are all relevant to the history of the Italian Renaissance.

Also helpful in understanding the Renaissance, paradoxical as this might have seemed to Burckhardt, is the work of some social and cultural anthropologists. If the culture of Renaissance Italy has become a half-alien culture, so that historians need both to acknowledge and to try to overcome cultural distance, they have something to learn from the so-called symbolic anthropologists, who try to place myths, rituals and symbols in their social setting. Hence, like other historians of the European old regime, such as Carlo Ginzburg in *Cheese and Worms* (1976) and Robert Darnton in *The Great Cat Massacre* (1984), I have drawn on the work of anthropologists from Edward Evans-Pritchard to the late Clifford Geertz. Anthropology is obviously relevant to the study of Renaissance magic and astrology, as a great, though long neglected, cultural historian, Aby Warburg, realized long ago. It has also proved useful for approaching the problem of the functions and uses of images. More generally, the example of anthropologists helps us to distance

ourselves from modern concepts such as 'art', 'literature', and even 'the individual', concepts that were still in the process of formation in Italy in the fifteenth and sixteenth centuries and that did not have quite the same meanings that they have today.⁵

Within anthropology, particularly relevant to the questions discussed in this book is the work of the 'ethnolinguists' or the 'ethnographers of communication'. The main concern of Dell Hymes and other members of this group, like that of sociologists of language such as Joshua Fishman, is to study who is saying what to whom, in what situations and through what channels and codes. 'Saying' includes not only speaking and writing but a much wider range of 'communicative events' such as rituals, events that between them both express and constitute a culture. The relevance of this approach to a book like this, concerned as it is with the messages of paintings, plays and poems at a time when the Gothic 'code' or style was replaced by another one (at once newer and older), will be obvious enough.

The plan

The idea that the material base of society affects the arts pervasively but indirectly is expressed in this study by the order of the chapters, working outwards from a centre. The centre is what we now call the art, humanism, literature and music of Renaissance Italy, and it is briefly described in the first chapter. That chapter poses the basic problems that the rest of the book will address: Why did the arts take these particular forms at this place and time? Chapter 2 offers an account of the various solutions propounded, from the painter-historian Giorgio Vasari, already aware of the need to explain recent artistic achievements, to our own time.

The second part of the book is concerned with the immediate social environment of the arts. In the first place, in chapter 3, with the kinds of people who produced the paintings, statues, buildings, poems, and so on, that we admire so much today. Six hundred of the best-known artists and writers are studied in particular detail. Secondly, in chapter 4, with the kinds of people for whom this 'creative elite' produced their artefacts and performances, and what the patrons expected for their money. Widening out, chapters 5 and 6 examine the social uses of what we call 'works of art' and the responses of contemporary viewers and listeners – in other words, the taste of the time. These chapters present cultural and social level at the micro-level.

Some scholars, among them E. H. Gombrich, have argued that the

⁵ Burke, 'Anthropology of the Renaissance'.

⁶ Hymes, Foundations in Sociolinguistics; Fishman, 'Who speaks what language'.

social history of the arts should stop at this point, but I believe that to do this is to leave the job half done. Hence the third and last section of the book widens out still further. A description of contemporary standards of taste does not make full sense if it is not inserted into the dominant worldview of the time, described in chapter 7. Again, social groups such as artists and patrons need to be situated in the whole social framework (chapter 8) if we are to understand their ideals, intentions or demands. A final problem is that of the relation between cultural and social change. Every chapter discusses specific changes, but chapters 9 and 10 attempt to draw these different threads together and to illuminate developments in Italy by means of comparisons and contrasts, first with the Netherlands in the same period and then with a culture more remote in both space and time – Japan in its famous 'Genroku era'.

Quantitative methods

One major feature of this study, and still a controversial one, is its use of quantitative methods. The discussion of the changing subject matter of paintings, for instance, is based on a sample of some 2,000 dated paintings and illustrates what the French call *bistoire sérielle*, the analysis of a time-series. Again, the chapter on artists and writers is based on the analysis of six hundred careers. The original analysis, made in the 1960s, was facilitated by a computer, an ICT 1900, that must by now be regarded as an antique. This method of collective biography or 'prosopography' has been followed in some later studies of Renaissance Italy.[§] On the other hand, my use of statistics was described by one of the first reviewers as 'pseudoscientism'. This reaction suggests that a few words of clarification are needed, making at least two points.

The first point is that historians make implicitly quantitative statements whenever they use terms such as 'more' or 'less', 'rise' or 'decline', terms without which they would find their task of discussing change to be extremely difficult. Quantitative statements require quantitative evidence. A common criticism of quantitative methods is that they tell us only what we already know. They do indeed often confirm earlier conclusions but, like the discovery of new evidence, they also put these conclusions on a firmer base.

The second point concerns precision. The statistics are speciously precise because the exact relation of the sample analysed to the world outside it is less than certain. Hence it is useless, and indeed misleading,

⁷ Gombrich, In Search of Cultural History.

⁸ Bec, 'Statuto socio-professionale'; De Caprio, 'Aristocrazia e clero'; King, Venetian Humanism.

in this historical field at least, to offer figures as precise as '7.25 per cent', and so I have deliberately dealt in round numbers. All the same, the calculation of rough absolute figures is probably the least unreliable means of assessing relative magnitudes and the extent of changes, which are the true objects of the exercise.

A REVISED EDITION

I was invited to write this book in 1964 by John Hale, a leading figure in Renaissance studies. The moment was a good one for me, since I had recently been appointed Assistant Lecturer at the new University of Sussex, where I was teaching a course on 'Culture and Society' and another on Jacob Burckhardt. Invading the field of art history was a daunting prospect, but my entry was facilitated by a few months at the Institute for Advanced Study at Princeton in 1967, allowing fruitful conversations with Millard Meiss, James Beck and Julius Held.

A great deal has happened in, or to, art history since that time, as it has to 'plain' or general history. The social history of art, once regarded by the majority of art historians as marginal or even (given its Marxist past) as subversive, has moved closer to the centre of the discipline. Studies of art patronage in particular, in the Renaissance as in other periods, have proliferated.9 The history of collecting has attracted increasing interest from the 1980s onwards, an interest reflected in the conferences and journals devoted to this subject. In Renaissance Italy, for example, humanists such as Poggio Bracciolini, painters such as Neroccio de' Landi, aristocrats such as Isabella d'Este and even popes such as Paul II (formerly Pietro Barbo) collected classical statues, coins, cameos and, in the case of the humanist bishop Paolo Giovio, the portraits of famous people. 10 Many collectors loved the objects that they collected, but, like other forms of conspicuous consumption, collecting became a fashion and allowed individuals to maintain or improve their social status by distinguishing themselves from ordinary people in this way. Artists might portray members of the elite against a background that included favourite objects from their collections, as in the case of Bronzino's Ugolino Martelli (Plate 4.5). 11

In the 1960s, I felt somewhat isolated in my attempt to invade the ter-

⁹ Kempers, Painting, Power and Patronage; Kent and Simons, Patronage, Art and Society; Hollingsworth, Patronage in Renaissance Italy; Kent, Cosimo de' Medici; Burke, Changing Patrons, etc.

¹⁰ Pomian, Collectors and Curiosities; Elsner and Cardinal, Cultures of Collecting; Findlen, 'Possessing the past'; Salomon, 'Cardinal Pietro Barbo's collection'; Michelacci, Giovio in Parnasso.

¹¹ Bourdieu, Distinction; Burke, Historical Anthropology, ch. 10; Urquizar Herrera, Coleccionismo y nobleza.

ritory of art historians. Today, however, some art historians are invading the territory of 'plain' or general historians, writing about the family or about shopping in the Renaissance, and in the process making more use and more effective use of the evidence of images than their plain colleagues. The idea of art history has been challenged from within the discipline by partisans of what is commonly called 'visual culture'.

Plain history has changed as well. In Renaissance studies, three movements are particularly visible. We might call them the feminine, domestic and global turns.

The feminine turn

The feminine turn is linked to the rise of women's history in the 1970s, a part of the wider feminist movement. It was in that decade that the art historian Linda Nochlin asked in print, 'Why have there been no great women artists?', while the historian Joan Kelly followed this question with another, 'Did women have a Renaissance?', and the feminist Germaine Greer wrote a study of female artists under the title *The Obstacle Race*.¹³ The search for female artists in Renaissance Italy did not produce substantial results (below, p. 48). Female writers were another matter: indeed, some of them had been well known for a long time, though they now attracted more interest. Increasing attention was also paid to a number of learned ladies whose place in the history of humanism had hitherto been marginal: Isotta Nogarola of Verona, for instance (below, p. 49). Studies on the position of women in the Renaissance and on 'Renaissance feminism' multiplied.¹⁵

Since the obstacles in the way of women entering the creative elite were so numerous, scholars turned their attention to other ways in which women had made contributions to the arts, either directly as patrons or indirectly as supporters or stimulators – what the French call *animateurs*. Studies of women in Renaissance Italy who commissioned paintings, statues and buildings have proliferated. Studies of the patronage of

¹² Brown, Private Lives; Welch, Shopping in the Renaissance.

¹³ Nochlin, 'Why have there been'; Kelly, 'Did women have a Renaissance?'; Greer, Obstacle Race.

¹⁴ Pesenti, 'Alessandra Scala'; King, 'Thwarted ambitions'; Labalme, *Beyond their Sex*; Jardine, 'Isotta Nogarola' and 'Myth of the learned lady'.

¹⁵ Jordan, Renaissance Feminism; Migiel and Schiesari, Refiguring Woman; Niccoli, Rinascimento al femminile; Panizza, Women in Italian Renaissance.

¹⁶ King, Renaissance Women Patrons; Matthews-Greco and Zarri, 'Committenza artistica feminile'; Welch, 'Women as patrons'; Reiss and Wilkins, Beyond Isabella; McIver, Women, Art and Architecture; Roberts, Dominican Women; Solum, 'Problem of female patronage'.

Isabella d'Este, marchioness of Mantua, now fill half a shelf by themselves.¹⁷ Other women acted as patrons at one remove, recommending artists and writers to male relatives.¹⁸ The court of Urbino, the setting for Castiglione's famous dialogue on the courtier, has been studied from a feminist or, at any rate, from a female point of view, noting that, owing to the illness of Duke Guidobaldo, the court was dominated by the duchess, Elisabetta Gonzaga, and that women play a discreet but important role in the dialogue.¹⁹

These studies are part of a much broader trend towards making women visible in history, in the economy and in politics as well as in culture, a trend in which historians of Italy have participated.²⁰ Interest in the cultural role of women has also encouraged what might be called the 'domestic turn' in Renaissance studies.

The domestic turn

The domestic turn includes a concern with private life, with the everyday world of families, but it is most visible in the field of material culture. A major shift of interest in Renaissance studies since this book was first published in 1972 has been the rise of interest in and the revaluation of the decorative or 'applied' arts and their settings, especially the domestic interior. An earlier phase of interest was associated with the Arts and Crafts movement in Britain and its equivalents elsewhere and led to a few studies of the Renaissance from this point of view. The current shift or turn forms part of broader historical trends, notably the rise of interest in both private life and material culture.

At this conjuncture, it was possible for British scholars to obtain grants from the Arts and Humanities Research Board for two collective research projects, one on the 'Material Renaissance' and the other on the 'Domestic Interior' (including Italian interiors of the fifteenth and sixteenth centuries), while the Victoria and Albert Museum mounted an exhibition in 2006–7 entitled 'At Home in Renaissance Italy'. Scholars in Italy, the United States and France have also made important contri-

¹⁷ Braghirolli, 'Carteggio di Isabella d'Este'; Cartwright, *Isabella d'Este*; Fletcher, 'Isabella d'Este'; Brown, 'Ferrarese lady'; Campbell, *Cabinet of Eros*; Ames-Lewis, *Isabella and Leonardo*.

¹⁸ Regan, 'Ariosto's threshold patron'.

¹⁹ Zancan, 'Donna e il cerchio'; Finucci, 'Donna di corte'.

²⁰ For example, Brown and Davis, *Gender and Society*; Muir, 'In some neighbours we trust'.

²¹ Brown, Private Lives; Musacchio, Art, Marriage and Family.

²² Schiaparelli, Casa fiorentina; Schubring, Cassoni.

²³ Findlen, 'Possessing the past'; O'Malley and Welch, Material Renaissance.

butions to the turn from the 1980s to the present. Female scholars are prominent in this new field and so are museum curators. Participants in the turn have produced an important body of work on the interiors of houses, especially the urban palaces of the upper classes, as a setting for display.²⁴

Other scholars have focused attention on the different kinds of object to be found in houses, such as chairs, beds, tapestries, carpets, plates, dishes, mirrors, goblets and inkwells. They were often designed and decorated with care and skill, as in the case of the bronze inkstands by Andrea Riccio, which have become objects of interest alongside the texts written with their aid. Bronze statuettes, sometimes copies of larger works in marble, displayed the owner's taste and interest in antiquity.²⁵ Beautiful domestic objects were displayed in reception rooms, studies and bedrooms (which were sometimes open to visitors) and attracted the interest of contemporary connoisseurs such as Lorenzo de'Medici and Isabella d'Este. Botticelli's Primavera, for instance, was originally hung in a bedroom.²⁶ Historians have also examined the family rituals associated with some of these items, with the cassone (a chest for the trousseau), for example, or the birth tray (bring refreshments to a woman in childbirth, and later displayed on the wall), and with the values embedded in them.²⁷ Chests and birth trays alike were sometimes decorated with elaborate scenes of love and marriage.

This new wave of research has not only helped to bring Renaissance Italy closer to us but also encouraged a revaluation of what we perhaps too easily call its 'works of art', reproducing a distinction between 'fine art' (or, in French, *beaux-arts*), considered to be superior, and 'decorative arts', treated as inferior. The distinction was clear enough in the eighteenth and nineteenth centuries, but it may be argued that, in the case of Renaissance Italy, it is anachronistic.²⁸ The same painters might be employed painting what we call 'easel pictures' one day and birth trays the next. More exactly, it may be suggested that the distinction between fine and decorative art was emerging in Italy in the course of the period discussed in this book, a suggestion supported by Vasari's remark

²⁴ Lydecker, *Domestic Setting*; Goldthwaite, 'Empire of things'; Thornton, *Italian Renaissance Interior*; Thornton, *Scholar in his Study*; Ajmar-Wollheim and Dennis, *At Home*; Currie, *Inside the Renaissance House*; Lindow, *Renaissance Palace*; Palumbo Fossati Casa, *Intérieurs vénitiens*.

²⁵ Radcliffe and Penny, Art of the Renaissance Bronze; Warren, 'Bronzes'.

²⁶ Smith, 'On the original location'; Syson and Thornton, Objects of Virtue; Ago, Gusto for Things; Motture and O'Malley, 'Introduction'.

²⁷ Klapisch-Zuber, Women, Family and Ritual; Baskins, Cassone Painting; Musacchio, Ritual of Childbirth; Randolph, 'Gendering the period eye'.

²⁸ Guerzoni, Apollo and Vulcan.

that, in the fifteenth century, 'even the most excellent painters' decorated chests 'without being ashamed, as many would be today' (below, p. 000). However, even during the 'High Renaissance' of the early sixteenth century, a painter as famous in his own time as Raphael designed metalwork and tapestries.²⁹

The global turn

Today, the rise of global history makes the Renaissance appear smaller than it used to do, thus 'provincializing Europe', in Dipesh Chakrabarty's memorable phrase.³⁰ Like Arnold Toynbee in the 1950s, some scholars now speak of 'renaissances' in the plural, using the term to refer to a family of movements of revival.³¹ A whole series of both Byzantine and Islamic renaissances have been identified. In architecture, for instance, the late classical tradition exemplified in the church of Santa Sophia was followed in many respects in the Ottoman Empire, successor to the Byzantine Empire, in a series of mosques built in Istanbul, Edirne and elsewhere. Turning to renaissances of non-classical traditions, one thinks of the Confucian revival in the age of Zhu Xi in what Westerners call the twelfth century. Just as Pico and Ficino are known as 'neo-Platonist' philosophers, Zhu Xi is generally described as a 'neo-Confucian'.

The Italian Renaissance may still be regarded as 'the Big One' in two senses: in the sense that it was unusually protracted (lasting for some three hundred years) and also in the sense that it was unusually influential, with a posthumous career of another three hundred and fifty years.³² However, what the movement owes to cultures other than ancient Greece and Rome and the medieval West deserves attention.³³ Some of these debts to other cultures have long been recognized, notably what was owed to the learned culture of Byzantium and (in the natural sciences at least) to that of the Islamic world.³⁴ Aby Warburg discovered an Indian astrological image in the Renaissance frescoes in Palazzo Schifanoia in Ferrara, an image transmitted to Italy via the Arab scholar Abu Ma'asar, known in the West as 'Albumazar'.³⁵ On the other hand, the contribution of Jewish scholars to the Renaissance, notably to the revival of Hebrew

30 Chakrabarty, Provincializing Europe.

²⁹ Syson and Thornton, Objects of Virtue, p. 160.

³¹ Toynbee, *Study of History*, Goody, *Renaissances*. ³² Burke, 'Jack Goody and the comparative history'.

³³ Burke, 'Renaissance Europe and the world'.

³⁴ Kristeller, 'Italian humanism and Byzantium'; Geanakoplos, *Interaction*; Gutas, *Greek Thought*.

³⁵ Warburg, Renewal of Pagan Antiquity, pp. 563-92.

studies, for example the ways in which the Renaissance affected communities of Jews in Italy, has been studied only relatively recently.³⁶

Turning to material culture, objects from the world beyond Europe were appreciated in Renaissance Italy. Lorenzo de'Medici received a piece of Chinese porcelain as a present in 1487, while some blue and white Chinese bowls are recognizable in Giovanni Bellini's *Feast of the Gods*. By the sixteenth century, Genoese craftsmen were producing imitations of Ming porcelain. Grand Duke Cosimo de'Medici owned objects from Africa such as forks, spoons, salt-cellars and ivory horns made in what is now known as an 'Afro-Portuguese' style. As for the New World, Mexican artefacts ranging from mosaic masks to pictographic codices circulated in the circle of the Medici.³⁷

However, the culture from which both artists and humanists appropriated the most was the Islamic world. Venetian merchants lived in Cairo, Damascus and Istanbul, while some visited Persia and India. Some artists also travelled eastwards, among them Gentile Bellini. Conversely, the Muslim geographer al-Hasan ibn Muhammad al-Wazzan, better known in the West as Leo Africanus, lived for some time in Rome and wrote his description of Africa there. In the case of literature, there is a remarkable parallel between the lyrics of Petrarch and his followers and Arab *ghazals*, evoking the sweet pain of love, the cruelty of the beloved, and so on, a tradition that was transmitted to Petrarch via Sicily or the troubadours of Provence, who were in touch with Muslim Spain. Under the control of the second of the secon

Among the Italian humanists, Giovanni Pico della Mirandola was particularly open to ideas from different cultures. In his famous oration on the dignity of humanity, Pico quoted a remark by 'Abdala the Saracen', as he called the scholar best known as 'Abd Allah Ibn Qutayba, to the effect that that nothing is more wonderful than man.⁴¹ The commentary on Aristotle's *Poetics* by the Muslim humanist Ibn Rushd ('Averroes') was published in Latin translation in Venice in 1481, while the physician Ibn Sina ('Avicenna') was studied in Italian universities in the Renaissance as he had been in the later Middle Ages.⁴² It was recently argued that Filippo Brunelleschi was in debt, for his famous discovery

³⁷ Heikamp, Mexico and the Medici.

³⁹ Zhiri, Afrique au miroir; Davis, Trickster Travels.

³⁶ Bonfil, 'Historian's perception' and *Rabbis and Jewish Communities*; Tirosh-Rothschild, 'Jewish culture'.

³⁸ Raby, *Venice*; Brotton, *Renaissance Bazaar*; Howard, 'Status of the oriental traveller'.

⁴⁰ Gabrieli, *Testimonianze*, p. 47; Menocal, *Arabic Role*, pp. xi, 63, 117–18.

Makdisi, Rise of Humanism, p. 307.
 Siraisi, Avicenna in Renaissance Italy.

of the laws of perspective, to the writings of another medieval Muslim scholar, Ibn al-Haytham ('Alhazen').⁴³

In the case of architecture, it is clear that the famous fifteenth-century hospitals of Florence and Milan followed the design of hospitals in Damascus and Cairo. It has also been suggested that Piazza San Marco was inspired by the courtyard of the Great Mosque at Damascus, while the Doge's Palace drew on Mamluk architecture. 44 Again, the façade of the palace of Ca' Zen in Venice, built between 1533 and 1553, includes oriental arches, doubtless an allusion to the economic and political involvement of the Zen family in the affairs of the Middle East. 45

The fashion for collecting Turkish objects, such as carpets from Anatolia and ceramics from Iznik, reveals that the Ottoman world was a source of attraction as well as anxiety at this time. Indeed, some Venetian craftsmen produced imitations of Turkish products such as leather shields. 46 Perhaps the biggest debt of Renaissance artists to Islamic culture was to the repertoire of decorative motifs that we still describe as 'arabesques', employed in printed ornaments, book-bindings, metalwork and elsewhere. These arabesques became fashionable in Venice around the year 1500, but the designs soon spread more widely. Cellini, for instance, attempted to emulate the decoration on Turkish daggers. 47 It is possible that Western culture had been more open to exotic influences in the Middle Ages than it became in the Renaissance, especially the 'High' Renaissance of the early sixteenth century, in which humanists and artists were impressed by the rules for good writing and good building formulated by the ancient Romans Cicero and Vitruvius. In the less dignified domain of the decorative arts, however, the obstacles to eclecticism were less powerful.

The challenge of a new edition is to take account of new research by hundreds of scholars and to offer readers a synthesis despite the centrifugal tendencies of research on this large topic. After more than forty years, two changes of name and much revision, the book is beginning to resemble the famous ship of the Argonauts, in which one plank after another was replaced in the course of a long voyage. Whether or not *The Italian Renaissance* remains the same book, I am very happy that Polity has decided to launch it once again.

Cambridge, February 2013

⁴³ Belting, Florence and Baghdad.

⁴⁴ Quadflieg, Filaretes Ospedale maggiore in Mailand; Howard, Venice and the East, pp. 104, 120, 178.

⁴⁵ Concina, Dell'arabico.

⁴⁶ Mack, Bazaar to Piazza; Contadini, 'Middle Eastern objects'.

⁴⁷ Morison, Venice and the Arabesque.

Part I

THE PROBLEM

-aar

THE ARTS IN RENAISSANCE ITALY

In the age of the cultural movement known as the Renaissance, more or less the two centuries 1350-1550, Italy was neither a social nor a cultural unit, although the concept of 'Italia' existed. It was simply 'a geographical expression', as Count Metternich said in 1814 (nearly half a century before Italy would become a unified state). However, geography influences both society and culture. For example, the geography of the region encouraged Italians to devote more attention to commerce and the crafts than their neighbours did. The central location of the peninsula in Europe, and easy access to the sea, gave its merchants the opportunity to become middlemen between East and West, while its terrain, one-fifth mountainous and three-fifths hilly, made farming more difficult than it was in England (say) or France. It is hardly surprising that Italian cities such as Genoa, Venice and Florence should have played a leading part in the commercial revolution of the thirteenth century, or that in 1300 some twenty-three cities in north and central Italy had populations of 20,000 or more apiece. City-republics were the dominant form of political organization at this time. A relatively numerous urban population and a high degree of urban autonomy underpinned the unusual importance of the educated layman (and to a lesser degree the educated laywoman). It would be difficult to understand the cultural and social developments of the fifteenth and sixteenth centuries without reference to these preconditions.1

In the late thirteenth and early fourteenth centuries, a number of citystates lost their independence, and in the 1340s Italians, like people elsewhere in Europe and in the Middle East, were hit by slump and plague. However, the tradition of the urban way of life and of an educated laity survived and was central to the Renaissance, a minority movement that probably meant little or nothing to the majority of the population. Most Italians, about 9 or 10 million people altogether, were peasants, living

¹ Waley, Italian City-Republics; Martines, Power and Imagination, chs 1-4; Larner, Italy in the Age of Dante and Petrarch.

for the most part in poverty. They too had a culture, which is worth study, can be studied and has been studied, but it is not the subject of this book, which is concerned with new developments in the arts in their social context.

The aim of this book is to place, or re-place, the painting, sculpture, architecture, music, literature and learning of Renaissance Italy in their original environment, the society of the period – its 'culture' in the wider sense of that flexible term. In order to do this it is advisable to begin with a brief description of the main characteristics of the arts at this time. In this description the stress will fall on the viewpoint of posterity rather than that of contemporaries. (Their point of view is discussed in chapters 5 to 7). Although they sometimes wrote of 'rebirth', they did not have a clear and distinct idea of the Renaissance as a period. They were interested in poetry and rhetoric, but our idea of 'literature' would have been foreign to them, while a concept something like our 'work of art' was only just beginning to emerge at the end of the period.

This description will emphasize characteristics common to several arts more than those which seem to be restricted to one of them, and attempt to present the period as a whole (leaving the discussion of trends within it to chapter 10). The cultural unity of the age will not be assumed (as it was, for example, by Jacob Burckhardt), but it will be taken as a hypothesis to be tested.²

The conventional nineteenth-century view of the arts in Renaissance Italy (a view still widely shared today, despite the labours of art historians) might be summarized as follows. The arts flourished, and their new realism, secularism and individualism all show that the Middle Ages were over and that the modern world had begun. However, all these assumptions have been questioned by critics and historians alike. If they can be saved, it is only at the price of radical reformulations.

To say that the arts 'flourished' in a particular society is to say, surely, that better work was produced there than in many other societies, which leads one straight out of the realm of the empirically verifiable. It no longer seems as obvious as it once did that medieval art is inferior to that of the Renaissance. Raphael has been judged a great artist and Ariosto a great writer from their own time to the present, but there has been no such consensus about Michelangelo, Masaccio or Josquin des Près, however high their reputation now stands. All the same, few would quarrel with the suggestion that Renaissance Italy was a society where

² The cases for and against the idea of the cultural unity of an age are concisely and elegantly presented in Huizinga, 'Task of cultural history', and Gombrich, *In Search of Cultural History*. Further discussion in Burke, *Varieties of Cultural History*, pp. 183–212.

artistic achievements 'clustered'.³ The clusters are most spectacular in painting, from Masaccio (or indeed from Giotto) to Titian; in sculpture, from Donatello (or from Nicola Pisano in the thirteenth century) to Michelangelo; and in architecture, from Brunelleschi to Palladio. The economic historian Richard Goldthwaite asks, 'Why did Italy produce so much art in the Renaissance?' Not only 'more art', but also 'a greater variety'.⁴

Literature in the vernacular is a more difficult case. After Dante and Petrarch comes what has been called the 'century without poetry' (1375–1475), which is in turn followed by the achievements of Poliziano, Ariosto and many others. The fourteenth and the sixteenth centuries are great ages of Italian prose, but the fifteenth century is not (partly because scholars preferred to write in Latin).⁵ In the realm of ideas, there are many outstanding figures – Alberti, Leonardo, Machiavelli – and a major movement, that of the 'humanists', most exactly defined as the teachers of the 'humanities'.⁶

The most conspicuous gaps in this account of Italian achievements are to be found in music and mathematics. Although much fine music was composed in Renaissance Italy, most of it was the work of Netherlanders, and it is only in the sixteenth century that composers of the calibre of the Gabrielis and Costanzo Festa appear. In mathematics, the famous Bologna school belongs to the later sixteenth century.⁷

It is more useful to investigate innovation rather than 'flourishing' in the arts because the concept is more precise. In Italy, the fifteenth and sixteenth centuries were certainly a period of innovation in the arts, a time of new genres, new styles, new techniques. The period is full of 'firsts'. This was the age of the first oil-painting, the first woodcut, the first copperplate and the first printed book (though all these innovations came to Italy from Germany or the Netherlands). The rules of linear perspective were discovered and put to use by artists at this time.⁸

The line dividing new from old is more difficult to draw in the case of genres than in the case of techniques, but the changes are obvious

⁴ Goldthwaite, Wealth and the Demand for Art, p. 1.

⁶ The definition (precise, if perhaps too narrow) is that of Kristeller, *Renaissance Thought*.

³ The term comes from Kroeber, *Configurations of Culture Growth*. Although he writes as if 'culture growth' can be measured like economic growth, his comparisons and contrasts remain suggestive.

⁵ Asor Rosa, Letteratura italiana.

⁷ On mathematics, Rose, *Italian Renaissance*; on music, Palisca, *Humanism*; Owens, 'Was there a Renaissance in music?'; Fenlon, *Music and Culture*; Grove, *New Dictionary of Music*, vol. 21, pp. 178–86.

⁸ Panofsky, Perspective as Symbolic Form; Edgerton, Renaissance Rediscovery.

enough. In sculpture we see the rise of the free-standing statue, and more especially that of the equestrian monument and the portrait-bust.9 In painting, too, the portrait emerged as an independent genre. 10 It was followed rather more slowly by the landscape and the still-life. 11 In architecture, one scholar has described the fifteenth century as the age of the 'invention' of conscious town planning, although some medieval towns had been designed on a grid plan. 12 In literature, there was the rise of the comedy, the tragedy and the pastoral (whether drama or romance).¹³ In music, the emergence of the frottola and the madrigal, both types of song for several voices.¹⁴ Art theory, literary theory, music theory and political theory all became more autonomous in this period. 15 In education, we see the rise of what is now called 'humanism' and was then called 'the studies of humanity' (studia humanitatis), an academic package which emphasized five subjects in particular, all concerned with language or morals: grammar, rhetoric, poetry, history and ethics.16

Innovation was conscious, though it was sometimes seen and presented as revival. The classic statement about innovation in the visual arts is that of the mid-sixteenth-century artist-historian Giorgio Vasari, with his three-stage theory of progress since the age of the 'barbarians'. The same pride in innovations is noticeable in his description of his own work in Naples, the first frescoes 'painted in the modern manner' (*lavorati modernamente*). He makes frequent contemptuous references to what he calls the 'Greek style' and the 'German style' – in other words, Byzantine and Gothic art.¹⁷ Musicians also thought that great innovations had been made in the fifteenth century. Johannes de Tinctoris,

⁹ Pope-Hennessy, *Italian Renaissance Sculpture*; Seymour, *Sculpture in Italy*; Avery, *Florentine Renaissance Sculpture*; Janson, 'Equestrian monument'.

¹⁰ The many studies include Pope-Hennessy, *Portrait in the Renaissance*; Campbell, *Renaissance Portraits*; Partridge and Starn, *Renaissance Likeness*; Simons, 'Women in frames'; Mann and Syson, *Image of the Individual*; Cranston, *Poetics of Portraiture*; Christiansen and Weppelmann, *Renaissance Portrait*.

¹¹ On the landscape, Gombrich, *Norm and Form*, pp. 107–21, and Turner, *Vision of Landscape*; on the still-life, Sterling, *Still Life Painting*, and Gombrich, *Meditations*, pp. 95–105.

¹² Westfall, In this Most Perfect Paradise. For general trends, Heydenreich and Lotz, Architecture in Italy; Millon, Italian Renaissance Architecture.

¹³ Herrick, Italian Comedy and Italian Tragedy.

¹⁴ Einstein, Italian Madrigal; Bridgman, Vie musicale, ch. 10.

¹⁵ Panofsky, *Idea*; Blunt, *Artistic Theory*; Weinberg, *History of Literary Criticism*; Skinner, *Foundations*.

¹⁶ Kristeller, Renaissance Thought, ch. 1

¹⁷ On Vasari's view of 'progress', Panofsky, Meaning in the Visual Arts, pp. 147–235; Gombrich, 'Vasari's Lives'.

a Netherlander living in Italy, writing in the 1470s, dated the rise of modern composers (the *moderni*) to the 1430s, adding that, 'Although it seems beyond belief, there does not exist a single piece of music regarded by the learned as worth hearing which was not composed within the last forty years.' 18

This disrespectful attitude to the past suggests the possibility that one reason for the central place of Italy in the Renaissance was the fact that Italian artists had been less closely associated with the Gothic style than their colleagues in France, Germany or England. Innovations often take place in regions where the previously dominant tradition has penetrated less deeply than elsewhere. Germany, for example, was less deeply affected by the Enlightenment than France, and this facilitated the German transition to Romanticism. Similarly, it may have been easier to develop a new style of architecture in Florence in the fifteenth century than in Paris or even Milan.

All the same, Renaissance Italians had not lost their reverence for tradition altogether. What they did was to repudiate recent tradition in the name of a more ancient one. Their admiration for classical antiquity allowed them to attack medieval tradition as itself a break with tradition. When, for example, the fifteenth-century architect Antonio Filarete referred to 'modern' architecture, he meant the Gothic style which he was rejecting. His position was not unlike that of the rebels and reformers of late medieval and early modern Europe, who regularly claimed to be going back to the 'good old days', before certain evil customs had become established. In any case the enthusiasm for classical antiquity is one of the main characteristics of the Renaissance movement, which cultural historians have to make intelligible, whether they discuss it in terms of the affinity between the two cultures, as a means of legitimating innovation in a traditional society, or as an extension to the arts of the political glamour of ancient Rome.

In architecture, this tendency to imitate the Greeks and Romans is particularly obvious. The treatise by the Roman writer Vitruvius was studied, and ancient buildings were measured, in order to learn the classical 'language' of architecture, not only the vocabulary (pediments, egg-and-dart mouldings, Doric, Ionic and Corinthian columns, and so on) but also the grammar, the rules for combining the different elements. In the case of sculpture, such innovations as the portrait-bust and the equestrian statue were ancient genres revived.²⁰ In the case of literature,

¹⁸ From the preface of Tinctoris, *Contrapunctus*, discussed in Lowinsky, 'Music of the Renaissance as viewed by Renaissance musicians'.

¹⁹ Filarete, Treatise on Architecture.

²⁰ Dacos, 'Italian art'.

it is again easy to see how writers of comedy imitated the Romans Terence and Plautus, writers of tragedy, Seneca, and writers of epic, Virgil.

Painting and music are more intriguing cases because classical models were not available (the Roman paintings now discussed by scholars were discovered only in the eighteenth century or later). The lack of concrete exemplars did not rule out imitation on the basis of literary sources. Botticelli's *Calumny* and his *Birth of Venus*, for example, are attempts to reconstruct lost works by the Greek painter Apelles.²¹ The literary criticism of classical writers such as Aristotle and Horace was pressed into service to provide criteria for excellence in painting on the principle that, 'as is poetry, so is painting'.²² Discussions of what Greek music must have been like were based on passages in Plato or on classical treatises such as Ptolemy's *Harmonika*.²³ However, this interest in Greek music comes relatively late, in the sixteenth century. For this reason the idea of a musical 'Renaissance' in the fifteenth century has been challenged.²⁴

Contemporary descriptions of changes in the arts are indispensable sources for understanding what was happening, but, like other historical sources, they cannot be taken at their face value. Contemporaries generally claimed to be imitating the ancients and breaking with the recent past, but in practice they borrowed from both traditions and followed neither completely. As so often happens, the new was added to the old rather than substituted for it. Classical gods and goddesses did not drive the medieval saints out of Italian art but coexisted and interacted with them. Botticelli's Venuses are difficult to distinguish from his Madonnas. while Michelangelo modelled the Christ in his Last Judgement on a classical Apollo. In sixteenth-century Venice, inventories of furnishings show that religious paintings in the 'Greek' style (in other words, icons) continued to be displayed.²⁵ Architecture in particular developed hybrid forms, partly classical and partly Gothic.²⁶ As we have seen (above, pp. 12-14), cultural hybridity and cultural translation are much older than our own age of globalization.

In the case of literature, the poets Jacopo Sannazzaro and Marco Girolamo Vida wrote epics on the birth and the life of Christ in the manner of Virgil's *Aeneid*, combining Christian material with classi-

²¹ Cast, Calumny of Apelles; Massing, Du texte à l'image.

²² Lee, 'Ut pictura poesis'.

²³ Palisca, Humanism.

²⁴ Owens, 'Was there a Renaissance in music?'.

²⁵ Morse, 'Creating sacred space', p. 159.

²⁶ Schmarsow, Gotik.

cal form.²⁷ A Renaissance prince would be as likely to read or listen to the medieval romance of Tristan as to the classical epic of Aeneas, and Ariosto's *Orlando Furioso* is a hybrid epic-romance set in the age of Roland and Charlemagne. Indeed, the interpenetration of chivalric and humanist attitudes was great enough for one scholar to speak of 'chivalric humanism'.²⁸ Poliziano's pastoral drama *Orfeo* begins with the entry of Mercury, who takes over the place and function of the angel who commonly introduced Italian mystery plays.

Again, the rise of humanism did not drive out medieval scholastic philosophy (despite the deprecating remarks the humanists made about the *scholastici*). Indeed, leading figures in the Renaissance movement, such as the neo-Platonist Marsilio Ficino, were well read in medieval as well as in classical philosophy. Lorenzo de'Medici, the ruler of Florence, can be found writing to Giovanni Bentivoglio, the ruler of Bologna, asking him to search the local bookshops for a copy of the commentary on Aristotle's *Ethics* by the late medieval philosopher Jean Buridan, while Leonardo da Vinci studied the work of Albert of Saxony and Albert the Great.²⁹

Realism, secularism and individualism are three features commonly attributed to the arts in Renaissance Italy. All three characteristics are problematic. In the case of the term 'realism', several different problems are involved. In the first place, although artists in a number of cultures have claimed to abandon convention and imitate 'nature' or 'reality', they have nevertheless made use of some system of conventions.³⁰ In the second place, since the term 'realism' was coined in nineteenth-century France to refer to the novels of Stendhal and the paintings of Courbet, its use in discussions of the Renaissance encourages anachronistic analogies between the two periods. In the third place, the term has too many meanings, which need discrimination. It may be useful to distinguish three kinds of realism: domestic, deceptive and expressive.

'Domestic' realism refers to the choice of the everyday, the ordinary or the low status as a subject for the arts, rather than the privileged moments of privileged people. Courbet's stonebreakers and Pieter de Hooch's scenes from everyday Dutch life are examples of this 'art of describing'. 'Deceptive' realism, on the other hand, refers to style, for example to paintings which produce or attempt to produce the illusion

²⁷ Wind, Pagan Mysteries, p. 29.

Folena, 'Cultura volgare'.
 Ady, Bentivoglio of Bologna.

³⁰ The classic discussion of this problem in the case of painting is Gombrich, *Art and Illusion*. Other important studies of realism are Huizinga, 'Renaissance and realism', Auerbach, *Mimesis*, and Wellek, *Concepts of Criticism*, pp. 222–55.

³¹ Alpers, Art of Describing, esp. the introduction.

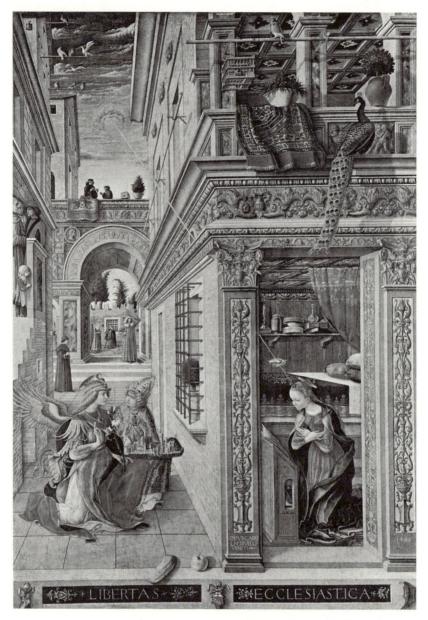

Plate 1.1 Carlo Crivelli: The Annunciation with Saint Emidius, 1486

that they are not paintings. 'Expressive' realism also refers to style, but to the manipulation of outward reality the better to express what is within, as in the case of a portrait where the shape of the face is modified to reveal the sitter's character or a natural gesture is replaced by a more

eloquent one.

How useful are these concepts in approaching the arts in Renaissance Italy? Expressive realism is not difficult to identify in Leonardo's Last Supper, say, or in the paintings of Raphael and Michelangelo; the only difficulty lies in finding a period in which works of art do not have this trait. More of an innovation in the paintings of the Italian Renaissance (as in the Flemish art of the period) is the domestic realism of the backgrounds, Carlo Crivelli's Annunciation, for example (Plate 1.1), lingers lovingly on carpets, embroidered cushions, plates, books and the rest of the interior decoration of the Virgin's room. Ghirlandaio's Adoration of the Shepherds (Plate 1.2) includes, as the art historian Heinrich Wölfflin put it, 'the family luggage - a shabby old saddle lying on the ground with a small cask of wine beside it'. 32 It is important to see that the details are there, but also to remember that they are merely in the background. Today, we often see the details as genre paintings in miniature, and reproduce them as such. Contemporaries, on the other hand, did not have the concept of genre picture, and may well have seen the details as symbolic or as ornaments to fill up a blank space.

It is possible to find similar domestic details in the literature of the time, in the mystery plays, for example. In one anonymous play on the birth of Christ the shepherds, Nencio, Bobi, Randello and the rest, bring food with them when they go to adore the Saviour, and eat it on stage.³³ In literature, however, unlike painting, there were genres in which domestic realism filled the foreground. There was the novella, for example, the short story dealing with the lives of ordinary people, a favourite Italian genre between Boccaccio in the fourteenth century and Bandello in the sixteenth. The comedy might portray peasant life, as in the case of the plays in Paduan dialect written and performed by Antonio Beolco il Ruzzante ('the jester'). Music too might attempt to re-create hunting or market scenes. The idea of domestic realism might be extended to include pictorial narratives in what has come to be called the 'eyewitness style', by Vittore Carpaccio, for example (Plate 5.7), on the grounds that these paintings might be used to prove that certain events had really taken place.34

More difficult is the question of deceptive realism. From Vasari to

³² Wölfflin, Renaissance and Baroque, p. 218.

D'Ancona, Sacre rappresentazioni, pp. 197–8; cf. Phillips-Court, Perfect Genre.
 Brown, Venetian Narrative Painting; cf. Hope, 'Eyewitness style'.

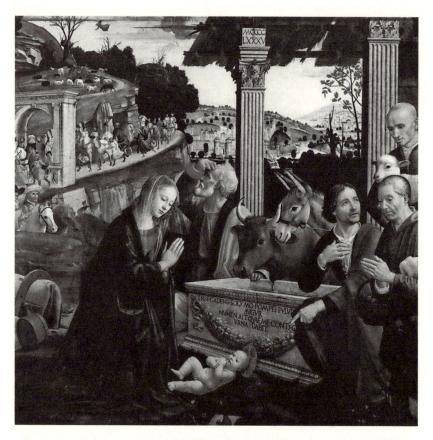

Plate 1.2 Domenico Ghirlandaio: Adoration of the Shepherds, Santa Trinità, Florence

Ruskin and beyond, the Renaissance was generally seen as an important step in the rise of more and more accurate representations of reality. At the beginning of this century, however, this notion was challenged, just at the time (surely no coincidence) of the development of abstract art. Heinrich Wölfflin, for example, suggested that 'it is a mistake for art history to work with the clumsy notion of the imitation of nature, as though it were merely a homogeneous process of increasing perfection', while another celebrated art historian, Alois Riegl, wrote more dramatically still that 'Every style aims at a faithful rendering of nature and nothing else, but each has its own conception of nature.'³⁵

³⁵ Wölfflin, *Principles of Art History*, p. 13; Riegl, quoted in Gombrich, *Art and Illusion*, p. 16.

At this point the reader may well be thinking that the Renaissance discovery of linear perspective is a counter-example, but even this argument was challenged by the art historians Erwin Panofsky and Pierre Francastel, who argued that perspective is a 'symbolic form', 'a set of conventions like any other', depending on monocular vision. This was the point of Brunelleschi's famous box with a peephole in it, to which the viewer could put one eye and see, reflected in a mirror, a view of the Baptistery in Florence.36

If these arguments are valid, to talk about 'Renaissance realism' is to talk nonsense. However, Riegl's arresting formulation is in danger of unfalsifiability, of circularity. The evidence of an artist's conception of nature comes from his paintings, but the paintings are then interpreted in terms of that same conception. It seems more useful to start from the empirical fact that some societies, like some individuals, take a particular interest in the visible world, as it appears to them, and that Renaissance Italy was one of these. Wax images, often life-size and dressed in the clothes of the person they represented, were placed in churches, lifemasks and death-masks were frequently made, and some artists dissected corpses in order to understand the structure of the human body.³⁷ The point is not that deceptive realism was the only aim of the artists of the time; it is easy to show such a statement to be false. Paolo Uccello, for example, coloured his horses according to quite different criteria. However, Vasari criticized Uccello precisely for this lack of verisimilitude, and the literary sources discussed in chapter 6 suggest that many viewers expected this kind of realism and judged paintings in terms of truth to appearances.

Another distinctive feature of the Italian culture of the Renaissance was that, relative to the Middle Ages, it was secular.³⁸ The contrast should not be exaggerated. A sample study suggests that the proportion of Italian paintings that were secular in subject rose from about 5 per cent in the 1420s to about 20 per cent in the 1520s. In this case, 'secularization' means only that the minority of secular pictures grew somewhat larger.³⁹ In the case of sculpture, literature and music, it is

³⁶ On 'symbolic form', Panofsky, Perspective as Symbolic Form, a formulation which echoes the philosophy of symbolic forms of his friend Cassirer (Holly, Panofsky and the Foundations of Art History, ch. 5). On 'conventions', Francastel, Peinture et société, pp. 7, 79. Brunelleschi's box is described in Manetti, Vita di Brunelleschi, p. 9, and discussed in Edgerton, Renaissance Rediscovery, ch. 10.

³⁷ On wax images, Warburg, Renewal of Pagan Antiquity, pp. 185–222.

³⁸ Fubini, Humanism and Secularization.

³⁹ The sample taken was that of dated paintings, listed in Errera, Répertoire des peintures datées. The dangers of bias in the sample are discussed in chapter 7, and details of the pattern decade by decade are analysed in chapter 10. Cf Rowland,

more difficult to use quantitative methods, or to go beyond the obvious point that several of the new genres were secular: the equestrian statue, for example, the comedy and the madrigal.

If one tries to go further, conceptual problems become acute, as the case of what might be called 'crypto-secularization' illustrates. Pictures which are officially concerned with St George (say) or St Jerome seem to devote less and less attention to the saint and more and more to the background; the saints become smaller, for example. This trend suggests a possible tension between what the patrons really wanted and what they considered legitimate. The difficulty is that contemporaries did not make the sharp distinctions between the sacred and the secular that became obligatory in Italy in the late sixteenth century, following the Council of Trent. By later standards they were continually sanctifying the profane and profaning the sacred. Masses were based on the tunes of popular songs. The philosopher Marsilio Ficino liked to call himself a 'priest of the Muses', and there was a 'chapel of the Muses' in the palace at Urbino. God and his vicar the pope might be addressed as 'Jupiter' or 'Apollo'. Some people, such as Erasmus, who visited Rome in 1509, were scandalized by practices such as these, but they persisted throughout the period. as chapter 9 will suggest. If we are going to discuss the Renaissance in terms of 'secularization', we should at least be aware that we are imposing later categories on the period.

A third characteristic generally ascribed to the culture of Renaissance Italy, and discussed in detail in Burckhardt's famous book on the subject. is 'individualism'. Like 'realism', 'individualism' is a term which has come to bear too many meanings (discussed on pp. 000 below). It will be used here to refer to the fact that works of art in this period (unlike the Middle Ages) were made in a personal style. But is this really a 'fact'? To twenty-first-century observers, medieval paintings look much less like the work of different individuals than Renaissance paintings do, but this may be an illusion of the type 'all Chinese look alike' (to the non-Chinese). At all events, the testimony of contemporaries suggests that, in the fifteenth and sixteenth centuries, artists and public alike were interested in individual styles. 40 In his craftsman's handbook, Cennino Cennini advised painters 'to find a good style which is right for you' (pigliare buna maniera propia per te). In his discussion of the perfect courtier and his understanding of the arts, Baldassare Castiglione suggested that Mantegna, Leonardo, Raphael, Michelanglo and Giorgione were each perfect 'in his own style' (nel suo stilo). The Portuguese visitor to Italy Francisco de Hollanda made a similar point about Leonardo, Raphael

Heaven to Arcadia.

⁴⁰ Ames-Lewis, Drawing in Early Renaissance Italy, pp. 274-6.

and Titian: 'each one paints in his own style' (cada um pinta por sua maneira). ⁴¹ In literature, the imitation of ancient models was a matter for debate, in which some protagonists, notably Poliziano, attacked the ideal of writing like Cicero, and argued the value of individual self-expression. ⁴² There was, of course, much imitation of classical and modern artists and writers. Indeed, it was probably the norm. The point about individualism, like secularism, is not that it was dominant, but that it was relatively new, and that it distinguishes the Renaissance from the Middle Ages.

So much for the apparently obvious features of Italian Renaissance culture and the need to describe them with care. Some other general characteristics of more than one art may be worth a brief mention. There was, for example, a trend towards greater autonomy, in the sense that the arts were becoming increasingly independent from practical functions (discussed in chapter 5) and from one another. Music, for example, was ceasing to depend on words. Instrumental pieces, such as the organ compositions of Andrea Gabrieli and Marco Antonio Cavazzoni, were growing longer and more important. Sculpture was becoming more independent from architecture, the statue from the niche. There are even a few sculptures, such as the battle scene made by Bertoldo for Lorenzo de'Medici, which have no subject in the sense that they do not illustrate a story, and a few paintings at least which appear to be independent of religious, philosophical or literary meanings (a topic discussed in chapter 7). 43 It may well be significant that the term fantasia is used in this period of pictorial and musical compositions alike, to mean a work which the painter or musician has created out of pure imagination, rather than to illustrate or accompany a literary theme.

Another general characteristic of Italian culture at this time was the breakdown of compartments, the cross-fertilization of disciplines. The gap between theory and practice in a number of arts and sciences narrowed at this time, and this was a cause or consequence of a number of famous innovations. For example, Brunelleschi's box, which dramatized his discovery of the rules of linear perspective, was a contribution to optics (called *perspective* in his day) as well as to the craft of painting. The humanist Leon Battista Alberti was a man of theory, a mathematician, as well as a man of practice, an architect, and each

⁴¹ Cennini, *Libro dell' arte*, p. 15; Castiglione, *Cortegiano*, bk 1, ch. 37, adapting Cicero, *De oratore*, bk 2, ch. 36; Hollanda, *Da pintura antigua*, p. 23. Cf. Wittkower, 'Individualism in art and artists'.

On this debate, Fumaroli, L'âge de l'éloquence, pt 1; Greene, Light in Troy.
 C. Gilbert, 'On subject and not-subject'; Gombrich, Norm and Form, pp. 122-8;
 Hope, 'Artists, patrons and advisers'; Hope and McGrath, 'Artists and humanists'.

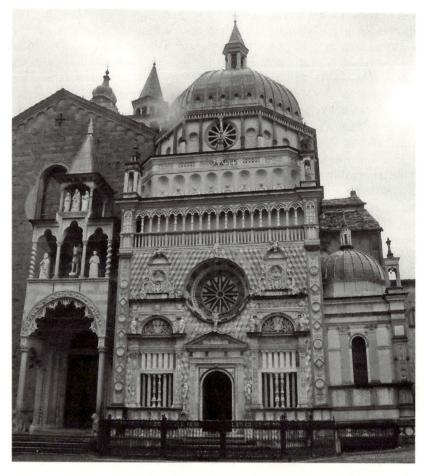

PLATE 1.3 THE COLLEONI CHAPEL IN BERGAMO

kind of study helped the other. His churches and palaces were built on a system of mathematical proportions, while he told scholars that they could learn from observing craftsmen at work. Again, Leonardo's studies of optics and anatomy were used in his paintings. Some writers on music, such as the monk Pietro Aron, a member of the papal chapel in Pope Leo X's time and the author of a series of treatises known as *Toscanella*, bridged the traditional gap between the theorist of music and the player–composer. In the history of political thought Machiavelli, a sometime professional civil servant, bridged the gap between the academic mode of thought about politics, exemplified in the 'mirror of princes' tradition of treatises dealing with the moral quali-

ties of the ideal ruler, and the practical mode of thought, which can be illustrated in the records of council meetings and in the dispatches of ambassadors.⁴⁴

Another gap which was closing was the one between the culture of the different regions of the peninsula, as Tuscan achievements became the model for the rest. The reception of the Italian Renaissance abroad was preceded by the reception of the Tuscan Renaissance in other parts of Italy. Florentine innovations were introduced by Florentine artists, such as Masolino in Castiglione Olona (in Lombardy), Donatello in Padua and Naples, Leonardo in Milan, and so on, while the dialect of Tuscany established itself as the literary language of the entire peninsula. Marked regional variations continued to exist throughout the period; Venetian painting, for example, stressed colour where Tuscan painting stressed form (disegno), and Lombard architecture emphasized ornament (Plate 1.3) where Tuscan architecture emphasized simplicity (Plate 6.1). However, the minor art centres, such as Siena or Emilia, were gradually attracted into the orbit of the greater ones. The rise of Rome, a city which lacked a strong artistic tradition of its own but became a major centre of patronage in the early sixteenth century, encouraged an inter-regional art. Like literature, the visual arts were more Italian in 1550 than they had been a hundred or two hundred years before.⁴⁵

⁴⁴ Cf. Panofsky, 'Artist, scientist, genius', p. 128, on 'decompartmentalization'; Chastel, 'Art et humanisme au quattrocento' on 'décloisonnement'. On Machiavelli, Albertini, *Das florentinisch Staatsbewusstsein*, and Gilbert, 'Florentine political assumptions'.

⁴⁵ A succinct survey of regional styles can be found in the *Encyclopaedia of World* Art under 'Italian art'.

THE HISTORIANS: THE DISCOVERY OF SOCIAL AND CULTURAL HISTORY

The problem of explaining the clustering of so many outstandingly creative individuals in this period – as in the case of ancient Greece and Rome – is one which has concerned historians since the Renaissance itself. The humanist Leonardo Bruni believed that politics was the key to the problem. Like Tacitus, he thought that the end of the Roman Republic had meant the decline of Roman culture. 'After the Republic had been subjected to the power of a single head, those outstanding minds vanished, as Tacitus says.' Conversely, he suggested (at least by implication) that the literary achievements of the Florentines were the result of their liberty.¹ A hundred years later, Machiavelli remarked that letters flourish in a society later than arms; first come the captains, then the philosophers.²

It was Giorgio Vasari, however, who first offered a detailed analysis of the problem. Vasari is, of course, the most indispensable source for the art history of the Italian Renaissance: a writer who was also an artist (though he lived towards the end of the period, so that he is as far away from Masaccio as we are from the Pre-Raphaelites, and his information is correspondingly second- or third-hand). We use him, as some Renaissance architects used the ruins of ancient Rome, as a quarry for raw material. However, we should remember that he was himself, in collaboration with the Florentine scholar Don Vincenzo Borghini, a serious historian.³ Although he was concerned most with individual achievement, Vasari found room in his lives of painters, sculptors and architects for what we might call the social factor. Impressed by the clustering of talents of the order of Brunelleschi, Donatello and Masaccio, he commented that 'It is Nature's custom, when she creates a man who really excels in some profession, often not to create him by himself, but to

¹ Bruni, 'Panegyric to the city of Florence', pp. 154, 174.

² Machiavelli, *Istorie fiorentine*, Bk 5, prologue.

³ Hope, 'Vite vasariane'.Cf. Frangenberg, 'Bartoli'.

produce another at the same time and in a neighbouring place to compete with him.'4

Vasari also addressed himself, in his life of Perugino, to the problem of explaining the outsized contribution of Florence to the arts, placing into the mouth of Perugino's teacher the suggestion that three incentives were present in that city which were generally lacking elsewhere.

The first was the fact that many people were extremely critical (because the air was conducive to freedom of thought), and that men were not satisfied with mediocre works . . . Secondly, that it was necessary to be industrious in order to live, which meant using one's wits and judgement all the time . . . for Florence did not have a large or fertile countryside round about it, so that men could not live cheaply there as they could in other places. Thirdly . . . came the greed for honour and glory which that air generates in men of every occupation.

Modern readers may find this emphasis on the air as the ultimate cause rather difficult to take seriously, but this difficulty should not prevent them from seeing that Vasari has offered explanations of what we would call an economic, social and psychological kind, in terms of challenge and response and the need for achievement.

It was only in the eighteenth century, however, that what contemporaries called the 'history of manners', which more or less coincides with what we describe as cultural and social history, became the object of systematic study. Voltaire, for example, tried to shift the attention of historians from wars to the arts. His *Essay on Manners* (1756) made the point – in language not unlike Vasari's – that the sixteenth century was a time when 'nature produced extraordinary men in almost all fields, above all in Italy'. ⁵

Enlightenment writers offered essentially two explanations for this phenomenon: liberty and opulence. Lord Shaftesbury explained the 'revival of painting' by the 'civil liberty, the free states of Italy as Venice, Genoa and then Florence'. If Gibbon had written the history of Florence which he once planned, it is likely that the relation between liberty and the arts would have been a central theme, as it was in his famous *Decline and Fall of the Roman Empire*. In any case the book he failed to write, or something like it, was produced only a few years later by the Liverpool banker William Roscoe. His *Life of Lorenzo de'Medici* (1795) began as follows:

⁴ Vasari, Life of Masaccio. On Vasari as historian, see Gombrich, 'Vasari's Lives'; Boase, Giorgio Vasari, Rubin, Giorgio Vasari.

⁵ Voltaire, Essai sur les moeurs, ch. 118.

⁶ Shaftesbury, Second Characters, p.129.

⁷ Hale, England and the Italian Renaissance, ch. 4.

Florence has been remarkable in modern history for the frequency and violence of its internal dissensions, and for the predilection of its inhabitants for every species of science, and every production of art. However discordant these characteristics may appear, they are not difficult to reconcile . . . The defence of freedom has always been found to expand and strengthen the mind.

The liberty theme was developed still further in the *History of the Italian Republics* (1807–18) by the Swiss historian J. C. L. S. de Sismondi.

A common Enlightenment view was that liberty encouraged commerce, while commerce encouraged culture. As Charles Burney, the historian of music, put it, 'All the arts seem to have been the companions, if not the produce, of successful commerce; and they will, in general, be found to have pursued the same course . . . that is, like commerce, they will be found, upon enquiry, to have appeared first in Italy; then in the Hanseatic towns; next in the Netherlands.' The social theorists of Scotland agreed. Adam Ferguson noted that 'the progress of fine arts has generally made a part in the history of prosperous nations'; John Millar of Glasgow pointed out that Florence led the way in 'manufactures' as well as in the arts; and Adam Smith planned to write a book about the relationship between the arts and sciences and society in general in which it is likely that – as in his Wealth of Nations – the city-states of Italy would have had a prominent place.

The Scottish theorists dreamed of a science of society on Newtonian lines. It is not unfair to describe their model of cultural change as a mechanical one. At much the same time, an alternative, organic model was being created in Germany. J. J. Winckelmann took the important step of replacing the lives of artists, in the manner of Vasari, by a *History of Ancient Art* (1764), in which he discussed the relation between art and the climate, the political system, and so on, in order to make art history 'systematically intelligible'. ¹⁰ J. G. Herder did much to develop the history of literature, which he saw as growing naturally out of particular local environments. Where the Scottish theorists had discussed cultural changes in terms of the impact of commerce, Herder saw art and society as parts of the same whole. 'As men live and think, so they build and inhabit.' In the case of Italy, he stressed the 'spirit' of commerce, of industry, of competition. ¹¹ A similar stress on the organic unity of a given culture can be found in the *Philosophy of History* (1837) of the philosopher

⁸ Burney, General History, vol. 2, p. 584.

⁹ Weisinger, 'English origins of the sociological interpretation'.

¹⁰ Winckelmann, Geschichter der Kunst des Altertums, vol. 1, pp. 285ff; Testa, Winckelmann.

¹¹ Herder, Ideen, bk 20. Cf. Berlin, Vico and Herder.

G. W. F. Hegel, who described the arts (like politics, law and religion) as so many 'objectifications' of spirit, the 'spirit of the age'. Discussing the Renaissance, Hegel suggested that the flowering of the arts, the revival of learning and the discovery of America were three related instances of spiritual expansion.¹²

Karl Marx was also interested in the place of the Renaissance in world history. Rejecting Hegel's emphasis on consciousness ('life is not determined by consciousness, but consciousness by life'), he returned to the eighteenth-century concern with the relation between the arts and the economy, though he showed more interest than Ferguson or even Adam Smith in the precise relationship between material production and what he called 'cultural production' (geistige Produktion). Marx and Engels (1846) suggested that the cultural 'superstructure' was shaped by the economic 'base' and that, in the case of the Italian Renaissance, 'Whether an individual like Raphael succeeds in developing his talent depends wholly on demand, which in turn depends on the division of labour and the conditions of human culture resulting from it.'13 A complementary point about 'supply' rather than 'demand' and the role of the individual in the history of the Renaissance was made by the Russian Marxist Plekhanov (1898) when he wrote that, 'If ... Raphael, Michelangelo and Leonardo da Vinci had died in their infancy, Italian art would have been less perfect, but the general trend of its development in the period of the Renaissance would have remained the same. Raphael, Leonardo da Vinci and Michelangelo did not create this trend; they were merely its best representatives.'14

It should by now be obvious that Jacob Burckhardt's famous study of *The Civilization of the Renaissance* in Italy, first published in 1860 and still influential, stands in a long tradition of attempts to relate culture to society. Burckhardt's discovery of Italy was, like Winckelmann's, one of the great experiences of his life. He came from an art-loving patrician family of Basel, which when he was born in 1818 was still a quasi-city-state, much like Florence. In the middle of the eighteenth century, a member of a rival family expressed the hope that 'Heaven would deliver us from these Medicis!' Burckhardt himself was something of a 'universal man' who sketched, played the piano, and wrote music and poetry.

Renaissance Italy was for him not unlike an idealized version of the

¹² Hegel, *Philosophy of History*, pt 4, section 2. Cf. Gombrich, *In Search of Cultural History*, a vigorous, if somewhat exaggerated critique, and Podro, *Critical Historians*, ch. 2.

¹³ Marx and Engels, German Ideology, p. 430.

¹⁴ Plekhanov, Role of the Individual, p. 53.

¹⁵ Gossman, Basel, p. 203.

world of his youth, as well as an escape from the modern, centralized. industrial society he hated. Himself a 'good private individual', he saw the Renaissance as an age of individualism. 16 In this sense his interpretation was a contribution to what has been called the nineteenth-century 'myth of the Renaissance'. 17 His 'essay', as he called it, also owes a good deal to his predecessors. Like Voltaire and Sismondi, he emphasized the importance for Renaissance culture of the wealth and freedom of the towns of northern Italy. Burckhardt's approach also owes something to Herder, Hegel, and perhaps Schopenhauer, despite the fact he claimed to put forward no philosophy of history, preferring to study what he called 'cross-sections' through a culture at particular moments in time. He shared with the philosophers a concern with the polarities of inner and outer, subjective and objective, conscious and unconscious. His study of Renaissance Italy resembles Hegel's discussion of ancient Greece in its stress on the growth of individualism and its awareness of the state as a 'work of art'. Like Herder and Hegel, Burckhardt believed that some periods, at least, should be seen as wholes, and in his Reflections on History he analysed societies in terms of the reciprocal interaction of three 'powers': the state, culture and religion. 18 In so doing he made explicit his method in The Civilization of the Renaissance in Italy.

One does not have to be a Marxist to be struck by the absence from both studies of a fourth 'power': the economy. Burckhardt admitted this himself. To a younger friend he wrote fourteen years after the publication of his *The Civilization of the Renaissance in Italy* that 'your ideas about the early financial development of Italy as the foundation (*Grundlage*) of the Renaissance are extremely important and fruitful. That was what my research always lacked.'19

What that study also lacked, as its author again admitted, was any serious discussion of Renaissance art. Burckhardt had been collecting material on the prices of paintings and on patronage, and these and other papers were found after his death with instructions that they were not to be printed. His executors were able to print three late essays on the art collector, the altarpiece and the portrait. But these essays, fascinating as they are, do not fill the gap.²⁰ Nor does the volume on the architecture of Renaissance Italy, despite its occasional remarks on the functions of buildings. It is possible that the gap was left deliberately. Although he

¹⁶ Kaegi, *Jacob Burckhardt*, esp. vol. 3. Cf. Baron, 'Burckhardt's *Civilisation*'; Ghelardi, *Scoperta del Rinascimento*; Gossman, *Basel*.

¹⁷ Bullen, Myth of the Renaissance.

¹⁸ Burckhardt, Reflections on History, ch. 3.

¹⁹ Letter to Bernhard Kugler, 21 August 1874.

²⁰ Burckhardt, *Beiträge*; the unpublished manuscripts are discussed in the introduction.

was interested in the relation between the three 'powers', each shaping and in turn being shaped by the other two, Burckhardt also believed that 'the connection of art with general culture is only to be understood loosely and lightly. Art has its own life and history.'

This last remark was made by Burckhardt in conversation with his pupil Heinrich Wölfflin, who was in a sense his intellectual heir. Wölfflin is often described as a supporter of an autonomous (or even isolationist) art history, but his approach was more subtle and somewhat ambivalent. He distinguished two approaches to innovation in the arts: the 'internalist' approach with which he is generally associated, which accounts for change in terms of an inner development, and the 'externalist' approach. according to which 'to explain a style . . . can mean nothing other than to place it in its general historical context and to verify that it speaks in harmony with the other organs of its age.'21 The illuminating observations on historical context which Wölfflin sometimes produced (such as the remarks on the social history of gesture, below p. 250) are enough to make one regret the self-denving ordinance by which he generally restricted himself to explanations of style in intrinsic terms. As a result, Burckhardt's intellectual heritage passed not to Wölfflin but to Aby Warburg.

Aby Warburg's life is reminiscent of more than one character in the novels of his contemporary Thomas Mann. The eldest son of a Hamburg banker, he rejected the world of business for the world of scholarship. It is hardly surprising that he should have been fascinated by the Medici. Warburg was not a pupil of Burckhardt's, but in 1892 he sent the older man his essay on Botticelli, and the generous comments on this 'fine piece of work' suggest that Burckhardt thought that this study of a painter's contacts with poets and humanists did not diverge in essentials from his own. It was a testimony, wrote Burckhardt, to 'the general deepening and many-sidedness' that research on the Renaissance had reached.²² Warburg was indeed many-sided. He treated the history of art as part of the general history of culture and disliked any kind of intellectual 'frontier control', as he called it. On the other hand, he was faithful to the maxim that God is to be found in the details ('Der liebe Gott steckt im Detail'). To interpret the paintings of Botticelli, for example, he went to the poems of Poliziano and the philosophy of Ficino. Warburg's interests

²¹ Wölfflin, Renaissance and Baroque, p. 79. Cf. Antoni, From History to Sociology, ch. 5, Podro, Critical Historians, ch. 6, and Holly, Panofsky and the Foundations of Art History.

²² Quoted in Kaegi, 'Das Werk Aby Warburgs', p. 285. Cf. Bing, 'A. M. Warburg'; Gombrich, *Aby Warburg*; Podro, *Critical Historians*, ch. 7, Maikuma, *Begriff der Kultur*; Bredekamp et al., *Aby Warburg*; Galitz and Reimers, *Aby M. Warburg*; Roeck, *Junge Aby Warburg*; Forster, 'Introduction'.

extended to social and economic history; in his own work the concept of the Florentine 'bourgeoisie' played a considerable part, while his friend the economic historian Alfred Doren dedicated to him a study of the Florentine cloth industry.²³

Warburg's central concern was, however, with the persistence and transformation of the classical tradition. For a thorough and detailed social history of Renaissance art, it was necessary to wait for Martin Wackernagel. Wackernagel, an art historian from Basel, made a study of Florence in the period 1420–1530 which concentrated on the organization of the arts: on workshops, patrons and the art market. In other words, he focused on what (with a rather unhappy choice of term for a book published in 1938) he called the artist's *Lebensraum*, his milieu, defined as 'the whole complex of economic-material as well as sociocultural circumstances and conditions'. Although the present study is concerned with learning, literature and music as well as the visual arts, and with Italy as a whole rather than Florence, its debt to Wackernagel is considerable.²⁴

Another attempt was made in the 1930s to fill the gap between the social and cultural history of the Renaissance. Where Wackernagel provided a detailed social history or 'sociography', Alfred von Martin (a pupil of the Hungarian social theorist Karl Mannheim) offered a sociology. His concise, elegant essay reads like a mixture of Marx and Burckhardt, with a dash of Mannheim and the German sociologist Georg Simmel. Like Burckhardt, von Martin was concerned with the themes of individualism and the origins of modernity, but he placed much more emphasis than Burckhardt on the economic basis of the Renaissance and its 'curve of development' through time. Alfred von Martin's Renaissance is a 'bourgeois revolution'. In the first part of his essay he charted the rise of the capitalist, who replaces the noble and the cleric as the leader of society. It is this social change that underlies the rise of a rational calculating mentality. In parts two and three, however, we see the bourgeois becoming timid and conservative and the individualist ideal of the entrepreneur replaced by the conformist ideal of the courtier.²⁵

It is easy to criticize this essay for its confident use of general terms such as 'Renaissance man' (or indeed 'bourgeois') or for its speculations on 'the analogy of money and intellectualism' (two powerful forces which can be applied to any end) or between democracy and the representation

²³ Doren, 'Aby Warburg'.

²⁴ On Wackernagel, see Alison Luchs's introduction to her translation of his World of the Florentine Renaissance Artist.

²⁵ W. K. Ferguson's introduction to the 1963 edition of von Martin's *Sociology of the Renaissance* offers a balanced assessment.

of nude figures in art (the idea being that nakedness is egalitarian). Its defects are partly those of a pioneer, lacking sufficient case studies in the social history of culture on which to base generalizations. *The Sociology of the Renaissance* (1932) nevertheless remains a valuable corrective and complement to Burckhardt.

Another study of the Renaissance in the tradition of Marx and Mannheim - despite the fact that its author had studied with Wölfflin - is Frederick Antal's Florentine Painting and its Social Background (1947). It starts with a vivid contrast between two Madonnas, hanging side by side in the National Gallery in London, both of them painted between 1425 and 1426, one by Masaccio and the other by Gentile da Fabriano, Masaccio's is described as 'matter-of-fact, sober and clearcut', while Gentile's is 'ornate', 'decorative' and 'hieratic' (cf. Plate 2.1). Antal went on to explain the differences by the fact that the works were intended for 'different sections of the public', more exactly different social classes, with different worldviews. The 'upper middle class', whose worldview was sober, rational and 'progressive', preferred the paintings of Masaccio, while those of Gentile appealed to the conservative 'feudal' aristocracy. Antal concluded that Masaccio's appearance on the Florentine scene reflected the rise of the upper middle class, and that he lacked followers because this class was assimilated into the aristocracy.²⁶

It is difficult not to admire this brilliant application of Marxist theory to art history. With great intellectual economy, a few central ideas of Marx are used to generate interpretations of art and society in a specific milieu as well as at a general level. All the same, Antal lays himself open to two serious charges. The first is that of anachronism, of applying to fifteenth-century Florence such modern terms as 'progressive' or even 'class' without expressing any awareness of the problems involved (some of which will be discussed in chapter 9). The second charge - and one to which von Martin must also plead guilty - is that of circularity. As Antal knew, one of Gentile da Fabriano's patrons, Palla Strozzi, was the fatherin-law of one of Masaccio's patrons, Felice Brancacci. Do these two men belong to different classes? Antal modifies his thesis by arguing that the upper middle class contained a less progressive section which borrowed a feudal ideology from the aristocracy. How do we distinguish the more progressive section of the upper middle class from the rest? By looking at the paintings they commissioned.

The most powerful critique of the Marxist approach has come from Sir Ernst Gombrich, in what was originally a review of a social history of art by Arnold Hauser (1951). Like Antal, Hauser was a Hungarian refugee who had participated in the Sunday circle in the house of the

²⁶ Meiss, 'Review of Antal'; Renouard, 'L'artiste ou le client?'.

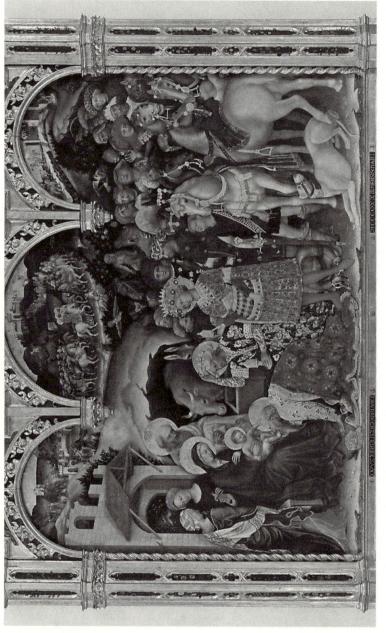

PLATE 2.1 GENTILE DA FABRIANO: ADORATION OF THE SHEPHERDS (DETAIL), GALLERIA UFFIZI, FLORENCE

critic Georg Lukács in Budapest. Gombrich distinguished two senses of the phrase 'social history of art'. The first sense he defined as the study of art 'as an institution', or as 'an account of the changing material conditions under which art was commissioned and created'. The second sense he described, and dismissed, as social history reflected in art.²⁷

It is indeed dangerous to assume that art 'reflects' society in a direct way, but the phrase 'art as an institution' is also somewhat ambiguous. It may refer to Wackernagel's *Lebensraum* – in other words, to the world of the workshop and the patron, to what sociologists call a 'micro-social' approach. Much valuable work on the social history of Renaissance art has been done along these lines, from Wackernagel to Gombrich's own study of Medici patronage and Margot and Rudolf Wittkower's study of artists. The social history of Italian literature has been approached along similar lines, following the pioneering study of Renaissance writers by Carlo Dionisotti.²⁸

The problem remains whether the study of 'the changing material conditions under which art was commissioned and created' should be limited to the immediate milieu or extended to society as a whole. It is obviously illuminating to consider the relationship between paintings and the art patronage of the time, but many historians will want to go further and ask what sociologists call 'macro-social' questions about the relationship of art patronage to other social institutions and to the state of the economy. Some historians have indeed asked this kind of question about the Italian Renaissance and come up with rather different answers, some stressing economic factors, such as Robert Lopez, and others politics, among them Hans Baron.

Lopez, was particularly interested in the economic history of Genoa (his native city), notorious for making a much smaller contribution to the Renaissance than Florence, Venice or Milan.²⁹ He argued that the fourteenth and fifteenth centuries were a period of economic recession for Europe in general and Italy in particular. He was well aware of the difficulties this recession theory creates for the conventional view of the economic preconditions of the Renaissance. The 'superstructure' seems to be out of phase with the 'base'. All the same, Lopez firmly rejected any attempt to explain away the discrepancy by suggesting that culture lags behind the economy: 'Cultural lags, as everybody knows, are ingenious elastic devices to link together events which cannot be linked by any other

²⁷ Gombrich, 'Social history of art'. Later Marxist approaches to the Renaissance include Batkin, *Italienische Renaissance*, and Heller, *Renaissance Man*.

²⁸ Gombrich, Norm and Form, pp. 35-57; Wittkower, Born under Saturn; Dionisotti, Geografia e storia.

²⁹ On the Renaissance in Genoa, Doria, G. 'Una città senza corte'.

means ... Personally, I doubt the paternity of children who were born two hundred years after the death of their fathers ... the Renaissance ... was conditioned by its own economy and not by the economy of the past.' What Lopez did was to turn the conventional view upside down and propound a theory of 'hard times and investment in culture'. Struck by the fact that medieval Italy had a booming economy and small churches, while medieval France had great cathedrals and a less successful economy, he put forward the hypothesis that the cathedrals ate up capital and labour that might otherwise have gone into economic growth. Conversely, Renaissance merchants may have had more time to spare for cultural activities because they were less busy in the office. The value of culture 'rose at the very moment that the value of land fell. Its returns mounted when commercial interest rates declined.' It is not clear how seriously, how literally, we are to take the notion of 'investment' here, and it will be necessary to return to the problem in chapter 4. However, it is plain that the prosperity theory of culture had a serious competitor.³⁰

A more political explanation of the Renaissance has been put forward by Hans Baron, a scholar who grew up during the Weimar Republic and remained committed to republican values. His study of Florence and the 'crisis' of the early Italian Renaissance (1955) noted the important changes in ideas which took place in the years around 1400. 'By then, the civic society of the Italian city-states had been in existence for many generations and was perhaps already past its prime', thus ruling out any simple social explanation of intellectual change. Instead, Baron offered a political explanation, returning to the traditional theme of liberty dear to Shaftesbury, Roscoe and Sismondi, but placing more stress on selfconsciousness and offering a close analysis of key political events. He argued that, around the year 1400, Florentines suddenly became aware of their collective identity and of the unique characteristics of their society. This awareness led them to identify with the great republics of the ancient world, Athens and Rome, and this identification with antiquity led in turn to major changes in their culture. Baron explained this rise of Florentine self-consciousness and what he called 'civic humanism' as a response to the threat to the city's liberty from the ruler of Milan, Giangaleazzo Visconti, who made an unsuccessful attempt to incorporate Florence into his empire. To become aware of one's ideals, there is nothing like fighting for them.³¹

³⁰ Lopez, 'Économie et architecture' and 'Hard times and investment'. Contrast Cipolla, 'Economic depression'; Burke, 'Investment and culture'; Goldthwaite, Wealth and the Demand for Art and Economy of Renaissance Florence; Esch and Frommel, Arte, committenza ed economia.

³¹ Baron, Crisis of the Early Italian Renaissance; cf. Fubini, 'Renaissance histo-

The value of Baron's approach, like that of Lopez, lies in what it has added to the common store rather than in sweeping away all previous accounts of the Renaissance. Baron's emphasis on political events, for example, does not make full sense without some consideration of underlying structures. Why, for instance, did Florence resist Milan when other city-states capitulated?

At a more general level, micro-social and macro-social approaches should be taken as complementary rather than contradictory. Each has its own dangers and defects. The macro-social approach runs the risk of what has been called 'Grand Theory' – too little information, too much interpretation, too rigid a framework. This approach tends to give the impression that 'social forces' (which take on a life of their own) act on 'culture' in a crudely direct way. The micro-social approach, on the other hand, runs the opposite danger of hyper-empiricism – description rather than analysis, too many facts, too little interpretation.³²

There seems to be a case for a pluralistic approach which attempts to test the broader theories, old and new, and to weave empirical studies into a general synthesis. To do this, and in particular to link micro-social to macro-social approaches, is in fact the aim of this book. It is not concerned, as is the sociology of art, with cross-cultural generalization (apart from the comparisons and contrasts offered in the last few pages). Nor is it as sharply focused on the particular as historical monographs tend to be. It deals essentially with styles, attitudes, habits and structures which were typical of a particular society over a few generations – Italy in the fifteenth and early sixteenth centuries.

Regional variation, discussed in the next chapter, was important – as it still is in Italy. The Venetian cultural achievement of the period long received considerably less than its due, partly for accidental reasons. In the sixteenth century, a Venetian (perhaps the patrician Marcantonio Michiel) collected material on the lives of painters, but this Venetian Vasari did not complete his enterprise, let alone publish it, thus robbing posterity of material necessary to counter the real Vasari's Tuscan bias. An equivalent of Wackernagel's book on Florence, planned early in the twentieth century, also remained unpublished and incomplete. It is only relatively recently that studies of the social history of the arts in Venice in this period have been published in sufficient numbers to make possible serious comparisons and contrasts with Florence.³³ Studies

rian'; Hankins, 'Baron thesis' and *Renaissance Civic Humanism*; Witt et al., 'Baron's humanism'; Molho, 'Hans Baron's crisis'. Cf. Molho, 'Italian Renaissance'.

³² Mills, Sociological Imagination, chs. 1–3.

³³ Logan, Culture and Society; Howard, Jacopo Sansovino; Rosand, Painting in Cinquecento Venice; Foscari and Tafuri, L'armonia e i conflitti; Tafuri, Venice and

of the regional cultures of Milan and Naples are also beginning to appear.³⁴

I tried to avoid giving the Florentines more than their share of the limelight; indeed, only a quarter of the artists and writers discussed in the next chapter came from Tuscany.³⁵ The primary aim of this book, however, is not so much to redress any regional imbalance, or even to explore the cultural differences between different parts of Italy, as to present a general picture against which to measure regional variation. In a similar way, the discussion of change within the period (within each section as well as in chapter 10) has been made relatively brief, in order to free the maximum space for the description and analysis of structures, for explaining how what might be called the 'art system' worked and in what ways it was related to other activities in the society. In other words, pluralistic as it is, this study does not claim to offer all the possible social interpretations of the Renaissance. In any case, the social approach is only one of a number of possible avenues to the study of the arts.

the Renaissance; Goffen, Piety and Patronage; Humfrey and MacKenney, 'Venetian trade guilds'; King, Venetian Humanism; Huse and Wolters, Art of Renaissance Venice; Feldman, City Culture; Fenlon, Ceremonial City; Humfrey, Venice and the Veneto.

³⁴ On Milan, Welch, *Art and Authority*; Pyle, *Milan and Lombardy*; Schofield, 'Avoiding Rome'. On Naples, Hersey, *Alfonso II*; Bologna, *Napoli e le rotte mediterranee*; Atlas, *Music at the Aragonese Court*; Bentley, *Politics and Culture*; Bock, 'Patronage standards'.

³⁵ The artists to be studied were drawn from the region-by-region account of the Italian Renaissance in the *Encyclopaedia of World Art*.

Part II

The Arts in their Milieu

ARTISTS AND WRITERS

RECRUITMENT

et us begin by assuming that artistic and other creative abilities are randomly distributed among the population. In conditions of perfect opportunity, a cultural elite – that is, the people whose creative abilities are recognized in that society – would be in all other respects a random sample of the population. In practice this never happens. Every society erects obstacles to the expression of the creativity of some groups, and Renaissance Italy was no exception. Six hundred painters, sculptors, architects, humanists, writers, 'composers' and 'scientists' will be studied in this chapter (and described for simplicity's sake as 'artists' and 'writers' or 'the creative elite'). Conclusions will be drawn from their collective biographies or 'prosopography'. The choice of the six hundred is necessarily somewhat arbitrary, though no more arbitrary than the choice of named individuals in other studies of the Renaissance.

In this context the terms 'architect', 'composer' and 'scientist' are convenient but problematic. The emergence of the architect, as opposed to the master mason, was taking place in this very period.³ Although the word *compositore* existed in this period, men whom we call 'composers' were more commonly described as 'musicians'. The term 'scientist' is a convenient anachronism to avoid the circumlocution 'writer in physics, medicine, etc.' As for *artista*, although Michelangelo uses the term in the

¹ On problems raised by this method, Burke, 'Prosopografie van der Renaissance'.

² For the composition of this group, see the names marked with an asterisk in the Index. No references will be given for information about individual artists derived from the Thieme–Becker *Allgemeines Lexicon*; about humanists from Cosenza's *Biographical and Bibliographical Dictionary*; or about musicians from Grove's *New Dictionary of Music*. Nor will page references be given for Vasari's *Lives*, since the lives are short and the editions are many.

³ Ettlinger, 'Emergence of the Italian architect'. Cf. Pevsner, 'The term "architect"; Ackerman, 'Ars sine scientia nihil est'; Murray, 'Italian Renaissance architect'.

modern sense, in the early fifteenth century it meant a university student of the seven liberal arts (below, p. 60).

The artists and writers examined here were in many ways untypical of the Italian population of the time. To begin with the most spectacular example of bias, one 'variable' in the survey of artists and writers appears to have been almost invariable: their sex. Only three out of the six hundred are women: Vittoria Colonna, Veronica Gambara and Tullia d'Aragona. All three are poets, and all come at the end of the period. This bias is not, of course, uniquely Italian or confined to this period, whether it is to be explained psychologically, as male creativity as a substitute for inability to bear children, or sociologically, as a result of the suppression of women's abilities in a male-dominated society. There were few 'old mistresses' in an age of 'old masters' because female artists were engaged in an 'obstacle race'.⁴

It is surely significant that, when the social obstacles were a little less massive than usual, women artists and writers made their appearance. For example, the daughters of artists sometimes painted. Tintoretto's daughter Marietta is known to have painted portraits, though nothing that is certainly by her hand has survived. Vasari tells us that Uccello had a daughter, Antonia, who 'knew how to draw' and became a Carmelite nun. Nuns sometimes worked as miniaturists, among them Caterina da Bologna, better known as a saint. There was a sculptress active in Bologna, Properzia de'Rossi, whose life was written by Vasari, with appropriate references to such gifted women of antiquity as Camilla and Sappho. Only in the later sixteenth century did female painters, notably Sofonisba Anguissciola and Lavinia Fontana, become more visible as they became more independent.

In the case of writers, it has been noted that, although 'a striking confluence of female literary talent' is already discernible in the 1480s and 1490s, 'the first literary works by living secular women began to be published in any numbers' only in the 1530s and 1540s.⁷ To the names of Vittoria Colonna, Veronica Gambara and Tullia d'Aragona one might add those of the poets Gaspara Stampa, Laura Terracina and Laura Battiferri, all six women writing towards the end of our period. Their emergence may well be a result of the increasing importance of Italian (as opposed to Latin) literature and to the opening up of literary society.

Recent research has also uncovered a small group of women who were

⁴ Nochlin, 'Why have there been no great women artists?'; Greer, Obstacle Race; Parker and Pollock, Old Mistresses.

⁵ Tietze-Conrat, 'Marietta, fille du Tintoret', attempted some identifications.

Niccoli, Rinascimento al femminile; Jacobs, Defining the Renaissance Virtuosa.
 Cox, Women's Writing in Italy, p. xiii.

interested in humanism. The most important of these learned ladies were Laura Cereta, Cassandra Fedele, Isotta Nogarola and Alessandra della Scala. They attracted some attention at the time, but they also had to face male ridicule and, whether they married or became nuns, their studies generally came to a premature end.⁸ Nuns deserve a special mention because the 'convent culture' of cities such as Florence, Rome and Venice offered opportunities for writing chronicles, performing in plays, making music and delivering Latin orations as well as needlework and copying manuscripts.⁹

Even among adult males, however, the creative elite is far from a random sample. It is, for example, geographically biased. If we divide Italy into seven regions, we find that about 26 per cent of the elite came from Tuscany, 23 per cent from the Veneto, 18 per cent from the States of the Church, 11 per cent from Lombardy, 7 per cent from south Italy, 1.5 per cent from Piedmont and 1 per cent from Liguria. Another 7 per cent came from outside Italy altogether (leaving 5.5 per cent unknown). If we compare these figures with those for the populations of these seven regions, we find that four regions (Tuscany, the Veneto, the States of the Church and Lombardy, in that order) produced more than their share of artists and writers, while the other three, from Piedmont to Sicily, were culturally underdeveloped. It is also clear that, on these criteria, Tuscany is well ahead of the others.

Another striking regional variation concerns the proportion of the elite practising the visual arts. In Tuscany, the Veneto and Lombardy the visual arts are dominant, while in Genoa and southern Italy the writers are more important. In other words, the region in which he (or occasionally she) was born appears to have affected not only the chances of an individual's entering the creative elite but also the part of it he entered.¹¹

Chances of becoming a successful artist or writer (or at least of entering the select six hundred) were also affected by the size of the community in which an individual was born. Some 13 per cent of Italians, living

⁸ Pesenti, 'Alessandra Scala'; King, 'Thwarted ambitions'; Jardine, 'Isotta Nogarola' and 'Myth of the learned lady'; Cox, Women's Writing in Italy, pp. 2–17.
9 Lowe, Nuns' Chronicles.

¹⁰ Tuscany had 10 per cent of the population and 26 per cent of the elite; the Veneto, 20 and 23 per cent; the States of the Church, 15 and 18 per cent; Lombardy, 10 and 11 per cent. On the other hand, south Italy had 30 per cent of the population and 7 per cent of the elite; Piedmont, 10 and 1.5 per cent; Liguria, 5 and 1 per cent. For statistics on writers alone, Bec, 'Lo statuto socio-professionale', p. 247.

¹¹ Tuscany, 60 per cent visual (95 to 62); the Veneto, 55 per cent (75 to 62); Lombardy, 70 per cent (45 to 19); south Italy, 58 per cent non-visual (24 to 17); while the Genoese had four humanists to one artist.

in towns of 10,000 or more people, formed the reservoir from which at least 60 per cent of the elite were drawn.

Rome's poor contribution deserves emphasis. Only four of our artists and writers were born in the city: the humanist Lorenzo Valla, the architect-painter Giulio Pippi ('Giulio Romano', Plate 3.7), the sculptor Gian Cristoforo Romano and the painter Antoniazzo Romano. It is true that Rome was no more than the eighth city in Italy at this period, but Ferrara, which was smaller, produced fifteen members of the elite, and even tiny Urbino produced seven. 12 The importance of Rome in the Renaissance, as we shall see, was as a centre of patronage, a magnet that attracted creative individuals from other parts of Italy. 13

It is only to be expected that sculptors and architects tended to come from regions where stone was plentiful and suitable for carving and building. In Tuscany, Isaia da Pisa did indeed come from Pisa, near the white marble of the west coast, while four major sculptors (Desiderio da Settignano, Antonio and Bernardo Rossellino, and Bartolomeo Ammannati) were all born in Settignano, a village near Florence with important stone quarries. Michelangelo was put out to nurse there with a stonecutter's wife, and later joked about sucking in his love of sculpture with his nurse's milk. Lombardy, with 10 per cent of the elite, had 22 per cent of the sculptors and 25 per cent of the architects, as well as much of the best stone. Domenico Gaggini and Pietro Lombardo, founders of whole dynasties of sculptors and architects, both came from the area around Lake Lugano. A third region rich in sculptors and architects as well as in stone was Dalmatia, beyond the frontiers of Italy but not far away and with economic links to Venice in particular. Luciano Laurana the architect and Francesco Laurana the sculptor both came, in all probability, from the Dalmatian town of La Vrana, while the famous sculptor Ivan Duknovic came from Trogir and the architect-sculptor Juraj Dalmatinac came from Šibenik.

These Dalmatians are a reminder of the importance of the foreign artists and writers who worked in Italy, forty-one of them altogether. There were twenty-one musicians, mostly Flemings such as Guillaume Dufay, Josquin des Près, Heinrich Isaac and Adriaan Willaert, 14 some Greek humanists, notably Janos Argyropoulos, Georgios Gemistos Plethon, and Cardinal Bessarion, and a few Spaniards, including the poet Benedetto

¹² Urbino had a population of less than 5,000, but it included the historian Polidore Vergil, the mathematician Commandino, the composers M. A. Cavazzoni and his son Girolamo, and the painters Genga, Santi and Raphael. The architect Bramante was born nearby.

¹³ Hall, Rome.

¹⁴ Bridgman, Vie musicale, ch. 7.

Gareth from Barcelona, the painter Jacomart Baço from Valencia, and the composer Ramos de Pareja.

Some of the most distinguished Italian artists and writers in Italy were 'foreign' in another sense – that is, born outside the city in which they did most of their work. The humanist Leonardo Bruni, famous for his eulogy of the city of Florence, came from Arezzo; the philosopher Ficino from Figline in the Valdarno; Leonardo da Vinci from Vinci, a village in Tuscany; the humanist Poliziano from Montepulciano. Giorgio Merula, Giorgio Valla and Marcantonio Sabellico were three non-Venetian humanists who spent considerable time in Venice. The most famous Venetian painters were not in fact from Venice itself; Giorgione was born in the small town of Castelfranco, Titian in Pieve di Cadore. It is possible that as outsiders they were freer from the pressures of local cultural traditions and so found it easier to innovate.

The creative elite appears to have been biased socially as well as geographically. A note of caution has to be sounded because the father's occupation in 57 per cent of the group is unknown. All the same, the remaining 43 per cent do tend to come from a fairly restricted social milieu. The majority of the Italian population at this time was made up of peasants or agricultural labourers, but only seven members of the elite are known to have had fathers from this class: two humanists, Bartolommeo della Scala and Giovanni Campano; one engineer–sculptor, Mariano Taccola; and four painters, Fra Angelico, Andrea del Castagno, Andrea Sansovino and Domenico Beccafumi. Of the remaining artists and writers, 114 were children of artisans and shopkeepers, 84 were noble and 48 the children of merchants and professional men. In fact, the artists tended to be the children of nobles and professional men; the contrast is a dramatic one.¹⁵

Since at least 96 artists came from artisan or shopkeeper families, it may be worth attempting to subdivide this group. It turns out that, the nearer a craft is to painting or sculpture, the higher the chance of the craftsman's son becoming an artist. In 26 cases there was no connection with the arts; the father was a tailor, for example, or a poultry-seller. In 34 cases there was an indirect connection with the arts; the father was a carpenter, a mason, a stonecutter, and so on. In 36 cases, the artist was the son of an artist, as Raphael was, for example. It is clear that

¹⁵ The known fathers of painters, sculptors and architects include 96 artisans and shopkeepers compared to 40 nobles, professional men or merchants. The known fathers of writers, humanists and scientists include 7 artisans and shopkeepers compared to 95 nobles, professional men and merchants. Cf. Bec, 'Lo statuto socio-professionale', pp. 248–9.

the arts ran in families. The Bellini family of Venice included the father, Jacopo; his more famous sons, Gentile and Giovanni; and his son-in-law, Mantegna. The Lombardo dynasty has already been mentioned – the founder, Pietro, his sons Tullio I and Antonio I, and their descendants. In the case of the Solaris, sculptors in Milan and elsewhere, there were at least five generations of artists, among them four members of the creative elite.

The sheer number of these artist families deserves emphasis. Think of an artist of the Italian Renaissance; the odds are roughly fifty–fifty that he had relatives practising the arts (48 per cent of the artists in the creative elite are known to have artist relatives). Masaccio, for example: his brother Giovanni was a painter, and Giovanni had two sons, a grandson and a great-grandson who were also painters. Titian had a brother and a son who were artists. ¹⁶ Tintoretto had two artist sons as well as his daughter Marietta.

What is the significance of these artist dynasties? The Victorian scientist Francis Galton quoted some of these examples to support his views on the importance of 'hereditary genius'. 17 However, a sociological explanation is at least as plausible as a biological one. In Renaissance Italy painting and sculpture were family businesses, like grocery or weaving. There is evidence to suggest that some artist fathers hoped that their sons would follow them into the craft; two of them at least named their children after famous artists of antiquity. The painter Sodoma called his son Apelles; the boy died young. The architect Vincenzo Seregni, equally hopeful, named his son Vitruvio; the boy survived to become an architect like his father. Guild regulations encouraged family businesses by reducing entry fees for the relatives of masters. The statutes of the painters' guild at Padua, for example, laid down that an apprentice should pay 2 lire to enter the guild unless he was the son, brother, nephew or grandson of a master, in which cases the price was halved. A master was also allowed to take a relative as an apprentice without charge. 18 The contrast between the visual arts on one side and literature and learning on the other supports the sociological against the biological explanation of artist dynasties. Nearly half the artists in the creative elite are known to have had artist relatives. In the case of literature and learning, however, which was not organized on family lines, the proportion sinks to just over a quarter (the exact figures are 48 per cent and 27 per cent, respectively). The difference between the two groups indicates the strength of social forces.

17 Galton, Hereditary Genius.

¹⁶ Tagliaferro and Aikema, Le botteghe di Tiziano.

¹⁸ Gaye, Carteggio inedito d'artisti, vol. 2, pp. 43ff.

The significance of this information about the geographical and social origins of artists and writers is that it helps to explain why the arts flourished in Italy. It is unlikely that social forces can produce great artists, but it is plausible to suggest that social obstacles can thwart them. If that is the case, it follows that art and literature flourish in those places and periods in which able men and women are least frustrated. In early modern Europe, including Italy, talented males faced two major obstacles, placed at the opposite ends of the social scale and discriminating respectively against the able sons of nobles and of peasants.

In the first place, a talented but well-born child might be unable to become a painter or a sculptor because his parents considered these manual or 'mechanical' occupations beneath him. In his lives of artists, Vasari tells several stories about parental opposition. For example, he says that, when the father of Filippo Brunelleschi (Plate 3.1) found that young Filippo had artistic inclinations, he was 'greatly displeased' because he had wanted the boy to become either a notary like himself or a physician like his great-grandfather.¹⁹ Again, we learn that Baldovinetti's family had long been merchants and that young Alesso became interested in art 'more or less against the will of his father, who would have liked him to have gone into business'. In the case of Michelangelo, the son of a patrician, Vasari comments that his father 'probably' thought Michelangelo's interest in art unworthy of their old family; but another pupil of Michelangelo claimed that the latter's father and uncles hated art and thought it shameful that their boy should practise it.²⁰

At the other end of the social scale, it was difficult for the sons of peasants to become artists and writers because they could not easily acquire the necessary training, if indeed they knew that such occupations even existed. Scala the humanist was a miller's son, but millers were relatively well off. The painter Fra Angelico and the humanist Giovanni Antonio Campano climbed the traditional ladder for poor men's sons; they entered the Church.²¹

Of four sons of peasants who became artists, stories were told which sound like folktales. Of the great fourteenth-century painter Giotto we learn that he was set to mind the sheep but was discovered by the artist Cimabue – who just happened to be passing – drawing on a rock with a piece of stone.²² In the case of Andrea del Castagno, we are told that 'he

¹⁹ However, the life of Brunelleschi attributed to Manetti and written some sixty years closer to the events records that Filippo's father made no objection, 'as he was a man of discernment'.

²⁰ Condivi, Vita di Michelangelo Buonarroti, p. 24.

²¹ On Campano, D'Amico, Renaissance Humanism, pp. 14–15.

²² The story is told by Ghiberti, Commentari, p. 32, followed by Vasari.

was taken from keeping animals by a Florentine citizen who found him drawing a sheep on a rock, and brought him to Florence.'23 Vasari adds, perhaps to flatter his own Medici patron, that this citizen was a member of the Medici family. He tells a similar story about Domenico Beccafumi, who was observed by a landowner 'drawing with a pointed stick in the sand of a little stream as he was keeping his sheep', and taken to Siena, and another about Andrea Sansovino, who 'kept cattle like Giotto, drawing in the sand and on the ground the beasts which he was watching', before he too was discovered and taken to Florence for training. These reworkings of the old myth of the birth and childhood of the hero do not have to be taken too literally. What they illustrate are contemporary perceptions of the poor boy with talent.²⁴ Yet something almost as dramatic must have happened for these boys to have become artists, and, in the case of the architect Palladio, life seems to have imitated art. There is documentary evidence that his father, a poor man, apprenticed his son to a stone-carver at Padua. The boy ran away to Vicenza, where his gifts were noticed by the humanist nobleman Gian Giorgio Trissino, on whose house he was working.25

Unlike the sons of nobles and peasants, the sons of artisans did not run such a high risk of discouragement and frustration, and many of them would have been used to thinking in a plastic manner from childhood, having watched their fathers at work. The conclusion seems inescapable that, for the visual arts to flourish in this period, a concentration of artisans was necessary – in other words, an urban environment. In the fifteenth and sixteenth centuries, the most highly urbanized regions in Europe were in Italy and the Netherlands, and these were indeed the regions from which most of the major artists came (on the Netherlands, see chapter 10).

The most favourable environment for artists to grow up in seems to have been a city which was orientated towards craft-industrial production, such as Florence, rather than towards trade or services, such as Naples or Rome. It was only when Venice turned from trade to industry, at the end of the fifteenth century, that Venetian art caught up with that of Florence.

The predominance of the sons of nobles and professional men in literature, humanism and science is not difficult to explain. A university education was much more expensive than an apprenticeship. It seems to have been as difficult for the son of an artisan to become a writer,

²³ Frey, Il libro de Antonio Billi, pp. 21-2.

²⁴ Kris and Kurz, Legend, Myth and Magic, ch. 2. Cf. Barolsky, Why Mona Lisa Smiles.

²⁵ Puppi, Andrea Palladio, ch. 1.

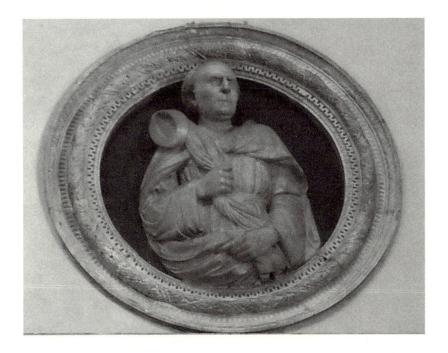

Plate 3.1 A bust of Filippo Brunelleschi, Florence Cathedral

humanist or scientist as for a peasant's son to become an artist. There are five known cases. The humanist Guarino of Verona was the son of a smith; the physician Michele Savonarola (father of the more famous friar) was the son of a weaver; the poet Burchiello, the son of a carpenter; while the professional writers Pietro Aretino and Antonfrancesco Doni were the sons of a shoemaker and a scissors-maker respectively. In other words, from the social point of view the creative elite was not one group but two, a visual group recruited in the main from artisans and a literary group recruited from the upper classes (the composers, whose social origins are rarely known, were in any case mostly foreigners).

However, the major innovators in the visual arts were often untypical of the group in their social origin. Brunelleschi (Plate 3.1), Masaccio and Leonardo were all the sons of notaries, while Michelangelo was the son of a patrician. Socially as well as geographically it was the outsiders, those with least reason to identify with local craft traditions, who made the greatest contribution to the new trends.

TRAINING

Training, like recruitment, suggests that artists and writers belonged to two different cultures, the cultures of the workshop and the university.²⁶

The painter Carlo da Milano is described in a document as 'a doctor of arts', while another painter, Giulio Campagnola, was a page at the court of Ferrara; but, in the overwhelming majority of cases, painters and sculptors were trained, like other craftsmen, by apprenticeship in workshops (botteghe) which were part of guilds that might include other kinds of artisan as well. In Venice, for instance, the guild of painters encompassed gilders and other decorators. At the beginning of our period, the process of apprenticeship was described as follows:

To begin as a shop-boy studying for one year, to get practice in drawing on the little panel; next, to serve in the shop under some master, to learn how to work at all the branches which pertain to our profession; and to stay and begin the working up of colours; and to learn to boil the sizes, and grind the *gessos* [the white ground used in painting]; and to get experience in gessoing *anconas* [panels with mouldings], and modelling and scraping them; gilding and stamping; for the space of a good six years. Then to get experience in painting, embellishing with mordants, making cloths of gold, getting practice in working on the wall, for six more years, drawing all the time, never leaving off, either on holidays or on workdays.²⁷

Thirteen years' training is a long time, and it is probably a counsel of perfection. The statutes of the painter's guild at Venice required a minimum apprenticeship of only five years, followed by two years as a journeyman, before a candidate could submit his 'masterpiece' and become a master painter with the right to open his own shop. All the same, painters were required to perform a wide variety of tasks in a variety of media (wooden panels, canvas, parchment, plaster, and even cloth, glass and iron), and it is scarcely surprising to find that they often started young. Andrea del Sarto was seven when he began his apprenticeship. Titian was nine, Mantegna and Sodoma ten. Paolo Uccello was already one of Lorenzo Ghiberti's shop-boys when he was eleven. Michelangelo was thirteen when he was apprenticed to Ghirlandaio, and Palladio the same age when he began work as a stone-carver. Child labour was common enough in early modern Europe. From the contemporary point of view,

²⁶ On workshop training, Thomas, *Painter's Practice*; Welch, *Art and Society*, pp. 79–102; Ames-Lewis, *Drawing in Early Renaissance Italy*, pp. 35–46. Cf. Ames-Lewis, *Intellectual Life*.

²⁷ Cennini, *Libro dell'arte*, p. 65. Cf. Cole, *Renaissance Artist at Work*, ch. 2; on Florence, Wackernagel, *World of the Florentine Renaissance Artist*, ch. 12, and Thomas, *Painter's Practice*; on Venice, Tietze, 'Master and workshop'.

Botticelli and Leonardo left things a little late, for Botticelli was still at school when he was thirteen, while Leonardo was not apprenticed to Verrocchio until he was fourteen or fifteen. Artists did not have time for many years at school and most of them probably learned no more than a little reading and writing. Arithmetic, taught at the so-called abacus school, was considered an advanced subject leading to a commercial career.²⁸ Brunelleschi, Luca della Robbia, Bramante and Leonardo were probably exceptional among artists in attending schools of this kind.

Apprentices generally formed part of their master's extended family. Sometimes the master was paid for providing board, lodging and instruction; Sodoma's father paid the considerable sum of 50 ducats for a seven-year apprenticeship (on the purchasing power of the ducat, see p. 230 below). In other instances, however, it was the master who paid the apprentice, at higher rates as the boy grew more highly skilled. Michelangelo's contract with the Ghirlandaio workshop laid down that he was to receive 6 florins in the first year, 8 in the second and 10 in the third.

The fact that apprentices sometimes took their master's name, as in eighteenth-century Japan, is a reminder of the importance of the master by whom an artist was trained. Jacopo Sansovino and Domenico Campagnola were not the sons but the pupils of Andrea Sansovino and Giulio Campagnola. Piero di Cosimo took his name from his master Cosimo Rosselli. It is in fact possible to identify whole chains of artists, each the pupil of the one before. Bicci di Lorenzo, for example, taught his son Neri di Bicci, who taught Cosimo Rosselli, who taught Piero di Cosimo, who taught Andrea del Sarto, who taught Pontormo, who taught Bronzino. The differences in individual style among these examples show that the Florentine system of cultural transmission was far from producing a traditional art. Again, Gentile da Fabriano taught Jacopo Bellini, who taught his sons Gentile (named after his old master) and Giovanni (who had a whole host of pupils, traditionally said to have included Giorgione and Titian).

A few workshops seem to have been of central importance for the art of the period: among Lorenzo Ghiberti's pupils, for example, were Donatello, Michelozzo, Uccello, Antonio Pollaiuolo, and possibly Masolino, and among Verrocchio's were not only Leonardo da Vinci but also Botticini, Domenico Ghirlandaio, Lorenzo di Credi and Perugino. The most important workshop in the whole period was probably that of Raphael, in which the pupils and assistants included Giulio Romano, Gianfrancesco Penni, Polidoro da Caravaggio, Perino del Vaga and Lorenzo Lotti (to be distinguished from Lorenzo Lotto). A recent study

²⁸ Goldthwaite, 'Schools and teachers'.

speaks of Raphael's 'managerial style'. Michelangelo also made considerable use of assistants, of whom thirteen have been identified for the Sistine Chapel project alone. ²⁹

An important part of the training of painters was the study and copying of the workshop collection of drawings, which served to unify the shop style and to maintain its traditions. A humanist described the process in the early fifteenth century: 'When the apprentices are to be instructed by their master . . . the painters follow the practice of giving them a number of fine drawings and pictures as models of their art.'³⁰ Such drawings formed an important part of a painter's capital, and might receive a special mention in wills, as they do from Cosimo Tura of Ferrara in 1471. Designs might be lettered in code because they were considered trade secrets, as in the case of a notebook from Ghiberti's studio.³¹

It is possible that, as deliberate individualism in style came to be prized more highly (above, p. 28), workshop drawings lost their importance. Vasari tells us that Beccafumi's master taught him by means of 'the designs of some great painters which he had for his own use, as is the practice of some masters unskillful in design', a comment which suggests that the practice was dying out.

For humanists and scientists (and, to a lesser extent, writers, for 'writer' was a role played by amateurs), the equivalent of an apprentice-ship was an education at a Latin school and a university (Plate 3.2).³² There were thirteen universities in Italy in the early fifteenth century: Bologna, Ferrara, Florence, Naples, Padua, Pavia, Perugia, Piacenza, Pisa, Rome, Salerno, Siena and Turin. Of these universities, the most important in this period was Padua, where fifty-two members of the elite were educated, seventeen of them between 1500 and 1520. The growth of the university was encouraged by the Venetian government, in whose territory Padua lay. They increased the salaries of the professors, forbade Venetians to go to other universities, and made a period of study at Padua a prerequisite for office. It was convenient to have a university outside the capital. Lodgings were cheap, and the prosperity which the students brought with them helped to secure the loyalty of a subject

²⁹ Talvacchia, 'Raphael's workshop'; Wallace, 'Michelangelo's assistants'.

³⁰ Gasparino Barzizza, quoted by Baxandall, 'Guarino, Pisanello and Manuel Chrysoloras', p. 183n. On drawings, Ames-Lewis, *Drawing in Early Renaissance Italy*, ch. 4, and Ames-Lewis and Wright, *Drawing in the Italian Renaissance Workshop*.

³¹ Prager and Scaglia, Brunelleschi, pp. 65ff.

³² Kagan, 'Universities in Italy'; Black, 'Italian Renaissance education'; Grendler, Schooling in Renaissance Italy and Universities of the Italian Renaissance; Belloni and Drusi, Umanesimo ed educazione.

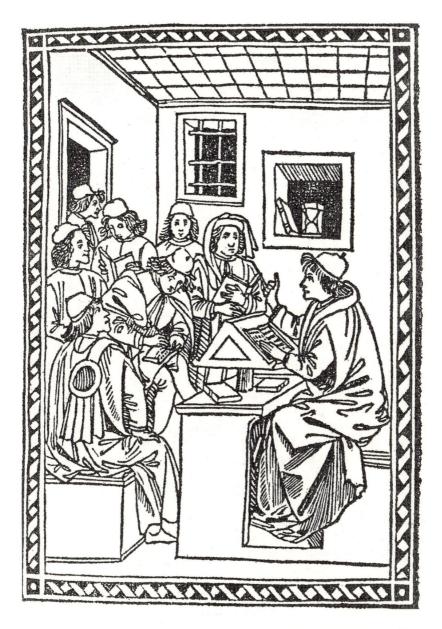

Plate 3.2 The training of a humanist at university, from C. Landino: Formulario di lettere e di orationi volgari con la preposta, Florence

town. Padua also attracted students from other regions; of the fifty-two humanists and writers who attended the university, about half were born outside the Veneto. Students of scientific subjects ('natural philosophy', as it was called, and medicine) were attracted particularly to Padua. Of the fifty-three 'scientists' in the creative elite, at least eighteen studied there.³³

The next most popular university among the elite was Bologna, with twenty-six students. The senior university of Italy, Bologna had been through a decline, but it was reviving in the fifteenth century. Next came Ferrara, with twelve members of the elite. It had an international reputation for low fees; a sixteenth-century German student wrote that Ferrara was commonly known as 'the poor man's refuge' (miserorum refugium).³⁴ Pavia (which serviced the state of Milan as Padua did Venice), Pisa (which serviced Florence), Siena, Perugia and Rome each accounted for about half a dozen of the elite. It is a pleasure to add that two of them (John Hothby and Paul of Venice) were Oxford men. Their colleges are not known.

Students tended to go to university younger than they do now; the historian Francesco Guicciardini was fairly typical in going up to Ferrara when he was sixteen. They began by studying 'arts' - in other words, the seven liberal arts, divided into the more elementary, grammar, logic and rhetoric (the trivium), and the more advanced, arithmetic, geometry, music and astronomy (the quadrivium) - and proceeded to one of the three higher degrees in theology, law or medicine. The curriculum was the traditional medieval one, and officially nothing changed during the period. However, it is well known that what is taught at university - let alone what is studied - does not always correspond to what is on the curriculum. Research on British universities in the sixteenth and seventeenth centuries, based on the notes taken by students, has shown that a number of new subjects, including history, had been introduced unofficially. No equivalent study of Italian universities has vet been made, but there is reason to believe that what was described at the time as the 'humanities' (the studia humanitatis, the phrase from which our term 'humanism' is derived), a package of rhetoric, history, poetry and ethics, was coming to displace the quadrivium. 35

³³ Since this book first appeared, there has been something of a boom in the history of universities in Italy and elsewhere, thanks to Verde, *Studio fiorentino*; Schmitt, 'Philosophy and science'; Denley, 'Recent studies on Italian universities' and 'Social function of Italian Renaissance universities'; Kagan, 'Universities in Italy'; and the synthesis by Grendler, *Universities of the Italian Renaissance*. On Padua, Giard, 'Histoire de l'université'.

³⁴ Rashdall, *Universities of Europe*, vol. 2, p. 54.

³⁵ Kearney, Scholars and Gentlemen; Kristeller, Renaissance Thought, ch. 1;

In some ways, university students resembled apprentices. The disputation by means of which the bachelor became 'master of arts' was the equivalent of the craftsman's 'masterpiece'. A master of arts had the right to teach his subject, which was something like setting up shop on his own. However, teaching and learning, oral as well as written, took place in Latin, the symbol of a separate learned culture. Spies (lupi or 'wolves') ensured that the students spoke Latin even among themselves, and those who broke the rule were fined. Another obvious difference between apprentices and university students was the expense of training. It has been calculated that, in Tuscany at the beginning of the fifteenth century, it cost about 20 florins a year to keep a boy at a university away from home, a sum which would have kept two servants.³⁶ In addition, a new recruit to the doctorate would be expected to lay on an expensive banquet for his colleagues. The doctorate of civil law at Pisa which Guicciardini took in 1505 cost him 26 florins. Even the 'poor man's refuge', Ferrara, was really the standby of the not so very well off.

Architects and composers need to be considered apart from the rest. Architecture was not recognized as a separate craft, so there was no guild of architects (as opposed to masons) and no apprenticeship system. Consequently, the men who designed buildings during this period had one curious characteristic in common – that they had been trained to do something else. Brunelleschi, for example, was trained as a goldsmith, Michelozzo and Palladio as sculptors or stone-carvers, and Antonio da Sangallo the elder as a carpenter, while Leon Battista Alberti was a university man and a humanist. There were, however, opportunities for informal training. Bramante's workshop in Rome was the place where Antonio da Sangallo the younger, Giulio Romano, Peruzzi and Raphael learned how to design buildings; its importance in the history of architecture is something like that of Ghiberti's workshop in Florence a hundred years earlier. Some famous architects, such as Tullio Lombardo and Michele Sammicheli, learned their trade from relatives.³⁷

Composers, as we call them, were trained as performers. A number of them went to choir school in their native Netherlands; Josquin des Près, for example, was a choirboy at St Quentin. The Englishman John Hothby taught music as well as grammar and arithmetic at a school attached to Lucca Cathedral which presumably catered for choirboys. Music (meaning the theory of music) was part of the arts course in universities, and several composers in the elite had degrees; Guillaume

Denley, 'Social function of Italian Renaissance universities'; Grendler, *Universities of the Italian Renaissance*, pp. 199–248.

Martines, Social World, p. 117.
 Ackerman, 'Architectural practice'.

Dufay was a bachelor of canon law, and Johannes de Tinctoris a doctor in both law and theology. There was no formal training in composition, but informally the circle of Johannes Ockeghem, in the Netherlands, was the equivalent of the workshops of Ghiberti and Bramante. Ockeghem's pupils – to mention only those who worked in Italy – included Alexander Agricola, Antoine Brumel, Loyset Compère, Gaspar van Weerbeke, and probably also Josquin des Près. From Josquin there runs a kind of apostolic succession of master–pupil relationships which links the great Netherlanders to sixteenth-century Italian composers and the Italians to the major seventeenth-century Germans. Josquin taught Jean Mouton, who taught Adriaan Willaert (Plate 3.3), a Netherlander who went to Venice and taught Andrea Gabrieli, who, at the end of our period, taught his nephew Giovanni Gabrieli, who taught Heinrich Schütz.³⁸

To sum up. In Italy at this time there were two cultures and two systems of training: manual and intellectual, Italian and Latin, workshop-based and university-based. Even in the cases of architecture and music it is not difficult to identify the ladder which a particular individual has climbed. The existence of this dual system raises certain problems for historians of the Renaissance. If artists were such 'early leavers', how did they acquire the familiarity with classical antiquity that is revealed in their paintings, sculptures and buildings? And has the famous 'universal man' of the Renaissance any existence outside the vivid imaginations of nineteenth-century historians?

Contemporary writers on the arts were well aware of the relevance of higher education. Ghiberti, for example, wanted painters and sculptors to study grammar, geometry, arithmetic, astronomy, philosophy, history, medicine, anatomy, perspective and 'theoretical design'.³⁹ Alberti wanted painters to study the liberal arts, especially geometry, and also the humanities, notably rhetoric, poetry and history.⁴⁰ The architect Antonio Averlino, who took the Greek name Filarete ('lover of virtue'), wanted the architect to study music and astrology, 'For when he orders and builds a thing, he should see that it is begun under a good planet and constellation. He also needs music so that he will know how to harmonize the members with the parts of a building.²⁴ The ideal sculptor, according to Pomponio Gaurico, who wrote a treatise on sculpture as well as practising the art, should be 'well-read' (*literatus*) as well as skilled in arithmetic, music and geometry.⁴²

³⁸ Bridgman, Vie musicale, ch. 4.

³⁹ Ghiberti, Commentari, p. 2.

⁴⁰ Alberti, On Painting; and On Sculpture, bk 3, pp. 94ff.

⁴¹ Filarete, Treatise on Architecture, bk 15, p. 198.

⁴² Gauricus, De sculptura, pp. 52ff.

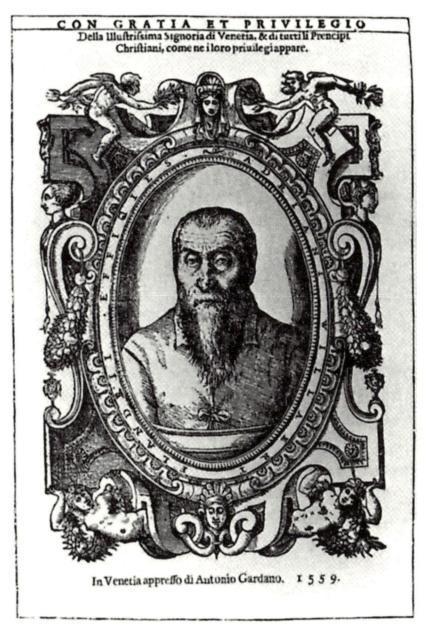

Plate 3.3 Woodcut of Adriaan Willaert, from MUSICA NOVA, 1559

Did real artists conform to this ideal? It used to be thought that the education many of them missed by leaving school early was provided for them in institutions called 'academies' (on the model of the learned societies of the humanists and ultimately of Plato's Academy at Athens), notably in Florence, centring on the sculptor Bertoldo; in Milan, around Leonardo da Vinci; and in Rome, in the circle of the Florentine sculptor Baccio Bandinelli, whose pupils were portrayed studying by candlelight (Plate 3.4). However, there is no hard evidence of the formal training of artists in institutions of this kind until the foundation in 1563 of the Accademia di Disegno in Florence, the model for the academic system set up in seventeenth-century France, eighteenth-century England and elsewhere.⁴³

All the same, it should not be assumed that artists' workshops of the Renaissance were empty of literary or humanistic culture. There was a tradition that Brunelleschi was 'learned in holy scripture' and 'well-read in the works of Dante'. 44 Some artists are known to have owned books: the brothers Benedetto and Giuliano da Maiano, for example, Florentine sculptors, owned twenty-nine books between them in 1498. More than half of the books were religious: among them a Bible, a life of St Jerome and a book of the miracles of Our Lady. Among the secular books there were the two Florentine favourites, Dante and Boccaccio, as well as an anonymous history of Florence. Classical antiquity was represented by a life of Alexander and Livy's history of Rome. The intellectual interests of the brothers revealed in this collection, traditional in orientation but with some tincture of the new learning, are not unlike those of Florentine merchants earlier in the century. 45 Artists with books like these in their possession were clearly interested in the classical past, and not only in its art, although that kind of interest can also be documented from inventories. At the time of his death in 1500, the Sienese painter Neroccio de'Landi owned several pieces of antique marble sculpture, together with forty-three plaster casts of fragments.46

The most conspicuous absence from the library of Benedetto and Giuliano da Maiano is classical mythology. There is no copy of Ovid's *Metamorphoses* or Boccaccio's *Genealogy of the Gods*. Artists with such a library as theirs would have been more at home with religious paintings and sculptures than with the mythological paintings demanded by some

⁴³ Pevsner, *Academies of Art*, ch. 1, gives the traditional view. Vasari's famous account of Bertoldo's academy has been questioned by Chastel, *Art et humanisme*, pp. 19ff. Cf. Elam, 'Lorenzo de'Medici's sculpture garden'.

⁴⁴ Frey, Il libro de Antonio Billi, p. 31.

⁴⁵ Cèndali, Giuliano e Benedetto da Maiano, pp. 182ff.; Bec, Marchands écrivains; cf. Bec, Livres des florentins.

⁴⁶ Coor, Neroccio de'Landi, p. 107.

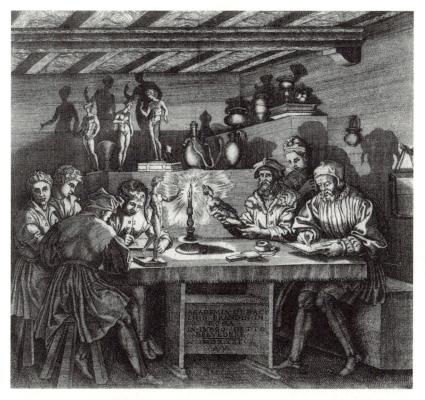

PLATE 3.4 AGOSTINO VENEZIANO'S ENGRAVING OF BACCIO BANDINELLI'S 'ACADEMY' IN ROME

patrons. One wonders whether Botticelli, who was of the same generation, city and social origin as the da Maianos, had a collection of books very different from theirs. If not, then the role of a patron or his adviser must have been crucial in the creation of paintings such as the *Birth of Venus* or the so-called *Primavera*, and conversations are likely to have formed an important part of an artist's education (cf. p. 116 below).

That modest collection of books needs to be set in time. In 1498, printing had been established in Italy for a generation. It is unlikely that an artist could have amassed twenty manuscripts early in the fifteenth century. On the other hand, in the next century larger libraries are not uncommon. Leonardo da Vinci, sneered at in his own day as a 'man without learning' (omo sanza lettere), turns out to have had 116 books in his possession at one point, including three Latin grammars, some of the Fathers of the Church (Augustine, Ambrose), some modern Italian

literature (the comic poems of Burchiello and Luigi Pulci, the short stories of Masuccio Salernitano), and treatises on anatomy, astrology, cosmography and mathematics.⁴⁷

It would be unwise to take Leonardo as typical of anything, but there is a fair amount of evidence about the literary culture of sixteenthcentury artists. The study of their handwriting offers some clues. In the fifteenth century, they tended to write in the manner of merchants, a style which was probably taught at abacus school. In the sixteenth century, however, Raphael, Michelangelo and others wrote in the new italic style. 48 Some artists, among them Michelangelo, Pontormo and Paris Bordone, are known to have gone to grammar school. The painter Giulio Campagnola and the architect Fra Giovanni Giocondo both knew Greek as well as Latin. 49 A few artists acquired a second reputation as writers. Michelangelo's poems are famous, while Bramante, Bronzino and Raphael all tried their hands at verse. Cennini, Ghiberti, Filarete, Palladio and the Bolognese architect Sebastiano Serlio all wrote treatises on the arts. Cellini and Bandinelli wrote autobiographies, while Vasari is better known for his lives of artists than for his own painting, sculpture and architecture. It is worth adding that Vasari was able to bridge the two cultures by the happy accident of powerful patronage which gave him a double education - a training in the humanities from Pierio Valeriano as well as an artistic training in the circle of Andrea del Sarto.⁵⁰

These examples are impressive, but it is worth underlining the fact that they do not include all distinguished artists. Titian, for example, is absent from the list: it is unlikely that he knew Latin. In any case, the examples do not add up to the 'universal man' of the Renaissance. Was he fact or fiction? The ideal of universality was indeed a contemporary one. One character in the dialogue On Civil Life by the fifteenth-century Florentine humanist Matteo Palmieri remarks that 'A man is able to learn many things and make himself universal in many excellent arts' (farsi universale di piu arti excellenti). Another Florentine humanist, Angelo Poliziano, wrote a short treatise on the whole of knowledge, the Panepistemon, in which painting, sculpture, architecture and music have their place. The most famous exposition of the idea comes in count Baldassare Castiglione's famous Courtier (1528), in which the speakers expect the perfect courtier to be able to fight and dance, paint and sing,

⁴⁷ Fumagalli, Leonardo; Reti, 'Two unpublished manuscripts', pp. 81ff.

⁴⁸ Petrucci, La scrittura.

⁴⁹ Rossi, *Dalle botteghe alle accademie*; Dempsey, 'Some observations'; Bolland, 'From the workshop to the academy'.

⁵⁰ Boase, Giorgio Vasari; Rubin, Giorgio Vasari, pp. 72-3.

⁵¹ Palmieri, Vita civile, bk 1, p. 43.

⁵² Poliziano, Panepistemon; Summers, Michelangelo, ch. 17.

write poems and advise his prince. Did this theory have any relation to practice? The careers of Alberti (humanist, architect, mathematician and even athlete), Leonardo and Michelangelo are dazzling testimony to the existence of a few universal men, and another fifteen members of the elite practised three arts or more, among them Brunelleschi, Ghiberti and Vasari. The humanist Paolo dal Pozzo Toscanelli (a friend of Alberti and Brunelleschi) also deserves a place in this company since his interests included mathematics, geography and astronomy. 4

About half of these eighteen universal men were Tuscans; about half had fathers who were nobles, professional men or merchants; and no fewer than fifteen of them were, among other things, architects. Either architecture attracted universal men or it encouraged them. Neither possibility is surprising, because architecture was a bridge between science (since the architect needed to know the laws of mechanics), sculpture (since he worked with stone) and humanism (since he needed to know the classical vocabulary of architecture). Apart from Alberti, however, these many-sided men belong to the tradition of the non-specialist craftsman rather than that of the gifted amateur. The theory and the practice of the universal man seem to have coexisted without much contact. The greatest of all, Michelangelo, did not believe in universality. At the time he was painting the ceiling of the Sistine Chapel, he wrote to his father complaining that painting was not his job (non esser mia professione). He created masterpieces of painting, architecture and poetry while continuing to protest that he was just a sculptor.

THE ORGANIZATION OF THE ARTS

For painters and sculptors, the fundamental unit was the workshop, the *bottega* – a small group of men producing a wide variety of objects in collaboration and a great contrast to the specialist, individualist artist of modern times.⁵⁵ Although distinctions were sometimes drawn between painters of panels and frescoes, on the one hand, and painters of furniture, on the other, one still finds Botticelli painting *cassoni* (wedding

⁵³ Only seven arts are distinguished here: painter, sculptor, architect, writer, humanist, scientist and composer, a classification which tends to play down the many-sidedness of the elite rather than exaggerate it. The eighteen men who practised three arts or more are Alberti, Aquilano, Bramante, Brunelleschi, Filarete, Ghiberti, Giocondo, Francesco di Giorgio, Leonardo, Ligorio, Mazzoni, Michelangelo, Alessandro Piccolomini, Serlio, Tebaldeo, Vasari, Vecchietta and Zenale.

⁵⁴ Santillana, 'Paolo Toscanelli and his friends'.

⁵⁵ Cole, *Renaissance Artist at Work*; Thomas, *Painter's Practice* and 'Workshop as the space'; Welch, *Art and Society*, pp. 79–101; Comanducci, 'Il concetto di "artista"' and 'Organizazzione produttiva'; Tagliaferro and Aikema, *Le botteghe di Tiziano*.

chests) and banners; Cosimo Tura of Ferrara painting horse trappings and furniture; and the Venetian Vincenzo Catena painting cabinets and bedsteads. Even in the sixteenth century, Bronzino painted a harpsichord cover for the duke of Urbino. To deal with this wide variety of commissions, masters often employed assistants as well as apprentices, particularly if they worked on a large scale or were much in demand, as were Ghirlandaio, Perugino or Raphael. It is reasonably certain that Giovanni Bellini employed at least sixteen assistants in the course of his long working life (c. 1460–1516), and he may have used many more. Some of these 'boys' (garzoni) - as they were called irrespective of age - were hired to help with a particular commission, and the patron might guarantee to pay their keep, as the duke of Ferrara promised Tura in 1460 in contracting for the painting of a chapel.⁵⁶ Others worked for their master on a permanent basis, and they might specialize. In Raphael's workshop, for example, which might be better described as 'Raphael Enterprises', Giovanni da Udine (Plate 3.5) concentrated on animals and grotesques.⁵⁷

The workshop was often a family affair. A father, for example, Jacopo Bellini, would train his sons in the craft. When Jacopo died he bequeathed his sketchbooks and unfinished commissions to his eldest son, Gentile, who took over the shop. Giovanni Bellini succeeded his brother Gentile, and was succeeded in turn by his nephew Vittore Belliniano. Again, Titian's workshop included his brother Francesco, his son Orazio, his nephew Marco and his cousin Cesare. The *garzoni* were generally treated as members of the family, and might marry their master's daughter, as Mantegna and others did.

The signing of paintings used to be taken to be a mark of 'Renaissance individualism'. However, it has been argued that when a painting is signed by the head of a workshop it does not mean that he painted it with his own hand. It may even mean the reverse; the point is to declare that the work meets the standards of the shop.⁵⁹

Not all master painters could afford to set up shop on their own. Like other small masters (dyers, for example), painters sometimes shared expenses for rent and equipment. Usually, though not always, they acted as a trading company and pooled expenses and receipts. ⁶⁰ Giorgione, for instance, was in partnership with Vincenzo Catena. An association of

⁵⁶ Chambers, Patrons and Artists, nos. 7, 11, 15.

⁵⁷ Marabottini, 'Collaboratori'; Burke, 'Italian artist'.

⁵⁸ On the persistence of the family workshop in Venice, Rosand, *Painting in Cinquecento Venice*, pp. 7ff.; Tagliaferro and Aikema, *Le botteghe di Tiziano*, pp. 152–91.

⁵⁹ Tietze, 'Master and workshop'; cf. Fraenkel, Signature, genèse d'un signe; Matthew, 'Painter's presence'.

⁶⁰ Procacci, 'Compagnie di pittori'.

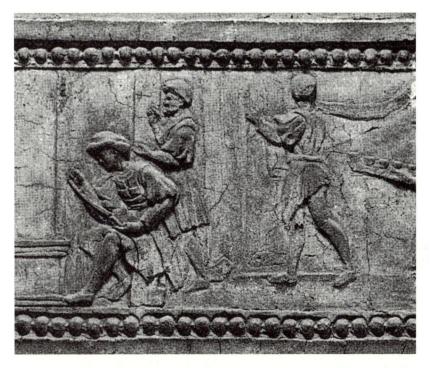

Plate 3.5 Giovanni de Udine: Stucco relief showing Raphael's workshop (detail), in the Vatican Loggia

this kind had the advantage of offering a kind of insurance against illness and defaulting clients. There may also have been a division of labour inside the shop.

These habits of collaboration make it easier to understand how well-known artists could work on the same paintings, together or consecutively. In the Ovetari Chapel at Padua, for example, four artists worked on the frescoes in pairs: Pizzolo with Mantegna, and Antonio da Murano with Giovanni d'Allemagna. Pisanello finished a picture of St John the Baptist begun by Gentile da Fabriano. This practice continued into the sixteenth century. Pontormo made two paintings from cartoons by Michelangelo, while Michelangelo agreed to finish a statue of St Francis by Pietro Torrigiani. This system of collaboration obviously militated against deliberate individualism of style and helps explain why this individualism emerged only slowly.

Sculptors' workshops were organized in a similar way to those of painters. Donatello was in partnership with Michelozzo, while the

Plate 3.6 The architect Filarete leading his apprentices, from the doors of St Peter's, Rome

Gaggini and Solari dynasties furnish obvious examples of family businesses. Assistants were all the more necessary, since statues take longer to make and because the head of the shop might have to arrange for marble to be quarried in order to carry out a particular commission, with the problem that, if it turned out badly, as Michelangelo complains in his letters, hundreds of ducats might be wasted, and it might be difficult to prove to the client that the expenditure had been necessary or even that it had taken place at all. The workshop of Bernardo Rossellino was one in which there was considerable division of labour, on 'apparently arbitrary' lines.⁶¹

Architecture was, of course, organized on a larger scale with a more elaborate division of labour. Even a relatively small palace like the Ca D'Oro, still to be seen on the Grand Canal in Venice, had twenty-seven craftsmen working on it in 1427. There were carpenters; two main kinds of mason, concerned respectively with hewing and laying stone; unskilled workmen, to carry materials; and perhaps foremen. Coordination was therefore a problem. As Filarete put it, a building project is like a dance; everyone must work together in time (Plate 3.6). The man who ensured coordination was sometimes called the *architetto*, sometimes the *protomaestro* or chief of the master masons. It is likely that the two names reflect two different conceptions of the role, the old idea of the senior craftsman and the new idea of the designer. In any case, considerable administrative work was involved. Besides designing the building, someone had to appoint and pay the workmen and arrange for the supply of

⁶¹ Schulz, Sculpture of Bernardo Rossellino, p. 11; Caplow, 'Sculptors' partnerships'; Sheard and Paoletti, Collaboration in Italian Renaissance Art. On the quarries, Klapisch-Zuber, Maîtres du marbre; Chambers, Patrons and Artists, no. 2.

lime, sand, brick, stone, wood, ropes, and so on. All this work could be organized in a number of different ways. In Venice, building firms were small because master masons were not allowed to take more than three apprentices each. When a large building was needed, it was common for an entrepreneur (padrone) to contract for the whole work and then subcontract pieces of it to different workshops. At the other extreme, at St Peter's in the 1520s and 1530s, there was only one workshop, with a large staff including an accountant (computista), two surveyors (mensuratori) and a head clerk (segretario), as well as masons and other workmen. Filarete recommends an agent (commissario) as middleman between the architect and the craftsmen. Alberti seems to have followed this system and employed at least three artists in this way: Matteo de'Pasti as his agent in Rimini, Bernardo Rossellino as his agent in Rome, and Luca Fancelli as his agent in Mantua and Florence.

This division of labour has created problems for art historians as it doubtless did for the agents. It is difficult enough to assess individual responsibility for particular paintings and statues, and still harder, in the case of a building, to know whether patron, architect, agent, master mason or mason was responsible for a given detail. The difficulty is increased by the fact that it was not yet customary for the architect to give his men measured drawings to work from. Many of the instructions were given *a bocca*, by word of mouth. 63

If we know something about Alberti's intentions, it is because he did not stay in Rimini while the church of San Francesco was being built, but designed it by correspondence, some of which has survived. On one occasion the agent, Matteo de'Pasti, was apparently thinking of altering the proportions of some pilasters, but Alberti wrote to stop him. A letter from Matteo to the client, Sigismondo Malatesta, explains that a drawing of the façade and of a capital had arrived from Alberti, and that it

⁶² Wyrobisz, 'Attività edilizia a Venezia'.

⁶³ Manetti, Vita di Brunelleschi, p. 77.

had been shown to 'all the masters and engineers'. The problem was that the drawing was not completely consistent with a wooden model of the building which Alberti had previously provided. 'I hope to God that your lordship will come in time, and see the thing with your own eyes.' Later on, another craftsman working on the church wrote to Sigismondo for permission to go to Rome and talk to Alberti about the vaulting. ⁶⁴

The fact that architecture was such a cooperative enterprise must have acted as a brake on innovation. Since craftsmen were trained by other craftsmen, they learned fidelity to tradition as well as to techniques. When executing a design which broke with tradition, they would be likely, if they were not supervised very closely, to 'normalize' it – in other words, to assimilate it to the tradition from which the designer was deliberately diverging. Michelozzo's design for the Medici Bank at Milan was executed by Lombard craftsmen in a local style (a fragment of this building may still be seen in the museum of the Castello Sforzesco). A small detail, but a significant one, is the difference in proportions between capitals made by Florentine craftsmen for Brunelleschi when he was on the spot and one made in 1430 while he was away.⁶⁵

There seems to be a relationship between the development of a new architectural style and the rise of a new kind of designer – the architect who, like Alberti, had not been trained as a mason. A parallel with shipbuilding may be illuminating. In fifteenth-century Venice, ships were designed by senior ship carpenters, the nautical equivalent of master masons. In the sixteenth century, they were challenged by an amateur. The role of Alberti was played by the humanist Vettor Fausto, who designed a ship (which was launched in 1529) on the model of the ancient quinquereme.⁶⁶

The larger unit of organization for painters, sculptors and masons, but not architects, was the guild. Guilds had several functions. They regulated both standards of quality and relations between clients, masters, journeymen and apprentices. They collected money from subscriptions and bequests and lent or gave some of it to members who were in need. They organized festivals in honour of the patron of the guild, with religious services and processions. In some cities, such as Milan, painters had a guild of their own, often under the patronage of St Luke, who was supposed to have painted a portrait of the Virgin. Elsewhere they formed part of a larger guild, such as that of the papermakers in Bologna or

⁶⁴ Ricci, *Tempio malatestiano*, pp. 588ff.; Wittkower, *Architectural Principles*, pp. 29ff; Chambers, *Patrons and Artists*, pp. 181–3.

⁶⁵ Saalman, 'Filippo Brunelleschi'.

⁶⁶ Lane, Venetian Ships and Shipbuilders; Concina, Arsenale della Repubblica di Venezia, pp. 108ff.

that of the physicians and apothecaries in Florence (though Florentine painters did have a social guild of their own, the Company of St Luke).⁶⁷

For a more vivid impression of the activities of a guild, we may look at the fifteenth-century statutes of one of them, the 'brotherhood' or fraglia of the painters of Padua. 68 The officers of the guild were a bursar, two stewards, a notary and a dean. There were several social and religious activities in which participation was compulsory. On certain days in the year the guild marched in procession with 'our gonfalon', and absentees were fined. There was a rota for visiting sick members and for encouraging them to confess and communicate, and fines for non-attendance at funerals. Alms were given to the poor and to lepers. There were also arrangements for the relief of needy members. A poor master had the right to sell a piece of work to the guild, which the bursar would try to sell 'as best he could' (ut melius poterit). Other guilds lent money; Botticelli, for example, received a loan from the Company of St Luke in Florence. The Paduan statutes also required masters to keep apprentices for three years at least, and forbade them to make overtures to the apprentices of other masters 'with gifts or blandishments' (donis vel blandimentis). There were regulations for the maintenance of standards; candidates aspiring to be masters were examined in the usual way, and houses were inspected to see if work was being 'falsified' (si falsificetur aliquod laborerium nostre artis). Standards and fair prices were also maintained by the new but common practice of calling in artists to evaluate the work of others - artistic judgment by one's peers - in cases of dispute with the client.⁶⁹ Finally, there was the restrictive side of the guild's activities. The Padua statutes forbade members to give or sell to non-members anything pertaining to the craft. They laid down that no work was to be brought from another district to sell in Padua, and three days only were allowed for the transit of such 'alien' work through the territory of the guild.

In Venice too the guild or *arte* seems to have had a strong territorial imperative. When Albrecht Dürer visited Venice in 1506, he commented on the suspicion or sensitivity to competition of the painters there: 'They have summoned me before the magistrates three times, and I have had to pay four florins to their guild.'⁷⁰ It has been suggested that, when he was working in Venice in the middle of the fifteenth century, the Tuscan

⁶⁷ MacKenney, 'Arti e stato a Venezia', 'Guilds and guildsmen' and *Tradesmen and Traders*; Motta, 'Università dei pittori'.

⁶⁸ Gaye, Carteggio inedito d'artisti, vol. 2, pp. 43ff.

 ⁶⁹ Conti, 'Evoluzione dell artista', pp. 151ff.
 ⁷⁰ Dürer, Schriftlicher Nachlass, vol. 1, pp. 41ff.

painter Andrea del Castagno had to be supervised by a less gifted artist, Giambono, simply because the latter was a Venetian.⁷¹

In Florence, however, guilds did not have so much power. The Florentine government would not allow them to force all craftsmen to join. Some artists, such as Botticelli, entered a guild only at the end of their career. As a result 'foreigners' could come and work in Florence. This more liberal policy, which exposed local tradition to stimuli from outside, may help to explain Florence's cultural lead.

Writers, humanists, scientists and musicians had no guilds and no workshops. The nearest analogy to the guild in their world was the university (a term which simply meant 'association' and was sometimes used in the period to refer to guilds of painters). However, the analogy between students and apprentices, tempting as it is in some respects, is also misleading. Most of the students did not go to university to learn how to be professors but looked forward to careers in Church and state. The students had more power in Italian universities than apprentices had in guilds. It was thanks to a petition from the students from the University of Pisa, for example, that one of their teachers, the scientist Bernardo Torni, had his salary raised. The university was not geared to the production of books by the dons. Their job was lecturing, and their books were something of a sideline.

If humanists and scientists had their universities, writers had no form of organization at all. With the exception of a few professionals, known as *poligrafi*, writing was something a man did in his spare time, whereas his occupation was soldier, diplomat or bishop. Hence it was a little easier for women to become writers than for them to practise as painters or sculptors. There were, however, some full-time poets who made a living from this occupation. I hesitate to use such a modern term as 'professional', however, because these singers of tales or *cantastorie*, improvisers of epic poetry, such as Cristoforo Altissimo (who died about 1515) or Bernardo Accolti (1458–1535), who wandered from one court to another, represented survivals in Renaissance Italy of an oral culture that we tend to associate with heroic ages like Homeric Greece.⁷²

In other words, the production of literature was not yet an industry in fifteenth-century Italy, although it was becoming one in the mid-sixteenth century, as it was to be in eighteenth-century France and England. The reproduction of literature, on the other hand, was certainly industrialized. Of course, some people who needed particular books simply copied them by hand, while others asked someone else to do the copying for them (as

⁷¹ Muraro, 'Statutes of the Venetian Arti'.

⁷² Lord, Singer of Tales; Bronzini, Tradizione di stile aedico; Burke, 'Learned culture and popular culture' and 'Oral culture and print culture'.

Coluccio Salutati, the chancellor of Florence, asked the young humanist Poggio Bracciolini), and in these cases no formal organization of production was needed. However, in fifteenth-century Italy the production of manuscripts had become commercialized and standardized. It was in the hands of stationarii - a word from which the modern English 'stationer' is derived, and a term which referred in those days both to booksellers and to organizers of scriptoria, workshops for producing manuscripts. The term stationarius had two meanings because the same man tended to perform the two functions, publishing and retail distribution.

The most famous stationarius of the Renaissance is the Florentine Vespasiano da Bisticci, who immortalized himself by writing biographies of his customers. These biographies give the impression of a highly organized system for the copying of manuscripts, reminiscent of the Rome of Cicero and his friend the 'publisher' Atticus. For example, Vespasiano explains how he built up a library for Cosimo de'Medici by engaging forty-five scribes who were able to complete two hundred volumes in twenty-two months. What is impressive in this case is not the speed of the individual copyist (since five months per volume seems rather slow. unless the volumes were large ones or the quality was unusually high). but the fact that a man (or at any rate Cosimo, the uncrowned ruler of Florence) could go to a bookseller and place an order for two hundred volumes which would be delivered within two years. One wonders how the actual writing was organized: whether works which were much in demand were ever copied by ten or twenty scribes writing from dictation, or whether the whole industry was organized on a 'putting-out' basis, with each scribe turning up at the bookseller's every few months to collect supplies of vellum and the volume to be copied and returning to his house to write. The latter method seems likely in view of the fact that scribe was often a part-time occupation, paid at piece-work rates (by the 'quintern', a set of five sheets). Although one or two illuminators worked in Vespasiano's shop, it was too small to be a proper scriptorium. Vespasiano's letters to scribes show that manuscripts were copied for him elsewhere, often by notaries or priests.⁷³

From the mid-fifteenth century onwards, this copying system had to compete with the mass production of books which were 'written' mechanically (as early printed books sometimes describe themselves). In 1465, two German clerics called Sweynheym and Pannartz arrived at the Benedictine monastery of Subiaco, a few miles east of Rome, and set up a press there, the first in Italy. Two years later they moved to Rome itself.

⁷³ Vespasiano da Bisticci, Vite di uomini illustri, especially the life of Cosimo de'Medici; De la Mare, 'Vespasiano da Bisticci'; Martini, Bottega di un cartolaio fiorentino; Petrucci, 'Libro manoscritto'; Richardson, Manuscript Culture.

It has been estimated that in five years they produced 12,000 volumes, a number for which Vespasiano would have had to find 1,000 scribes to equal in the time. It is clear that the new machine was a formidable competitor. By the end of the century, some 150 presses had been founded in Italy. It is hardly surprising that Vespasiano, who had for the new method something of the contempt a skilled wheelwright may have felt for the horseless carriage, gave up bookselling in disgust and retired to his country estate to relive the past.

Other scribes were rather more adaptable. Some became printers themselves, such as Domenico de'Lapi and Taddeo Crivelli, who produced the famous Bologna Ptolemy in 1477. Early printed books often look rather like manuscripts, down to the illuminated initials. Similarly the printers, a new occupation, stepped into the shoes of the stationarii. Like their predecessors, the printers tended to unite roles which in the twenty-first century we tend to distinguish, those of producing books and selling them. They soon added a third, that of 'publisher' - that is, an individual who issues under his imprint and takes responsibility for books which were in fact printed by someone else. For example, the colophon of the illustrated edition of Ovid's Metamorphoses produced in Venice in 1497 declares that it was printed by Zoare Rosso (otherwise known as Giovanni Rubeo) 'at the instance of' Lucantonio Giunti. Printers sometimes exercised a fourth role as well, that of merchants in commodities other than books. After all, who could be sure that the new product was not going to go out of fashion? This was still a worry in the late sixteenth century.74

The effects of the invention of printing on the organization of literature were as diverse as they were shattering. In the first place, it was a disaster to scribes and *stationarii* who were not prepared to adapt themselves and begin a new career. In the second place, the expansion of book production led to the creation of new occupations which helped support creative writers. As libraries became bigger, there was a greater need for librarians. Several members of the creative elite were in fact occupied in this way. The grammarian Giovanni Tortelli was the first Vatican librarian (to the so-called humanist pope, Nicholas V), a post that was later held by the humanist Bartolommeo Platina. The poet–scholar Angelo Poliziano was librarian to the Medici. The Venetian poet–historian Andrea Navagero was librarian of the Marciana, while the philosopher Agostino Steuco was librarian to the Venetian cardinals Marino and Domenico Grimani.⁷⁵

⁷⁴ Lowry, World of Aldus Manutius, esp. ch. 1; Zeidberg and Superbi, Aldus Manutius and Renaissance Culture; Tenenti, 'Luc'Antonio Giunti'.

⁷⁵ Branca, Poliziano e l'umanesimo della parola; Petrucci, 'Biblioteche antiche'.

Another new occupation dependent on the rise of printing was that of corrector for the press, a useful part-time occupation for a writer or scholar. Platina worked as corrector for Sweynheym and Pannartz in Rome, while the humanist Giorgio Merula was corrector to the first press to be established in Venice, that of Johan and Windelin Speyer.

By the sixteenth century, printers and publishers had begun to ask writers to edit books, to translate them and even to write them, a new form of literary patronage which led to the rise of *poligrafo*, or professional writer, in Venice towards the middle of the sixteenth century. The most famous of this group of professionals was Pietro Aretino, who made even his 'private' letters saleable. Around Aretino's sun circulated lesser planets (not to say Grub Street hacks) such as his secretary Niccolò Franco, his sometime friend and later enemy Anton Francesco Doni, Giuseppe Betussi, Lodovico Dolce, Ludovico Domenichi, Girolamo Ruscelli, and Francesco Sansovino, son of the artist Jacopo.⁷⁷

The firm of Giolito at Venice, which concentrated on books that were popular rather than scholarly at a time when this was still unusual, seems to have been a pioneer in its use of professional writers. Betussi and Dolce were both in Giolito service, editing, translating, writing and (as hostile critics pointed out) plagiarizing.⁷⁸ Even at the end of our period, however, the professional writer was only just beginning to emerge.

Music resembled literature in that reproduction was organized but production was not. Churches had their choirs, towns had their drummers and pipers, and courts had both, but the role of composer was scarcely recognized. Although the word *compositore* sometimes occurs, the more common term is the more vague *musico*, which makes no disinction between someone who invents a tune and someone who plays it.⁷⁹ In their own day, all the forty-nine composers in the creative elite were viewed as writers on the theory of music, or as singers, or as players of instruments, as some of their names, for example Alfonso della Viola and Antonio degli Organi, remind us.

An important feature of the organization of the arts in different places and times is the relative opportunity (or need) for mobility. About 25 per cent of the creative elite are known to have done a great deal of travelling. Some moved about because they were successful enough to receive invitations from abroad, like the painter Jacopo de'Barbari, who worked in Nuremberg, Naumburg, Wittenberg, Weimar, Frankfurt-on-Oder and

⁷⁶ Trovato, Con ogni diligenza; Grafton, Culture of Correction.

⁷⁷ Bareggi, Mestiere di scrivere; Larivaille, Pietro Aretino; Grendler, Critics of the Italian World and 'Francesco Sansovino'.

⁷⁸ Quondam, 'Mercanzia d'honore'.

⁷⁹ Bridgman, Vie musicale, ch. 2.

Malines. Others, on the contrary, seem to have travelled because they had little success in any one place, like Lorenzo Lotto, who worked in Venice, Treviso, Bergamo, Rome, Ancona and Loreto, Architects were hardly ever sedentary. Humanists and composers tended to be more mobile than painters and sculptors, presumably because their services were required in person, while painters and sculptors could always dispatch their work abroad while remaining at home themselves. One good example of a mobile humanist is Pomponio Leto, whose career took him not only to Salerno, Rome and Venice, but also to Germany and even to Muscovy. However, he is easily surpassed by Francesco Filelfo, who visited Germany, Hungary, Poland and Constantinople and, when in Italy, worked in Padua, Venice, Vicenza, Bologna, Siena, Milan, Pavia, Florence and Rome. The theme of the wandering scholar, often emphasized, has provoked a sceptical reaction. 'It can probably be shown', writes one historian, 'that every itinerant humanist like Aurispa, Panormita, or the youthful Valla had his stay-at-home counterpart in humanists like Andrea Giuliano, Francesco Barbaro and Carlo Marsuppini.'80 So far as the creative elite is concerned, however, the balance tips in favour of the wanderers: fifty-eight compared to forty-three.81

Printers also travelled widely, like Simon Bevilacqua, who worked in Venice, Saluzzo, Cuneo, Novi Ligure, Savona and Lyons during the decade 1506–15. If humanists and printers were often on the road from year to year, actors, singers of tales and pedlars of books (not to mention students in vacation) travelled from day to day. There may also have been some artists in this class, for the fifteenth-century painter Dario da Udine is described in a document as *pictor vagabundus*.

Another important aspect of the organization of the arts is the extent to which they were full-time or part-time, amateur or professional occupations. It has already been suggested that painting, sculpture and music were usually professional and full-time occupations, and the importance of the 'rise of the professional artist in Renaissance Italy' has been emphasized in both older and newer studies. 82 Writing, on the other hand, was usually amateur and part-time, while architects usually practised another art besides architecture. What is here described as a 'scientist' was a man whose professional description would usually have been 'teacher' or 'physician' (twenty-two out of the fifty-three, including Giovanni

⁸⁰ Martines, Social World, p. 97.

⁸¹ Of 103 humanists in the elite, 14 may be classified as extremely sedentary, 29 as fairly sedentary, 12 as fairly mobile, and 46 as extremely mobile, with two individuals unknown. On transient foreign humanists in Venice, King, *Venetian Humanism*, pp. 220ff.

⁸² Wittkower, 'Individualism in art and artists'; Wittkower and Wittkower, *Born under Saturn*; Kempers, *Painting*, *Power and Patronage*.

Marliani, actually more distinguished in physics than in physic). Scholars were usually professional teachers, and at least forty-five out of the 178 writers and humanists in the elite taught in universities or schools or were engaged as private tutors (Poliziano to Piero de'Medici, Matteo Bandello to the Gonzagas). However, it is possible to point to amateurs (or at any rate to non-academics) such as the civil servant Leonardo Bruni, the merchant Cyriac of Ancona, the printer Aldo Manuzio, the statesman Lorenzo de'Medici, and the noblemen Giovanni Pico della Mirandola and Pietro Bembo. These exceptions are numerous and important enough to make one a little uncomfortable with Paul Kristeller's famous definition of the humanist as a teacher of the humanities.83 It should be added that if some humanists, notably Vittorino da Feltre and Guarino of Verona, treated teaching as a vocation, others considered it a fate to be cursed. 'I, who have until recently enjoyed the friendship of princes', wrote one of them sadly in 1480, 'have now, because of my evil star, opened a school.'84

The Church remained an important source of part-time employment for writers (twenty-two members of the elite), humanists (twenty-two more) and composers (twenty), not to mention seven scientists (such as Paul of Venice), six painters (of whom the most famous are Fra Angelico and Fra Bartolommeo), and one architect (Fra Giovanni Giocondo of Verona).⁸⁵

Another common employment for writers and humanists was that of secretary; their rhetorical skills were in high demand. Leonardo Bruni, Poggio Bracciolini and Bartolommeo della Scala were made chancellors of Florence for their skill in writing persuasive letters; the humanists Antonio Loschi and Pier Candido Decembrio performed similar services for the Visconti of Milan; while the poets Benedetto Chariteo and Giovanni Pontano were secretaries of state in Naples. Other writers were more like private secretaries: Masuccio Salernitano, best known for his prose fiction, was secretary to Prince Roberto Sanseverino, while the poet Annibale Caro served various members of the Farnese family.⁸⁶

In a few cases, artists and writers pursued occupations that had little or nothing to do with art or literature. The painter Mariotto Albertinelli was at one time an innkeeper (as was another painter, Jan Steen, in seventeenth-century Leiden). The artist Niccolò dell'Abbate, like the humanists Platina and Calcagnini, was at one time a soldier. Another

⁸³ Kristeller *Renaissance Thought*, ch. 1, a salutary reaction against some extremely vague conceptions of the humanist.

⁸⁴ Acciarini to Poliziano, quoted in Usmiani, 'Marko Marulić', p. 19.

⁸⁵ Dionisotti, Geografia e storia.

⁸⁶ On humanists as secretaries in Venice, King, Venetian Humanism, pp. 294ff.

painter, Giorgio Schiavone, sold salt and cheese. Giorgione's partner Catena seems to have sold drugs and spices, while Giovanni Caroto of Verona kept an apothecary's shop; this combination of art and drugs may be explained by the fact that some apothecaries sold artists' materials. The Fogolino brothers combined their work as painters with that of spying for the Venetians in Trento. Antonio Squarcialupi kept a butcher's shop as well as playing the organ and composing. Domenico Burchiello was a barber as well as a comic poet. Mariano Taccola was a notary as well as a sculptor and an engineer. The dramatists Giovanni Maria Cecchi and Anton Francesco Grazzini were respectively a wool merchant and an apothecary.⁸⁷ These occupations warn us not to attribute too high a status to artists and writers at this time.

THE STATUS OF THE ARTS

The status associated with the roles of artist and writer was problematic. The problem was a special case of the more general difficulty of accommodating in the social structure, as the division of labour progressed, all roles other than those of priest, knight and peasant – those who prayed, fought and worked – the 'three orders' officially recognized in the Middle Ages. 88 If the status of an artist was ambiguous, so was that of a merchant. And just as Italians, in some regions at least, had gone further towards the social acceptance of the merchant than had most other Europeans, so it was in Italy that the status of the artist seems to have been at its peak. In the discussion that follows, the evidence of high status comes first, then the evidence of contempt and, finally, an attempt to reach a balanced conclusion.

Artists regularly declared that they had or ought to have a high status. Cennini at the beginning of the period and Leonardo towards the end both compared the painter with the poet, on the grounds that painter and poet alike use their imagination, their *fantasia*. Another point in favour of the high status of painting, and one which reveals something of Renaissance assumptions or mentalities, was that the painter could wear fine clothes while he was at work. As Cennini put it: 'Know that painting on panel is a gentleman's job, for you can do what you want with velvet on your back.' And Leonardo: 'The painter sits at his ease in front of his work, dressed as he pleases, and moves his light brush with the beautiful colours . . . often accompanied by musicians or readers of various beau-

88 Duby, Three Orders; Niccoli, Sacerdoti.

⁸⁷ That Grazzini actually practised as an apothecary has been questioned by Plaisance, 'Culture et politique', p. 82n.

tiful works.'89 In his treatise on painting, Alberti offered several more arguments which recur during the period, such as the argument that painters need to study liberal arts such as rhetoric and mathematics and the argument from antiquity – that in Roman times works of art fetched high prices, while distinguished Roman citizens had their sons taught to paint, and Alexander the Great admired the painter Apelles.

Some people who were not artists seem to have accepted the claim that painters were not ordinary craftsmen. The humanist Guarino of Verona wrote a poem in praise of Pisanello, while the court poet of Ferrara dedicated a Latin elegy to Cosimo Tura and Ariosto praised Titian in his Orlando Furioso (more exactly, he inserted the praise of Titian into the 1532 edition of his poem). St Antonino, archbishop of Florence, noted that, whereas in most occupations the just price for a piece of work depends essentially on the time and materials employed, 'Painters claim, more or less reasonably, to be paid the salary of their art not only by the amount of work, but more in proportion to their application and greater expertness in their trade.'90 When the ruler of Mantua gave Giulio Romano a house, the deed of gift opened with a firm statement of the honour due to painting: 'Among the famous arts of mortal men it has always seemed to us that painting is the most glorious (praeclarissimus) ... we have noticed that Alexander of Macedon thought it of no small dignity, since he wished to be painted by a certain Apelles.'91

A few painters achieved high status according to the criteria of the time, notably by being knighted or ennobled by their patrons. Gentile Bellini was made a count by the emperor Frederick III, Mantegna by Pope Innocent VIII, and Titian by the emperor Charles V. The Venetian painter Carlo Crivelli was knighted by Prince Ferdinand of Capua; Sodoma by Pope Leo X; Giovanni da Pordenone by the king of Hungary. For the patron it was a cheap way of rewarding service, but for the artist the honour was real enough. Some painters held offices which conferred status as well as income. Giulio Romano held an office at the court of Mantua, while the painters Giovanni da Udine and Sebastiano del Piombo held office in the Church. (Sebastiano's nickname, 'the lead', was a reference to his office as Keeper of the Seal.) Other painters held high civic office. Luca Signorelli was one of the priors (aldermen) of Cortona; Perugino, one of the priors of Perugia; Jacopo Bassano, consul of Bassano; Piero della Francesca, a town councillor of Borgo San Sepolcro.

Again, a few painters are known to have become rich. Pisanello inherited wealth, but Mantegna, Perugino, Cosimo Tura, Raphael, Titian,

⁸⁹ Cennini, Libro dell'arte, vol. 2; Leonardo da Vinci, Literary Works, p. 91.

Gilbert, 'The archbishop on the painters'.
 Hartt, Giulio Romano, doc. 69.

Vincenzo Catena of Venice and Bernardino Zenale of Treviso all seem to have become rich by their painting. Wealth gave them status, and the prices they commanded show that painting was not held cheap.

The testimony of Albrecht Dürer carries considerable weight. On his visit to Venice he was impressed by the fact that the status of artists was higher than in his native Nuremberg, and he wrote home to his friend the humanist patrician Willibald Pirckheimer, 'Here I am a gentleman, at home a sponger' (*Hie bin ich ein Herr, doheim ein Schmarotzer*). ⁹² In Castiglione's famous dialogue, one of the speakers, Count Lodovico da Canossa, declares that the ideal courtier should know how to draw and paint. A few sixteenth-century Venetian patricians, notably Palladio's patron Daniele Barbaro, actually did do this. ⁹³

There is similar evidence for the status of sculptors and architects. Ghiberti's programme of studies for sculptors, and Alberti's for architects, implies that these occupations are on a level with the liberal arts. Ghiberti suggested that the sculptor should study ten subjects he calls 'liberal arts': grammar, geometry, philosophy, medicine, astrology, perspective, history, anatomy, design and arithmetic. Alberti advised architects to build only for men of quality, 'because your work loses its dignity by being done for mean persons'. 94 The patent issued in 1468 by Federigo da Montefeltro, the ruler of Urbino, on behalf of Luciano Laurana declares that architecture is 'an art of great science and ingenuity', and that it is 'founded upon the arts of arithmetic and geometry, which are the foremost of the seven liberal arts'. 95 A papal decree of 1540, freeing sculptors from the need to belong to the guilds of 'mechanical craftsmen', remarked that sculptors 'were prized highly by the ancients', who called them 'men of learning and science' (viri studiosi et scientifici).96 Some sculptors, Andrea il Riccio of Padua for example, had poems addressed to them. Some were ennobled. The king of Hungary, Matthias Corvinus, not only made Giovanni Dalmata a nobleman but gave him a castle as well. Charles V made Leone Leoni and Baccio Bandinelli knights of Santiago. Ghiberti's work made him rich enough to be able to buy an estate complete with manor house, moat and drawbridge. Other prosperous sculptors and architects include Brunelleschi, the brothers da Maiano, Bernardo Rossellino, Simone il Cronaca of Florence, and Giovanni Amadeo of Pavia, while Titian was among the wealthiest of all artists. The houses of artists are a sign of their rising status - in par-

⁹² Dürer to Pirckheimer, 13 October 1506, Schriftlicher Nachlass, vol. 1, pp. 41ff.

⁹³ Castiglione, Cortegiano, bk 1, ch. 49; on Barbaro, Dolce, Aretino, pp. 106ff.

⁹⁴ Ghiberti, Commentari, p. 2.

⁹⁵ Chambers, Patrons and Artists, no. 104.

⁹⁶ Steinmann, Sixtinische Kapelle, vol. 2, p. 754.

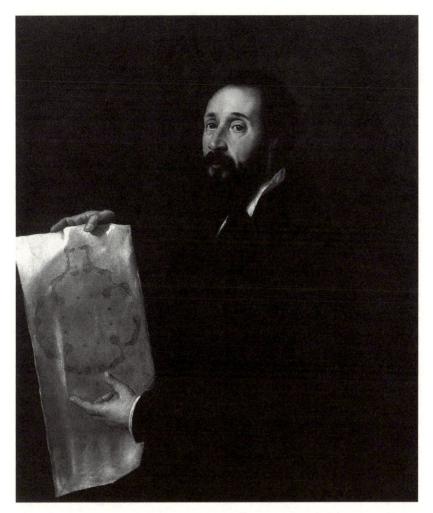

PLATE 3.7 TITIAN: PORTRAIT OF GIULIO ROMANO

ticular, the palaces of Mantegna and Giulio Romano at Mantua and of Raphael in Rome. 97

Composers of the period sometimes compared themselves to poets. Johannes de Tinctoris, who had impeccable credentials as an academic theorist of music, dedicated his treatise on modes to two practitioners, Ockeghem and Busnois – an unusual thing to do since the conventional view was that theory was the master and practice (composition no less

⁹⁷ Conti, 'Evoluzione dell'artista', pp. 206ff.

than performance) merely the servant. A number of composers were treated with honour in Italy at this time, although it is not easy to decide whether this was a tribute to their compositions or their performances (if indeed such a distinction was taken seriously at all). The humanists Guarino of Verona and Filippo Beroaldo wrote epigrams in praise of the lutenist Piero Bono, and medals were struck in his honour. Ficino and Poliziano wrote elegies on the death of the organist Squarcialupi, while Lorenzo de'Medici composed his epitaph and had a monument to him erected in the cathedral in Florence. Lorenzo's son Pope Leo X made the lutenist Gian Maria Giudeo a count, while Philip the Handsome of Burgundy did the same for the Italian singer-composer Mambriano da Orto. The elaborate preparations made for the arrival of Jakob Obrecht in Ferrara show how highly he was prized by Duke Ercole d'Este. At the court of Mantua in the time of Ercole's daughter Isabella, Marchetto Cara and Bartolommeo Tromboncino were honoured members of a musical circle. In Venice, Willaert, master of St Mark's chapel, died rich, while Gioseffe Zarlino, another master of St Mark's, had medals struck in his honour by the Republic and ended his days as a bishop.98

A number of humanists also achieved high status. In the case of Florence, it has been argued that humanists belonged to the top 10 per cent of Florentine families. Leonardo Bruni, Poggio Bracciolini, Carlo Marsuppini, Giannozzo Manetti and Matteo Palmieri, for example, were all wealthy men. Bruni, Poggio and Marsuppini all held the high office of chancellor of Florence, while Palmieri held office at least sixty-three times and Manetti had a distinguished career as a diplomat and a magistrate. Of these five, three were born into the upper class, while Bruni (the son of a grain dealer) and Poggio (the son of a poor apothecary) entered it through their own efforts. All five made good marriages. Finally, Bruni, Marsuppini and Palmieri were all given splendid state funerals.⁹⁹

In case Florence was not typical, it may be useful to take a brief look at twenty-five humanists who were born outside Tuscany and active in the fifteenth and early sixteenth centuries. 100 Of these twenty-five, at

⁹⁸ Anthon, 'Social status of Italian muscians'; Bridgman, *Vie musicale*, ch. 2; Lowinsky, 'Music of the Renaissance as viewed by Renaissance musicians'.

Martines, Social World, a study of 45 humanists in the period 1390–1460.
The 25 are as follows: Andrea Alciati, from Alzate in Lombardy; Ermolao Barbaro, from Venice; Filippo Beroaldo, from Bologna; Flavio Biondo, from Forli in the Papal States; Angelo Decembrio, from Lombardy; Mario Equicola, from Caserta; Bartolommeo Fazio, from La Spezia in Liguria; Francesco Filelfo, from Tolentino, near Ancona; Guarino Veronese; Pomponio Leto, from Lucania; Antonio Loschi, from Vicenza; Pietro Martire d'Anghiera, from Lombardy; Andrea Navagero, from Venice; Agostino Nifo, from Calabria; Antonio Panormita, from Palermo; Giovanni

least fourteen had fathers from the upper classes, while only three are definitely of humble origin (Guarino, Vittorino and Platina). Two were ennobled: Filelfo by King Alfonso of Aragon, Nifo by both Pope Leo X and Charles V. Three were famous university teachers: the lawyer Andrea Alciati, the philosopher Pietro Pomponazzi, and the literary critic Sperone Speroni. The Venetians Ermolao Barbaro and Andrea Navagero had distinguished political careers as senators and ambassadors. Angelo Decembrio, Antonio Loschi, Mario Equicola and Giovanni Pontano all held high administrative or diplomatic posts at the courts of Milan, Mantua and Naples. By worldly standards, almost all of them seem to have had successful careers.

There is, however, another side to the picture. Artists and writers were not respected by everyone. Some members of the elite whose achievements have been recognized by posterity had a difficult time of it in their own age. Three social prejudices against artists retained their power in this period. Artists were considered ignoble because their work involved both manual labour and retail trade and because they lacked learning.

To use a twelfth-century classification still current in the Renaissance, painting, sculpture and architecture were not 'liberal' but 'mechanical' arts. They were also dirty; a nobleman would not like to soil his hands using paints. The argument from antiquity, which Alberti had used in defence of artists, was actually double-edged, since Aristotle had excluded craftsmen from citizenship because their work was mechanical, while Plutarch had declared in his life of Pericles that no man of good family would want to become a sculptor like Phidias. 101 Leonardo's vigorous protest against views like these is well known: 'You have set painting among the mechanical arts! . . . If you call it mechanical because it is by manual work that the hands represent what the imagination creates, your writers are setting down what originates in the mind by manual work with the pen.' He might have added the example of fighting sword in hand. Even Leonardo, however, shared the prejudice against sculptors: 'The sculptor produces his work by . . . the labour of a mechanic, often accompanied by sweating which mixes with the dust and turns into mud, so that his face becomes white and he looks like a baker.'102

The second point commonly made against artists was that they made a living from retail trade, so that they deserved the same low status as

Pico, from Mirandola; Bartolommeo Platina, from Cremona; Pietro Pomponazzi, from Mantua; Giovanni Pontano, from Ponte in Umbria; Sperone Speroni, from Padua; Giorgio Valla, from Piacenza; Lorenzo Valla, from Rome; Maffeo Vegio, from Lodi; Pietro Paolo Vergerio the elder, from Capodistria; and Vittorino da Feltre from the Veneto.

¹⁰¹ Mondolfo, 'Greek attitude'.

¹⁰² Leonardo da Vinci, Literary Works, p. 91.

cobblers and grocers. Noblemen, on the other hand, were ashamed to take money for their work. Giovanni Boltraffio, a Lombard nobleman and humanist who also painted, usually worked on a small scale, perhaps because he intended his pictures to be gifts for his friends, and his epitaph emphasized his amateur status. Leonardo threw this accusation, too, back into the faces of the humanists: 'If you call it mechanical because it is done for money, who fall into this error . . . more than you yourselves? If you lecture for the schools, do you not go wherever you are paid the most?'103 In practice, a distinction was often drawn between being on the payroll of a prince, which could happen to the best people, and keeping a shop. Michelangelo insisted strongly on this distinction: 'I was never a painter or a sculptor like those who set up shop for that purpose. I always refrained from doing so out of respect for my father and brothers' (this did not prevent him from being concerned with money). 104 In a similar manner Vasari, after years in Medici service, was able to refer with contempt to a minor painter, in his life of Perino del Vaga, as 'One of those who keep an open shop and stand there in public, working at all sorts of mechanical tasks.'

The third prejudice against the visual arts was that artists were 'ignorant' – in other words, they lacked a certain kind of training (in theology and the classics, for example) that had a higher esteem than the training which they had received and their critics had not. When cardinal Soderini was trying to excuse Michelangelo's flight from Rome (below, p. 114), he told the pope that the artist 'has erred through ignorance. Painters are all like this both in their art and out of it.' It is a pleasure to record that Julius did not share this prejudice. He told Soderini roundly: 'You're the ignorant one, not him!' 105

Although a few artists, already mentioned, became rich by means of their art, many remained poor. Their poverty was probably as much the cause as the result of prejudices against the arts. The Sienese painter Benvenuto di Giovanni declared in 1488 that 'The gains in our profession are slight and limited, because little is produced and less earned.' Vasari made a similar point: 'The artist today struggles to ward off famine rather than to win fame, and this crushes and buries his talent and obscures his name.' Vasari's comment might be dismissed as special pleading, inconsistent with what he says elsewhere (let alone with his own wealth). Benvenuto's remarks, on the other hand, come from his tax return, which he knew would be subject to checking. The same goes

¹⁰³ Ibid.

¹⁰⁴ Michelangelo, Carteggio, 2 May 1548.

¹⁰⁵ Condivi, Vita di Michelangelo Buonarroti, p. 45.

¹⁰⁶ Coor, Neroccio de'Landi, p. 10.

for Verrocchio, whose return for 1457 claims that he was not earning enough to keep his firm in hose (*non guadagniamo le chalze*).¹⁰⁷ Botticelli and Neroccio de'Landi went into debt. Lotto was once reduced to trying to raffle thirty pictures, and he was able to dispose of only seven of them.

Humanists too did not always make fortunes and they were not invariably respected. The Greek scholar Janos Argyropoulos is said to have been so poor at one time that he was forced to sell his books. Bartolommeo Fazio had an up-and-down career, at one time a school-teacher in Venice and Genoa, at another a notary in Lucca, before he landed a safe and well-paid job as secretary to Alfonso of Aragon. Bartolommeo Platina worked in a variety of occupations – soldier, private tutor, press-corrector, secretary – before becoming Vatican librarian. Angelo Decembrio was at one time a schoolmaster in Milan, Pomponio Leto in Venice and Francesco Filelfo in several different towns. Jacopo Aconcio was at one time a notary, at another secretary to the governor of Milan, at another trying his luck in England.

These humanists were the distinguished ones. To calculate the status of the group as a whole, it is also necessary to consider the less important ones. Ideally, if the evidence permits, a study should be made of the careers of all the students of the humanities. Until such a study is published, it is difficult to do more than guess at the status of humanists. My own guess would be that there was a considerable gap between the few stars and the less successful majority, even if a small-town teacher or impoverished corrector for the press might enjoy a status higher than that of a successful but 'ignorant' artist. Musicians, whose low status was lamented by Alberti, seem to have been in a similar position. For every lutenist who was rewarded by a patron as generous as Pope Leo X, there must have been many who were poor, since there were few Italian courts and still fewer honourable positions outside them.

In summing up, it is tempting to take the easy way out and to close on a note of 'on the one hand . . . on the other'. However, it is possible to make a few more precise points – three at least. As in the case of training, so in status the creative elite formed two cultures, with literature, humanism and science enjoying more respect than the visual arts and music. All the same, to choose the humanities as a career was to take a considerable risk. Many were trained but few were chosen. In the second place, Renaissance artists were an example of what sociologists call 'status dissonance'. Some of them achieved high status, others did not. According to some criteria, artists deserved honour; according to others, they were just craftsmen.

Artists were in fact respected by some of the noble and powerful,

¹⁰⁷ Mather, 'Documents'.

but they were despised by others. The status insecurity which naturally resulted may well explain the touchiness of certain individuals, such as Michelangelo and Cellini. In the third place, the status of both artists and writers was probably higher in Italy than elsewhere in Europe, higher in Florence than in other parts of Italy, and higher in the sixteenth century than it had been in the fifteenth. They might be represented as melancholy geniuses (plate 3.8). ¹⁰⁸ By the middle of the sixteenth century it was no longer extraordinary for artists to have some knowledge of the humanities; the distinction between the two cultures was breaking down. ¹⁰⁹ The social mobility of painters and sculptors is symbolized if not confirmed by the appearance of the term 'artist' in more or less its modern meaning.

ARTISTS AS SOCIAL DEVIANTS

If the artist was not an ordinary craftsman, what was he? He could if he wished imitate the style of life of a nobleman, a model suitable for those endowed with wealth, self-confidence and the ability to behave like something out of Castiglione's Courtier. A number of artists, mainly sixteenth-century ones, are described in these terms in Vasari's Lives. An obvious example is Raphael, who was in fact one of Castiglione's friends. Other instances of the artist as gentleman are Giorgione, Titian, Vasari's kinsman Signorelli, Filippino Lippi (described as 'affable, courteous and a gentleman'), the sculptor Gian Cristoforo Romano (who makes an appearance in The Courtier), and a small number of others, including, of course, Vasari himself. All the same, the artist who adopted this role still had to face the social prejudice against manual labour which has just been described. For those who were no longer content to be ordinary craftsmen, yet lacked the education and poise necessary to pass as gentlemen, a third model was developed in this period (how self-consciously, it is hard to say) - that of the eccentric or social deviant.

At this point distinctions are necessary. Vasari and others have recorded a number of highly dramatic stories about artists of the period who killed or wounded men in brawls (Cellini, Leone Leoni and Francesco 'Torbido' of Venice) or committed suicide (Rosso, Torrigiani). Others were described by contemporaries as 'sodomites' (Leonardo, 'Sodoma'). The significance of these stories is difficult to assess. The evidence is insufficient to determine whether these artists were what they were described as being, and, even if they were, we cannot conclude from a few cases that artists were more likely than other social

¹⁰⁸ Zilsel, Entstehung des Geniebegriffes.

¹⁰⁹ Rossi, Dalle botteghe alle accademie; Dempsey, 'Some observations'.

groups to kill others or themselves or to love members of the same sex.^{110}

There is a much richer vein of contemporary comment about a more significant kind of eccentricity associated with artists: irregular working habits. In one of the stories of Matteo Bandello, who was in a good position to know, there is a vivid description of Leonardo's way of working, which stresses his 'caprice' (capriccio, ghiribizzo).¹¹¹ Vasari made similar comments about Leonardo, and told a story in which the artist justified his long pauses to the duke of Milan with the argument that 'Men of genius sometimes accomplish most when they work the least; for they are thinking of designs' (inventioni). The key concept here is a relatively new one, 'genius' (genio), which turned the eccentricity of artists from a liability into an asset.¹¹² Patrons had to learn to put up with it. On one occasion the marquis of Mantua, explaining to the duchess of Milan why Mantegna had not produced a particular work on time, made the resigned remark that 'usually these painters have a touch of the fantastic' (hanno del fantasticho).¹¹³

Other clients were less tolerant. Vasari remarked of the painter Jacopo Pontormo that 'What most annoyed other men about him was that he would not work save when and for whom he pleased and after his own fancy.' Composers – or their patrons – posed similar problems. When the duke of Ferrara wanted to hire a musician, he sent one of his agents to see – and hear – both Heinrich Isaac and Josquin des Près. The agent reported that 'It is true that Josquin composes better, but he does it when he feels like it, not when he is asked.' It was Isaac who was hired (below, p. 120).¹¹⁴

In the case of other artists, their eccentricity took the form of doing too much work rather than too little, and neglecting everything but their art. Vasari has a series of such stories. Masaccio, for example, was absent-minded (persona astratissima): 'Having fixed his mind and will wholly on matters of art, he cared little about himself and still less about others . . . he would never under any circumstances give a thought to the cares and concerns of this world, nor even to his clothes, and was not in the habit of recovering his money from debtors.' Again, Paolo Uccello was so fascinated by his 'sweet' perspective that 'He remained secluded in his house, almost like a hermit, for weeks and months, without

¹¹⁰ Wittkower and Wittkower, Born under Saturn; Zanrè, Cultural Non-Conformity.

¹¹¹ Bandello, Novelle, novella 58, dedication.

¹¹² Zilsel, Entstehung des Geniebegriffes; Klibansky et al., Saturn and Melancholy.

¹¹³ Chambers, Patrons and Artists, no. 61.

¹¹⁴ Straeten, Musique aux Pays-Bas, p. 87.

knowing much of what was going on in the world and without showing himself.'115 Vasari also gives a vivid account of the 'strangeness' of Piero di Cosimo, who was absent-minded, loved solitude, would not have his room swept, and could not bear children crying, men coughing, bells ringing or friars chanting (is his attempt to preserve himself from distraction really so 'strange'?).

The fact that Masaccio, in early fifteenth-century Florence, is presented as uninterested in money is a trait worth emphasis. A still more conspicuous contempt for wealth is shown by Donatello, of whom 'It is said by those who knew him that he kept all his money in a basket, suspended from the ceiling of his workshop, so that everyone could take what he wanted whenever he wanted.'116 This looks very much like a conscious rejection of the fundamental values of Florentine society. Why Donatello should have rejected these values emerges from another story of Vasari's, about a bust made by the sculptor for a Genoese merchant, who claimed to have been overcharged because the price worked out at more than half a florin for a day's work.

Donatello considered himself grossly insulted by this remark, turned on the merchant in a rage, and told him that he was the kind of man who could ruin the fruits of a year's toil in the hundredth part of an hour; and with that he suddenly threw the bust down into the street where it shattered into pieces, and added that the merchant had shown he was more used to bargaining for beans than for bronzes.

Whether the point was Donatello's or Vasari's, the moral is clear: works of art are not ordinary commodities, and artists are not ordinary craftsmen to be paid by the day.

One is reminded of what the attorney-general said to Whistler about his *Nocturne*, and the artist's reply: 'The labour of two days then is that for which you ask 200 guineas?' 'No: I ask it for the knowledge of a lifetime.' The point still needed to be made in 1878. However, the question was very much alive in Renaissance Italy. The archbishop of Florence recognized, as we have seen (p. 81), that artists claimed with some justification to be different from ordinary craftsmen. Francisco de Hollanda, a Portuguese in the circle of Michelangelo, argued still more forcefully that 'Works of art are not to be judged by the amount of useless labour spent

¹¹⁶ The story is best known from Vasari, but I quote a version current fifty years closer to Donatello's day: Gauricus, *De sculptura*, p. 53.

¹¹⁵ Masaccio died in 1428, Uccello in 1475. Vasari could have learned about them from the oral traditions of the artists of Florence, but in Masaccio's case this would have been more than a hundred years after the event. Readers can make their own assessment of the reliability of information transmitted orally over such a period.

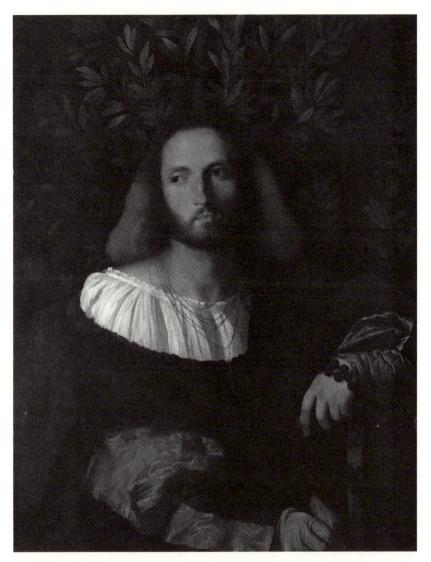

PLATE 3.8 PALMA VECCHIO: PORTRAIT OF A POET

on them but by the worth of the knowledge and skill which went into them' (lo merecimento do saber e da mao que as faz). 117

The same idea, that the artist is not an ordinary craftsman, may well

¹¹⁷ Hollanda, Da pintura antigua, 3rd dialogue, p. 59.

PLATE 3.9 GIULIO ROMANO: THE PALAZZO DEL TE, MANTUA, DETAIL OF A FRIEZE WITH SLIPPED TRIGLYPHS

underlie the behaviour of Pontormo (again according to Vasari) when he rejected a good commission and then did something 'for a miserable price'. He was showing the client that he was a free man. Artistic eccentricity carried a social message.

PATRONS AND CLIENTS

Why do you think there was such a great number of capable men in the past, if not because they were well treated and honoured by princes?

Filarete, *Treatise on Architecture*

I cannot live under pressures from patrons, let alone paint.

Michelangelo, Carteggio

ystems of patronage differ. It may be useful to distinguish five main types. First, the household system: a rich man takes the artist or Writer into his house for some years, gives him board, lodging and presents, and expects to have his artistic and literary needs attended to. Second, the made-to-measure system: again, a personal relationship between the artist or writer and his patron ('client' might be a better term in this case), but a temporary one, lasting only until the painting or poem is delivered. Third, the market system, in which the artist or writer produces something 'ready-made' and then tries to sell it, either directly to the public or through a dealer. This third system was emerging in Italy in the period, although the first two types were dominant. The fourth and fifth types – the academy system (government control by means of an organization staffed by reliable artists and writers) and the subvention system (in which a foundation supports creative individuals but makes no claim on what they produce) - had not yet come into existence.1

This chapter is concerned with two problems: first, with discovering what kinds of people gave artists commissions, and why they did so, and, second, with assessing the extent to which it was the patron or client, rather than the artist or writer, who determined the shape and content of the work. In the background lurks the more elusive question to which the epigraphs above allude. Was the patronage system encouraging or

¹ Edwards, 'Creativity', distinguishes four types; I have divided his 'personalized' system into two.

discouraging to artists and writers? In other words, did the Renaissance happen in Italy because of the system or in spite of it?²

WHO ARE THE PATRONS?

Patrons may be classified in various ways. The division into ecclesiastical and lay is a simple and useful one, at least at first sight, contrasting (say) the monks of San Pietro in Perugia, for whom Perugino painted an altarpiece of the Ascension, with Lorenzo de Pierfrancesco de'Medici (not the famous Lorenzo, but his cousin), for whom Botticelli painted the Primavera. The Church was traditionally the great patron of art, and this is the obvious reason for the predominance of religious paintings in Europe over the very long term (from the fourth century or thereabouts to the seventeenth). In Renaissance Italy, however, it is likely that most religious paintings were commissioned by laymen. They might order the painting for a church (for their family chapel, for example); Palla Strozzi asked Gentile da Fabriano to paint his Adoration of the Magi to hang in the Strozzi Chapel in the church of Santa Trinità in Florence. Lav people might also commission religious paintings to hang in their own homes. The Medici did this, for example, as we know from the inventory of the contents of their palace.3 Just as the laity asked for religious works, so the clergy commissioned paintings with secular subjects, such as the Parnassus which Raphael painted for Julius II in the Vatican. It would be interesting to know whether the laity were more likely to commission secular works, or whether the gradual secularization of painting reflected a secularization of patronage, but the evidence is too fragmentary to allow such questions to be answered.

A second way of classifying patrons is to distinguish public from private. The guild patronage of early fifteenth-century Florence is particularly well known. The wool guild, the Arte della Lana, was responsible for the upkeep of the cathedral, which involved new commissions – one to Donatello for a statue of the prophet Jeremiah, another to Michelangelo for his *David*. The cloth guild, the Calimala, was responsible for the

³ Müntz, Collections des Médicis.

² The vast literature on art patronage includes Burckhardt, Beiträge; Wackernagel, World of the Florentine Renaissance Artist, pt 2; Renouard, 'L'artiste ou le client?'; Chambers, Patrons and Artists; Baxandall, Painting and Experience, pp. 3–14; Logan, Culture and Society, ch. 8; Settis, 'Artisti e committenti'; Gundersheimer, 'Patronage in the Renaissance'; Goffen, Piety and Patronage; Kent and Simons, Patronage, Art and Society; Hollingsworth, Patronage in Renaissance Italy; Anderson, 'Rewriting the history'; Welch, Art and Society, pp. 103–29; Marchant and Wright, With and Without the Medici; Christian and Drogin, Patronage. On music, Bridgman, Vie musicale, ch. 1; Fenlon, Music and Patronage; and Feldman, City Culture, pp. 3–82.

Baptistery, and so it was this guild which commissioned Ghiberti to make the famous doors. The lesser guilds as well as the greater placed statues on the façade of the church of Orsanmichele; Donatello's *St George*, for example, was commissioned by the armourers.⁴ The guilds were interested in paintings as well as sculptures. In 1433, the linen guild commissioned Fra Angelico to paint a Madonna for their guildhall.⁵

Another kind of corporate patron, still more important if one takes the whole period and the whole of Italy into account, was the religious fraternity. 6 The fraternity was in effect a social and religious club, usually attached to a particular church, which might perform works of charity and might also act as a bank. The patronage of the Venetian fraternities, known as scuole, was particularly lavish. The huge pictures of St Ursula which Vittore Carpaccio painted in the 1490s were designed for the hall of the guild dedicated to that saint, a small guild with a mixed membership of men and women, nobles and commoners. Still more important was the patronage of the six scuole grandi, including San Giovanni Evangelista, for whom Gentile Bellini painted a number of large pictures, and San Rocco, whose Tintorettos may still be viewed in the hall of the fraternity. Indeed, their expenditure on building and pageants was so great as to provoke criticism from contemporaries who considered that all this magnificence was at the expense of the poor, charity to whom was the original purpose of these organizations.8

The patronage of fraternities was important not just in Venice but all over Italy, as the paintings of Vecchietta and Battista Dossi remind us (Plates 4.1, 4.2). Leonardo's Virgin of the Rocks was commissioned by a fraternity, that of the Conception of the Virgin in the church of San Francesco at Milan. It was the fraternity of Corpus Christi at Urbino which commissioned Justus of Ghent's Institution of the Eucharist, as well as Uccello's Profanation of the Host. The importance of organizations like these in the history of art is that they made possible the participation in patronage of people who did not have the money to commission works individually. One would love to know what discussions went on before a particular artist or subject was chosen. It is intriguing to find that in 1433 the Florentine Board of Works for the Cathedral (the Operai del Duomo) delegated their authority to one man to work out

⁴ Baron, 'Historical background'; Haines, 'Brunelleschi and bureaucracy' and 'Market for public sculpture'.

⁵ Chambers, *Patrons and Artists*, nos. 20–30; for Venice, Humfrey and MacKenney, 'Venetian trade guilds'.

⁶ Pignatti, Scuole di Venezia; Eisenbichler, Crossing the Boundaries; Esposito, 'Confraternite romane'; Wisch and Ahl, Confraternities and the Visual Arts.

⁷ Molmenti and Ludwig, Vittore Carpaccio;

⁸ Pullan, Rich and Poor, pp. 119ff.; Brown, Venetian Narrative Painting.

PLATE 4.1 LORENZO VECCHIETTA: SAN BERNADINO DA SIENA (DETAIL)

details of a commission to Donatello. Was this because the board was unable to agree? Would groups have been more conservative in their tastes than individuals, as they have generally been over the past couple of centuries, or is this assumption anachronistic?

Another kind of corporate patron was the state, whether republic or principality. It was the Signoria, the government of Florence, which commissioned Leonardo's *Battle of Anghiari* and its companion piece, Michelangelo's *Battle of Cascina*. In Venice there existed an official position of Protho, or architect to the Republic (held by Jacopo Sansovino, among others), and a quasi-official position of painter to the Republic (offered to Dürer on one occasion and held by both Giovanni Bellini and Titian).

However, one painter alone could not cope with all the state's commissions. In 1495 there were nine painters, including Giovanni Bellini and Alvise Vivarini, working on battle scenes to decorate the Hall of the Great Council in the Doge's Palace. The problems of patronage by committee emerge clearly from the documents referring to a battle scene by Titian for the same place. In 1513 Titian petitioned the Council of Ten to be allowed to paint it, with the help of two assistants. A resolution accepting the offer was carried (10 votes to 6); Bellini protested. In March 1514 the decree was revoked (14 votes to 1) and the assistants were struck off the payroll; Titian protested. In November, the revocation was revoked (9 votes to 4), and the assistants reappeared on the payroll. Then it was reported that three times as much money had been spent as need have been, and all arrangements were cancelled. Titian agreed to accept a single assistant, and his offer was accepted in 1516, but the battle painting was still unfinished in 1537.¹⁰

Individual patrons came from a wide range of social groups, not just the social and political elites. Architecture and sculpture were usually expensive, but the evidence of wills shows that some shopkeepers and artisans commissioned chapels.¹¹ There is also evidence that some people with modest incomes commissioned paintings. The surviving documents are concerned mainly with upper-class patronage, but those are the precisely the documents that are most likely to survive. In any case there are records of some commissions by merchants, shopkeepers, artisans and even peasants.

Take the case of portraits. Portraits of merchants were not uncommon. Among those that have survived are Leandro Bassano's Orazio

⁹ Logan, Culture and Society, pp. 181ff.; Howard, Jacopo Sansovino; Hope, Titian, p. 98.

¹⁰ Lorenzi, Monumenti, pp. 157–65; Chambers, Patrons and Artists, nos. 42–3. ¹¹ Cohn, 'Renaissance attachment to things', pp. 988–9.

Lago and Giovanni Battista Moroni's *Paolo Vidoni Cedrelli*. Lorenzo Lotto noted in his account-book the names of five businessmen he painted – 'a merchant from Ragusa', 'a merchant from Lucca', 'a wine merchant', and so on. Lotto also painted a surgeon from Treviso (at this time the status of surgeons, who were associated with barbers, was rather low) and a portrait of 'Master Ercole the shoemaker', who paid him in kind rather than in cash. ¹² Hence Moroni's famous portrait of a tailor, still to be seen in the National Gallery in London, is likely to be a portrait rather than, as was once thought, a genre painting.

Again, take the case of religious paintings. There are casual references in Vasari to artisan clients, such as the mercer and the joiner who commissioned Madonnas from Andrea del Sarto and the tailor who commissioned Pontormo's first recorded work. Again, the will of an agricultural labourer who lived near Perugia leaves 10 lire to pay for a painting of Christ in majesty (a *Maestà*) to hang above his grave. Ex-votos (discussed below, p. 136) were also commissioned by ordinary people. What we do not know is whether popular patronage of art was as commonplace as it would be in the Dutch Republic in the seventeenth century.

Recent research, as we have seen (above, pp. 9–10) has revealed that female patrons were an important group. Scholars now go far beyond the unusually well-documented case of Isabella d'Este (Plate 4.4). ¹⁴ They distinguish the patronage of nuns, the Dominicans for instance, and of laywomen, that of wives and that of widows (widows had more freedom to do as they liked). A few noblewomen built palaces, such as Ippolita Pallavicino-Sanseverina at Piacenza. ¹⁵ Some women, such as Margarita Pellegrini of Verona, were able to commission a chapel, while Giovanna de'Piacenza commissioned Correggio's now famous frescoes in the Camera di San Paolo, a room in a convent in Parma. Others, such as the widow Lucretia Andreotti of Rome, commissioned a tomb. Yet others commissioned altarpieces, which might include their portrait as the donor, as in the case of a panel by Carlo Crivelli that has a tiny figure of the donor, Oradea Becchetti of Fabriano, kneeling at the feet of St Francis. ¹⁶

¹² Lotto, *Libro*, pp. 28, 50.

¹³ Cohn, 'Renaissance attachment to things', p. 989. Cf. Wackernagel, World of the Florentine Renaissance Artist, p. 10.

¹⁴ Braghirolli, 'Carteggio di Isabella d'Este'; Cartwright, *Isabella d'Este*; Fletcher, 'Isabella d'Este'; Brown, 'Ferrarese lady'; Reiss and Wilkins, *Beyond Isabella*; Campbell, *Cabinet of Eros*; Ames-Lewis, *Isabella and Leonardo*.

¹⁵ Roberts, Dominican Women; McIver, Women, Art and Architecture, pp. 63-106

¹⁶ King, Renaissance Women Patrons.

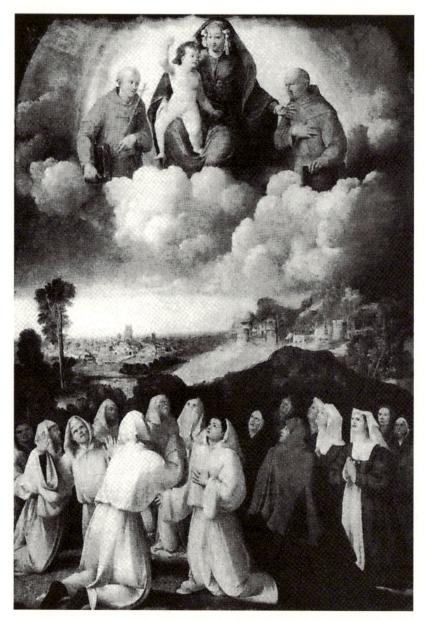

Plate 4.2 Battista Dossi: Madonna with Saints and the Confraternity

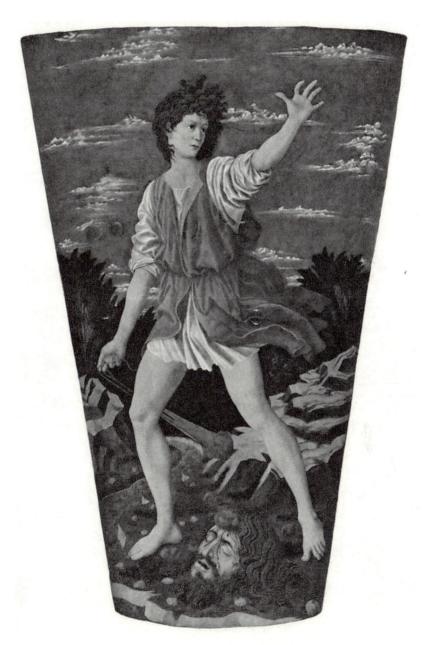

Plate 4.3 Andrea del Castagno: *The Youthful David*, tempera on leather mounted on wood, c.1450

How patrons and artists met

How did artists acquire patrons or clients, or patrons acquire artists? When artists heard that projects were in the air, they might approach the patron directly or through an intermediary. For example, in 1438 the painter Domenico Veneziano wrote to Piero de'Medici: 'I have heard that Cosimo [Piero's father] has decided to have an altarpiece painted, and wants a magnificent work. This pleases me a great deal, and it would please me still more if it were possible for me to paint it, through your mediation' (*per vostra megianita*).¹⁷ In 1474, there was news in Milan that the duke wanted a chapel painted at Pavia. The duke's agent complained that 'all the painters of Milan, good and bad, asked to paint it, and trouble me greatly about it.' Again, in 1488, Alvise Vivarini petitioned the doge to let him paint something for the Hall of the Great Council in Venice as the Bellinis were doing, and in 1515, as we have seen, Titian made a similar request.¹⁸

In these cases, as in many other matters, friendships, equal and unequal, counted for a great deal. Art patronage was part of a much larger patron-client system, discussed in chapter 9. The importance of friends and relations may be illustrated from the careers of two sixteenth-century Tuscan artists, Giorgio Vasari and Baccio Bandinelli. Vasari came to work for Ippolito and Alessandro de'Medici because he was a distant relative of their guardian, Cardinal Silvio Passerini. After his hopes had been 'blown away', as we have seen, by the death of Duke Alessandro, Vasari managed to enter the permanent service of his successor Cosimo. Bandinelli also had a family connection with the Medici in the sense that his father had worked for them before their expulsion from Florence in 1494. After their restoration in 1513, Baccio introduced himself to the brothers Giovanni (soon to become Pope Leo X; Plate 4.7) and Giuliano, offered them a gift, and received commissions in return. Bandinelli also worked for Giulio de'Medici, who became Pope Clement VII. He expected the commission to make the tombs of both Medici popes and visited Cardinal Salviati so often to arrange this that, as Vasari tells us in his biography of Bandinelli, he was mistaken for a spy and nearly assassinated.

It is less easy to discover how patrons chose particular artists. The less expert sometimes asked advice of others, such as Cosimo de'Medici (as we have seen) or his grandson Lorenzo the Magnificent. It was Lorenzo,

¹⁷ Gaye, Carteggio inedito d'artisti, vol. 1, p. 136; Chambers, Patrons and Artists, no. 46.

¹⁸ ffoulkes and Maiocchi, Vincenzo Foppa, pp. 300ff.; Chambers, Patrons and Artists, nos. 41-2.

for example, who recommended the sculptor Giuliano da Maiano to prince Alfonso of Calabria. Princes might commission artists via intermediaries, such as court officials, as in Milan under the Sforza. Some patrons seem to have chosen between rival offers on financial grounds, others for stylistic reasons. The duke of Milan's agent, in the case of the chapel quoted above, chose the artists who offered to do the work for 150 rather than for 200 ducats. Twenty years later, however, a memorandum from the papers of the new duke of Milan, Ludovico Sforza, attempted to distinguish between Botticelli, Filippino Lippi, Perugino and Ghirlandaio on the grounds of style (cf. p. 152 below).

Formal competitions for commissions also took place on occasion, especially in Florence and Venice, which is what one might have expected from republics of merchants. The most famous of these competitions are surely those for the Baptistery doors in Florence in 1400 (in which Ghiberti defeated Brunelleschi) and for the cupola of Florence Cathedral (in which it was Brunelleschi's turn to win), but there are many other examples. In 1477, for instance, Verrocchio defeated Piero Pollaiuolo for the commission for the tomb of Cardinal Forteguerri. In 1491, there was a competition for designs for the façade of the cathedral in Florence. In 1508, Benedetto Diana won and Vittore Carpaccio lost a commission from the Venetian Scuola della Carità. In Venice, incidentally, even the organists at San Marco were appointed only after a competition.

The motives for patronage

It may be useful to distinguish three main motives for art patronage in the period: piety, prestige and pleasure (see also chapter 5). A fourth has been suggested, but it may be anachronistic: investment.²² If investment in works of art means buying them on the assumption that they will be worth more in the future, then it is difficult to find evidence for it before the eighteenth century.²³ 'The love of God', on the other hand, is frequently mentioned in contracts with artists; and if piety had not been an important as well as a socially acceptable motive for patrons, it would be difficult to explain the predominance of religious paintings and sculptures in the period (above, pp. 27–8). Prestige, or what the sociologist

¹⁹ Welch, Art and Authority.

²⁰ Chambers, Patrons and Artists, no. 95.

²¹ Gaye, Carteggio inedito d'artisti, vol. 1, p. 256; Chambers, Patrons and Artists, no. 51.

²² Lopez, 'Hard times and investment'; cf. Goldthwaite, *Building of Renaissance Florence*, pp. 397ff.

²³ Burke, 'Investment and culture'.

Pierre Bourdieu called the desire for 'distinction' from others, was also a socially acceptable motive, above all in Florence. It is not infrequently mentioned in contracts. When the *Operai del Duomo* of Florence commissioned twelve apostles from Michelangelo, for example, they referred to the 'fame of the whole city' and its 'honour and glory'. When Giovanni Tornabuoni commissioned frescoes for his family chapel in Santa Maria Novella, he referred openly to the 'exaltation of his house and family', and ensured that the family coat of arms was prominently displayed.²⁴

The most extraordinary example of the desire for prestige, however, is surely the tabernacle commissioned by Piero de'Medici for the church of the Annunziata in Florence and inscribed 'the marble alone cost 4,000 florins' (Costò fior. 4 mila el marmo solo).²⁵ This classic example of nouveau-riche exhibitionism makes one wonder whether – as seems to have been the case in eighteenth-century Venice – rising families saw art patronage as a way of showing the world that they had reached the top, and whether they were more active as patrons than families already established.²⁶

The prestige acquired by art patronage might be of political value to a ruler. Filarete, who had of course an axe to grind, or, rather, a palace to build, argued this case and tried to demolish the economic argument that buildings were too expensive:

Magnanimous and great princes and republics as well, should not hold back from building great and beautiful buildings because of the expense. No country was ever impoverished nor did anyone ever die because of the construction of buildings . . . In the end when a large building is completed there is neither more nor less money in the country but the building does remain in the country or city together with its reputation or honour.²⁷

Machiavelli too saw the political use of art patronage and suggested that 'a prince ought to show himself a lover of ability, giving employment to able men and honouring those who excel in a particular field.'28

The third motive for patronage was 'pleasure', a more or less discriminating delight in paintings, statues, and so on, whether as objects in their own right or as a form of interior decoration. It has often been suggested that this motive was more important as well as more self-conscious in Renaissance Italy than it had been anywhere in Europe for a thousand

²⁴ Bourdieu, Distinction; Chambers, Patrons and Artists, no. 107.

²⁵ Wackernagel, World of the Florentine Renaissance Artist, p. 245n.

²⁶ Haskell, Patrons and Painters, pp. 249ff.

²⁷ Filarete, Treatise on Architecture, p. 106.

²⁸ Machiavelli, *Prince*, ch. 21.

years.²⁹ This is likely enough, although the 'more' cannot be measured; all that can be done is to quote examples of the trend.

Filarete, for example, stressed the pleasure in building for its own sake, 'a voluptuous pleasure as when a man is in love'. The more the patron sees the building, the more he wants to see it, and he loves to talk to everyone about it - typical lover's behaviour. The names of some villas of the period suggest that they were playthings: Schifanoia ('Avoid boredom') at Ferrara; Casa Zoiosa (Happy House) at Mantua. According to the bookseller Vespasiano da Bisticci, who did not go out of his way to praise the visual arts, two of his prominent clients, Federigo of Urbino and Cosimo de'Medici, took a keen personal pleasure in sculpture and architecture. To hear Federigo talk to a sculptor, 'one would have thought it his trade', while Cosimo was so much interested in architecture that his advice was sought by those who intended to build.³⁰ The correspondence of Isabella d'Este leaves the impression that the reason she commissioned paintings was simply to have them. She was not the only patron to think in this way. Isabella failed to acquire two Giorgiones because they had been commissioned by two Venetian patricians 'for their own enjoyment'. 31 There seems to have been a circle of patrician collectors in Venice at this time, including Taddeo Contarini and Gabriele Vendramin, a well-known art-lover in whose house the famous Tempest could be seen in 1530,32

This desire to acquire works of art for their own sake is found above all in individuals who have something else in common: a humanist education. After Gianfrancesco Gonzaga, marquis of Mantua, engaged Vittorino da Feltre to teach his children, they grew up to become patrons of the arts, and so did Federigo of Urbino, who also studied with Vittorino. Similarly, the children of the ruling house of Este at Ferrara became patrons of the arts after they had been educated by Guarino of Verona. As a child, Lorenzo de'Medici had a humanist tutor, Gentile Becchi. Gabriele Vendramin moved in a social circle which took in humanists of the calibre of Ermolao Barbaro and Bernardo Bembo.³³ Although humanists did not always respect artists, the study of the humanities seems to have encouraged a taste for pictures and statues, including statuettes.³⁴

²⁹ Alsop, Rare Art Traditions.

³⁰ Carboni Baiardi, Federico di Montefeltro; Kent, Cosimo de' Medici.

³¹ Chambers, Patrons and Artists, no. 91.

³² Settis, Giorgione's Tempest, pp. 129ff.

³³ Logan, Culture and Society, p. 157.

³⁴ Baxandall, 'Guarino, Pisanello and Manuel Chrysoloras'.

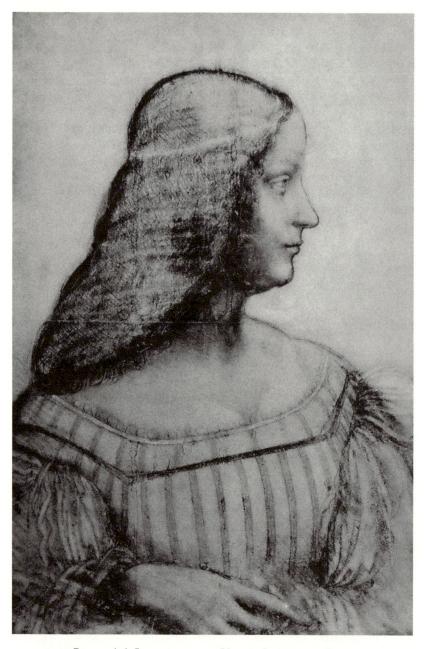

Plate 4.4 Leonardo da Vinci: Isabella d'Este

PATRONS V. ARTISTS

Now that the patron and the artist have been introduced to each other, we may consider their relative influence on the finished product. A study of Cosimo de'Medici bears the subtitle 'the patron's oeuvre', stressing his initiative and arguing that 'For most of the fifteenth century artists were not considered to be independent creative agents and did not behave as such.'35 The testimony of contemporaries does indeed suggest that the influence of the patron was considerable. The term 'made' (*fecit*) continued to be used of patrons, as it had been in the Middle Ages. Filarete described the patron as the father of the building, the architect as the mother. Titian told Alfonso duke of Ferrara that he was

convinced that the greatness of art amongst the ancients was due to the assistance they received from great princes content to leave to the painter the credit and renown derived from their own ingenuity in commissioning pictures . . . I shall, after all, have done no more than give shape to that which received its spirit – the most essential part – from Your Excellency. ³⁶

He was, of course, flattering the duke, but the different forms taken by flattery in different periods provide valuable evidence for social historians.

More precise evidence about the relative importance of patrons and artists and the expectations of both parties is provided by the scores of surviving contracts.³⁷ The contracts discuss many topics, including framing, installation and maintenance, but they concentrate on six issues. In the first place come materials, an important question because of the expense of the gold and lapis lazuli used for paintings or the bronze and marble for sculpture. Sometimes the patron provided the materials, sometimes the artist did so. Contracts often specified that the materials employed be of high quality. Andrea del Sarto promised to use at least 5 florins' worth of azure on a Virgin Mary, while Michelangelo promised that the marble for his famous *Pietà*, begun in 1501, should be 'new, pure and white, with no veins in it'.³⁸ The emphasis on materials is a clue to what the client thought he was buying. Leonardo's contract for *The Virgin of the Rocks* gives a ten-year guarantee; if anything was to need repainting within that period, it was to be at the expense of the artist.

³⁶ Crowe and Cavalcaselle, Life and Times of Titian, p. 181.

³⁵ Kent, Cosimo de' Medici, pp. 5, 331-2.

³⁷ Kemp, Behind the Picture, pp. 33–46; Welch, Art and Society, pp. 103–14; Gilbert, 'What did the Renaissance patron buy?', pp. 393–8; O'Malley, Business of Art.

³⁸ Shearman, Andrea del Sarto, doc. 30.

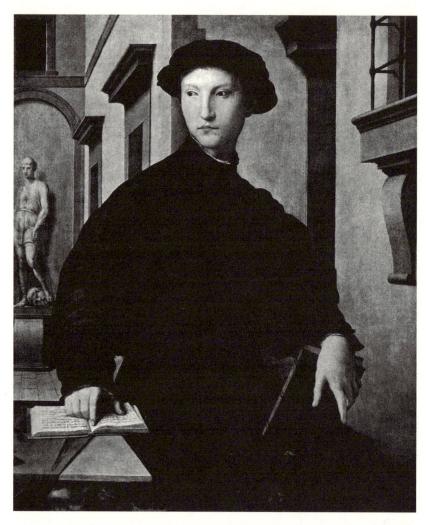

Plate 4.5 Agnolo Bronzino: Ugolino Martelli

One wonders whether Leonardo gave a similar guarantee in the case of his flaky *Last Supper*.

Secondly, there was the question of price, including the currency (large ducats, papal ducats, and so on). Sometimes the money was paid on completion, sometimes in instalments while the work was in progress. Alternatively, the price might not be fixed in advance; either the artist declared his readiness to accept what the patron thought good to offer, or the work would be valued by other artists, as it was in cases of dis-

pute.³⁹ Payments in kind were sometimes included. Signorelli's contract for frescoes in Orvieto Cathedral gave him the right to a sum of money, to gold and azure, to lodgings and a bed. After negotiations, he raised the offer to two beds.

Thirdly, there was the question of delivery date, vague or precise, with or without sanctions if the artist did not keep his word. A Venetian state commission to Giovanni Bellini stated that the paintings should be finished 'as quickly as possible'. In 1529, Beccafumi was given 'a year, or eighteen months at most', to finish a picture. Other clients were more precise, or more demanding. In 1460, Fra Lippo Lippi promised a painting by September of that year and, if he failed to produce it, the client was given the right to ask someone else to finish it. On 25 April 1483, Leonardo promised to deliver The Virgin of the Rocks by 8 December. Michelangelo's contract of 1501 for fifteen statues laid down that he was not to make any other contracts which would delay the execution of this one. (It is perhaps surprising that academic publishers do not make this stipulation today.) Raphael was given two years to paint an altarpiece, with a large fine (40 ducats, over half the price) if he failed to meet the deadline. The contract which Andrea del Sarto made in 1515 to paint an altarpiece within a year contained the clause 'that if he did not finish the said picture within the said time, the said nuns would have the right to give the said commission to someone else' (dictam tabulam alicui locare).

Princes were particularly impatient. 'We want you to work on some paintings which we wish to have made, and we wish you, as soon as you have received this, to drop everything, jump on your horse and come here to us', wrote the duke of Milan to the Lombard painter Vincenzo Foppa. The same ruler commanded painters to work night and day to decorate the Castello Sforzesco, and a contemporary chronicle tells a story of a room painted 'in a single night'. His successor was equally demanding and on one occasion resolved, as he put it, 'to have our ballroom at Milan painted immediately with stories, at all possible speed'.⁴⁰

Alfonso d'Este of Ferrara was a man of the same stamp. When Raphael kept him waiting, Alfonso sent him a message: 'Let him beware of provoking our anger.' When Titian failed to produce a painting on time in 1519, Alfonso instructed his agent 'To tell him instantly, that we are surprised that he should not have finished our picture; that he must finish it whatever happens or incur our great displeasure; and that he may be made

³⁹ Chambers, Patrons and Artists, nos. 123-7.

⁴⁰ Malaguzzi-Valeri, *Pittori Lombardi*; Chambers, *Patrons and Artsts*, nos. 96–100.

to feel that he is doing a bad turn to one who is in a position to resent it.'41

Another impatient patron was Federico II, marquis of Mantua. For example, he wrote to Titian in 1531 asking for a picture of St Mary Magdalen, 'and above all, let me have it quickly' (Titian sent it in less than a month). Again, when Giulio Romano and his assistants failed to decorate the Palazzo del Te with sufficient speed, the marquis wrote: 'We are not amused that you should again have missed so many dates by which you had undertaken to finish.' Giulio replied obsequiously: 'The greatest pain I can receive is when Your Excellency is angry . . . if it is pleasing to you, have me locked up in that room until it is done.' This seems a far cry from Federico's flattering comparison of his painter to Apelles (above, p. 81), unless Alexander the Great treated his painters in the same way.

Fourthly, there was the question of size. This is surprisingly often left unspecified, perhaps an indication of sixteenth-century vagueness about measurements, although in many cases the fact that a fresco was painted on a particular wall, or a statue made from the client's block of marble or to fit a particular niche, would have made precision unnecessary. However, Michelangelo promised in 1514 to make his *Christ Carrying the Cross* 'life size'. Andrea del Sarto agreed to make his altarpiece of 1515 at least 3 braccia wide and 3½ braccia high. Isabella d'Este, who wanted a set of matching pictures for her study, enclosed a thread in her letter commissioning Perugino so that he would get the measurements right.

Fifthly, the question of assistants. Some contracts were made with groups of artists rather than individuals. Others mention assistants, usually to specify the responsibility for paying them. Some stipulate that the artist signing the contract should produce all or part of the work 'with his own hand' (*sua mano*), though this phrase cannot always be taken literally.⁴⁴ In the course of the period, however, patrons came to demand the personal intervention of the signatory. Indeed, as early as 1451 a merchant of Perugia refused to pay Filippo Lippi for an altarpiece that he had ordered because the work was 'made by others' (*fatta ad altri*), whereas 'he should have made it himself' (*egli la dovea fare esso medesimo*).⁴⁵ Raphael promised to paint with his own hand the figures in his altarpiece

⁴¹ Crowe and Cavalcaselle, *Life and Times of Titian*, pp. 183–4. I have modified the translation.

⁴² Bodart, Tiziano e Federico II Gonzaga.

⁴³ Hartt, Giulio Romano, vol. 1, pp. 74–5; original text in D'Arco, Giulio Pippi Romano, appendix.

⁴⁴ O'Malley, Business of Art, pp. 90-6.

⁴⁵ Ruda, Fra Filippo Lippi, pp. 525-6.

of the coronation of the Virgin. Perugino and Signorelli, however, promised to paint the figures in the frescoes in Orvieto Cathedral only 'from the waist up'.

The final question, crucial to posterity, of what actually went into the picture has been left till last because it does not loom large in the contracts themselves. On occasion, the subject is spelled out in words, sometimes in detail, but on other occasions rather briefly. Elaborate details were laid down for Domenico Ghirlandaio by Giovanni Tornabuoni in the Santa Maria Novella frescoes which have already been mentioned. Domenico and the others were to paint the right-hand wall of the chapel with seven specified scenes from the life of the Virgin. The painters also promised 'in all the aforesaid histories . . . to paint figures, buildings, castles, cities, mountains, hills, plains, rocks, garments, animals, birds and beasts . . . just as the patron wants, if the price of materials is not prohibitive' (secundum tamen taxationem colorum). 46

A more common formula in contracts was to give a relatively brief description of the iconographical essentials. On some occasions the description of even these essentials in legal Latin seems to have been too much for the notary, and the document suddenly lapses into Italian. The Ghirlandaio frescoes were to be 'as they say in the vernacular, frescoed' (ut vulgariter dicitur, posti in frescho). A contract for a church at Loreto from 1429 asks for the Virgin 'with her son in her lap, according to custom' (secondo l'usanza), an interestingly explicit demand on a painter to follow tradition. It was often simpler to refer to a sketch, plain or coloured, or a model.⁴⁷ When the duke of Milan was having his chapel painted in 1474, his agent sent him two designs to choose from, 'with cherubs or without' (cherubs cost extra), and asked for the designs back 'to see, when the work is finished, whether the azure was as fine as was promised'.48 Alternatively, the client might send the sketch to the artist (as Isabella d'Este did when commissioning Perugino) or ask for something along the lines of a painting by someone else which had taken his or her fancy. A contract for a Crucifixion between a painter called Barbagelata and the Confraternity of St Bridget at Genoa (1485) required the figures to be painted in the same manner and quality 'as those which are painted in the altarpiece of St Dominic for the late Battista Spinola in the church of the said St Dominic, made and painted by master Vincent of Milan' (Vincenzo Foppa).49

Besides these descriptions and drawings, there may be more or less

⁴⁶ Chambers, Patrons and Artists, no. 107.

⁴⁷ Ibid., nos. 5, 68, 86, 101, 113, 137, etc.

⁴⁸ Ibid., no.99.

⁴⁹ ffoulkes and Maiocchi, Vincenzo Foppa.

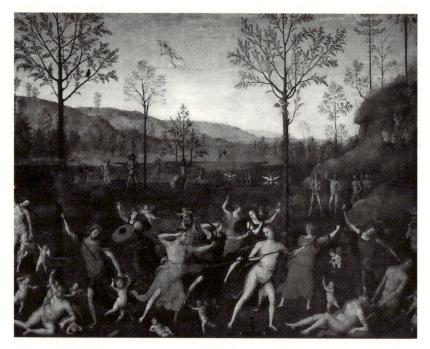

PLATE 4.6 PIETRO PERUGINO: BATTLE OF LOVE AND CHASTITY

precise references to the initiative of the artist or, more often, to the wishes of the patron. Tura contracted with the duke of Ferrara to paint the chapel of Belriguardo 'with the histories which please his said Excellency most'. When the monks of San Pietro in Perugia contracted with Perugino for an altarpiece, the predella was to be 'painted and adorned with histories according to the desire of the present abbot'. Isabella left Perugino a restricted area of freedom: 'you may leave things out if you like, but you are not to add anything of your own.'50 A study of 238 contracts suggests that, from the late fifteenth century onwards, painters were allowed more freedom than before.⁵¹ Michelangelo, late in the period and a law unto himself, seems usually to have got his own way. The contract for Christ Carrying the Cross says simply that the figure should be posed 'in whatever attitude seems good to the said Michelangelo', while the commission for a work never finished which was at one point Hercules and Cacus, at another Samson and a Philistine, describes the transfer of a block of marble to the sculptor, 'who is to

⁵⁰ Chambers, Patrons and Artists, no. 76.

⁵¹ O'Malley, Business of Art, p. 180.

make from it a figure together or conjoined with another, just as it pleases the said Michelangelo.'52

Contracts, however valuable their testimony to the relationships between artists and clients, do not tell the whole story. They offer evidence of intentions, and historians, however interesting they find intentions, also want to know whether things went according to plan. In some cases we can be sure that they did not. In the case of Andrea del Sarto's Madonna of the Harpies, for example, both contract and painting have survived, but there are serious discrepancies between them. The contract refers to two angels; they do not appear in the finished painting. The contract refers to St John the Evangelist: in the painting he has turned into St Francis. Such alterations may well have been negotiated with the client; we do not know. They are none the less a warning not to take one kind of evidence too seriously.⁵³ The most effective way to discover the true balance of power between artists and patrons in this period is surely to study the open conflicts between them - conflicts that made manifest the tensions inherent in the relationship. Although the evidence for these conflicts is fragmentary, a coherent picture does at least appear to emerge.

There were two main reasons for conflicts between artists and patrons at this time. The first, which need not detain us, was money. It was a special instance of the general problem of getting clients of high status to pay their debts. Mantegna, Poliziano and Josquin des Près were driven to remind their patrons of their obligations by pictorial, literary and musical means respectively.

The second reason for conflict, which reveals a good deal more about the relationship between culture and society in this period, concerns the works themselves. What happened when the artist did not like the patron's plan or the patron was dissatisfied with the result? Here are some examples. In 1436 the *Opera del Duomo* of Florence commissioned Paolo Uccello to paint the equestrian portrait of Sir John Hawkwood on the cathedral wall, but a month later they ordered the picture to be destroyed 'because it is not painted as it should be' (*quia non est pictus ut decet*). One wonders what experiments in perspective Uccello had been trying out. Again, Piero de'Medici objected to certain small seraphs in a fresco by Benozzo Gozzoli, who wrote to say: 'I'll do as you command; two little clouds will take them away.'54

In other cases, the conflict seems to have reached deadlock. Vasari tells a story about Piero di Cosimo painting a picture for the Foundling

⁵² Tolnay, Michelangelo.

⁵³ Shearman, Andrea del Sarto, doc. 30 and pp. 47-51.

⁵⁴ Poggi, Duomo di Firenze; Gaye, Carteggio inedito d'artisti, vol. 1, p. 191; Chambers, Patrons and Artists, no. 49.

Hospital in Florence. The client, who was the director of the hospital, asked to see the picture before it was finished; Piero refused. The client threatened not to pay; the artist threatened to destroy the painting. Again, Julius II, the irresistible force, and Michelangelo, the immovable object, came into conflict over the Sistine ceiling. Before he had finished, Michelangelo left Rome in secret and returned to Florence. Vasari's explanation for Michelangelo's flight was 'that the pope became angry with him because he would not allow any of his work to be seen; that Michelangelo distrusted his own men and suspected that the pope ... disguised himself to see what was being done.' Why did Piero and Michelangelo object to their work being seen before it was finished? Some artists today are touchy about laymen looking over their shoulder; but there may have been something more to these cases than that. Suppose an artist did not want to treat a subject in the way that the client wanted. A possible tactic would be to hide the picture from him until it was finished, hoping that he would accept a fait accompli rather than wait for another version. For another Sistine ceiling the pope would have had to wait quite a while.

Giovanni Bellini was another painter who did not easily submit to the will of others. The humanist Pietro Bembo described him as one 'whose pleasure is that sharply defined limits should not be set to his style, being wont, as he says, to wander at his will in paintings' (vagare a sua voglia nelle pitture). Isabella d'Este asked him for a mythological picture. It appears that he wanted neither to paint such a picture nor to lose the commission, so he used delaying tactics while hinting, via the agents Isabella used in her dealings with artists, that another subject might not take so long. As one of the agents told her, 'If you care to give him the liberty to do what he wants, I am absolutely sure that Your Highness will be served much better.' Isabella knew when to give way gracefully, and replied: 'If Giovanni Bellini is as reluctant to paint his history as you say, we are content to leave the subject to him, provided that he paints some history or ancient fable.' In fact, Bellini was able to beat her down still further, and she ended by accepting a Nativity. This example supports the recent critique of scholarly emphasis on Isabella's 'ungrateful and demanding nature' and the argument that 'her activity as an art patron was subtle and flexible'.55

In this last case, the history of events leads us to the history of structures. The fact that Bellini kept a shop, and that he was in Venice while Isabella was at Mantua, probably helped him to get his way. Had he been attached to the court, the outcome of the conflict would probably have

⁵⁵ Chambers, *Patrons and Artists*, nos. 64–72; Braghirolli, 'Carteggio di Isabella d'Este'; Fletcher, 'Isabella d'Este'; Ames-Lewis, *Isabella and Leonardo*, pp. viii, 34.

been very different. Isabella seems to have learned this lesson, and soon afterwards she took Lorenzo Costa into her permanent service.

From the artist's point of view, in so far as it is possible to reconstruct it, each of the two systems – service at court or keeping an open shop – had its advantages and disadvantages. Permanent service at court gave the artist a relatively high status, without the social taint of shop-keeping (above, p. 86). It also meant relative economic security: board and lodging and presents of clothes, money and land. When the prince died, however, the artist might lose everything. When the duke of Florence, Alessandro de'Medici, was murdered in 1537, Giorgio Vasari, who had been in the duke's service, found his hopes 'blown away by a puff of wind'. Another disadvantage of the system was its servitude. At the court of Mantua, Mantegna had to ask permission to travel or to accept outside commissions. It was not possible to avoid the demands of patrons as easily as those of temporary clients.

What patrons often wanted was an artist, or artisan, able to perform a variety of tasks. When Cosimo Tura entered the service of Borso d'Este, duke of Ferrara, he earned his regular salary not only from pictures but by painting furniture, gilding caskets and horse trappings, and designing chair backs, door curtains, bed quilts, a table service, tournament costumes, and so on. A surviving painting by Andrea Castagno decorates a shield, probably for a tournament (Plate 4.3). At the court of Ludovico Sforza, duke of Milan, Leonardo was similarly occupied in miscellaneous projects. He painted the portrait of the duke's mistress, Cecilia Gallerani; he decorated the interior of the Castello Sforzesco; he worked on 'the horse', an equestrian monument to the duke's father; he designed costumes and stages for court festivals; and he was employed as a military engineer. One might say that at least he went to Milan with his eyes open, since the draft of the letter he wrote to the duke asking to be taken into his service has survived; it lists what he could do in the way of designing bridges, mortars and chariots, ending, 'in the tenth place', that he could also paint and sculpt. All the same, from posterity's point of view it is ironic that we remember Leonardo at Milan for two works, neither of which was created for the duke (though he may have arranged the first commission); the Last Supper was painted for a monastery, the Virgin of the Rocks for a fraternity.56

The disadvantages of courts as a milieu for artists should not be exaggerated. Republics too commissioned temporary decorations on festive occasions, and to regret this is perhaps only to express the bias towards the permanent of our age of museums. All the same, an impression remains that court artists were more likely than others to have to

⁵⁶ Kemp, Leonardo da Vinci, pp. 78ff.

dissipate their energies on the transient and the trivial, like the court mathematicians in seventeenth-century Versailles, concerned with the hydraulics of fountains or with the probable outcomes of royal games of cards.

When an artist kept a shop, on the other hand, he had less economic security and a lower social status, but it was easier for him to evade a commission that he did not want, as Giovanni Bellini seems to have done in the case of a request from Isabella d'Este (above, p. 114). Clients too might offer artists a variety of odd jobs, but some workshops were so organized that different members could specialize. It is hard to say how important this freedom of working was to artists, but it may be significant that when Mantegna was appointed court painter in Mantua, in 1459, he lingered in Padua, as if the decision to leave had been a difficult one. Whether individual artists cared about their freedom or not, the difference in working conditions seems to be reflected in what was produced. The major innovations of the period took place in Florence and Venice, republics of shop-keepers, and not in courts.

These examples of conflict are some of the most celebrated and bestdocumented ones. They are not a sufficient basis for generalization. The range of variation between patrons was considerable, while even a single patron, such as Isabella d'Este, might grant some artists more freedom than others.⁵⁸ However, there is other evidence to suggest that the balance of power between patron and artist was changing in this period in the artist's favour, allowing a greater individualism of style. As the status of artists rose, patrons made fewer demands. To Leonardo, Isabella made concessions from the start: 'We shall leave the subject and the time to you.'59 Again, a famous letter to Vasari from the poet Annibale Caro acknowledges the freedom of the artist by comparing the two roles: 'For the subject matter (invenzione) I place myself in your hands, remembering ... that both the poet and the painter carry out their own ideas and their own schemes with more love and with more diligence than they do the schemes of others.' It is unfortunate that he was to follow this compliment with fairly precise instructions for an Adonis on a purple garment, embraced by Venus.

Caro also drew up a detailed programme for the decoration of the palace for the Farnese family at Caprarola. He was, in other words, a humanist adviser, an intellectual middleman between patron and client. The hypothesis of the humanist adviser – Poliziano in this case – was put

⁵⁷ Chambers, Patrons and Artists, nos. 59-60.

⁵⁸ Gilbert, 'What did the Renaissance patron buy?', pp. 416–23.

⁵⁹ Chambers, Patrons and Artists, nos. 85–90.

⁶⁰ Gombrich, Symbolic Images, pp. 9-11, 23-5; cf. Robertson, 'Annibal Caro'.

forward by Aby Warburg when discussing the mythological paintings of Botticelli. Since artists, as we have seen, generally lacked a classical education, they must have needed advice when required to paint scenes from ancient history or mythology. There is, in fact, evidence of such advice being given on a few occasions.

In the earliest known case the subject was not classical but biblical: in 1424, the Calimala guild of Florence asked the humanist Leonardo Bruni to draw up a programme for the 'Gates of Paradise', the third pair of doors for the Baptistery in Florence. Bruni chose twenty stories from the Old Testament. However, the sculptor, Ghiberti, claimed in his memoirs to have been given a free hand, and the Bruni programme was not followed, for the doors illustrate only ten stories.⁶²

In Ferrara in the mid-fifteenth century, the humanist Guarino of Verona suggested a possible programme for a painting of the Muses for the marquis, Leonello d'Este.⁶³ Later in the century, the court librarian, Pellegrino Prisciani, was concerned with the programme of the famous astrological frescoes in the Palazzo Schifanoia in Ferrara, painted by Francesco del Cossa.⁶⁴ In the Medici circle in the later fifteenth century, there is more indirect evidence for the advice of two humanists, the poet-philologist Angelo Poliziano and the philosopher Marsilio Ficino, on the programme of Botticelli's *Primavera*, the meaning of which still divides scholars. According to his pupil Condivi, the young Michelangelo made his relief of *The Battle of the Centaurs* at the suggestion of Poliziano, 'who explained the whole myth to him from beginning to end' (*dichiarandogli a parse per parse tutta la favola*).⁶⁵

Another milieu in which there is firm evidence of humanist advisers is the court of Mantua in the early sixteenth century. When Isabella d'Este planned a series of pagan 'fantasies' for her study and grotto, it was to the humanists Pietro Bembo and Paride da Ceresara that she turned for advice. It was Paride who provided the programme for the *Battle of Love and Chastity* which Isabella, as we have seen, commissioned from Perugino (Plate 4.6).⁶⁶

It would not be difficult to add to these examples, particularly for the sixteenth century. One thinks of the humanist bishop Paolo Giovio planning the decoration of the Medici villa at Poggio a Caiano, or the

⁶¹ Warburg, Renewal of Pagan Antiquity.

⁶² Krautheimer and Krautheimer-Hess, Lorenzo Ghiberti, pp. 169ff.; Chambers, Patrons and Artists, no. 24.

⁶³ Baxandall, 'Guarino, Pisanello and Manuel Chrysoloras'.

⁶⁴ Warburg, Renewal of Pagan Antiquity, pp. 249–69. Cf. Gombrich, Symbolic Images; Dempsey, Portrayal of Love; Snow-Smith, Primavera of Sandro Botticelli.

⁶⁵ Condivi, Vita di Michelangelo Buonarroti, pp. 28-9.

⁶⁶ Chambers, Patrons and Artists, nos. 76, 80.

poet Annibale Caro doing the same, as noted above, for the Farnese at Caprarola.⁶⁷ Whether they were called in by artists or patrons, and whether their advice was taken seriously or not, classical scholars, and more rarely theologians, were involved in the planning of pictorial and sculptural programmes. They helped artists to cope with the sudden demand for classical mythology and ancient history which workshop traditions had not trained artists to provide. 68

ARCHITECTURE, MUSIC AND LITERATURE

Architecture needs to be considered separately because architects did not work with their hands. They provided nothing but the programme, so that, in cases where patrons took an active interest, their role was diminished. Filarete's treatise presents a picture, no doubt a wish-fulfilment, of a prince who accepts the plans of his architect with enthusiasm. In practice, however, patrons often wanted to interfere, or at least to intervene, in the building process. They had political and social reasons for choosing particular designs, from the desire to display their status to the obligation of hospitality and the need to meet with their followers and dependants.⁶⁹ Some of them studied treatises on architecture. Alfonso of Aragon, for example (Plate 5.2), asked for a copy of Vitruvius when the plans for a triumphal arch at Naples were being discussed. Federigo of Urbino owned a copy of Francesco di Giorgio's treatise on architecture, presented by the author. 70 Ercole d'Este borrowed Alberti's treatise on architecture from Lorenzo de'Medici before deciding how to rebuild his palace. A panegyric on Cosimo de'Medici describes him as wanting to build a church and a house in his own way (more suo).⁷¹ As for Cosimo's grandson Lorenzo, he went so far as an amateur architect as to submit a design for the competition for the façade of Florence Cathedral in 1491. The judges were unable to choose either the design of the effective ruler of Florence or that of any other competitor, so the facade was left unbuilt.

In the case of music, it was the performers who were the recipients of patronage, and on a permanent basis, precisely because their perfor-

⁶⁷ Zimmermann, Paolo Giovio.

⁶⁸ A more sceptical view of the importance of the humanist adviser is to be found in Hope, 'Artists, patrons and advisers'; Robertson, 'Annibal Caro'; Hope and McGrath, 'Artists and humanists'.

⁶⁹ Kent, 'Palaces, politics and society'; Frommel, *Architettura e committenza*.
⁷⁰ Hersey, *Alfonso II*; Serra-Desfilis, 'Classical language'; Heydenreich, 'Federico da Montefeltre'; Clough, 'Federigo da Montefeltre's patronage of the arts'.

⁷¹ Brown, 'Humanist portrait'; cf. Gombrich, Norm and Form, pp. 35-57; Jenkins, 'Cosimo de' Medici's patronage'; Kent, Cosimo de' Medici.

mances were ephemeral. There were three main types of patron: Church, city and court.⁷²

The Church was a great patron of singers, although not a particularly generous one. Singers were needed for masses and other parts of the liturgy, and they were needed all the time, as were organists. Choirmasters included men we now remember as composers, such as Giovanni Spataro, choirmaster at the church of San Petronio at Bologna from 1512 to 1541.

Cities also took musicians into their permanent service. Trumpeters, for example, were in demand for civic events such as state visits or major religious festivals. The best civic posts were in Venice. The church of San Marco was the doge's chapel, and so its choirmaster was a civic (in other words, a political) appointment. The post was created in 1491 for a Frenchman, Pierre de Fossis. When he died, Doge Andrea Gritti, who was used to getting his own way, forced through the appointment of an outsider, the Netherlander Adriaan Willaert, against considerable opposition. The musical importance of sixteenth-century Venice may owe something to the relative munificence of its civic patronage.

Court patronage was the least secure of the three main types, but it offered the possibility of the greatest rewards. Some princes took a great interest in their chapels: Galeazzo Maria Sforza of Milan, for example, Ercole d'Este of Ferrara or Pope Leo X. When the duke of Milan decided. in 1472, to found a choir, he spared no effort to make it a good one. He wrote to his ambassador in Naples with instructions to persuade some of the singers there to move to Milan. He was to talk to them and to make promises of 'good benefices and good salaries', but in his own name, not that of the duke: 'Above all, take good care that neither his royal majesty nor others should imagine that we are the cause of those singers being taken away.' Presumably a diplomatic incident might have followed this discovery. By 1474 the duke had acquired a certain 'Josquino', perhaps Josquin des Près. He continued to take a great interest in his chapel choir, which had to follow him to Pavia, Vigevano and even outside the duchy. As for Alfonso of Aragon, he even took his choir with him when he went hunting!73

Isabella d'Este was interested in music as well as painting, and two major composers of *frottole* (songs for several voices), Marchetto Cara and Bartolommeo Tromboncino, were active at her court.⁷⁴ A still greater interest in music was taken by Pope Leo X. He played and composed himself (a canon written by him still survives). His enthusiasm was well known and, when news arrived that Leo had been elected

⁷² Bridgman, Vie musicale, ch. 2.

⁷³ Motta, 'Musici alla corte degli Sforza'.

⁷⁴ Fenlon, Music and Patronage, pp. 15ff.

pope, many of the marquis of Mantua's singers left for Rome. The most distinguished composers in Leo's service were Elzéar Genet, who was in charge of the music for the papal chapel; Costanzo Festa, who was famous for his madrigals; and the organist Marco Antonio Cavazzoni. The contemporary anecdotes of Leo's generosity to musicians have been confirmed from the papal accounts. He had more than fifteen musicians in his private service in 1520. He paid the famous lutenist Gian Maria Giudeo 23 ducats a month and made him a count into the bargain.

A fourth kind of patronage should not be forgotten. It was possible for musicians to make careers in the service of private individuals. Willaert, for example, organized concerts for a Venetian lady, Pollissena Pecorina, and a nobleman, Marco Trivisano.⁷⁵ The organist Cavazzoni was at one time in the service of the humanist Pietro Bembo.

In all these cases, it is difficult to say whether musicians were hired because they could sing or play well or because they could compose or invent. There is a little evidence of interest in the activity of invention. Some compositions were dedicated to individuals or written in their honour. For example, a certain Cristoforo da Feltre wrote a motet on the election of Francesco Foscari as doge of Venice in 1423. Heinrich Isaac, who spent the decade 1484–94 in Florence, wrote an instrumental piece, 'Palle, palle', presumably for the Medici, since it refers to their rallying-cry and their device, and he also set to music Poliziano's lament for the death of Lorenzo the Magnificent. New compositions were required for court festivals; Costanzo Festa, for example, wrote the music for the wedding, in 1539, of Cosimo de'Medici, duke of Tuscany, and Eleonora of Toledo.

What patrons wanted from musicians emerges most vividly from a letter to Ercole d'Este, duke of Ferrara, written by one of his agents about 1500. The duke was trying to make up his mind which of two candidates to hire, Heinrich Isaac or Josquin des Près.

Isaac the singer ... is extremely rapid in the art of composition, and besides this he is a man ... who can be managed as one wants ... and he seems to me extremely suitable to serve your lordship, more than Josquin, because he gets on better with his colleagues, and would make new things more often; it is true that Josquin composes better, but he does it when he feels like it, not when he is asked; and he is demanding 200 ducats, and Isaak will be satisfied with 120.⁷⁶

In other words, the fact that Josquin 'composes better' is recognized, but it is not the most important consideration. The social historian

⁷⁵ Einstein, Essays on Music, pp. 39-49.

⁷⁶ Straeten, Musique aux Pays-Bas, p. 87.

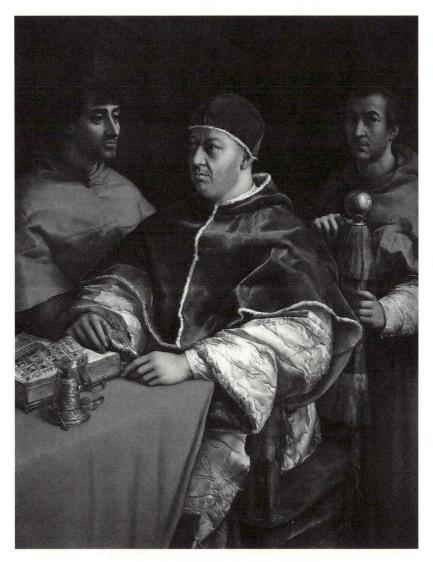

PLATE 4.7 RAPHAEL: LEO X

could hardly ask for a more revealing document about the workings of patronage.

In the case of literature and learning, patronage was less necessary because so many writers were amateurs with private means and so many scholars were academics. Patronage was most necessary when it was least likely, when a writer was poor, young and unknown and wanted to study. In some cases, aid was forthcoming. Lorenzo de'Medici, for example, made it possible for Poliziano to study, while Landino was financed by a notary and Guarino by a Venetian nobleman. The Greek cardinal Bessarion, who was a generous and discerning patron of scholars such as Flavio Biondo, Poggio Bracciolini and Bartolommeo Platina, also financed the studies of his compatriot Janos Lascaris. If Alfonso I of Aragon knew of boys who were poor but able (so his official biographer, the humanist Antonio Panormita, informs us), he paid for their education. At Ferrara, Duke Borso d'Este paid for the food and clothes of poor students at the university. However, these examples are not many, and one wonders how many promising careers came to nothing for lack of patronage of this kind.

For humanists, it was possible to make a career in the service of the Church or the state. This was in part because particular popes (Nicholas V, for example, or Leo X) and princes (such as Alfonso I) appreciated their achievements, and in part because their skills, notably the art of writing an elegant and persuasive Latin letter, were needed in administration. The chanceries of Rome and Florence in particular were staffed by humanists, among them Flavio Biondo, Poggio Bracciolini and Lorenzo Valla in the first case and Coluccio Salutati and Leonardo Bruni in the second.⁷⁷

For writers who were already established, court patronage was often forthcoming because princes were interested in fame and believed that poets had it in their gift. It might, however, take a gift for intrigue as well as for literature to defeat rival candidates for a particular post. Augustus, as Horace and Virgil had known, could only be approached through Maecenas, and, on occasion in Renaissance Italy, Maecenas could only be approached through intermediaries - 'Mecenatuli', as Panormita contemptuously called them. His own search for patronage led him up several blind alleys before eventual success.⁷⁸ He tried Florence, dedicating a poem to Cosimo de'Medici as early as 1425; he tried Mantua, only to discover that, having Vittorino da Feltre, they needed no more humanists; he tried Verona, via Guarino, with similar results. Finally, thanks to the help of the archbishop, he obtained the post of court poet at Milan. Another ploy was to attract the attention of what has been called a 'threshold patron', often a woman (Isabella d'Este, for example, in the case of Ariosto), who facilitated the approach to her husband or other male relative.79

⁷⁷ On Rome, D'Amico, *Renaissance Humanism*, pp. 29ff.; on Florence, see Garin, 'Cancellieri umanisti'.

 $^{^{78}}$ Sabbadini, 'Come il Panormita diventò poeta aulico'; cf. Ryder, 'Antonio Beccadelli'.

⁷⁹ Regan, 'Ariosto's threshold patron'.

For an actual or aspiring court poet, an obvious move – following Virgil's precedent – was to write an epic about the prince. Thus the humanist Francesco Filelfo wrote a *Sforziad* to celebrate the ruling house of Milan. Federigo of Urbino had his *Feltria* and Borso d'Este his *Borsias*, the first of a series of epics for a ruling house which became the patrons of Boiardo, Ariosto and Tasso. Ariosto made his hero and heroine Ruggiero and Bradamante ancestors of the house of Este. In the third canto, modelled on the sixth book of Virgil's *Aeneid*, Merlino prophesies that the golden age will return in the reign of Ariosto's patron Alfonso I.

Court historians were also in request in the fifteenth century, especially on the part of new princes. Alfonso of Aragon commissioned works of history from the rival humanists Lorenzo Valla and Bartolommeo Fazio. Ludovico Sforza commissioned a history of Milan from a nobleman, Bernardino Corio. ⁸⁰ Machiavelli's *History of Florence* was commissioned by the Medici pope Clement VII, and dedicated to the pope by his 'humble slave'. Republics too were aware of the value of official history. The Venetian government, for example, commissioned histories from the humanist Marcantonio Sabellico and the patricians Andrea Navagero and Pietro Bembo. ⁸¹

Rulers might also act as patrons of natural science for practical reasons. Leonardo da Vinci went to the court of Milan, as we have seen, as a military engineer rather than an artist. Pandolfo Petrucci, lord of Siena, was the patron of the engineer Vannoccio Biringuccio. Fra Luca Pacioli, who wrote on mathematics, attracted the patronage of the dukes of Milan and Urbino.⁸² As a friar, however, he did not depend on patrons. Since most 'scientists' made their living through university teaching or the practice of medicine, they did not depend on patrons either.

Less directly useful works might also be commissioned by patrons who had a taste for literature or a liking for particular authors. Cosimo de'Medici gave the philosopher Marsilio Ficino a farm in the Tuscan countryside at Careggi and encouraged him to translate Plato and other ancient authors. Poliziano wrote a poem to celebrate a famous joust in which Giuliano de'Medici, the brother of Lorenzo the Magnificent, had taken part. Like painters and musicians, poets might have to help provide the entertainment at festivals. When Poliziano was in Mantuan service, he wrote his famous drama *Orfeo* to order for a wedding. He also wrote

⁸⁰ Soria, *Humanistas de la corte*; Ianziti, *Humanistic Historiography*, p. 53; Burke, 'L'art de la propagande'.

⁸¹ Cozzi, 'Cultura, politica e religione'; Gilbert, 'Biondo, Sabellico and the beginings of Venetian official historiography'.

⁸² Rose, Italian Renaissance.

begging poems to Lorenzo de'Medici describing how his clothes had worn out. The verse request was a conventional literary genre, but its existence is a reminder of the importance of patronage for the culture of the time and also in the life of the individual writer.

As in the case of painters, court patronage offered writers status. It also offered protection, which might well be necessary. The poet Serafino of Aquila, for example, left the service of Cardinal Ascanio Sforza to live in Rome without a patron. However, his satirical verses provoked an attempt to assassinate him. When he recovered, 'considering that to be without a protector was dangerous and shameful', Serafino went back to the cardinal.⁸³

Despite the examples of official historians of Venice, there was virtually no civic patronage for writers. Their choice was limited to the Church, the court or the occasional private individual, such as the patrician Alvise Cornaro of Padua, who encouraged the dramatist Angelo Beolco 'il Ruzzante' to write his plays, and had them collected and published. Some Venetian patricians, such as Francesco Barbaro and Bernardo Bembo (the father of Pietro Bembo, and himself a writer of distinction) regarded the patronage of scholars as a duty. The Church offered the greatest security, and so we find such writers as Alberti, Poliziano and Ariosto, who are difficult to see as career clergymen, trying to get benefices. Castiglione, the complete courtier, ended his life as a bishop, and his friend Pietro Bembo as a cardinal.

The difficulty of depending on patronage for a living can be illustrated from the career of Arctino (Blate 4.8), who began life as the son of a shoemaker. He attracted the attention first of the rich and cultivated banker Agostino Chigi, then of Cardinal Giulio de'Medici, and later of Federico Gonzaga, marquis of Mantua, and of the *condottiere* Giovanni de'Medici. Multiplying patrons increased Arctino's freedom but increased the risk of loss of favour, so he changed his strategy. In 1527 he moved to Venice, where, despite accepting protection from Doge Andrea Gritti and gifts from a number of noblemen, he was more or less his own master.⁸⁷ That he was able to do this depended not only on his own remarkable talents for writing and self-advertisement but also on the rise of the market.

⁸³ V. Calmeta's life of the author prefixed to Serafino dell'Aquila's Opere.

⁸⁴ Mortier, Etudes italiennes, pp. 5-19.

⁸⁵ King, Venetian Humanism, pp. 54ff.

⁸⁶ Dionisotti, Geografia e storia, pp. 47–73.

⁸⁷ Larivaille, Pietro Aretino.

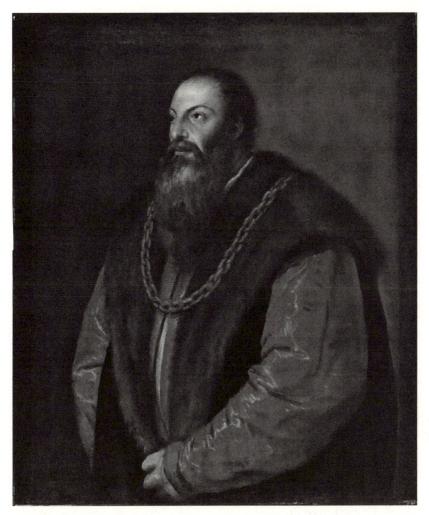

PLATE 4.8 TITIAN: PIETRO ARETINO

THE RISE OF THE MARKET

In the long run, the invention of printing led to the decline of the literary patron and to his or her replacement by the publisher and the anonymous reading public. In this period, however, the new system coexisted with the old and interacted with it. It is possible to find instances of the commercialization of patronage (the dedication of a book in the hope of an instant reward in cash) and even of multiple dedications. Matteo

Bandello dedicated each story in his collection to a different individual, and, although some of the dedicatees were friends of his, they were in most cases members of noble families such as the Farnese, the Gonzaga and the Sforza, from whom he doubtless expected a return. Printers also looked for patrons. When Aldo Manuzio published his famous octavo edition of Virgil in 1501, he had several copies printed on vellum, as if they were manuscripts, and distributed to important people such as – once again – Isabella d'Este.

With the rise of the market in literature it is possible to find examples of successful printer-businessmen, such as the Giolito and the Giunti families.88 The printed book, originally viewed as a manuscript 'written' by machine, came to be regarded as a commodity standardized in size and price. The catalogue issued by the Venetian printer Aldo Manuzio in 1498 is the first to give prices, while the Aldine catalogue of 1541 is the first to use the terms 'folio', 'quarto' and 'octavo'.89 The sales of the new commodity were boosted by means of advertisements, in prose or verse, placed by the printer at the end of one book to recommend the reader to go to his shop for another. One edition of Ariosto's Orlando Furioso, for example, contained the following advertisement: 'Whoever wants to buy a Furioso, or another work by the same author, let him go to the press of the Bindoni twins, the brothers Benedetto and Agostino.'90 One finds printers, such as Gabriele Giolito, employing professional authors, such as Lodovico Dolce, to write, translate and edit for them. This is how the Venetian 'Grub Street', just off the Grand Canal, came into existence in the middle of the sixteenth century (above, p. 77).91 At much the same time, the mid-sixteenth century, came the rise of the commercialized newsletter, or avviso, which flourished in Rome in particular, and of the 'professional theatre' (the literal translation of the famous term commedia dell'arte).

In the visual arts, too, we find the rise of the market system, in which customers bought works 'ready-made', sometimes through a middle-man. ⁹² This art market, the importance of which is increasingly recognized by scholars, coexisted with the more important and better-known personalized system of patrons and clients, and some painters, such as the Pollaiuolo brothers, navigated between them. ⁹³ Examples of the sale

⁸⁸ Quondam, 'Mercanzia d'honore'; Tenenti, 'Giunti'.

⁸⁹ Mosher, 'Fourth catalogue'.

⁹⁰ Venezian, Olimpo da Sassoferrato, p. 121.

⁹¹ Quondam, 'Mercanzia d'honore'; Bareggi, Mestiere di scrivere; Richardson, Print Culture in Renaissance Italy and Printing, Writers and Readers.

⁹² Lerner-Lehmkul, Zur Struktur und Geschichte; Fantoni et al., Art Market; Neher and Shepherd, Revaluing Renaissance Art.

⁹³ Wright, 'Between the patron and the market'.

of uncommissioned works of art go back at least as far as the fourteenth century. The demand for Virgins, Crucifixions or St John the Baptists was sufficiently great for workshops to be able to produce them without a particular customer in mind, although they might be left unfinished in order to accommodate special requirements. Some merchants – the 'merchant of Prato' Francesco Datini, for instance – dealt in works of art as in other commodities.⁹⁴ Cheap reproductions of famous sculptures were already being manufactured in fourteenth-century Florence.

In the fifteenth century, there are signs that ready-made works were becoming more common. Some merchants, such as the Florentine Bartolommeo Serragli, now specialized in the sale of these commodities. Serragli searched Rome for antique marble statues for the Medici; he ordered fabrics in Florence for Alfonso of Aragon; he employed Donatello, Fra Lippo Lippi and Desiderio da Settignano; he dealt in illuminated manuscripts and terracotta madonnas, chess sets and mirrors. Fagain, Vespasiano da Bisticci, whose activities as a bookseller have already been discussed, was also a middleman who arranged for illuminators, such as Attavante degli Attavanti, to work for customers they did not know, such as Federigo, duke of Urbino, and Matthias, king of Hungary.

The market in reproductions and replicas also increased in importance at this time. Woodcuts of devotional images began to be produced shortly before the invention of printing. In the later fifteenth century, they were joined by woodcuts of topical events, such as the meeting of the pope and the emperor in 1468. After the invention of printing, book illustrations became important. Aldo Manuzio produced famous illustrated editions of Dante, Petrarch, Boccaccio, and so on. Some prints reproduced famous paintings. Prints of Leonardo's *Last Supper* were in circulation by the year 1500, while Giulio Campagnola made prints after paintings by Mantegna, Giovanni Bellini and Giorgione, and Marco Raimondi made his reputation by his free 'translations' of paintings by Raphael into prints. Prints of Leonardo's paintings by Raphael into prints.

Reproduction extended to sculptures. Around 1470, the Della Robbia workshop in Florence was turning out coloured sculptures in terracotta, such as the miniature replicas of the Madonna of Impruneta, which were cheap and standardized and so presumably uncommissioned. In Florence at about the same time, portrait medals were being turned out by what one scholar has described as 'assembly-line' methods, repetitive

⁹⁴ See Origo, Merchant of Prato, pp. 41ff.

⁹⁵ Corti and Hartt, 'New documents'.

⁹⁶ Emison, 'Replicated image in Florence'.

⁹⁷ Oberhuber, 'Raffaello e l'incisione'; Landau and Parshall, Renaissance Print.

in form and making use of the division of labour. 98 Statuettes sometimes reproduced famous classical statues in miniature: the sculptor known as 'Antico' gained his nickname for making small bronze replicas of the Apollo Belvedere, for example, or the Dioscuri. 99

Another fifteenth-century development was the rise of majolica – in other words, of the painted, tin-glazed pottery jars and plates produced in Bologna, Urbino, Faenza and elsewhere. Some of them were large, splendid and expensive and appreciated by connoisseurs such as Lorenzo de'Medici, but others were cheap enough to be bought by modest artisans. Some of the majolica plates produced in Urbino showed scenes from paintings by Raphael, among them a plate commissioned by Isabella d'Este.

In the sixteenth century, the art market became still more important than it had been in the fifteenth. Isabella d'Este, for example, was prepared to buy paintings and statues second-hand. When Giorgione died in 1510, she wrote to a Venetian merchant:

we are informed that among the stuff and effects of the painter Zorzo of Castelfranco there exists a picture of a night (*una nocte*), very beautiful and singular; if so it might be, we desire to possess it and we therefore ask you, in company with Lorenzo da Pavia and any other who has judgment and understanding, to see whether it is a really fine thing and if you find it such, to go to work . . . to obtain this picture for me, settling the price and giving me notice of it.¹⁰¹

However, the answer was that the two pictures of this kind to be found in Giorgione's studio had been painted on commission, and that the clients were not prepared to let them go. Here, as elsewhere, Isabella was a little in advance of her time.

A year later, in 1511, it was an artist who took the initiative in a sale of uncommissioned work to the Gonzagas. Vittore Carpaccio wrote to Isabella's husband, Gianfrancesco II, marquis of Mantua, that he possessed a watercolour painting of Jerusalem for which an unknown person, perhaps from the court of Mantua, had made an offer. 'And so it has occurred to me to write this letter to Your Sublime Highness in order to draw attention both to my name and to my work.' The apologetic preamble suggests that selling pictures in this way was not yet quite

⁹⁸ Flaten, 'Portrait medals'; cf. Comanducci, 'Produzione seriale'.

⁹⁹ Syson and Thornton, Objects of Virtue, pp. 128-9.

¹⁰⁰ Goldthwaite, Building of Renaissance Florence, p. 402; Ajmar, 'Talking pots', p. 58.

¹⁰¹ Chambers, Patrons and Artists, nos. 149-50.

proper.¹⁰² However, in 1535 Gianfrancesco's son Federico bought 120 Flemish paintings second-hand.

Isabella's agents, whom she employed to arrange commissions as well as to make offers for ready-made paintings, were not full-time specialist art dealers. One of them was a maker of clavichords. In Florence, however, a patrician, Giovanni Battista della Palla, has been described as 'an art dealer in the fullest and truest sense, that is, a systematic purchaser of contemporary as well as antique art works'. 103 He is most celebrated for his activities on behalf of Francis I, king of France, for whom he bought, among other things, a statue of Hercules by Michelangelo, a statue of Mercury by Bandinelli, a St Sebastian by Fra Bartolommeo and a Raising of Lazarus by Pontormo. It was in pursuit of further works by the last artist that - according to Vasari in his life of Pontormo -Palla went to the house of a certain Borgherini, but was driven out by Borgherini's wife, who called him 'a vile second-hand dealer, a fourpenny merchant [vilissimo rigattiere, mercantatuzzo di quattro danari]'. It was doubtless worth risking a scolding, since there were great profits to be made selling to the king of France. Vasari tells us that 'the merchants' received from Francis four times what they had paid Andrea del Sarto. 104

There are other cases of the sale of uncommissioned works in sixteenth-century Florence. Ottaviano de'Medici, a keen collector, bought two paintings by Andrea del Sarto which had been made for someone else. There are also references by Vasari to the exhibition of paintings in public, a form of advertising perhaps related to the rise of the market. Bandinelli, for example, painted a Deposition of Christ and 'exhibited it' (lo messe a mostra) in a goldsmith's shop. 105 In Venice too there is evidence of an art market. To return to Bellini's Nativity: at one point, when negotiations with Isabella d'Este seemed to be breaking down, the artist informed her that he had found someone who wanted to buy it. The first-known case of a Titian portrait being bought by someone other than the sitter is a purchase by the duke of Urbino in 1536. A certain Zuan or Giovanni Ram, a Catalan resident in Venice, seems to have been active as an art dealer in the early sixteenth century. Paintings were exhibited at the Ascension Week fair in Venice - Lotto and the Bassanos were among the exhibitors - and also at St Anthony's fair at Padua. 106

¹⁰² Ibid., no. 63.

Wackernagel, World of the Florentine Renaissance Artist, p. 283.

¹⁰⁴ La-Coste-Messelière, 'Giovanni Battista della Palla'; Elam, 'Battista della Palla'.

¹⁰⁵ A general discussion in Koch, Kunstaustellung.

¹⁰⁶ Francastel, 'De Giorgione à Titien'.

Recent research suggests that more works were produced for the market in Renaissance Venice than used to be thought.¹⁰⁷

Woodcuts and engravings, made to be sold to an unknown public, became more common in the sixteenth century. Some artists were beginning to specialize in the new media: Giulio and Domenico Campagnola, for example, who concentrated on landscape, or Marcantonio Raimondi, who produced engraved versions of paintings by Leonardo and Raphael, thus making them much better known. The age of the mechanically reproduced work of art, lamented by critics such as Walter Benjamin, goes back further than is generally realized.¹⁰⁸

In the middle of the sixteenth century, the market system was still very far from having equalled, let alone displaced, the personalized patronage system. For examples of the dominance of the new system, we have to wait till the seventeenth century, to the commercial opera houses of Venice and the art market of the Dutch Republic.

It is impossible to give a direct answer to the question whether the arts flourished in Renaissance Italy because of the patrons, as Filarete suggests in the epigraph to this chapter, or in spite of them, as is implied by Michelangelo. What can be discussed, however, is the somewhat complicated relation between patronage and the unequal distribution of artistic achievement among different parts of Italy.

In the previous chapter, it was suggested that art flourished in Florence and Venice in particular because these cities produced many of their own artists. This is not the whole story. Besides 'producer cities' there were also 'consumer cities' that acted as magnets, attracting artists and writers from elsewhere. Properties of the popes (notably Nicholas V and Leo X) and of the cardinals is the obvious explanation. Urbino, Mantua and Ferrara are other famous examples of cities with few important native artists which nevertheless became important cultural centres. In these three small courts the stimulus came from the patron, from the ruler or his wife. In Urbino, it was Federigo da Montefeltro who made the arts important by attracting Luciano Laurana from Dalmatia, Piero della Francesca from Borgo San Sepolcro, Justus from Ghent, and Francesco di Giorgio from Siena. In Mantua, Isabella d'Este and her husband gave commissions, as we have

¹⁰⁷ Matthew, 'Were there open markets'.

¹⁰⁸ Benjamin, 'Work of art'; Hind, Early Italian Engraving; Alberici, Leonardo e l'incisione.

¹⁰⁹ Hall, Cities in Civilization.

¹¹⁰ Shearman, 'Mecenatismo di Giulio II e Leone X'. Leo's patronage, often exaggerated, was cut down to size by Gnoli, *Roma di Leon X*.

¹¹¹ Clough, 'Federigo da Montefeltre's patronage of the arts'; Ciammitti et al., Dosso's Fate.

seen, to Bellini, Carpaccio, Giorgione, Leonardo, Mantegna, Perugino, Titian and other non-Mantuans. Their only Mantuan painter was a minor master, Lorenzo Leombruno.¹¹²

In these 'court cities', the patron seems to be calling art into existence where there was none before. However, two qualifications to this thesis need to be borne in mind. The first is that such patronage was parasitic on the art of major centres such as Florence and Venice in the sense that it would have been impossible without them. The second qualification is that the achievements of princely patrons rarely outlived them. Alfonso of Aragon, for example, was an effective patron in many fields. He took five humanists into his permanent service (Panormita, Fazio, Valla and the Decembrio brothers). He built up a chapel of twenty-two singers and paid his organist the unusually large sum of 120 ducats a year. He invited the painter Pisanello to his court in Naples and commissioned works from major sculptors such as Mino da Fiesole and Francesco Laurana. He bought Flemish tapestries and Venetian glass. 113 The death of Alfonso 'brought an end to the halcyon days of Neapolitan humanism', because the King's son and successor 'did not support men of learning and culture on as grand a scale', while Neapolitan nobles did not follow Alfonso's example and take an interest in patronage. 114

In contrast to Alfonso, Lorenzo de'Medici had everything in his favour as a patron. 115 Living in Florence, he had instant access to major artists and did not to have to go to the trouble of attracting them from a distance. He was not a lone patron but one of many, great and small. The importance of his patronage has been exaggerated in the past. The issue here, however, is not its extent but its facility. Patronage was structured – easier in some parts of Italy, more difficult in others.

As for the rise of the market, it is likely to have given artists and writers more freedom at the price of more insecurity. It involved the rise of reproduction and even mass production. Yet it may well have encouraged the increasing differentiation of subject matter and individualism of style noted in the first chapter: the exploitation of the artist's unique qualities in order to catch the eye of a purchaser.

¹¹² Rosenberg, Court Cities.

¹¹³ Serra Desfilis, 'Classical language'.

¹¹⁴ Bentley, Politics and Culture, pp. 63, 95.

¹¹⁵ Roscoe, *Life of Lorenzo de'Medici*; Chastel, *Art et humanisme*; Elam, 'Lorenzo de'Medici'; Alsop, *Rare Art Traditions*, ch. 12; Kent, *Lorenzo de' Medici*.

~

THE USES OF WORKS OF ART

Chi volessi per diletto
Qualche gentil figuretta,
Per tenerla sopra letto
O in su qualche basetta?
Ogni camera s'asetta
Ben con le nostre figure.
(Who wants some elegant statuette for their delight?
You can put it above your bed or on a stand.
Our figures make any room look well).
Carnival song of the sculptors of Florence,
in Singleton, Canti carnascialeschi

The idea of a 'work of art' is a modern one, although art galleries and museums encourage us to project it into the past. Before 1500 it is more exact to speak of 'images'.¹ Even the idea of 'literature' is a modern one. This chapter, however, is concerned with the different uses, for contemporary owners, viewers or listeners, of paintings, statues, poems, plays, and so on. They did not regard these objects in the same ways as we do. For one thing, paintings might be regarded as expendable. A Florentine patrician, Filippo Strozzi the younger, asked in his will of 1537 for a monument in the family chapel in Santa Maria Novella, which contained a fresco by Filippino Lippi. 'Do not worry about the painting which is there now, which it is necessary to destroy', Strozzi ordered, 'since of its nature it is not very durable' (di sua natura non è molto durabile).² If we want to understand what the art of the period meant to contemporaries, we have to look first at its uses.

¹ Belting, *Likeness and Presence*; Ferino Pagden, 'From cult images to the cult of images'.

² Quoted, but translated differently, in Goldthwaite, *Private Wealth*, p. 102n.

MAGIC AND RELIGION

The most obvious use of paintings and statues in Renaissance Italy was religious. In a secular culture like ours, we may well have to remind ourselves that what we see as a 'work of art' was viewed by contemporaries primarily as a sacred image. The idea of a 'religious' use is not very precise, so it is probably helpful to distinguish magical, devotional and didactic functions, although these divisions blur into one another, while 'magic' does not have quite the same meaning for us as it did for a sixteenth-century theologian. It is more precise and so more useful to refer to the thaumaturgic and other miraculous powers attributed to particular images, as in the case of certain famous Byzantine icons.

Some gonfalons or processional banners – for example, those painted by Benedetto Bonfigli in Perugia – seem to have been considered a defence against plague. The Madonna is shown protecting her people with her mantle against the arrows of the plague, and the inscription on one gonfalon begs her 'to ask and help thy son to take the fury away'.³ The popularity in the fifteenth and sixteenth centuries of images of St Sebastian, who was also associated with defence against plague (below, p. 000), suggests that the thaumaturgic function was still an important one. When he was working in Italy in the 1420s and 1430s, the Netherlander Guillaume Dufay wrote two motets to St Sebastian as a defence against plague. Music was generally believed to have therapeutic power; stories were current about cures effected by playing to the patient.⁴

A celebrated Italian example of another kind of miraculous power is the image of the Virgin Mary in the church of Impruneta, near Florence, which was carried in procession to produce rain in times of drought or to stop the rain when there was too much, as well as to solve the political problems of the Florentines. For example, the Florentine apothecary Luca Landucci records in his journal that in 1483 the image was brought to Florence 'for the sake of obtaining fine weather, as it had rained for more than a month. And it immediately became fine.'5

Some Renaissance paintings appear to belong to a magical system outside the Christian framework (below, p. 000). The frescoes by Francesco del Cossa in the Palazzo Schifanoia at Ferrara are concerned with astrological themes, as Aby Warburg pointed out, and they may well have been painted to ensure the good fortune of the duke.⁶ It has also been

³ Bombe, 'Tafelbilder, Gonfaloni und Fresken'.

⁴ Tomlinson, Music in Renaissance Magic.

⁵ Casotti, *Memorie istoriche*; Landucci, *Florentine Diary*; Trexler, 'Florentine religious experience'.

⁶ Warburg, Renewal of Pagan Antiquity, pp. 563-92.

argued (following a suggestion of Warburg's), that Botticelli's famous Primavera may have been a talisman - in other words, an image made in order to draw down favourable 'influences' from the planet Venus.⁷ We know that the philosopher Ficino made use of such images, just as he played 'martial' music to attract influences from Mars: a Renaissance Planets suite.8 Again, when Leonardo (as Vasari tells us) painted the thousand-eyed Argus guarding the treasury of the duke of Milan, it is difficult to tell whether he intended simply to make an appropriate classical allusion or whether he was also attempting a piece of protective magic. It is similarly difficult to tell how serious Vasari is being when he works a variant of the Byzantine icon legends into his life of Raphael. He tells us that a painting of Raphael's was on the way to Palermo when a storm arose and the ship was wrecked. The painting, however, 'remained unharmed . . . because even the fury of the winds and the waves of the sea had respect for the beauty of such a work.' In a similar way, we need at least to entertain the possibility that the images of traitors and rebels painted on the walls of public buildings in Florence and elsewhere were a form of magical destruction of fugitives who were beyond the reach of conventional punishment – the equivalent of sticking pins in wax images of one's enemies.

Many images were made and bought for sacred settings and religious purposes. The term 'devotional pictures' (quadri di devotione) was current in this period, when images and religious fervour seem to have been more closely associated than usual, whether the images were crucifixes (recommended by leading preachers such as Bernardino of Siena and Savonarola), the new medium of the woodcut, or a new type of religious painting, small and intimate, suitable for a private house, not so much an icon as a narrative, which would act as a stimulus to meditation on the Bible or the lives of the saints. 10

A vivid illustration of the devotional uses of the image comes from Rome, from the fraternity of St John Beheaded (*San Giovanni Decollato*), which comforted condemned criminals in their last moments by means of *tavolette* – small pictures of the martyrdom of saints which

⁸ Walker, Spiritual and Demonic Magic; Tomlinson, Music in Renaissance

Magic, pp. 101-44.

Wackernagel, World of the Florentine Renaissance Artist, pp. 180ff.; Ringbom,

Icon to Narrative; Baxandall, Painting and Experience, pp. 45ff.

⁷ Yates, Giordano Bruno, pp. 76ff.

⁹ Goffen, *Piety and Patronage*; Hills, 'Piety and patronage'; Verdon and Henderson, *Christianity and the Renaissance*; Eisenbichler, *Crossing the Boundaries*; Welch, *Art and Society*, pp. 131–207; Ladis and Zuraw, *Visions of Holiness*; Kubersky-Piredda, 'Immagini devozionali'; Kasl, *Giovanni Bellini*; Niccoli, *Vedere con gli occhi del cuore*.

were employed, in the words of their recent historian, 'as a kind of visual narcotic to numb the fear and pain of the condemned criminal during his terrible journey to the scaffold'. The wear and tear visible today on some sacred images of the period offers vivid evidence of what one scholar calls the 'tactile devotion' of the owners.

The increasing importance of devotional images seems to have been linked to the increasing lay initiatives in religious matters characteristic of the fourteenth and fifteenth centuries, from the foundation of religious fraternities to the singing of hymns or the reading of pious books at home. Surviving inventories of the houses of the wealthy, in Venice for instance, reveal images of Our Lady in almost every room, from the reception room or *portego* to the bedrooms. In the castle of the Uzzano family, Florentine patricians, there were two paintings of the 'sudary' (Christ's face imprinted on Veronica's towel), and immediately before one of them a *predella* or prie-Dieu is listed, as if the inhabitants of the castle commonly knelt before the sacred image.¹³

As the fifteenth-century friar Giovanni Dominici put it, parents should keep sacred images in the house because of their moral effect on the children. The infant Jesus with St John would be good for boys, and also pictures of the Massacre of the Innocents, 'in order to make them afraid of arms and armed men'. Girls, on the other hand, should fix their gaze on Saints Agnes, Cecilia, Elizabeth, Catherine and Ursula (with her legendary eleven thousand virgins) to give them 'a love of virginity, a desire for Christ, a hatred for sins, a contempt for vanities'. ¹⁴ In a similar way, Florentine girls, whether young nuns or young brides, would be given images, or more exactly dolls, of the Christ-child to encourage identification with his mother. ¹⁵

An interesting example of the devotional use of certain images, and a material sign of spectator response, is what one might call pious vandalism – the defacing of the painted devils in a painting by Uccello, for instance, or the scratching out of the eyes of the executioner of St James in a fresco by Mantegna¹⁶ – the equivalent, one might say, of the audience hissing the villain in a melodrama. In fact, the religious plays of the period had similar aims. These *rappresentazioni sacre*, as they were called, which were written and acted in the fourteenth, fifteenth and sixteenth centuries, were rather like the miracle and mystery plays of late

¹¹ Edgerton, *Pictures and Punishment*, p. 172.

¹² Niccoli, Vedere con gli occhi del cuore, p. 59.

¹³ Morse, 'Creating sacred space'; Bombe, Nachlass-Inventare.

¹⁴ Dominici, Regola del governo, pp. 131ff.

¹⁵ Klapisch-Zuber, Women, Family and Ritual, ch. 14.

¹⁶ Edgerton, Pictures and Punishment, p. 91.

medieval England (a reminder of the difficulty of distinguishing between 'Renaissance' and 'Middle Ages', particularly in the case of popular culture). They usually end with angels exhorting the audience to take to heart what they have just seen. At the end of a play about Abraham and Isaac, for example, the angel points out the importance of 'holy obedience' (santa ubidienzia).¹⁷

Ex votos are a kind of devotional image of which Italian examples remain from the fifteenth century onwards, recording a vow made to a saint in a time of danger, whether illness or accident. Those that have survived, in the sanctuary of the Madonna of the Mountain at Cesena, for example, which contains 246 examples earlier than 1600, are probably only a tiny proportion of those that once existed. 18 It may well have been this kind of occasion that most often persuaded ordinary people to commission paintings. The artistic level of the majority of ex votos is not high, but the category does include a few well-known Renaissance paintings, notably Mantegna's Madonna della Vittoria, commissioned by Gianfrancesco II, marquis of Mantua, after the battle of Fornovo, in which he had, at least in his own eyes, defeated the French army. It was the Jews of Mantua who actually paid for the painting, though not out of choice. Again, Carpaccio's Martyrdom of 10,000 Christians and Titian's St Mark Enthroned were both commissioned to fulfil vows in time of plague, while Raphael's Madonna of Foligno was painted for the historian Sigismondo de'Conti, apparently to express his gratitude for his escape when a meteor fell on his house.

Another use of religious paintings was didactic. As Pope Gregory the Great had already pointed out in the sixth century, 'Paintings are placed in churches so that the illiterate can read on the walls what they cannot read in books', a sentence much quoted in the Renaissance. A good deal of Christian doctrine was illustrated in Italian church frescoes of the fourteenth centuries: the life of Christ, the relation between the Old and New Testaments, the Last Judgment and its consequences, and so on. The religious plays of the period consider many of the same themes, so that each medium reinforced the message of the others and made it more intelligible. It does not seem useful to argue which came first, art or theatre. O

A special case of the didactic is the presentation of controversial topics from a one-sided point of view - in other words,

¹⁷ D'Ancona, Sacre rappresentazioni.

¹⁸ Novelli and Massaccesi, Ex voto.

¹⁹ By Fra Michele da Carcano (quoted in Baxandall, *Painting and Experience*, p. 41, for example), and by Dolce, *Aretino*, p. 112.

²⁰ Kernodle, From Art to Theatre.

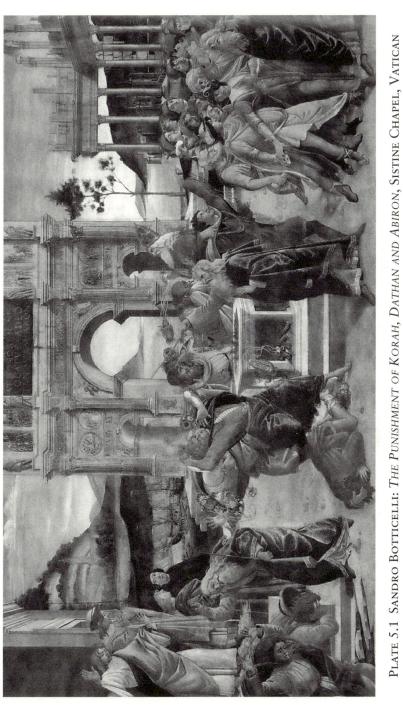

propaganda. Like rhetoric, painting was a means of persuasion. Paintings commissioned by Renaissance popes, for example, present arguments for the primacy of popes over general councils of the Church, sometimes by drawing historical parallels. For Pope Sixtus IV, for example, Botticelli painted the *Punishment of Korah*, illustrating a scene from the Old Testament in which the earth opened and swallowed up Korah and his men after they had dared to challenge Moses and Aaron (Plate 5.1). An earlier fifteenth-century pope, Eugenius IV, had made reference to Korah when condemning the Council of Basel.²¹ In a similar manner, Raphael painted for Pope Julius II, who was in conflict with the Bentivoglio family of Bologna, the story of Heliodorus, who tried to plunder the Temple of Jerusalem but was expelled by angels.²² Again, after the Reformation, paintings in Catholic churches in Italy and elsewhere tended to illustrate points of doctrine which the Protestants had challenged.²³

Following the Reformation, the Catholic Church became much more concerned to control literature and, to a lesser degree, painting. An Index of Prohibited Books was drawn up (and made official at the Council of Trent in the 1560s), and Boccaccio's *Decameron*, among other works of Italian literature, was first banned and then severely expurgated.²⁴ Michelangelo's *Last Judgement* was discussed at the Council of Trent, which ordered the naked bodies to be covered by fig-leaves.²⁵ An Index of Prohibited Images was considered, and Veronese was on one occasion summoned before the Inquisition of Venice to explain why he had included in a painting of the *Last Supper* what the inquisitors called 'buffoons, drunkards, Germans, dwarfs and similar vulgarities'.²⁶

POLITICS

The visual defence of the papacy has introduced the subject of political propaganda, at least in the vague sense of images and texts glorifying or justifying a particular regime, if not in the more precise sense of recommending a particular policy.²⁷ There are so many examples of glorification from this period that it is difficult to know where to begin, whether to look at republics or principalities, at large-scale works such as frescoes

²¹ Ettlinger, Sistine Chapel; cf. Numbers, 16: 1–34.

²² Jones and Penny, Raphael, ch. 5; cf. 2 Maccabees, 3: 7-40.

²³ Mâle, L'art religieux après le concile de Trente; Ostrow, Art and Spirituality.

²⁴ On Boccaccio, Sorrentino, *Letteratura italiana*; on Italian literary censorship in general, Guidi, in Rochon, *Le pouvoir et la plume*; Grendler, 'Printing and censorship'; Fragnito, *Church*, *Censorship and Culture*; Fragiese, *Nascita dell'Indice*.

²⁵ Blunt, Artistic Theory, ch. 9; De Maio, Michelangelo e la Controriforma.

²⁶ Schaffran, 'Inquisitionsprozesse'.

²⁷ Welch, Art and Society, pp. 209-73.

or small-scale ones such as medals. Like the coins of ancient Rome, the medals of Renaissance Italy often carried political messages. Alfonso of Aragon, for example, had his portrait medal by Pisanello (1449) inscribed 'Victorious and a Peacemaker' (Triumphator et Pacificus).28 On his triumphal arch there was a similar inscription, 'Pious, Merciful, Unvanquished' (Pius, Clemens', Invictus). The king, who had recently won Naples by force of arms, seems to be telling his new subjects that if they submit they will come to no harm, but that in a conflict he is bound to win. In Florence, at the end of the regime of the elder Cosimo de'Medici, a medal was struck showing Florence, personified in the usual manner as a young woman, with the inscription 'Peace and Public Liberty' (Pax Libertasque Publica).29 Under Lorenzo the Magnificent, medals were struck to commemorate particular events, such as the defeat of the Pazzi conspiracy or Lorenzo's successful return from Naples in 1480. The sculptor Gian Cristoforo Romano commemorated the peace arranged between Ferdinand of Aragon and Louis XII with a medal giving the credit to Pope Iulius II and describing him as 'the restorer of justice, peace and faith' (Iustitiae pacis fideique recuperator). Mechanically reproducible as they were, and relatively cheap, medals were a good medium for spreading political messages and giving a regime a good image.

Statues displayed in public were another way of glorifying warriors, princes and republics. Donatello's great equestrian statue at Padua honours a condottiere in Venetian service, Erasmo da Narni, nicknamed 'Gattamelata', who died in 1443, and it was commissioned by the state (by contrast, the monument to Bartolommeo Colleoni in Venice was effectively paid for by the condottiere himself). A number of Florentine statues had a political meaning which is no longer immediately apparent. In their wars with greater powers (notably Milan), the Florentines came to identify with David defeating Goliath, with Judith cutting off the head of the Assyrian captain Holofernes (Plate 5.3), or with St George (leaving the role of the dragon to Milan). Donatello's memorable renderings of all three figures are thus republican statements. When the Florentine Republic was restored in 1494, political symbols of this kind reappeared, notably Michelangelo's great David, which refers back to Donatello's David and so by extension to the dangers which the Republic had successfully survived in the early fifteenth century. The statue thus 'demands a knowledge of contemporary political events before one can understand it as a work of art'.30

²⁹ Ibid., p. 236.

²⁸ Hill, Corpus of Italian Medals, p. 12 and plate 9.

³⁰ Seymour, *Michelangelo's David*, p. 56; cf. Hartt, 'Art and freedom'; Ames-Lewis, 'Donatello's bronze *David*'; Kemp, *Behind the Picture*, pp. 202–7.

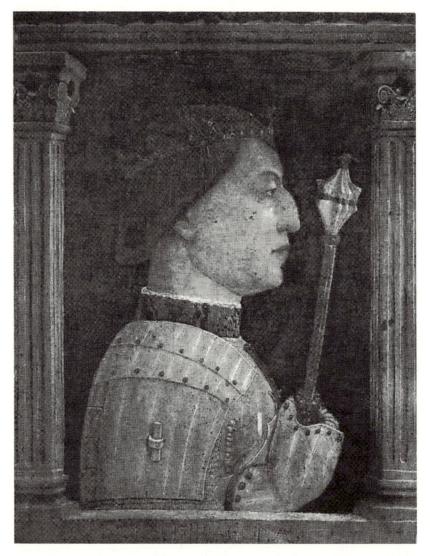

Plate 5.2 School of Piero della Francesca: Portrait of Alfonso of Aragon

Paintings, too, carried political meanings. In Venice, the Republic was glorified by the commissioning and display of official portraits of its doges, and of scenes of Venetian victories in the Hall of the Great Council in the Doge's Palace. In Florence, when the Republic was restored in 1494, a Great Council was set up on the Venetian model,

together with a hall in the Palazzo della Signoria as a meeting-place, complete with victory paintings on the walls, the battles of Anghiari and Cascina commissioned from Leonardo and Michelangelo. When the Medici returned in 1513, the paintings, still unfinished, were destroyed. This destruction of works by major artists suggests that the political uses of art were taken extremely seriously by contemporaries.³¹ So does the employment of Vasari, Bronzino and other painters by Cosimo de'Medici, grand duke of Tuscany (Plate 5.4), to redecorate the Palazzo Vecchio with frescoes of the achievements of the regime and to paint official portraits of the grand-ducal family.³² What is more difficult to decide, at this distance in time, is whether certain paintings carried more precise messages - whether, for instance, they recommended certain policies. One example which has attracted considerable attention is Masaccio's great fresco of The Tribute Money in the Brancacci Chapel in Santa Maria del Carmine in Florence (Plate 5.5). The subject is an unusual one; it carries a clear moral, 'Render unto Caesar', and it was painted in 1425, at a time, when proposals to introduce a new tax, the famous *catasto*, were under discussion. Is it a pictorial defence of the tax? Or is its message one about papal primacy, like Botticelli's Punishment of Korah?33

In other cases, the political reference of a painting is clear, but its political purpose is rather more doubtful: for example, the images of traitors and rebels. In 1440, for instance, Andrea del Castagno is said to have painted images of rebels hung by their feet on the façade of the gaol in Florence. As a result he was nicknamed 'Andrew the Rope' (Andrea degli impiccati). In 1478, it was Botticelli's turn to paint the images of the Pazzi conspirators in the same place. In 1529-30, during the siege of Florence, it was Andrea del Sarto who painted on the same building the images of captains who had fled (cf. Plate 5.6). One wonders why this was done. Was it, as suggested earlier, magical destruction? Or were the paintings made primarily to give information, like a 'wanted' poster? This would at least be a plausible explanation of the public display in Milan of the images of bankrupts. The most likely explanation of these paintings, however, given the importance of honour and shame in the value system of this society (below, p. 204), is that they were executed to dishonour the victims and their families, to destroy them socially, to make them infamous.³⁴ Such an explanation

³¹ Wilde, 'Hall of the Great Council'.

³² Pope-Hennessy, Portrait in the Renaissance, pp. 180-5; Levey, Painting at Court; Cox-Rearick, Dynasty and Destiny; Veen, Cosimo I de' Medici.

³³ Meiss, 'Masaccio and the early Renaissance'; Molho, 'Brancacci Chapel'.
³⁴ Ortalli, *Pittura infamante*; Edgerton, *Pictures and Punishment*, esp. p. 76.

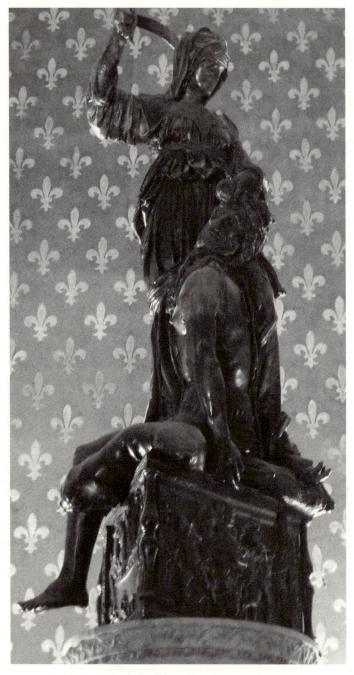

PLATE 5.3 DONATELLO: JUDITH AND HOLOFERNES

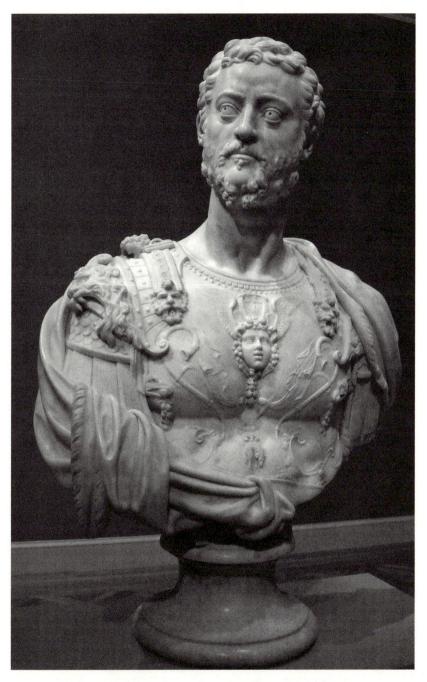

PLATE 5.4 BENVENUTO CELLINI: COSIMO I DE'MEDICI

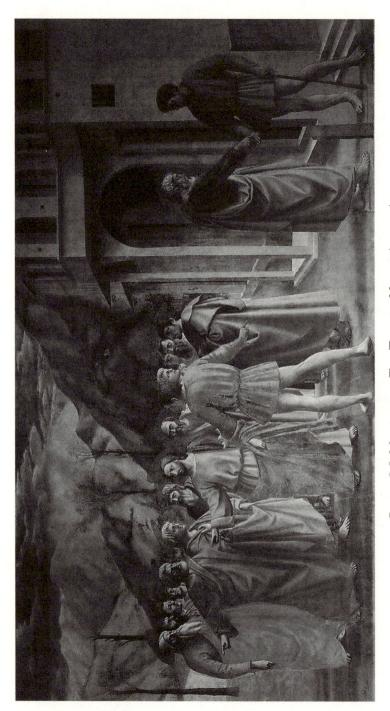

PLATE 5.5 MASSACCIO: THE TRIBUTE MONEY (DETAIL)

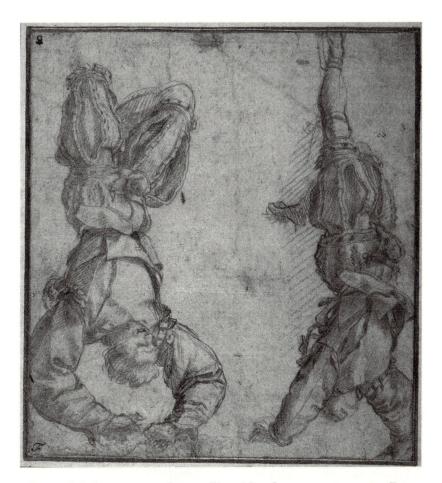

Plate 5.6 Andrea del Sarto: Two Men Suspended by their Feet (detail), red chalk on cream paper

is made more plausible by the existence of a literary equivalent. In Florence, the public herald had the duty of writing what were called *cartelli d'infamia* – in other words, verses insulting the enemies of the Republic.

Humanism too had its uses, whether to produce virtuous rulers (as the humanists claimed) or to foster habits of docility and obedience (as some scholars now argue).³⁵ It is less necessary to dilate upon literature here, since its potential for political persuasion is obvious enough. Suffice it to say that the epics in Latin and Italian discussed in the last chapter were

³⁵ Grafton and Jardine, 'Humanism'.

poems in praise of rulers through their ancestors, real and imaginary, and justifications of their rule, no less political than their model, Virgil's Aeneid, which was commissioned to give Augustus a good public image and - according to some classical scholars - even to defend certain of his policies. Historical works, the prose equivalents of epic according to Renaissance literary theory, were often used for similar purposes; that was why governments pensioned humanist historians such as Lorenzo Valla in Naples, Marcantonio Sabellico in Venice, or Benedetto Varchi in the Florence of the grand duke Cosimo de'Medici. They were supposed to be new Livys, just as the states they celebrated were new Romes. Some poems carried more precise and more topical messages - for example, the 'laments' put into the mouths of rulers at their fall (such as Cesare Borgia, who lost everything on the death of his father, Pope Alexander VI, or Giovanni Bentivoglio, who was driven from Bologna by Julius II) or cities at times of crisis (Venice in 1509, following a major defeat at Agnadello, or Rome in 1527, after it was sacked by imperial troops).³⁶ Luigi Pulci's famous epic the Morgante (1478) seems to be, among other things, a plea for a crusade against the Turks, an aim which the poet is known to have supported. Ariosto makes a similar point in his Orlando Furioso (1516), urging Frenchmen and Spaniards to fight Muslims rather than their fellow Christians (in other words, to desist from their wars in Italy).

The mobilization of the arts in an attempt to persuade was most elaborate in the cases where least is now left for posterity to view and judge - in other words, in court and civic festivals, which often carried fairly precise and extremely topical political messages as well as contributing to the general task of celebrating or legitimating a particular regime. In the case of Venice, with its elaborate ducal processions and its annual Marriage of the Sea, one historian speaks, not without reason, of 'government by ritual', stressing the image of a harmonious hierarchical society projected by these quasi-dramatic forms. As for topical references, a good example comes from 1511, during the famous war of the League of Cambrai, in which the very existence of Venice (or at least of her empire) was at stake. The Scuola di San Rocco (above p. 96) exhibited an allegorical tableau vivant, including Venice (personified as a woman) and the king of France (the principal enemy of the Republic), flanked by the pope with a placard asking why France had denied the true faith. ³⁷ In Florence, the political uses of festivals are most obvious in the period following the Medici restoration of 1513. A notable example is that of the state entry into Florence in 1515 of

³⁶ Medin and Frati, Lamenti.

³⁷ Muir, Civic Ritual, pp. 185ff., 238ff.

the Medici pope, Leo X, through an elaborate sequence of triumphal arches in which the theme of the return of the golden age was emphasized.³⁸ In this field, too, the second Cosimo – that is, the grand duke of Tuscany – showed his awareness of the political value of the arts. Not only was his wedding to Eleonora of Toledo in 1539 the occasion for an elaborate display, but the annual celebrations marking Carnival and the feast of St John the Baptist (patron saint of Florence) were more or less taken over by Cosimo and his men and used with what another writer calls – with particular appropriateness in this context – a 'conscious Machiavellianism'.³⁹

One has the impression – it is difficult to be more precise – that the political uses of the media were greater and also more self-conscious in the sixteenth century than they had been in the fifteenth. Faced with the wider diffusion of unorthodox ideas made possible by the invention of printing, governments, like the Church, turned to censorship. When Guicciardini's great *History of Italy* was published, posthumously, in 1561, a number of anticlerical remarks had been expurgated. It was, however, not the Church but Cosimo de'Medici of Tuscany who was responsible for the expurgations, so as to preserve good relations between his regime and the papacy. On the positive side, Cosimo showed his awareness of the political uses of culture by founding first the Florentine Academy and then the Academy of Design. In other words, he tried to turn Tuscan 'cultural capital' (the primacy of its language, its literature, its art) into political capital for his regime.⁴⁰

The political messages discussed so far are those delivered on behalf of those in power. However, opponents of the various regimes were far from silent. They could, for example, make their views known by a kind of secular iconoclasm. After the defeat of the Venetian forces at Agnadello in 1509 the revolt of the subject cities, such as Bergamo and Cremona, was marked by the defacing of the sculpted lion of St Mark, placed in each city as a sign of Venetian domination. On the death of Pope Julius II, his statue in Bologna, another sign of domination, also met its end. Graffiti already had their place in the politics of Italian city-states and were sometimes recorded in chronicles or private letters. A literary development from these graffiti were the so-called pasquinades (pasquinate), verses satirizing the popes and cardinals which came from the later fifteenth century onwards to be attached to the pedestal of a fragment of a classical statue. The verses, attributed to the statue, were written on occasion by distinguished writers, such as Pietro Aretino, whose pungent

³⁸ Shearman, 'Florentine entrata of Leo X'.

³⁹ Plaisance, 'Politique culturelle' and Florence.

⁴⁰ Plaisance, 'Une première affirmation'; Bertelli, 'Egemonia linguistica'.

verses on the conclave following the death of Leo X did much to make his reputation.⁴¹

THE PRIVATE SPHERE

There remain some uses of the arts which do not fit our categories of 'religion' and 'politics', at least in the strict sense. One could perhaps widen the latter category to include the use of portraits of marriageable daughters in negotiations between princes, or indeed between families of a middling social status. Even the portraits of private persons can be seen as a kind of propaganda, with the artist collaborating with the sitter to present a favourable image of an individual, or of his or her family, to impress rival families, or perhaps posterity. However, it is worth pausing to think how much of the material culture of Renaissance Italy was produced for a domestic setting (above, pp. 10–12). Ut It was for the use or the glory not so much of individuals as of families, especially noble families, or families with noble pretensions.

The most important and expensive item was of course the town house, or 'palace' as the Italians like to call it, a symbol of the family as well as a shelter for its members, designed to impress outsiders rather than to provide the inhabitants with comfortable surroundings. Comfort is a more recent ideal, dating from the eighteenth century or thereabouts. Older ideals were modesty and defence. The fifteenth, sixteenth and seventeenth centuries, on the other hand, were the heyday in Italy of what is often called 'conspicuous consumption', in which nobles built to sustain the honour of the house and to make their rivals envious. The house (especially its façade) and its contents formed part of a family's 'front', the setting and the stage props for the long-playing drama in which their status was enacted. The analysis of 'front' offered by Goffman seems particularly appropriate to the behaviour of nobles in Italy in the sixteenth and seventeenth centuries.

In the language of the time, the palace demonstrated the 'magnificence' of the family that owned it, although the 'propriety of display', or the scale of display, was a matter for debate.⁴⁷ Villas or houses in the

⁴¹ Larivaille, *Pietro Aretino*, pp. 47ff.

⁴² Fahy, 'Marriage portrait'.

⁴³ Burke, *Historical Anthropology*, pp. 150–67.

⁴⁴ Welch, Art and Society, pp. 275-311.

⁴⁵ Burke, *Historical Anthropology*, pp. 132–49; Goldthwaite, 'Empire of things', pp. 77ff.

⁴⁶ Goffman, Presentation of Self, pp. 22ff.

⁴⁷ Jenkins, 'Cosimo de'Medici's patronage'; Kent, Lorenzo de' Medici; Lindow, Renaissance Palace; Shepherd, 'Republican anxiety'.

countryside moved in a similar direction. In the early part of the period, they were essentially farmhouses, allowing the owners to supervise the workers on their estate. Gradually, however, the emphasis shifted from profit to pleasure.⁴⁸

Other material objects were associated with important and highly ritualized moments of family history, notably births, marriages and deaths. The desca di parto or 'birth tray', on which refreshments were brought to the new mother, was often painted with appropriate themes such as the triumph of love. The cassone, a large chest with paintings on the outside - and sometimes inside the lid as well - was associated with marriage, for it contained the bride's trousseau.⁴⁹ Pictures were frequently given as wedding presents, and newly-weds not infrequently had their portraits painted, the bride wearing the new clothes given her by the husband's family and sometimes bearing their badge, thus marking her as theirs.⁵⁰ The open allusions to sexuality permitted at weddings seem to have affected the conventions of nuptial art, which includes such Renaissance masterpieces as Mantegna's Camera degli Sposi at Mantua, Raphael's Galatea, and Sodoma's Marriage of Alexander and Roxanne, the last two painted for the Sienese banker Agostino Chigi. 51 Poetry and plays might also be associated with the happy occasion; Poliziano wrote his pastoral drama Orfeo for a double betrothal at the court of Mantua. To commemorate deaths in the family, there were funeral monuments, some of them extremely grand affairs. Since our period covers Michelangelo's Medici Chapel and his tomb for Pope Julius II, always concerned for the glory of the della Rovere family, no more need be said on that account. If states employed artists and writers to defame enemies, so, on occasion, did noble families. The painter Francesco Benaglio of Verona was once commissioned to go at night and paint obscene pictures by torchlight on the walls of the palace of a nobleman (the enemy of his client), presumably to put him to public shame.⁵²

⁴⁸ Lillie, Florentine Villas; Rupprecht, 'Villa'; Coffin, Villa in the Life of Renaissance Rome.

⁴⁹ Callmann, *Apollonio di Giovanni*; Tinagli, *Women in Italian Renaissance Art*, pp. 21–46; Baskins, *Cassone Painting*; Musacchio, *Ritual of Childbirth*; Randolph, 'Gendering the period eye'; Musacchio, *Art*, *Marriage and Family*.

⁵⁰ Klapisch-Zuber, Women, Family and Ritual, pp. 225ff.; Tinagli, Women in Italian Renaissance Art, pp. 47-83.

⁵¹ Barolsky, Infinite Jest, pp. 28ff., 89ff., 93ff.

⁵² Simeoni, 'Una vendetta signorile'.

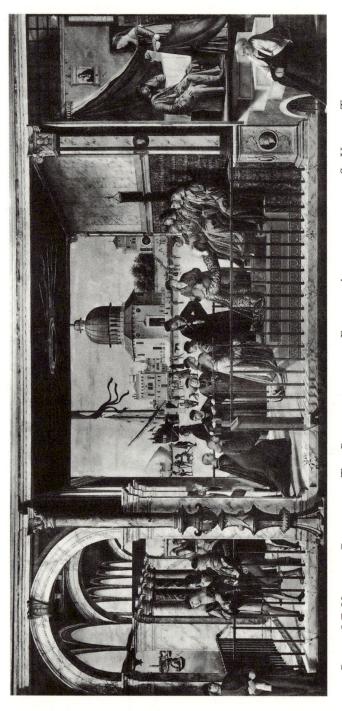

PLATE 5.7 VITTORE CARPACCIO: THE RECEPTION OF THE ENGLISH AMBASSADORS AND ST URSULA TALKING TO HER FATHER

ART FOR PLEASURE

We arrive at last at what has come to seem the natural 'use' of the arts: to give pleasure. The playful side of the arts must not be forgotten, although it has not often been studied.⁵³ The increasing importance of this function is one of the most significant changes in the period. By the mid-sixteenth century, the writer Lodovico Dolce went so far as to suggest that the purpose of painting was 'chiefly to give pleasure' (principalmente per dilettare). The carnival song of the sculptors of Florence – quoted in the epigraph to this chapter - catches the new mood. It should be noticed. however, that, as the song makes clear, pleasure (diletto) is taken in the statue as a contribution to interior decoration. We are still a long way from modern ideas of 'art for art's sake'. Even the Gonzagas, who cared a good deal about painting, seem to have thought of it primarily in this way. Isabella asked Giovanni Bellini for a picture 'to decorate a study of ours' (per ornamento d'uno nostro studio), while her son Federico wrote to Titian in 1537 telling him that the new rooms in the castle were finished; all that was lacking were the pictures 'made for these rooms' (fatte per tall lochi). Sabba di Castiglione, a knight of the Order of Rhodes, advised nobles to decorate their houses with classical statues or – if these were not available - with works by Donatello or Michelangelo.54

In architecture, we see the increasing importance of the pleasure house, the country villa, where, as the greatest designer of such houses, Palladio, put it, a man 'tired of the bustle of cities, will restore and console himself'. 55 In literature too there was increasing emphasis (especially in prefaces) on pleasure – the author's and, more particularly, the reader's – a shift that may well be related to the gradual commercialization of literature and art. But what exactly gave pleasure to spectators, readers or listeners in the Renaissance? An attempt to answer this question will be made in the next chapter.

⁵³ Barolsky, *Infinite Jest*, is one of the rare exceptions.

⁵⁴ Sabba di Castiglione, *Ricordi*, no. 109, trans. in Klein and Zerner, *Italian Art*, p. 23.

⁵⁵ Palladio, Quattro libri dell'architettura, bk 2, ch. 12.

Everyone has a certain natural taste . . . for recognizing beauty and ugliness (un certo gusto . . . del bello e del brutto).

Dolce, Aretino, p. 102

either artists nor patrons were completely free to make aesthetic choices. Their liberty was limited, whether they realized this or not, by the need to take into account the standards of taste of their period. These standards need to be described in order that we may look at works of art and literature – if only momentarily – with the eyes of contemporaries.¹ To reconstruct the taste of the time, historians can use two main kinds of literary source. A number of treatises on art and beauty were produced in this period by famous humanists such as Alberti and Bembo, and also by a number of lesser figures. These treatises, which have often been studied, have the advantage of explicitness, but they are often rather abstract. They need to be supplemented by the analysis of the standards implied by a more practical criticism, the judgements on individual works of art, literature, and so on, to be found in contracts, in private letters, in poems, in biographies and in stories.²

It is interesting to find, for example, that, whereas the term 'sublime' became important in art theory only in the eighteenth century, it was already used in this period by the poet Veronica Gambara, in a letter to Beatrice d'Este (sister of Isabella), praising Correggio's painting of St Mary Magdalen for expressing *il sublime*. Another precious piece of evidence is the memorandum to Ludovico Sforza, cited in chapter 4 (p. 103), in which the agent tries to find words to distinguish the styles of four leading painters to help the duke make a choice between them, contrasting the 'virile air' of Botticelli, the 'sweeter air' of Filippino Lippi, the 'angelic air' of Perugino and the 'good air' of Ghirlandaio.³

The sources are, of course, written in Latin as well as Italian. The Latin

¹ On 'the period eye', Baxandall, Painting and Experience, ch. 2.

² Land, Viewer as Poet.

sources will not be ignored, but the emphasis here will fall on Italian texts because they are closer to the ordinary speech and thought of the time.

THE VISUAL ARTS

It would not be difficult to draw up a list of some fifty terms which came regularly to the lips and pens of Italians of the period when they were appraising paintings, sculptures and buildings. Some are general, almost vacuous terms, such as 'beauty' (bellezza, pulchritudine), but others are more precise and so more revealing. It may be useful to distinguish five clusters of terms, centred on the concepts of nature, order, richness, expressiveness and skill.

Naturalism v. idealism

The 'return to nature', a favourite formula of modern historians of the Renaissance, does in fact correspond to a commonplace of the period. For example, the humanist Bartolommeo Fazio praised Ian van Evck for a portrait 'which you would judge to lack only a voice' and for 'a ray of the sun which you would take to be real sunlight', while he described Donatello's achievement as 'to produce lively expressions (vivos vultus ducere).4 Another humanist, Cristoforo Landino, described Donatello's statues as having 'great vivacity' (grande vivacità), so that the figures all seemed to be in movement.5 Another sought-after quality in painting was three-dimensionality or 'relief' (rilievo). The Florentine writer Giambattista Gelli, for example, made fun of Byzantine art as 'without any relief', so that the figures looked not like men but like clothes spread out on a wall or 'flayed skins'. 6 The great preacher Girolamo Savonarola seems to have been articulating the assumptions of his audience when he remarked: 'The closer they imitate nature, the more pleasure they give. And so people who praise any pictures say: look, these animals seem as if they were alive, and these flowers seem natural ones.'7

A similar concern with naturalism is to be found in Vasari's *Lives*.⁸ The horses painted in a stable by Bramantino, for example, were so lifelike that a horse mistook the image for reality and kicked it. The importance here of Vasari's variation on the well-known Greek stories

³ Chambers, *Patrons and Artists*, no. 95. Cf. Baxandall, *Painting and Experience*, pp. 26, 109ff.

⁴ Baxandall, 'Bartholomaeus Facius on painting'.

⁵ Morisani, 'Cristoforo Landino'.

⁶ Gelli, 'Vite d'artisti', p. 37.

⁷ Savonarola, *Prediche e scritti*, pp. 2, 47.

⁸ Blunt, Artistic Theory, ch. 8.

about illusionistic grapes and curtains is that the illusionism is described as a triumph. Again, what Vasari finds remarkable in the *Mona Lisa* is that the lady's mouth 'appeared to be living flesh rather than paint', while her eyebrows 'were completely natural, growing thickly in one place and lightly in another and following the pores of the skin'. Similarly, what impresses him in Leonardo's *Last Supper* is that 'The texture of the tablecloth is imitated so skillfully that linen itself cannot look more real (*non mostra il vero meglio*).' His praise of these particular paintings for naturalism rather than other qualities may make Vasari seem somewhat naif today, so it may be worth emphasizing that he was articulating a common assumption of the period, which was in fact shared by Leonardo, who once declared that, the closer a painting was to the object it was imitating, the better.

The assumption was not shared by everyone, however. Some writers who now appear to share it in fact did not, the phrase 'to imitate nature' being more ambiguous than it may seem. There were two different ideas of nature in the Renaissance: the physical world (natura naturata, as philosophers called it) and the creative force (natura naturans). Naturalism in the modern sense involves the imitation of the first nature, but what some Renaissance writers advocate is the imitation of the second. As Alberti put it in his treatise on painting, nature rarely achieves perfection, and artists should aim at beauty, as nature does, rather than at 'realism' (similitudine). Thus Alberti is saving in effect that artists should not paint what they see, but he is using the language of imitation to say so. Michelangelo expressed himself still more strongly. His objection to Flemish painting was that it was done merely 'to deceive the external eve'. Again, when he was designing the tombs of Lorenzo and Giuliano de'Medici, he did not represent these individuals as 'nature had sculpted and created them' (come la natura gli avea effigiati e composti) but produced his own idealized versions of their appearance.9

Order v. grace

A second cluster of evaluative terms refers to order or harmony. When Alberti tells the architect to imitate nature the creator, he explains that its aim is 'a certain rational harmony (concinnitas) of all the parts making up a whole so that nothing can be added or subtracted or changed for the better'. Similarly, Ghiberti wrote that 'only proportion makes beauty' (la proportionalità solamente fa pulchritudine). To say that they 'have proportion' is a favourite term of praise for works of art. Another

¹⁰ Alberti, De re aedificatoria, bk 6, ch. 2.

⁹ Clements, Michelangelo; Summers, Michelangelo, ch. 20.

term in this cluster is 'order' (ordine). 11 Another is 'symmetry', used not only of buildings, as might have been expected, but of paintings as well; Landino declared that symmetry had been revived by the thirteenthcentury painter Cimabue. 'Measure' (misura) is also common term; yet another is 'rule' (regola). Analogies were commonly drawn between the proportions of buildings and those of the human body and between visual and musical harmony. The basic attitude implied by the use of these terms and analogies was that beauty follows rules - rules which are not arbitrary but rational and indeed mathematical. Even gardens were supposed to be orderly: Alberti suggests that 'The trees ought to be planted in rows exactly even, and answering to one another exactly upon straight lines.'12 The little that is known about Italian gardens in this period suggests that he was expressing the conventional view. Topiary, for example, was revived in fifteenth-century Italy. 13 The 'elegant ordination of vegetables', as Sir Thomas Browne calls it in his Garden of Cyrus, is a vivid illustration of Renaissance values at a point where they differ strongly from our own.

Yet order was not to everyone's taste, whether in nature or in art. In the 1480s, in his pastoral romance the *Arcadia* – which was one of Sidney's models – the Neapolitan Jacopo Sannazzaro expressed a preference for wild beauty in the opening to his *Arcadia* (1504):

It is usual for high and spreading trees produced by nature in fearsome mountains to give greater pleasure to those who look at them than plants skilfully clipped and cultivated in elaborate gardens [le coltivate piante, da dotte mani expurgate, negli adorni giardini] ... who doubts that a fountain that issues naturally out of the living rock surrounded by green plants is more pleasing to us than all the other fountains, works of art made from the whitest marble and resplendent with much gold?

It is surely this attitude that underlies the rise of landscape painting in our period.

Around the 1520s, there was a more general rejection of symmetry and artistic rules. Michelangelo's theory and practice are the great examples of this reaction, though its violence should not be exaggerated. Two famous remarks attributed to Michelangelo sum up his attitude: the dismissal of Dürer's book on proportion, with the remark that 'one cannot make fixed rules, making figures as regular as posts', and the declaration that 'All the reasonings of geometry and arithmetic, and all the proofs of

¹¹ Summers, Michelangelo, pp. 197ff.

¹² Alberti, De re aedificatoria, bk 9, ch. 4.

¹³ Coffin, Italian Garden; Lazzaro, Italian Renaissance Garden.

perspective, are of no use to a man without the eye.'¹⁴ As for practice, Michelangelo's Medici Chapel was described by Vasari as a reversal of 'the work regulated by measure, order and rule [misura, ordine e regola] which other men did according to a common use'.

If these values were to be rejected, what was to be put in their place? A favourite sixteenth-century term for the beauty which cannot be reduced to formulas or rules is 'grace' (grazia). In his delightful dialogue on The Beauties of Women, the Florentine Agnolo Firenzuola suggested that this grace was not a matter of mere vital statistics but something more mysterious, 'born from a hidden proportion and from rules which are not in our books'. 15 Thus the language of rules is used to argue that rules do not exist. Another mid-sixteenth-century Florentine, Benedetto Varchi, contrasted grace with beauty. Beauty is physical, objective and based on proportions, while grace is spiritual, subjective and impossible to define. 16 But how does one represent the spiritual in art? As the term became more popular in the sixteenth century, 'grace' is used to mean something like 'sweetness', 'elegance' or 'loveliness' (dolcezza, leggiadria, venustà). It is associated with Raphael and Parmigianino in particular. 17 It would be uncharitable to conclude that the 'mystery' consisted in making girls with sweet expressions and ten heads high, but there can be little doubt that some artists, associated with the movement we now call 'Mannerism', believed that even grace could be reduced to a formula. 18

Richness v. simplicity

A third cluster of terms of appraisal centres on the notion of richness in a broad sense which encompasses 'variety' (varietà), 'abundance' (copiosità), 'splendour' (splendore) and 'grandeur' (grandezza). Recurrent adjectives, which it would be difficult – and perhaps useless – to distinguish, include illustre, magnifico, pomposo (without the pejorative overtones of the English 'pompous'), sontuoso and superbo. The humanist Leonardo Bruni, called in, as we have seen, to advise on the third pair of doors for the Baptistery in Florence, considered that they should be what he called illustri – in other words, that they should 'feed the eye well with variety of design'. Ghiberti, who actually designed the doors,

¹⁴ Clements, *Michelangelo*, no. 21; Summers, *Michelangelo*, pp. 352ff., 380 (with a warning not to assume that Michelangelo 'had no patience with theories of proportion at all').

¹⁵ Firenzuola, Prose, pp. 108ff.

¹⁶ Varchi, Due lezioni.

¹⁷ On Giovio's association of Raphael with *venustas*, Zimmermann, 'Paolo Giovio', p. 416.

¹⁸ Smyth, Mannerism and Maniera; Shearman, Mannerism.

tells us that he aimed at 'richness'. Again, Alberti objected to what he called 'solitude' in a 'history' (*istoria*, in the sense of a painting which tells a story), suggesting that pleasure comes primarily 'from copiousness and variety of things . . . I say that history is most copious in which in their places are mixed old, young, maidens, women, youths, boys, fowls, small dogs, birds, horses, sheep, buildings, landscapes and all similar things.' 19

Judgments on buildings in particular make frequent use of this cluster of terms. Filarete, for example, rather overworks the term 'imposing' (dignissimo). Vasari tends to describe houses as onoratissimo, sontuosissimo or superbissimo, the superlatives adding to the effect of richness. As for painting, Vasari identifies the 'grand style' (maniera grande) as the characteristic of the work he admires most, such as Michelangelo's.

However, the values associated with simplicity also had their admirers. Alberti, for example, despite his praise of copiousness, was hostile to ornament, a 'secondary' kind of beauty as he called it. He attacked 'confusion' in architecture, which sounds like a defect related to the qualities of richness and variety. He argued in favour of whitewashed churches on the grounds that 'purity and simplicity of colour, as of life, must be pleasing to the divine being'. He also suggested that a sculptor will prefer pure white marble, and that painters should use white rather than gold. One of his terms of praise for works of art was 'modesty' (*verecundia*).

Alberti's defence of simplicity suited the work of his friends Brunelleschi and Masaccio very well. Brunelleschi banished frescoes from his interiors, such as the church of San Lorenzo or the Pazzi Chapel in Santa Croce (Plate 6.1). Masaccio's paintings were praised by Landino because they were 'pure without ornament' (puro senza ornato).²¹

Expressiveness

For the humanist Bartolommeo Fazio, expressiveness was one of the most important gifts of a painter. Pisanello, he wrote, excelled 'in expressing feeling' (sensibus exprimendis). A St Jerome of his, for example, was remarkable for the saint's 'majesty of countenance'. Roger van der Weyden's Deposition, Fazio continued, was noteworthy for its depiction of the grief of the bystanders and his Passion for its 'variety of feelings and emotions'. Again, Alberti advised the painter to 'move the soul of the

¹⁹ Alberti, On Painting, p. 75.

²⁰ Alberti, *De re aedificatoria*, bk 7, ch. 10; *On Painting*, pp. 84–5. Cf. Gombrich, *Meditations*, pp. 16ff.

Morisani, 'Cristoforo Landino', pp. 267ff.
 Baxandall, 'Bartholomaeus Facius on painting'.

spectator', explaining that 'These movements of the soul are made known by the movements of the body' - motion is a sign of emotion - and implying that to represent an emotion was to induce it in the beholder, who would 'weep with the weeping, laugh with the laughing, and grieve with the grieving'. ²³ Leonardo emphasized the need for the painter to represent emotions such as anger, fear and grief, and his own comments in his notebooks on the subject of his Last Supper describe not the tablecloth that seems to have impressed Vasari so much, but gestures and emotions, such as the apostle who makes 'a mouth of astonishment'. 24 To be fair, Vasari also noticed the expressive qualities of the painting, and commented that 'Leonardo succeeded brilliantly in imagining and reproducing the tormented anxiety of the apostles to know who betrayed their master; so in their faces one can read the emotions of love, dismay and anger, or rather sorrow, at their failure to grasp the meaning of Christ.' He had similar praise for Michelangelo, whose figures 'reveal thoughts and emotions which only he has known how to express'.

Skill

The last of our clusters of terms centres on the notion of skill, and may be illustrated from Fazio's praise of van Eyck for that quality (artificium). Alberti praises artists for the 'effort' (istudio, industria) underlying their selection of elements from the visible world to create a work of beauty. A work may also be praised for its overcoming of difficulties. Vasari, for example, praised Raphael's Marriage of the Virgin because 'it is marvellous to see the difficulties which he went out of his way to look for' in representing the temple in perspective (Plate 6.2). 'Of all the terms of praise used by authors of the Late Renaissance', it has been suggested, 'perhaps none is more frequent or more important than difficultà.'25 The successful overcoming of difficulties is sometimes called 'facility'. The problem was that artists with facility might not seem to have this quality because the spectator might not realize that there was a problem to overcome. Hence the advice to young painters to 'introduce at least one figure who is completely affected, mysterious and difficult [sforciata, misteriosa e difficile], that will show those who understand art how skilled you are'.26 That the advice was taken seriously is suggested by the fact that the fashionable term *peregrino* could mean both 'strange' and 'elegant'.²⁷

²³ Alberti, On Painting, p. 77.

²⁴ Leonardo da Vinci, *Literary Works*, pp. 341ff. ²⁵ Summers, *Michelangelo*, p. 177; cf. ch. 11.

²⁶ Pino, *Dialoghi di pittura*, p. 45.

²⁷ Weise, 'Maniera und Pellegrino'.

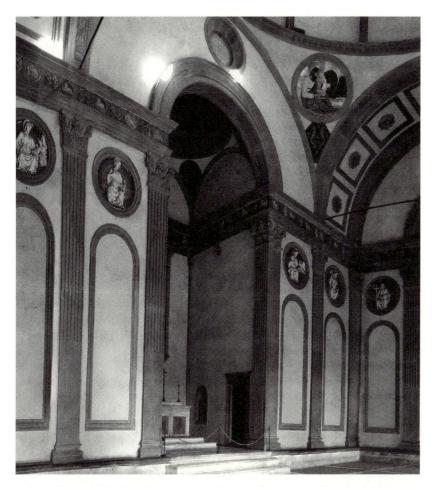

PLATE 6.1 INTERIOR OF THE PAZZI CHAPEL IN FLORENCE

Again, 'bizarre' does not seem to have been a pejorative term at this time. At any rate, Vasari could use it about his own work.²⁸

The increasingly frequent references to 'facility' and 'difficulty' suggest that the public – and perhaps the artists as well – were becoming more conscious of style and more interested in it. Pejorative terms tell a similar story. Artists such as Vasari and laymen such as Gelli, who has already been quoted, make considerable use of such terms as 'gross', 'rough' or 'clumsy' (grosso, rozzo, goffo) when

²⁸ Vasari, Literarische Nachlass, pp. 17ff.

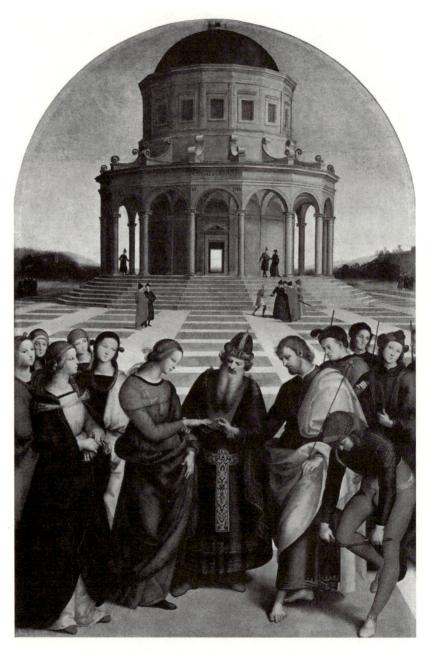

PLATE 6.2 RAPHAEL: MARRIAGE OF THE VIRGIN

describing medieval art. A final example is the increasing use of the term 'style' itself (*maniera*).²⁹ With the growing interest in individual style went a sharper awareness of what our post-romantic age calls creativity, inspiration or genius and contemporaries described in slightly different terms as inventiveness (*invenzione*), imagination (*fantasia*) or intelligence (*ingegno*).³⁰

In short, an analysis of the vocabulary used to appraise painting, sculpture and architecture in the fifteenth and sixteenth centuries suggests – as does an inspection of the objects themselves – a change in taste from the natural to the fantastic and from the simple and modest to the complex, difficult and splendid.

MUSIC

It was a Renaissance commonplace that there were parallels between music and other arts, architecture in particular. Audible and visible proportions were thought to be analogous. This was the point of Alberti's warning phrase to his assistant Matteo de'Pasti (above, p. 71) that, if he changes the proportions of the pilasters, 'all that music turns into discord' (*si discorda tutta quella musica*). In his report of 1535, the Franciscan scholar Francesco Zorzi (or Giorgi) described the proportions of the church of San Francesco della Vigna in Venice (Plate 6.3) in musical terms such as 'diapason' and 'diapente'.³¹

These analogies were treated as more than metaphors. They had practical consequences, at least on occasion. For example, Franchino Gaffurio, musical director at the cathedral of Milan, was called in as an architectural consultant. Analogies between music and the other arts were less precise, but they were not infrequently drawn, as in the case, already quoted, of the comparison between Michelangelo and Josquin des Près.

The musical taste of the period is harder to reconstruct than its visual or literary taste. There is no musical equivalent of Vasari's *Lives*, and in any case, then as now, it was more difficult for people to explain why they liked a particular musical composition than why they liked a particular poem or painting. Hence the following paragraphs rely heavily on three treatises of the period, written by Johannes de Tinctoris, Pietro Aron and Nicolò Vicentino.

The most overworked term of praise was 'sweet' (soave, dolce), but

²⁹ Weise, 'Maniera und Pellegrino'; Smyth, Mannerism and Maniera.

³⁰ Kemp, 'From "mimesis" to "fantasia".

³¹ Wittkower, Architectural Principles, pp. 90ff., 117ff.; cf. Foscari and Tafuri, L'armonia e i conflitti.

this tells us little more about taste in music than a term such as 'beauty' does in the case of the visual arts. More helpful is a cluster of terms centred on 'harmony' and having much in common with the visual cluster centred on 'order'. Again, the basic idea is that success depends on following rules. Tinctoris, for example, frequently criticizes the composers of his day for what he calls their 'inexcusable errors'. He wrote a treatise on proportion in music. Pietro Aron uses similar terms of praise, such as ordinato.

An acute problem for the writers on music of this period was that of the discord. The problem springs from a fundamental difference between music and the visual arts, a difference disguised by their use of a common vocabulary of order and harmony. The discords which occur in the music of the time can be compared either to decoration or to asymmetry in the visual arts. In the first case they are desirable, but in the second case they are to be shunned. Tinctoris found it difficult to make up his mind on this point. In one passage he compared musical discords to figures of speech, while in another he defined the discord as 'a mixture of two voices which naturally offends the ear'. His conclusion is a compromise – that discords may be permitted, provided that they are little ones (*discordantiae parvae*). Aron, nearly fifty years later, was prepared to go further towards accepting discords. For Tinctoris, a piece of music must both begin and conclude with a perfect concord; for Aron, it is only necessary for it to end that way.

Another group of terms centres on the idea of expressiveness. In this case the analogy with the visual arts will be obvious, but there seems to have been a time lag; it was only in 1500 or even later that the expressive became important, in theory and practice alike. Thus one of the characters in Castiglione's *Courtier* contrasts the effects on the listeners of two styles of singing practised by Bidon of Asti in Rome and Marchetto Cara in Mantua:

Bidon's style of singing is so skilful, quick, vehement, rousing and varied in its melodies [tanto artificiosa, pronta, veemente, concitata e di così varie melodie] that everyone who hears it is moved and set on fire . . . our Marchetto Cara is no less emotional in his singing, but with a softer harmony; he makes the soul tender and penetrates it calmly and in a manner full of mournful sweetness [flebile dolcezza]. 32

Some music of the period was clearly composed to communicate emotion, for example to reinforce the feelings expressed in a text. Josquin's mournful setting of Dido's lament from Virgil's Aeneid is a

³² Castiglione, Cortegiano, bk 1, ch. 37.

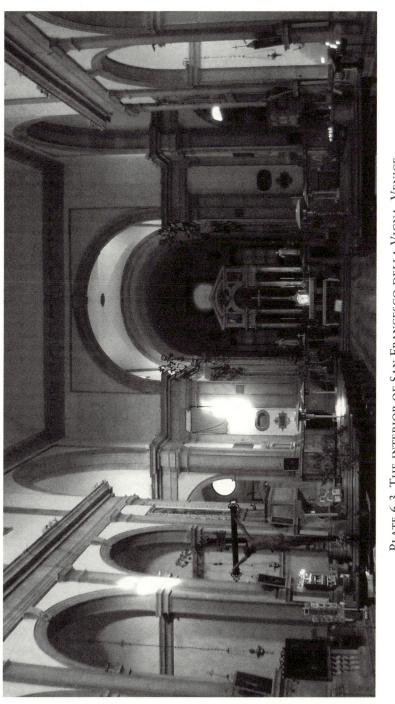

PLATE 6.3 THE INTERIOR OF SAN FRANCESCO DELLA VIGNA, VENICE

famous example. The madrigals of the 1520s and 1540s by Costanzo Festa, Adriaan Willaert, Jacques Arcadelt and others furnish many more instances. For the theory behind these expressive songs, however, we have to wait until the 1550s. As Nicolò Vicentino (a pupil of Willaert's) put it, 'If the words speak of modesty, in the composition one will proceed modestly, and not wildly; if they speak of gaiety, one will not write sad music, and if of sadness, one will not write gay music; when they are bitter, one will not make them sweet . . .' He is echoed by Gioseffe Zarlino:

Musicians are not supposed to combine harmony and text in an unsuitable manner. Therefore it would not be fitting to use a sad harmony and a slow rhythm with a gay text, or a gay harmony and quick and light-footed rhythms to a tragic matter full of tears . . . the composer should set each word to music in such a way that where it denotes harshness, hardness, cruelty, bitterness and other similar things the music will be similar to it, that is, somewhat hard and harsh, though without offending.³³

There are further parallels between music and the sister arts. Tinctoris suggested, for example, that 'variety should be most diligently searched for in all counterpoint.' Music was even expected to imitate nature, notably hunting scenes and battles, such as Heinrich Isaac's *A la battaglia*.

LITERATURE

'A picture is nothing but a silent poem', wrote Bartolommeo Fazio. If the idea was not already a commonplace in the early fifteenth century, when he was writing, it rapidly became one. The analogy, usually supported by a phrase from Horace – 'as is painting, so is poetry' (*ut pictura poesis*) – was one of which contemporaries never seemed to tire.³⁴ It also informed their practical criticism. When the humanist Poliziano described the medieval poet Cino da Pistoia as the first who 'began to abandon the old uncouthness' (*l'antico rozzore*), he was in effect describing Cino as a kind of Cimabue or Giotto. Five central concepts in the literary criticism of the period have their parallels in the visual arts in particular: decorum, grandeur, grace, variety and simulitude.³⁵

Decorum (decoro, convenevolezza) seems to have played a greater part in literary criticism than in art criticism. In the visual arts, it simply meant avoiding such obvious solecisms as placing an old head on an apparently youthful body or, more controversially, giving Christ on

³³ Zarlino, *Istitutioni harmoniche*, bk 4, ch. 32: the translation is Lowinsky's.

³⁴ Lee, 'Ut pictura poesis'.

³⁵ Weinberg, History of Literary Criticism, offers a guide to this subject.

the cross the features of a peasant. In literature, however, decorum was invoked when discussing the central problem of the relationship between form (*forma*) and content (*materia*).

Following the classical tradition, the Venetian humanist Pietro Bembo, in his authoritative formulation of what was, or was becoming, the conventional wisdom, distinguished three styles (*maniere e stili*) – high, medium and low: 'If the subject is a grand one, the words should be grave, stately, sonorous, spectacular, brilliant (*gravi, alte, sonanti, apparenti, luminose*); if the subject is a low and vulgar one, they should be light, plain, humble, ordinary, calm (*lievi, plane, dimesse, popolare, chete*); if a middle one, the words should be in between.' Bembo went on to argue that Dante had broken this rule in his *Divine Comedy* because he had picked a lofty subject, yet introduced 'the lowest and vilest things'.³⁶

As this example suggests, what most pleased the critics, if not the reading public, was a grand subject treated in the grand style. A whole cluster of terms centres on this idea of grandeur: 'dignity', for example, 'gravity', 'height', 'majesty', 'magnificence' (dignità, gravità, altezza, maestà, magnificenza). The contexts in which it was used suggest that the term 'sublime' (sublime) had a similar meaning, without the association with terror which it acquired, or regained, in the eighteenth century. To write in the grand style involved the exclusion of many topics – most obviously, ordinary people – and many words, such as 'owl' and 'bat'. Indeed, some critics even recommended the replacement of the terms 'sea' and 'sun' by such circumlocutions as 'Neptune' or 'the planet which marks the passage of time'. These phrases, which now seem unnatural and cumbrous, appear to have struck many readers of the time as elegant and stylish.³⁷

A central concept in literary criticism, corresponding more or less to 'richness' in the visual arts, was that of variety, whether it referred to content or form. Bembo gave Boccaccio a good mark for his skilful use of variation in the prologues to the hundred different tales in his *Decameron*. Ariosto was much praised for the variety of themes in his *Orlando Furioso*. Even the Bible was praised, by Savonarola, on these grounds, for its 'diversity of stories, multiplicity of meanings, variety of figures'.

Another cluster of terms centred on the idea of giving pleasure (*piacevolezza*), distinguished into 'elegance' (*leggiadria*), 'loveliness' (*vaghezza*), 'sweetness' and, of course, 'grace'. Perhaps the most important remark to make about these terms is that they often referred to what we might call the 'second-class' beauties of the middle style, lyric rather than epic, or

³⁶ Bembo, Prose della volgar lingua. Cf. Auerbach, Literary Language.

³⁷ Bembo, Prose della volgar lingua; Vida, De arte poetica; Daniello, Poetica.

even to the low style, to Boccaccio's *Decameron*, for example. The fact that the same adjectives were used of many paintings makes one wonder whether the same second-class implications were intended.

As in paintings, so in discussions of literature, the critics spoke much of 'imitation'. Not so much the imitation of nature, as in art criticism and indeed in the literary criticism of later periods, but rather the imitation of other writers - how to vary or transform what was borrowed, and how far to go without being a mere 'ape' of Virgil, Horace or Cicero. This topic, central to the whole Renaissance enterprise of the revival of antiquity, was also a controversial one, involving, among others, Poliziano and Bembo, Bembo, writing to Gianfrancesco Pico, favoured the imitation of a particular author such as Cicero, not in the sense of copying details but in that of absorbing the essence, of taking that author's style as a model to emulate. Poliziano, on the other hand, condemned what he called 'apes', 'parrots' and 'magpies' and declared his belief that he expressed himself, not Cicero (me tamen, ut opinor, exprimo). His letter to a fellow humanist, Paolo Cortese, now looks rather like a manifesto for Renaissance 'individualism', as Burckhardt saw it, but it should be added that Poliziano was not rejecting all literary imitation, merely the 'concern with reproducing Cicero alone' (anxiam . . . effingendi tantummodo Ciceronem).38

VARIETIES OF TASTE

So far the emphasis has fallen on general assumptions held in the period, on a common language of taste. It might be summed up, crudely, in the formula beauty = nature = reason = antiquity. These different values were not consistent with one another in the way that the formula implies, but they were very often treated as consistent by contemporaries. This is not to say that there were no aesthetic disagreements in the period; we have already noted, for example, not only the controversy over imitation but the different valuations of simplicity. What is being asserted is simply that disagreements took place within a common framework of assumptions that was all the more powerful for being unconscious. This common framework, which we might call a 'mentality', made it difficult for individuals to think beyond certain limits, which might be called 'invisible barriers'. Ideas beyond those barriers appeared self-evidently absurd to most contemporaries.³⁹

³⁸ Among the best discussions of this topic are Fumaroli, *L'âge de l'éloquence*, pp. 91ff., and Greene, *Light in Troy*, ch. 8 (the letter to Cortese, p. 319). For Bembo's exchange with Gianfrancesco Pico, Santangelo, *Epistole 'De imitatione'*, esp. pp. 45ff.
³⁹ Burke, 'Strengths and weaknesses'.

However, it is now time to say something more about the varieties of taste. There were differences in taste between individuals. There were differences between the arts. There were also changes in taste during the period, as we have seen, with an increasing concern with richness and a growing unease about rules. This section will concentrate on three major contrasts: those dividing the inhabitants of different regions, the members of different social groups and, finally, the participants *in* from the opponents *of* the movement we call the Renaissance.

Firstly, differences between regions. We have already seen that different parts of Italy made extremely unequal contributions to different arts. It is also obvious that different regions had their own styles in painting and building, which presumably correspond to differences in taste. In most cases, literary evidence about these regional variations is lacking, but there is one famous exception. The contrast between Florentine and Venetian traditions of taste became the subject of a debate, with the Venetians stressing colour while the Florentines stressed draughtsmanship (disegno). On the Florentine side, Vasari, however great his interest in Titian, was never prepared to admit that he was the equal of Michelangelo, while, on the other, Paolo Pino, who dramatizes the debate in his Dialogue on Painting, and Lodovico Dolce, in his Aretino, insist on Titian's supreme greatness. 40 Again, as we have seen (above, p. 31) the Florentine taste for simplicity in architecture, for instance, was very different from the Lombard taste for rich decoration.

Secondly, differences between social groups. Was Frederick Antal, for example (above, p. 39), correct in contrasting aristocratic and bourgeois taste in early fifteenth-century Florence? Or, if he was mistaken in this instance, can a similar contrast be sustained for Renaissance Italy as a whole?

In this period as in others the language of taste was closely related to the language used to appraise social behaviour. Decorum was a social ideal as well as an aesthetic one. 'Grace' was a term applied to deportment before it was employed to describe works of art, and even *maniera* was originally associated with good manners rather than with artistic style. ⁴¹ The use of these terms underlines the fact that what we tend to call the taste of 'the time' was the creation of particular social groups, and that it sometimes expressed their social prejudices. It was, for example, considered a breach of decorum to use technical terms when

⁴¹ Blunt, Artistic Theory, pp. 92ff.; Weise, 'Maniera und Pellegrino'; Baxandall, Giotto and the Orators.

⁴⁰ For the nuances in Vasari's attitude to Venice in general and Titian in particular, see Dolce, *Aretino*, pp. 45ff., and Rosand, *Painting in Cinquecento Venice*, pp. 20–1. On *disegno* in Michelangelo, see Summers, *Michelangelo*, pp. 250ff.

writing in the high style because an author should not show too much knowledge of the techniques of people of low status such as craftsmen. It was a breach of decorum to use new words because 'new men' were not acceptable socially. The poet Vida makes the analogy explicit: 'But yet admit no words into the song / Unless they prove the stock from whence they sprung.' Bembo's discussions of literary vocabulary suggest that he was preoccupied with the question of what was known in Britain in the 1960s as 'U' and 'non-U'. His preoccupation was brilliantly parodied by Aretino (a writer who did not come from the upper classes) in his story of the courtesan who declared that a window should be called *balcone*, never *finestra*; a door, *porta* rather than *uscio*; and a face, *viso* not *faccia*.⁴²

According to contemporary theorists, different styles of building or music were appropriate for different social groups. Filarete, for example, declared that he could design houses for 'each class of persons' (ciascheduno facultà di persone) which differed not only in size but in style. Nicolò Vicentino distinguished two kinds of ancient music, one public, for 'ordinary ears' (vulgari orecchie), the other private, for ears which were 'cultivated' (purgate). In literature, the hierarchy of styles – high, middle and low – was associated with different social groups. Aristotle had said in his Poetics that tragedy dealt with good men, comedy with ordinary ones, but in the Renaissance he was believed to be referring to noblemen and commoners. Literature in the high style was literature for and about the elite.

It is difficult enough to assess the effect of social background on artistic and literary taste even in our own day, let alone the fifteenth and sixteenth centuries. It would be unwise to make any very general or unqualified assertions. We certainly have to take account of the fact that humanists and nobles participated in what we call 'popular' culture. ⁴⁴ Poliziano declared his enjoyment of folksongs, Lorenzo de'Medici wrote songs for Carnival, while the Neapolitan humanist Giovanni Pontano stood in the piazza to listen to a singer of tales (*cantastorie*). ⁴⁵ Ariosto also took pleasure in the romances of chivalry sung by the *cantastorie*, and his *Orlando Furioso* draws on this popular tradition. Conversely, the *Orlando Furioso* made its way into Italian popular culture via chapbook versions of particular cantos. ⁴⁶

⁴² Aretino, Sei giornate, p. 82.

⁴³ Filarete, *Treatise on Architecture*, bks 11-12; Vicentino, quoted in Einstein, *Italian Madrigal*, vol. 1, p. 228.

⁴⁴ Burke, Popular Culture, pp. 8, 51-4.

⁴⁵ Cocchiara, Origini della poesia popolare, pp. 29ff.

⁴⁶ Guerri, Corrente popolare; Bronzini, Tradizione di stile aedico; Burke, 'Learned culture and popular culture' and 'Oral culture and print culture'.

All this has to be borne in mind, but it does not imply that literary tastes did not vary according to the social group of readers or listeners. Ariosto did not simply imitate the *cantastorie*; he adapted traditional romances to his own milieu, the court of Ferrara. He writes, for example, with an irony not to be found in the texts of his predecessors. He was aware of the classical epic, though he refused to take Bembo's advice and write in the Virgilian manner. Again, the chapbooks did not simply reproduce cantos of Ariosto; they made changes, most obviously in the direction of greater simplicity. It is reasonable to assume that all these singers, writers and publishers knew what their different audiences wanted. There is evidence from the inventories of libraries (such as those of the brothers da Maiano, already discussed) that Boccaccio's Decameron, with its 'low' style, was popular among merchants and their wives, especially in Tuscany, while Dante, despite Bembo's criticisms, was also widely read in this milieu. Petrarch's love lyrics, on the other hand, were read all over Italy, but by young men and young ladies of noble family.⁴⁷

The last division of opinion to discuss here is the most central to this study, because it concerns the Renaissance itself. It is obvious enough that the Renaissance was a minority movement because the majority of the Italian population of the period comprised peasants who would have had little opportunity to learn about these cultural innovations, even had they wished to do so. However, the minority with the leisure and the skills necessary for involvement in the movement was not all of one mind about it. To revive a useful term from the Oxford of the sixteenth century, there were 'Trojans' as well as 'Greeks' in Renaissance Italy. More exactly, there was distaste for, or, rather, strong disapproval of, aspects of the innovations of the period on two grounds in particular.

The more common argument put forward in this period against much art and literature was that they were temptations to immorality. San Bernardino of Siena was one of those who denounced the *Decameron*, long before it was ordered to be expurgated. Pope Eugenius IV condemned Panormita's poem *The Hermaphrodite*, which was burned in public in Bologna, Ferrara and Milan in 1431. Savonarola denounced painters who 'show the Virgin Mary dressed as a whore'. According to Vasari, the painter Baccio della Porta, better known as Fra Bartolommeo, was persuaded by Savonarola's sermons that 'it was not good to keep paintings of male and female nudes in the house, where there were children', and put them on the bonfire during the famous 'burning of vanities' in Florence in 1497.⁴⁸ The fig-leaves painted onto the figures in Michelangelo's *Last Judgement* have been mentioned already. The

⁴⁷ Graf, Attraversa il '500; Bec, Marchands écrivains.

⁴⁸ Steinberg, Fra Girolamo Savonarola.

Trojans must not be forgotten; but the number of surviving Renaissance nudes suggests that – till about 1550 at least – they were fighting a losing battle. The history of reactions to literature is a similar one. The year 1559 marked a turning point, with Pope Paul IV's condemnation, on moral grounds, of a number of famous books, such as the jests of Poggio Bracciolini, the stories of Masuccio Salernitano, the poems of Luigi Pulci and Francesco Berni, and the complete works of Aretino.

The second objection to the arts was that they were idolatrous because they so often dealt with the pagan gods. When Pope Adrian VI, a Netherlander of severe tastes, was shown the famous classical statue of Laocoön, installed in the Vatican by one of his predecessors, he is said to have remarked drily, 'Those are the idols of the ancients.' However, the number of paintings and poems from this period concerned with pagan mythology do not authorize the conclusion (drawn by some northerners, Erasmus no less than Adrian VI) that Italians were pagan. The myths were widely believed to have an allegorical meaning (a famous defence of mythology on these grounds was the humanist Coluccio Salutati's treatise *The Labours of Hercules*). What kind of meaning, and what kind of people believed it, are topics for discussion in the next chapter.

ICONOGRAPHY

Invenzione means devising poems and histories by oneself, a virtue practised by few modern painters, and it is something I regard as extremely ingenious and praiseworthy.

Pino, Dialoghi di pittura, p. 44

Conography is the study of the meaning of images, of the content of what some Renaissance Italians called 'inventions' or 'stories' (invenzioni, istorie). The iconographical – or iconological – method involves the attempt to 'read' images as if they were texts (often by juxtaposing them to texts) and to distinguish different levels of meaning. Developed in the early twentieth century by Emile Mâle, Aby Warburg, Erwin Panofsky and others in reaction against a purely formal approach to the history of art, iconography has in turn provoked criticism, or iconoclasm, on the grounds that it privileges what has been called the 'discursive' aspect of the image – in other words, those features which show the influence of language – at the expense of the 'figurative' aspects – which do not. Even if its importance is a matter for debate, this approach to the art of the Renaissance remains a necessary one.¹

For a social history of art, the question of the relative popularity of different images is an important one, but it is less easy to answer than it may look. There is not, for instance, any complete catalogue of the Italian paintings of the Renaissance, so it is necessary to study a sample instead. What does exist is a catalogue of dated paintings, with 2,229 examples from Italy for the 120 years 1420–1539. In 2,033 cases, the subject is described. Of these 1,796 (about 87 per cent) may be described as religious and 237 (about 13 per cent) as secular. Of the secular works, about 67 per cent are portraits. Of the religious paintings, about half represent the Virgin Mary and about a quarter show Christ, while nearly 23

¹ For the debate, see Panofsky, *Meaning in the Visual Arts*, ch. 1; Gilbert, 'On subject and not-subject'; Gombrich, *Symbolic Images*, pp. 1–25; Settis, 'Iconography of Italian art'; Hope, 'Artists, patrons and advisers'; and Bryson, *Word and Image*, ch. 1.

per cent are concerned with the saints (leaving a few paintings of God the Father, the Trinity, or scenes from the Old Testament).² The importance of images of the Virgin is confirmed by a list of recorded visions of her in Italy in the two centuries between 1336 and 1536: thirty-one in total.³

Is this sample a reliable one? There are two problems here. Surviving pictures and dated pictures may not be representative of the whole group. Since works commissioned by the Church, which never dies, have a better chance of preservation than those commissioned for individual collections, it may well be that the figure of 13 per cent for secular paintings is something of an underestimate. It should be taken as a minimum. Dated pictures may also be a biased sample, more especially because the number of dated paintings increased steadily from a mere thirty-one in the 1420s to 441 in the decade 1510–19. Here, as elsewhere, there is a danger of making generalizations about the Renaissance as a whole on the basis of evidence from the later part of the period. If one is conscious of the danger, however, the statistics have their uses. It remains to try to draw out their significance.

It may surprise a modern reader to learn that, in a Christian culture, pictures of Christ were only half as frequent as those of his mother and scarcely more frequent than images of the saints. It should be added that he had been much less important in the thirteenth century – in France at least – and also that he was represented more frequently in the second half of the period than in the first. From this point of view at least the Reformation, Catholic and Protestant, was more of a culmination of late medieval trends than a reaction against them.⁴ Pictures of Christ generally represent his birth or his passion, death and resurrection, but rarely anything in between. The obvious explanation for this pattern is a liturgical one: Christmas and Easter were and are the major events of the ecclesiastical year. Again, the Adoration of the Kings is a scene separate from the Nativity because it has its own feast, that of the Epiphany.

A bewildering variety of saints occurs in Italian paintings of this period. What modern art historians (or, for that matter, what Renaissance clerics) could confidently identify the attributes of (say) saints Eusuperio, Euplo, Quirico or Secondiano? Yet each of these saints had a church dedicated to him in Pavia. Which saints were the most popular? Exactly

⁴ The evidence may be summarized in the following table (the figures are percentages):

	Mary	Christ	Saints
1420-79	52	18	30
1480-1539	53	26	20

On thirteenth-century France, Mâle, L'art religieux du 13e siècle.

² Errera, Répertoire des peintures datées.

³ Niccoli, Vedere con gli occhi del cuore, p. 116.

a hundred saints occur in our sample. St John the Baptist (who occurs 51 times) tops the list. Then comes St Sebastian (34); St Francis (30); St Catherine of Alexandria (22); St Jerome (22); St Anthony of Padua (21); St Roche (19); St Peter (18); and St Bernardino of Siena (17). St Bernard and St Michael (with 15 paintings each) tie for tenth place.

The exact numbers should not be taken too seriously, but the relative position of the saints tells us something important about Italian culture. It may be worth juxtaposing this list of preferences with those revealed by the choice of children's names. In the group of six hundred selected for special attention in this study, the most popular Christian names were Giovanni, Antonio, Francesco, Andrea, Bartolommeo, Bernardo and Girolamo. To account for the pattern it would be necessary to write a monograph, or a whole shelf of monographs; here it is possible only to hazard a few hypotheses. The low position of St Peter, compared to his place in the formal Church hierarchy, deserves comment. One explanation might be the relative unimportance of Rome, and the weakness of the papacy, until the later fifteenth century. All the same, the split revealed here between official and unofficial religion is a remarkable one.

At the top, the position of St John the Baptist is only to be expected, given the two facts of his importance in the official hierarchy - as the precursor of Christ and as the patron of the city of Florence - and in particular of the great Calimala guild. St Sebastian, in the second place, and St Roche (San Rocco), in the seventh, owe their positions to their role as protectors against the plague. Rocco was a fourteenth-century Frenchman who went to Italy and ministered to plague victims. He was particularly popular in the Veneto, especially after the translation of his relics to Venice in 1485. Yet he was never formally canonized. In the late sixteenth century, Pope Sixtus V intended either to canonize him or to delete him, but died before the ambiguity was resolved. His cult was essentially unofficial.⁵ As for Sebastian, it seems to be the story of his martyrdom at the hands of archers which explains the belief in his protection against the 'arrows' of plague, as represented by Benozzo Gozzoli, for example, in a fresco in a church at San Gimignano, commemorating the plague of 1464.

The popularity of St Francis poses no problems: he was an Italian saint and he had the support of the religious order he had founded. His cult was strongest in his native Umbria and in Tuscany, but many important towns in other parts of Italy had churches dedicated to him. St Anthony of Padua might be regarded as a St Francis for the Veneto; he too was a Franciscan, who came from Portugal but preached in Padua, where he died in 1231. St Bernardino was another preacher and

⁵ Burke, Historical Anthropology, ch. 5.

another Franciscan. (It is worth noting that the rival order of friars, the Dominicans, produced no saint to rival the popularity of these three Franciscans.) St Jerome, like St Anthony, was particularly popular in the Veneto, in which he was born (near Aquileia). He was represented in two different ways, which suggests that he had two different 'images' and appealed to two kinds of people. Either he was a penitent in the desert, knocking his breast with a stone, the patron of hermits, or he was a scholar sitting in his study, making his translation of the Bible, an appropriate patron for humanists.⁶

The cult of St Catherine of Alexandria, who far outshone St Catherine of Siena, is to be explained by her patronage of young girls. Her 'mystic marriage' to Christ made her an appropriate subject for paintings given as wedding presents. If one female saint out of eleven seems surprisingly little, the reason may well be that the others were eclipsed by the Virgin Mary in her many forms, such as the Mother of Mercy (with supplicants sheltering under her cloak), the Virgin of the Rosary or the Virgin of Loreto (the Italian town to which the 'holy house' from Bethlehem was said to have been miraculously transported).

Since so much has been written about secular values in Renaissance Italy, the fact that the overwhelming majority of dated paintings are religious deserves emphasis. These images of the Virgin, Christ and the saints, doubtless commissioned for pious reasons, give us a glimpse of the culture of the silent majority. All the same, there is evidence of increasing interest in secular paintings in this period, and particularly in circles involved with the Renaissance as a movement. Federico Gonzaga, commissioning a work from Sebastiano del Piombo, wrote in 1524 that he did not want 'saints stuff' (cose di sancti), but 'some pictures that are attractive and beautiful to look at'. He seems to have been part of a trend.

As we have seen, most secular paintings were portraits. Before the middle of the fifteenth century they were relatively rare; only saints had their images painted. This is what gives its point to the opening lines of a poem by the Venetian patrician Leonardo Giustinian. The speaker tells his beloved that he has made a painting of her on a little sheet of paper as if she were one of the saints: io t'ho dipinta in su una carticella / Come se fussi una santa di Dio. Later on, it became customary to paint famous men, ancient or modern (the moderns including poets, soldiers and lawyers). The next stage, logically if not chronologically (one cannot be certain of the dates), was the painting of rulers in their own lifetime.

⁶ Rice, St Jerome.

⁷ According to the sample in Errera, *Répertoire des peintures datées*, the proportion of secular paintings rose from 5 per cent in the 1480s to 22 per cent in the 1530s.

Then came the portraits of patricians and their wives and daughters, and finally those of merchants and craftsmen, as we have seen (above, p. 99). By the end of the period, Aretino, himself a craftsman's son who was painted by Titian, was denouncing the democratization of the portrait in his own day, writing: 'it is the disgrace of our age that it tolerates the painted portraits even of tailors and butchers.' To distinguish themselves from others, nobles now had to surround themselves with objects symbolizing their status, from velvet curtains and classical columns to servants and hunting dogs.⁸

It is, however, with the iconography of narrative pictures that art historians have been most concerned, whether these *istorie* represent scenes from classical mythology, episodes from history, ancient or modern, or something more difficult to pin down. The scenes from classical mythology include some of the best-known paintings of the Renaissance. They frequently keep close to that favourite classical – and Renaissance – compendium of mythology, Ovid's *Metamorphoses*. Titian's famous *Bacchus and Ariadne*, for example, illustrates book 8, while the painting of the enchantress Circe by Dosso Dossi of Ferrara illustrates book 14. Others follow the descriptions of lost mythological paintings by the classical writer Philostratus of Lemnos. A number of paintings by Piero di Cosimo representing Bacchus, Vulcan and other mythological figures illustrate not only Ovid but also the account of the early history of mankind in the poem *On the Nature of Things* by the Roman poet Lucretius.⁹

How important the exact subject matter was to contemporary viewers is very difficult to say. Was a St Sebastian or a Venus chosen primarily for its own sake or as a pretext for representing a beautiful naked figure? How can a modern historian possibly answer such a question? It would certainly be a mistake to answer with confidence, but to avoid anachronistic interpretations we can at least investigate the ways in which paintings were described at the time. It is, for example, interesting to know that Titian called his mythological scenes 'poems' (poesie), even if we do not know exactly what he meant by the term – whether he was referring to the fact that he drew on Ovid's poem the *Metamorphoses* or whether he intended to imply that he was following his own imagination rather than a text.

Some of the most intriguing literary evidence concerns what we call 'landscape' because it suggests an increasing awareness of the backgrounds of paintings, and even a shift towards considering these

⁸ Bottari, *Raccolta di lettere sulla pittura*, vol. 3, p. 1360. Cf. Castelnuovo, 'Il significato del ritratto pittorico'; Burke, *Historical Anthropology*, ch. 11; Burke, 'The Renaissance, individualism and the portrait'.

⁹ Panofsky, Studies in Iconology, pp. 33-67.

features the true subject. Giovanni Tornabuoni asked Ghirlandaio in the 1480s, as we have seen, for 'cities, mountains, hills, plains, rocks' in a commission to paint stories from the life of the Virgin Mary. In the correspondence of Isabella d'Este and her husband Gianfrancesco Gonzaga, there are references to 'views' (vedute), and in one case to 'a night' (una nocte). The latter may have been a Nativity, but to describe a religious painting in this way would itself be significant. In 1521 an anonymous Venetian observer (often identified with the patrician Marcantonio Michiel) recorded the existence of 'many little landscapes' (molte tavolette de paesi) in the collection of cardinal Grimani. 10 Again, the humanist bishop Paolo Giovio described some of Dosso Dossi's paintings, in the 1520s, as 'oddments' (parerga), consisting of 'sharp crags, thick groves, dark shores or rivers, flourishing rural affairs, the busy and happy activities of farmers, the broadest expanses of the land and sea as well, fleets, markets, hunts and all that sort of spectacle'. 11 In other words, what we call 'the rise of landscape' in this period seems to correspond to changes in the way in which contemporaries looked at pictures.12

What has been discussed so far is the more or less manifest content of Renaissance paintings. However, it is clear that some of them at least, like literary works, were intended to contain hidden meanings. How often this was the case, what the meanings were and how many contemporaries understood them are questions which require discussion, but they are rather more obscure.

It is advisable to begin this discussion with literature, where the hidden is sometimes at least made explicit in commentaries. Contemporaries were used to looking for hidden meanings in literature, if only because they were told from the pulpit that the Bible had four different interpretations, not only the literal but also the allegorical, the moral and the anagogical. Some humanists looked for hidden meanings in worldly literature as well, even if they did not always distinguish the allegorical, the moral, and so on, as carefully as theologians did. In the fourteenth century, Petrarch, Boccaccio and Coluccio Salutati all interpreted classical myths as a 'poetic theology'. In the fifteenth century, Cristoforo Landino wrote that, when poetry 'most appears to be narrating something most humble and ignoble or to be singing a little fable to delight idle ears, at that very time it is writing in a rather secret way the most

¹⁰ Williamson, Anonimo.

¹¹ Quoted in Gilbert, 'On subject and not-subject', p. 204.

¹² Gombrich, Norm and Form, pp. 107-21; Turner, Vision of Landscape.

¹³ Caplan, 'Four senses'; Auerbach, 'Figura'.

¹⁴ Trinkaus, In our Image, pp. 689-721.

excellent things of all, which are drawn forth from the fountain of the gods.'¹⁵ Commentaries expounded the hidden meanings (usually religious or philosophical) underlying the apparently secular or even frivolous surface of classical writers such as Virgil and Ovid or modern ones such as Petrarch and Ariosto.

Ovid is a useful example to discuss at this point, because his *Metamorphoses* inspired artists as well as poets of the Renaissance. From the twelfth century onwards, it became customary to 'moralize' him – in other words, to give the poem an allegorical interpretation. The allegorizations of Ovid by Giovanni da Bonsignore in the fourteenth century were printed in some Renaissance editions of the *Metamorphoses*, so that the reader could learn, for instance, that Daphne (who, fleeing from Apollo, turned into a laurel tree) stands for prudence while the laurel stands for virginity. The question how commonly these myths were given this kind of interpretation in the period remains problematic.

Ariosto was treated in a similar way by the all-purpose writer Lodovico Dolce, who produced an edition of *Orlando Furioso* in 1542 in which the flight of Angelica in the first canto is interpreted in terms of 'the ingratitude of women', while Ruggiero's combat with Bradamante in the forty-fifth canto reveals 'the qualities of a perfect knight'. These interpretations are described as 'allegories', but in modern terms they might be better described as symbols. Whereas Bonsignore treated Ovid's characters as personifications of abstract qualities, Dolce simply generalizes about human nature from the actions of Angelica and Ruggiero.

One is left with the impression of a whole spectrum of hidden meanings, whether intended by authors or read into them by commentators – meanings which seem to have had considerable appeal to readers of the period. (Dolce, for example, would not have written anything if he had not thought it would sell.) This impression is worth bearing in mind when we turn to painting. Paintings of scenes from the Old Testament are likely to have been read by some people at least as the text was read, with an eye on what was to come – in other words, characters from the Old Testament were seen as 'types' or 'figures' of the New. Eve and Judith were both taken to prefigure the Virgin Mary. (Judith liberated Israel by cutting off the head of the Assyrian captain Holofernes; Mary liberated mankind by giving birth to Christ.)

New Testament scenes, by contrast, were painted for their own sake, but they may have been given a more subtle theological meaning on occasion, at least as an extra. At all events, it is interesting to find a friar, Pietro da Novellara, writing to Isabella d'Este about a sketch by

¹⁵ Landino's commentary on Horace's Art of Poetry, quoted in Weinberg, History of Literary Criticism, p. 80.

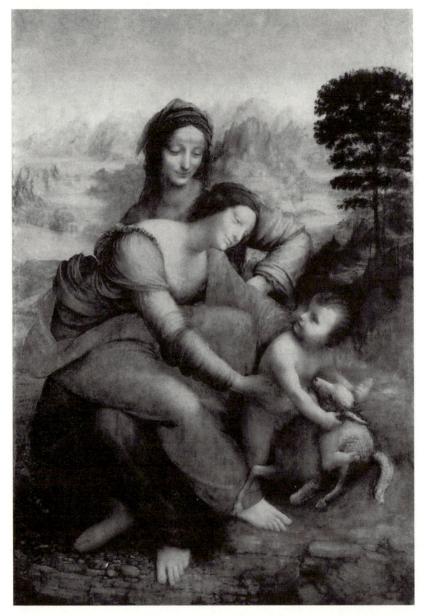

Plate 7.1 Leonardo da Vinci: The Virgin, Child and Saint Anne

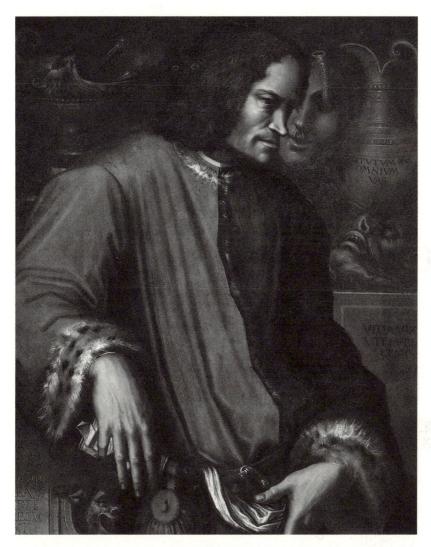

Plate 7.2 Giorgio Vasari: Portrait of Lorenzo de'Medici

Leonardo (Plate 7.1), offering the following theological interpretation, at least hypothetically (note the 'may be'):

A cartoon of a child Christ, about a year old, almost jumping out of his mother's arms to seize hold of a lamb. The mother is in the act of rising from St Anne's lap, and holds back the child from the lamb, an innocent creature which is a symbol of the Passion [significa la passion], while St

Anne, partly rising from her seat, seems anxious to restrain her daughter, which may be a type of the Church [forsi vole figurare la Chiesa], who would not hinder the Passion of Christ. 16

At this point it may finally be more or less safe to turn to the vexed question of the secular paintings of the Renaissance and their possible moral or allegorical meanings. At the end of the period, the evidence is sometimes extremely rich and precise – in the case of Vasari, for example, who explained his intentions in considerable detail. His portrait of the late Lorenzo de'Medici (Plate 7.2), he wrote, would depict in the background a vase, a lamp and other objects, 'showing that the magnificent Lorenzo, by his remarkable method of government . . . enlightened his descendants, and this magnificent city'. 17

The programmes devised by sixteenth-century humanists such as Paolo Giovio, Vincenzo Borghini and Annibale Caro (above, pp. 116) are similarly detailed. More of a problem is posed by paintings of the fifteenth century, notably Botticelli's, which have long been a subject of scholarly debate. His so-called *Primavera*, for example, illustrates a scene from another poem of Ovid's, the Fasti, dealing with the nymph Flora and the month of May, but there is a good deal in the painting which the text does not explain. Humanists sometimes interpret the classical gods, as we have seen, as symbols of moral or physical qualities. Marsilio Ficino wrote on one occasion that 'Mars stands for speed, Saturn for tardiness, Sol for God, Jupiter for the law, Mercury for reason, and Venus for humanity [humanitas].' As he was writing to the youth who commissioned the *Primavera*, it has been suggested that 'humanity' is what Venus represents in the picture.¹⁸ Again, Botticelli's Pallas and the Centaur may be given a moral interpretation, with Pallas Athene (or, as the Romans called her, Minerva) standing for wisdom and the tamed centaur for the passions. 19 In most cases we can do no more than conjecture what the hidden moral meaning may have been. Contemporaries (apart from the artist, the client and their intimates) will have had a similar problem. The important point is to remember that many contemporaries approached paintings with expectations of meanings of this

Hidden political meanings also figured on the contemporary 'horizon

¹⁶ Cartwright, Isabella d'Este, vol. 1, p. 319; Chambers, Patrons and Artists, no. 86.

¹⁷ Vasari, Literarische Nachlass, pp. 17ff.

¹⁸ Gombrich, *Symbolic Images*, pp. 31-81; cf. Dempsey, 'Mercurius Ver' and *Portrayal of Love*.

¹⁹ Ettlinger and Ettlinger, *Botticelli*, pp. 130ff.; cf. Kemp, *Behind the Picture*, pp. 20–5.

of expectations', though they are even more difficult to decode, since topicality stales so rapidly. Could Botticelli's Pallas, for example, whose gown is adorned with the Medici device of interlaced diamond rings, stand for Lorenzo the Magnificent and the Centaur for his enemies?²⁰

To be sure not to project on to paintings and statues meanings which the artists and their clients did not have in mind, it is prudent to start with literature, and with explicit discussions of implicit political meanings. The preface to the 1542 edition of Ariosto's *Orlando Furioso*, written by the publisher, Gabriel Giolito, suggests that the poem has a political message, contrasting 'the prudence and justice of an excellent prince' with 'the rashness and the negligence of an unwise king'. Did contemporaries really read this poem as if it were putting forward a political theory, as if Ariosto were another Machiavelli? Conversely, Machiavelli on occasion – in the seventeenth chapter of *The Prince* – quoted Virgil as an authority on politics, using Dido's apology to Aeneas for her initial suspicions as evidence that a new prince has to be harsher than one who is well established.

When reading the literature of this period it is always worth entertaining the possibility, as contemporaries seem to have done, that the events narrated, whether real or imaginary, recent or remote, refer to or stand for incidents of the writer's own day. Take for instance one of the Florentine religious plays of the period, *Santi Giovanni e Paolo*. Its particular interest in this context is that it was written by a ruler, Lorenzo the Magnificent. It is in fact much concerned with the political problems of the emperor Constantine. The rebellion of Dacia and its suppression by order of the emperor Constantine is reminiscent of the rebellion of the city of Volterra against Lorenzo and the suppression of that revolt by Federigo da Montefeltro. In the play, Constantine is made to emphasize the fact that he did everything for the common good. It looks as if Lorenzo was writing propaganda for himself.²¹

Paintings and statues may also carry political meanings. The figures represented may be allegories in the sense that the apparent subject stands for someone else. Decoding these allegories is necessarily speculative, and interpretations are bound to be controversial, but the attempt at interpretation is not anachronistic. In this period, as in the Middle Ages, it was not uncommon to refer to living individuals as a 'new' or 'second' Caesar, Augustus, Charlemagne, and so on. For instance, the great preacher Fra Girolamo Savonarola called Charles VIII of France the 'new

²⁰ On Medici symbolism in art, Cox-Rearick, *Dynasty and Destiny*. A cautionary note was sounded in some reviews of this monograph.

²¹ D'Ancona, Sacre rappresentazioni, esp. p. 257.

Cyrus' after the famous king of Persia, and also the 'new Charlemagne'.²² The comparisons are a kind of secular parallel to the Old Testament prefigurations of the New, discussed earlier in this chapter. It is therefore not implausible to suggest, for example, that certain statues of David stand for Florence, or that Piero della Francesca's paintings of the emperor Constantine refer to the Byzantine emperor John VII Palaeologus, who had visited Italy to enlist help in the defence of his capital, Constantinople (a city which had been founded by Constantine), against the Turks.²³

A particularly elaborate political allegory can be seen in Raphael's frescoes in the Vatican for Julius II and Leo X.24 The Expulsion of Heliodorus has already been discussed. Another fresco deals with the Repulse of Attila. Italians of the period, including Julius himself, often called the foreigners who invaded Italy after 1494 the 'barbarians'; this fresco elaborates the parallel between the two waves of barbarian invaders. Raphael went on to paint frescoes of Pope Leo III crowning Charlemagne as emperor in St Peter's and Leo IV thanking God for a Christian victory over the Saracens. To reinforce the parallel with his own day, Raphael has given the two popes the features of their namesake Leo X.²⁵ It would be a mistake to reduce these frescoes to a commentary on current events; even the political point they were making, as with Botticelli's Punishment of Korah (above, p. 138), was essentially a more general one – a pictorial legitimation of papal authority. All the same, the topical references and, still more important, the habit of using topical references and historical parallels to legitimate political claims are worth bearing in mind. The relation between art and power, between systems of meaning and systems of domination, is at its most transparent in instances such as these.

If the political messages and the historical parallel inscribed in these frescoes do not strike us with enough force today, one reason is that most of us are not sufficiently familiar with early medieval papal history, with Maccabees, or even with Numbers. Were contemporaries much better off? Who in this period was able to decode the iconography and read the message of the works we have been considering?

We know all too little about contemporary readings and responses, but the range of variation between them is clear enough. Raphael could afford to be allusive; the Vatican was not open to the public, and his paintings were for the eyes of members of the papal court. It is no coincidence that some of the paintings which have given art historians most

²² Weinstein, Savonarola and Florence, p. 145.

²³ Ginzburg, Enigma of Piero, ch. 2.

²⁴ Harprath, Papst Paul III

²⁵ Jones and Penny, Raphael, pp. 117ff., 150ff.; cf. Harprath, Papst Paul III.

trouble since they began to try to unravel their meanings, from Botticelli's *Primavera* to Giorgione's *Tempestà*, were made to hang in private houses and to be enjoyed by the patrons and their friends.²⁶ Posterity looks at them through the keyhole. Even well-informed contemporaries might fail to read them. Vasari complained in his life of Giorgione that he could not understand some of his pictures – 'nor have I, by asking around as I have done, ever found anyone who does'.

Most secular paintings were probably intelligible to a larger minority. Scenes from Greek and Roman history would not have been difficult to identify for anyone who had been to a grammar school. Ovid was also studied at grammar schools, and would have provided a key to most scenes from classical mythology. It is likely that the number of people able to understand these paintings rose in the fifteenth and sixteenth centuries, as humanist education spread. As for religious paintings, despite the difficulty of interpreting them today now that the legends of the saints are no longer part of the common culture, it is likely that they were generally easy to decode for anyone who heard sermons regularly or watched performances of religious plays – in other words, the majority of the urban population.

The attempt to discover which works of art and literature would have been intelligible to which groups, and the habits of mind with which they were interpreted, leads on to a wider question, that of the worldviews of Renaissance Italians. It will be investigated in the next chapter.

²⁶ Shearman, 'Collections of the younger branch of the Medici'; Smith, 'On the original location'. Settis, *Giorgione's Tempest*.

Part III

THE WIDER SOCIETY

Worldviews: Some Dominant Traits

A social group, large or small, tends to share certain attitudes – views of God and the cosmos, of nature and human nature, of life and death, space and time, the good and the beautiful. These attitudes may be conscious or unconscious. In a period of controversy people may be extremely conscious of their attitudes to religion or the state, while remaining virtually unaware that they hold a particular conception of space or time, reason or necessity.

It is not easy to write the history of these attitudes. Historians have stalked their quarry from different directions. One group, the Marxists, have concerned themselves with 'ideologies'. Aware of the need to explain as well as to describe ideas, they have sometimes ended by reducing them to weapons in the class struggle.¹ Another group, the French historians of 'collective mentalities', study assumptions and feelings as well as conscious thoughts, but find it difficult to decide where one mentality ends and another begins.² In this chapter I shall employ the somewhat more neutral term of 'worldview', while attempting to include what Raymond Williams calls 'structures of feeling' and to avoid the risk inherent in this third approach of providing description without analysis, or remaining at the level of consciously formulated opinions.³

In this chapter an attempt is made to move from the immediate environment of the art and literature of the Renaissance to the study of the surrounding society. The assumption behind it is that the relation between art and society is not direct but mediated through worldviews. More precisely, there are two assumptions behind the chapter, two

¹ Famous examples that avoid reductionism include Borkenau, *Übergang*, and Mannheim, *Essays*.

² Burke, 'Strengths and weaknesses'. Gilbert, 'Florentine political assumptions', is close to the French style.

³ Williams, Long Revolution, pp. 64–88. The original models for this chapter were Tillyard, Elizabethan World Picture, and Lewis, Discarded Image, modified so as to allow analysis of the kind practised by historians of mentalities and ideologies. Cf. O'Kelly, Renaissance Image of Man.

hypotheses which need to be tested: in the first place, that worldviews exist – in other words, that particular attitudes are associated with particular times, places and social groups, so that it is not misleading to refer, for example, to 'Renaissance attitudes', 'Florentine attitudes' or 'clerical attitudes'; in the second place, that these worldviews find their most elaborate expression in art and literature.

These hypotheses are not easy to verify. The sources, which are predominantly literary, are richer for the sixteenth century than for the fifteenth, much richer for Tuscany than for other regions, and in the overwhelming majority of cases the views they express are those of males of what we would call the upper or upper-middle class (the social structure of the period will be discussed in chapter 9 below). As in the case of the study of aesthetic taste, it pays to look not only at relatively formal literary works but also at documents produced in the course of daily life, such as official reports and private letters. To uncover unconscious attitudes the historian has to attempt to read between the lines, using changes in the frequency of certain keywords as evidence of a shift in values.⁴

This account will begin with a summary of some typical views of the cosmos, society, and human nature (needless to say, it will be extremely selective). It will end with an attempt to examine general features of the belief system and signs of change. The quotations will usually come from well-known writers of the period, but the passages have been chosen to illustrate attitudes they shared with their contemporaries.

VIEWS OF THE COSMOS

Views of time and space are particularly revealing of the dominant attitudes of a particular culture, precisely because they are rarely conscious and because they are expressed in practice more often than in texts. In his famous study of the religion of Rabelais, the French historian Lucien Febvre emphasized the vague, task-orientated conceptions of time and space in sixteenth-century France, such as the habit of counting in 'Aves' – in other words, the amount of time it takes to say a 'Hail Mary'. Febvre made the French appear, in these respects at least, almost as exotic as the Nuer of the Sudan, whose attitudes to space and time were described at much the same time in an equally classic work by the British anthropologist E. E. Evans-Pritchard.⁵

⁴ A pioneer in the study of what he called 'fashion words' (*Modewörter*) was Weise ('*Maniera* und Pellegrino' and *L'ideale eroico del Rinascimento*). Cf. Williams, *Keywords*.

⁵ Febvre, *Problem of Unbelief*; Evans-Pritchard, *Nuer*, ch. 3. The studies were independent, but both men owed a considerable debt to the ideas of Emile Durkheim.

Whatever may have been the assumptions of the Italian peasants of this period, the evidence from the towns suggests that much more precise attitudes to time were widespread, like the mechanical clocks which both expressed and encouraged these new attitudes. From the late fourteenth century, mechanical clocks came into use; a famous one was constructed at Padua to the design of Giovanni Dondi, a physician–astronomer who was a friend of Petrarch, and completed in 1364. About 1450, a clock was made for the town hall at Bologna; in 1478, one for the Castello Sforzesco in Milan; in 1499, one for Piazza San Marco in Venice; and so on. By the late fifteenth century, portable clocks were coming in. In Filarete's utopia, the schools for boys and girls had an alarm clock (*svegliatoio*) in each dormitory. This idea at least was not purely utopian, for in Milan in 1463 the astrologer Giacomo da Piacenza had an alarm clock by his bed.⁶

There is an obvious parallel between the new conception of time and the new conception of space; both came to be seen as precisely measurable. Mechanical clocks and pictorial perspective were developed in the same culture, and Brunelleschi was interested in both. The paintings of Uccello and Piero della Francesca (who wrote a treatise on mathematics) are the creations of men interested in precise measurement working for a public with similar interests. Fifteenth-century narrative paintings are located in a more precise space and time than their medieval analogues.⁷

Changing views of time and space seem to have coexisted with a traditional view of the cosmos. This view, memorably expressed in Dante's *Divine Comedy*, was shared in essentials by his sixteenth-century commentators, who drew on the same classical tradition, especially the writings of two Greeks, the astronomer–geographer Ptolemy and the philosopher Aristotle. According to this tradition, the fundamental distinction was that between Heaven and Earth.

'Heaven' should really be in the plural. In the centre of the universe was the Earth, surrounded by seven 'spheres' or 'heavens', in each of which moved a planet: Moon, Mercury, Venus, Sun, Mars, Jupiter and Saturn. The planets were each moved by an 'intelligence', a celestial driver often equated with the appropriate classical god or goddess. This fusion of planets and deities had permitted the survival of the pagan gods into the Middle Ages.⁸

⁶ Cipolla, Clocks and Culture; Wendorff, Zeit und Kultur, pp. 151ff.; Landes, Revolution in Time, pp. 53ff.

⁷ On Piero and the gauging of barrels, Baxandall, *Painting and Experience*, pp. 86ff. On space–time in narrative painting, see Francastel, 'Valeurs socio-psychologiques de l'espace–temps'.

⁸ Seznec, Survival of the Pagan Gods.

The importance of the planets resided in their 'influences'. As they sang in a Carnival song by Lorenzo de'Medici, 'from us come all good and evil things'. Different professions, psychological types, parts of the body and even days of the week were influenced by different planets (Sunday by the Sun, Monday by the Moon, and so on). Vasari offered an astrological explanation of artistic creativity in his life of Leonardo. remarking that 'The greatest gifts may be seen raining on human bodies from celestial influences.' To explain the past or discover what the future has in store, it was normal to consult specialists who calculated the configuration of the heavens at a particular time. The humanist physician Girolamo Fracastoro gave an account of the outbreak of syphilis in Europe in terms of a conjunction of the planets Saturn, Jupiter and Mars in the sign of Cancer. The philosopher Marsilio Ficino believed that the 'spirit' of each planet could be captured by means of appropriate music or voices ('martial' voices for Mars, and so on) and by making an appropriate (talisman' (an image engraved on a precious stone under a favourable constellation).9

These beliefs had considerable 'influence' on the arts. Aby Warburg's iconographical analysis of frescoes in the Palazzo Schifanoia in Ferrara showed that they represented the signs of the zodiac and their divisions into 36 'decans'. The Florentine patrician Filippo Strozzi consulted 'a man learned in astrology', just as the treatises of Alberti and Filarete recommended, to ensure a good constellation before having the foundations of the Palazzo Strozzi laid on 6 August 1489. When a Florentine committee was discussing where to place Michelangelo's *David*, one speaker suggested that it should replace Donatello's *Judith*, which was 'erected under an evil star'. Raphael's patron, the papal banker Agostino Chigi, was interested in astrology, and some of the paintings he commissioned refer to his horoscope.

Astrology was permitted by the Church; it was not considered incompatible with Christianity. As Lorenzo de'Medici put it, 'Jupiter is a planet which moves only its own sphere, but there is a higher power which moves Jupiter.' The twelve signs of the zodiac were associated with the twelve apostles. A number of popes took an interest in the stars. Paul III, for example, summoned to Rome the astrologer who had predicted his election (Luca Gaurico, whose brother Pomponio's treatise on sculpture

⁹ Walker, Spiritual and Demonic Magic, p. 17.

Warburg, Renewal of Pagan Antiquity, pp. 563-92.

¹¹ Goldthwaite, Building of Renaissance Florence, pp. 84-5.

¹² Gaye, Carteggio inedito d'artisti, vol. 2, p. 456; Klein and Zerner, Italian Art, p. 41.

¹³ Saxl, Fede astrologica.

¹⁴ D'Ancona, Sacre rappresentazioni, p. 264.

has already been quoted) and gave him a bishopric. Yet there was a sense in which theology and astrology formed two systems which in practice competed with each other. The saints presided over certain days; so did the planets. People might take their problems to a priest or to an astrologer. It was largely on religious grounds that some leading figures of the period rejected astrology, notably Pico della Mirandola (who declared that 'astrology offers no help in discovering what a man should do and what avoid') and Fra Girolamo Savonarola.¹⁵

Above the seven heavens and beyond the sphere of the 'fixed stars', God was to be found. In the writing of the period, God was indeed almost everywhere. Even commercial documents might begin with the monogram YHS, standing for 'Jesus the Saviour of Mankind' (Jesus Hominum Salvator). When disaster struck, it was commonly interpreted as a sign of God's anger. 'It pleased God to chastise us' is how the Florentine apothecary Luca Landucci comments on the plague. When the French invasion of 1494 left Florence virtually unharmed, Landucci wrote that 'God never removed His hand from off our head.' The name of God constantly recurs in private letters, such as those of the Florentine lady Alessandra Macinghi degli Strozzi: 'Please God free everything from this plague ... it is necessary to accept with patience whatever God wants ... God give them a safe journey', and so on. Even Machiavelli ends a letter to his family 'Christ keep you all.'16 Of all the ways in which Christians have imagined God, two seem particularly characteristic of the period. The emphasis on the sweetness of God and the 'pathetic tenderness' of attitudes to Christ, which the great Dutch historian Johan Huizinga noted in France and the Netherlands in the fifteenth century, can be found in Italy as well.¹⁷ Savonarola, for example, addresses Christ with endearments such as 'my dear Lord' (signor mio caro), or even 'sweet spouse' (dolce sposo). Christocentric devotion seems to have been spread by the friars, not only the Dominican Savonarola but the Franciscans Bernardino da Siena, who encouraged the cult of the name of Jesus, and Bernardino da Feltre, who was responsible for the foundation of a number of fraternities dedicated to Corpus Christi, the body of Christ. The Meditations on the Passion attributed to the Franciscan saint Bonaventura was something of a best-seller in fifteenth-century Italy, with at least twenty-six editions, as was the Imitation of Christ, a devotional text from the fourteenth-century Netherlands, with nine editions. 18

¹⁵ Garin, Astrology in the Renaissance.

¹⁶ Strozzi, Lettere di una gentildonna fiorentina; Machiavelli, letter of 11 April 1527.

¹⁷ Huizinga, Autumn of the Middle Ages, ch. 14.

¹⁸ Schutte, 'Printing, piety and the people in Italy', pp. 18–19.

This image of a sweet and human Saviour coexisted with a more detached view of God as the creator of the universe, its 'most beautiful architect' (*bellissimo architetto*), as Lorenzo de'Medici once called him. ¹⁹ He was also imagined, in this trade-oriented urban society, as the head of the firm. Leonardo da Vinci addressed God as you who 'sell us every good thing for the price of labour'. Giannozzo Manetti, a Florentine merchant and scholar, liked to compare God to 'the master of a business who gives money to his treasurer and requires him to render an account as to how it may have been spent'. ²⁰ He transposed the Gospel parable of the talents from its original setting, that of a landlord and his steward, to a more commercial environment. Thus Renaissance Italians projected their own concerns on to the supernatural world.

The lower, 'sublunary' world on which man lived was believed to be composed of four elements – earth, water, air and fire – as illustrated in Vasari's Room of the Elements in the Palazzo Vecchio in Florence. The elements were themselves composed of the four 'contraries' – hot, cold, moist and dry.

There were also four levels of earthly existence – human, animal, vegetable and mineral. This is what has been called the 'great chain of being'. The 'ladder' of being might be a better term because it makes the underlying hierarchy more evident. Stones were at the bottom of the ladder because they lacked souls. Then came plants, which had what Aristotle called 'vegetative souls', animals, which had 'sensitive souls' (that is, the capacity to receive sensations) and, at the top, humans, with 'intellectual souls' (in other words, the power of understanding). Animals, vegetables and minerals were arranged in hierarchies; the precious stones were higher than the semi-precious ones, the lion was regarded as the king of beasts, and so on.

More difficult to place on the ladder are the nymphs who wander or flee through the poems of the period; or the wood spirits who lived in lonely places and would eat boys (as the grandmother of the poet Poliziano used to tell him when he was small); or the 'demons' who lived midway between the Earth and the Moon and could be contacted by magical means (Ficino was one of those who tried). The philosopher Pietro Pomponazzi doubted whether demons existed at all.²² It seems, however, that he was expressing a minority view. When reading the poems of the period or looking at Botticelli's *Primavera*, it is worth bear-

¹⁹ D'Ancona, Sacre rappresentazioni, p. 267.

²⁰ Vespasiano da Bisticci, Vite di uomini illustri, p. 375.

²¹ Lovejoy, Great Chain of Being.

²² On demons, Walker, Spiritual and Demonic Magic, pp. 45ff., and Clark, Thinking with Demons.

ing in mind that the supernatural figures represented in them were viewed as part of the population of the universe and not as mere figments of the artist's imagination.

The status of another earthly power is even more doubtful: Fortune.²³ Two common images of Fortune associated it, or rather her, with the winds and with a wheel. The wind image seems to be distinctively Italian. The phrase 'fortune of the sea' (*fortuna di mare*) meant a tempest, a vivid example of a change in affairs which is both sudden and uncontrollable. The Rucellai family, Florentine patricians, used the device of a sail, still to be seen on the façade of their church of Santa Maria Novella in Florence; here the wind represents fortune and the sail the power of the individual to adapt to circumstances and to manage them.²⁴

The second image of fortune was the well-known classical one of the goddess with a forelock which must be seized quickly, because she is bald behind. In the twenty-fifth chapter of his *Prince*, Machiavelli recommended impetuosity on the grounds that fortune is a woman, 'and to keep her under it is necessary to strike her and beat her' (*è necessario volendola tenere sotto*, *batterla e urtarla*), while his friend the historian Francesco Guicciardini suggested that it is dangerous to try to make conspiracies foolproof because 'Fortune, who plays such a large part in all matters, becomes angry with those who try to limit her dominion.' It is difficult for a modern reader to tell in these instances whether the goddess has been introduced simply to make more memorable conclusions arrived at by other means, or whether she has taken over the argument; whether she is a literary device, or a serious (or at any rate a half-serious) way of describing whatever lies outside human control.²⁵

To understand and manipulate the world of earth, several techniques were available, including alchemy, magic and witchcraft. Their intellectual presuppositions need to be discussed.

Alchemy depended on the idea that there is a hierarchy of metals, with gold as the noblest, and also that the 'social mobility' of metals is possible. It was related to astrology because each of the seven metals was associated with one of the planets gold with the Sun, silver with the Moon, mercury with Mercury, iron with Mars, lead with Saturn, tin with Jupiter, and copper with Venus. It was also related to medicine because the 'philosopher's stone' which the alchemists were looking for was also the cure for all illnesses, the 'universal panacea'.

Jacob Burckhardt believed that alchemy 'played only a very

²³ Doren, Fortuna; González García, Diosa fortuna.

²⁴ Gilbert, 'Bernardo Rucellai'.

²⁵ Guicciardini, *Maxims and Reflections*, no. 20. Pitkin, *Fortune is a Woman*, has devoted an entire monograph to Machiavelli's phrase.

subordinate part' in Italy in the fifteenth and sixteenth centuries.²⁶ It is dangerous to make general assertions about the popularity of such a deliberately esoteric subject as alchemy, but the odds are that he was wrong. The Venetian Council of Ten took it more seriously when they issued a decree against it in 1488. Several Italian treatises on the subject from the later part of our period have survived. The most famous is a Latin poem, Giovanni Augurello's Chrysopoeia, published in 1515 and dedicated to Leo X: there is a story that the pope rewarded the poet with an empty purse. A certain 'I. A. Pantheus', priest of Venice, also dedicated an alchemical work to Leo before inventing a new subject, 'cabala of metals', which he carefully distinguished from alchemy, perhaps because the Council of Ten were still hostile. On the other hand, some people treated the claims of the alchemists with scepticism. St Antonino, the fifteenth-century archbishop of Florence, held that the transmutation of metals was beyond human power, while the Sienese metallurgist Vannoccio Biringuccio suggested that it was 'a vain wish and fanciful dream' and that the adepts of alchemy, 'more inflamed than the very coals in their furnaces' with the desire to create gold, ought to go mining instead, as he did.27

There are only a few tantalizing indications of the possible relation between alchemy and art and literature. Alchemy had its own symbolic system, possibly adopted as a kind of code, in which, for example, a fountain stood for the purification of metals, Christ for the philosopher's stone, marriage for the union of sulphur and mercury, a dragon for fire. To complicate matters, some writers used alchemical imagery as symbols of something else (religious truths, for example). The *Dream of Polyphilus*, an anonymous esoteric romance published in Venice in 1499, makes use of a number of these symbols, and it is possible that this love story has an alchemical level of meaning. Vasari tells us that Parmigianino gave up painting for the study of alchemy, and it has been suggested that his paintings make use of alchemical symbolism. Unfortunately, the fact that alchemists used a number of common symbols (while giving them uncommon interpretations) makes the suggestion impossible to verify.

Magic was discussed more openly than alchemy, at least in its white form; for, as Pico della Mirandola put it:

Magic has two forms, one of which depends entirely on the work and authority of demons, a thing to be abhorred, so help me the god of truth, and a monstrous thing. The other, when it is rightly pursued, is nothing

²⁶ Burckhardt, Civilization of the Renaissance in Italy, p. 334.

²⁷ Biringuccio, *Pirotechnia*, pp. 35ff. Cf. Thorndike, *History of Magic*, vol. 4. ²⁸ Fagioli Dell'Arco, *Parmigianino*.

else than the utter perfection of natural philosophy . . . as the former makes man the bound slave of wicked powers, so does the latter make him their ruler and lord. 29

It should be noted that Pico believed in the efficacy of the black magic he condemns.

From a comparative point of view it might be useful to define magic, cross-culturally, as the attempt to produce material changes in the world as the result of performing certain rituals and writing or uttering certain verbal formulas ('spells', 'charms' or 'incantations') requesting or demanding that these changes take place. It would follow from this definition that the most influential group of magicians in Renaissance Italy were the Catholic clergy, since they claimed in this period that their rituals, images and prayers could cure the sick, avert storms, and so on.³⁰

From the point of view of contemporaries, however, the distinction between religion and magic was an important one. The Church – or, to be more sociologically exact, the more highly educated clergy – generally regarded magic with suspicion. Books of spells were burned in public by San Bernardino of Siena and also by Savonarola. It would be too cynical to explain this opposition to magic (and in some cases, as we have seen, to astrology) merely in terms of rivalry and competition. There were other grounds for clerical suspicion.

Magic could be black for two reasons. In the first place, it could be destructive as well as productive or protective. Secondly, the magician might employ the services of evil spirits. Thus Giovanni Fontana, a fifteenth-century Venetian who made a number of mechanical devices for use in dramatic spectacles, gained the reputation of a necromancer who received assistance from spirits from hell, just as John Dee gained a sinister reputation in sixteenth-century Cambridge as a result of the too successful 'special effects' that he contrived for a performance of Aristophanes. No doubt many of their contemporaries viewed Brunelleschi and Leonardo in a similar light. At a more learned level, the philosopher Agostino Nifo argued that the marvels of magic showed that – contrary to Aristotle's belief – demons really existed.

The literature of the period is steeped in magic. Romances of chivalry, for example, are full of sorcerers and of objects with magical powers. In Ariosto's *Orlando Furioso*, the magician Merlino and the enchantress Alcina play an important part. Angelica has a magic ring, Astolfo is turned into a tree, Atlante's castle is the home of enchantment, and so on.

²⁹ Cassirer et al., Renaissance Philosophy, pp. 246ff.

³⁰ Thomas, *Religion and the Decline of Magic*, ch. 1, develops this argument in the case of England. On the magical use of images, see above, pp. 133–4.

We should imagine the book's first readers as people who, if they did not always take magic too seriously, did not take it too lightly either. They believed in its possibility. In the same milieu as Ariosto, at the court of Ferrara, Dosso Dossi painted a picture of Circe, the enchantress of the Odyssey, who attracted much interest in Renaissance Italy (Plate 8.1).

One reason for this interest in Circe is that she was taken to be a witch, notably by Gianfrancesco Pico della Mirandola (the nephew of Giovanni Pico), who published a dialogue on witchcraft in 1523 in which he made considerable use of the testimony of ancient writers such as Homer and Virgil.³¹ Witchcraft was the poor man's magic, or rather the poor woman's – that is, a considerable proportion of the elite of educated men distinguished magic from witchcraft and associated the latter with poor women, who were supposed to have made a pact with the devil, to have been given the power to do harm by supernatural means but without study, to fly through the air and to attend nocturnal orgies called 'sabbaths'. 32 Particularly vulnerable to these accusations were those villagers, male and female, who were called in by their neighbours to find lost objects by supernatural means or to heal sick people and animals. 'Who knows how to cure illness knows how to cause it' (Qui scit sanare scit destruere) went a proverb current at the time.³³ It is more difficult to say whether the neighbours thought that these powers were or were not diabolical, and hardest of all to reconstruct what the accused thought she or he was doing. In Rome in 1427, two women confessed that they turned into cats, murdered children and sucked their blood; but the record does not tell us, in this case as in the majority of trials, what pressure had been brought to bear on the accused beforehand.

An illuminating and well-documented case is that of a certain Chiara Signorini, a peasant woman from the Modena area, accused of witchcraft in 1520. She and her husband had been expelled from their holding, whereupon the lady who owned the land had fallen ill. Chiara offered to cure her on condition that the couple was allowed to return. A witness claimed to have seen Chiara place at the door of the victim's house 'fragments of an olive-tree in the form of a cross . . . a fragment of the bone of a dead man . . . and an alb of silk, believed to have been dipped in chrism'. When Chiara was interrogated, she described visions of the Blessed Virgin, which her interrogator attempted to interpret as a

³¹ Burke, 'Gianfrancesco Pico'.

³² Fifteenth-century Italian treatises on witchcraft are conveniently collected in Hansen, *Quellen*, pp. 17ff. Bonomo, *Caccia alle streghe*, although outdated in some respects, remains a useful survey of witch-hunting in Italy.

³³ So said a woman at a trial at Modena in 1499, quoted in Ginzburg, *Night Battles*, ch. 3. The Latin is of course that of the court, not the speaker.

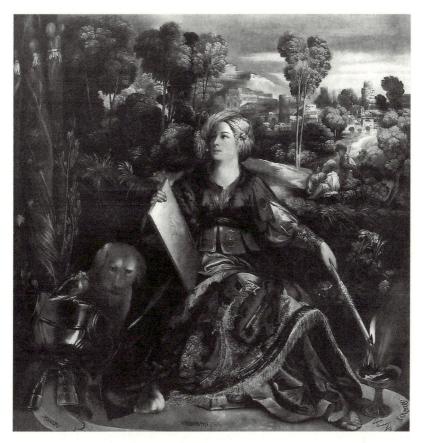

PLATE 8.1 Dosso Dossi: CIRCE

diabolical figure. After torture, Chiara agreed that the devil had appeared to her, but she would not admit to having attended a 'sabbath'. The use of the cross and the holy oil, like the vision of the Blessed Virgin, may well be significant. After all, the period 1450 to 1536 was the high point of recorded visions of the Virgin in Italy.³⁴ Some of the 'spells' which inquisitors confiscated took the form of prayers. What one group views as witchcraft, another may take to be religion. In this conflict of interpretations, it was the interrogator, backed by his instruments of torture, who had the last word.³⁵

Nevertheless, a few writers did express scepticism about the efficacy of

³⁴ Niccoli, Vedere con gli occhi del cuore, p. 116.

³⁵ Ginzburg, 'Stregoneria e pietà popolare'.

magic and witchcraft. The humanist lawyer Andrea Alciati, for example, suggested (as Montaigne was to do) that so-called witches suffered from hallucinations of night flight, and so on, and deserved medicine rather than punishment.³⁶ The physician Girolamo Cardano pointed out that the accused confessed to whatever the interrogators suggested to them, simply in order to bring their tortures to an end.³⁷ Pietro Pomponazzi, who taught the philosophy of Aristotle at the University of Padua, argued in his book On Incantations that the common people simply attributed to demons actions which they did not understand. He offered naturalistic explanations of apparently supernatural phenomena such as the extraction of arrows by means of incantations and the cure of the skin disease called 'the king's evil' by virtue of the royal touch. Pomponazzi held similar views about some of the miracles recorded in the Bible and about cures by means of relics, arguing that the cures may have been due to the faith of the patients, and that dogs' bones would have done just as well as the bones of the saints. It is not surprising to find that this book, which undermined the Church's distinction between religion and magic, was not published in the philosopher's lifetime.³⁸

VIEWS OF SOCIETY

The first thing to say about 'society' in Renaissance Italy is that the concept did not yet exist. It was not until the later seventeenth century that a general term began to be used (in Italian as in English, French and German) to describe the whole social system. A good deal was said and written, however, about various forms of government and social groups, and about the differences between the present and the past.³⁹

In Italy as in other parts of Europe, a recurrent image, which goes back to Plato and Aristotle, was that of the 'body politic' (corpo politico). It was more than a metaphor. The analogy between the human body and the political body was taken seriously by many people, and it underlay many more specific arguments. Thus a character in Castiglione's Courtier could defend monarchy as a 'more natural form of government' because, 'in our body, all the members obey the rule of the heart'. The ruler was often described as the 'physician' of this body politic, a commonplace which sometimes makes its appearance even in a writer as original and as deliberately shocking as Machiavelli, who wrote in the third

³⁶ Hansen, Quellen, pp. 310ff.

³⁷ Cardano, De rerum varietate, p. 567.

³⁸ Pomponazzi, De incantationibus.

³⁹ Pocock, Machiavellian Moment, and Skinner, Foundations, vol. 1.

⁴⁰ Castiglione, Cortegiano, bk 4, ch. 19. Cf. Archambault, 'Analogy of the body'.

chapter of *The Prince* that political disorders begin by being difficult to diagnose but easy to cure and end up easy to diagnose and difficult to cure.

However, in Italy this 'natural' or 'organic' language of politics was less dominant than elsewhere. A rival concept to the 'body politic', that of 'the state' (*lo stato*), was developing, with a range of reference which included public welfare, the constitution and the power structure. One character in Alberti's dialogue on the family declares: 'I do not want to consider the state as if it were my own property, to think of it as my shop' (ascrivermi lo stato quasi per mia ricchezza, riputarlo mia bottega).⁴¹ 'If I let a mere subject marry my daughter', says the emperor Constantine in a play written by Lorenzo de'Medici, Saints John and Paul, 'I will put the state into great danger' (in gran pericolo metto / Lo stato). Machiavelli uses the term 115 times in his The Prince (and only in five cases in the traditional sense of the 'state of affairs').⁴²

The existence within the peninsula of both republics and principalities made Italians unusually aware that the political system (governo, reggimento) was not God-given but man-made and that it could be changed. In a famous passage of his History of Italy, Francesco Guicciardini reports the discussions which took place in Florence after the flight of the Medici in 1494 about the relative merits of oligarchy (governo ristretto), democracy (governo universale) or a compromise between the two. 43 This awareness of the malleability of institutions is central to the contemporary literature on the ideal city-state. The treatises on architecture by Alberti and Filarete sketch social as well as architectural utopias. Leonardo's designs for an imaginary city express the same awareness that it is possible for social life to be planned.⁴⁴ Machiavelli offers a quite explicit discussion of political innovation (innovazione). In Florence between 1494 and 1530 the many reports and discussions of political problems which have survived show that the new language of politics, and the awareness of alternatives it implied, was not confined to Machiavelli and Guicciardini but was much more widespread. It was this awareness which Jacob Burckhardt emphasized and discussed in his Civilization of the Renaissance in Italy, in his chapter on 'The State as a Work of Art' (Der Staat als Kunstwerk).45

⁴¹ Alberti, *I libri della famiglia*, bk 3, p. 221.

⁴² D'Ancona, *Sacre rappresentazioni*, p. 244. Cf. Hexter, *Vision of Politics*, ch. 3; Rubinstein, 'Notes on the word *stato*'; Skinner, 'Vocabulary of Renaissance republicanism'.

⁴³ Guicciardini, *Storia d'Italia*, bk 1, pp. 122–31.
⁴⁴ Garin, 'Cité idéale'; Bauer, *Kunst und Utopie*.

⁴⁵ This point emerges clearly from the major and somewhat neglected study by Albertini, *Das florentinisch Staatsbewusstsein*.

Awareness of differences in social status seems also to have been unusually acute in Italy; at least, the vocabulary for describing these differences was unusually elaborate. The medieval view of society as consisting of three groups – those who pray, those who fight and those who work the soil – was not one which appealed to the inhabitants of Italian cities, most of whom performed none of these functions. ⁴⁶ Their model of society was differentiated not by functions but by grades (*generazioni*), and it probably developed out of the classification of citizens for tax purposes into rich, middling and poor. The phrases 'fat people' (*popolo grasso*) and 'little people' (*popolo minuto*) were commonly used, especially in Florence, and it is not difficult to find instances of a term such as 'middle class' (*mediocri*). ⁴⁷

However, contemporaries did not think exclusively in terms of income groups. They differentiated families and individuals according to whether they were or were not noble (nobili, gentilhuomini); whether or not they were citizens (cittadini), in possession of political rights; and whether they were members of the greater or lesser guilds. One of the most important but also one of the most elusive items in their social vocabulary was popolare, because it varied in significance according to the speaker. If he came from the upper levels of society, he was likely to use it as a pejorative term to denote all ordinary people. At the middle level, on the other hand, a greater effort was made to distinguish the popolo, who enjoyed political rights, from the plebe, who did not. The point of view of this 'plebs' has gone unrecorded.⁴⁸

This awareness of the structure of society and of potentially different structures is also revealed in discussions of the definition of nobility, whether based on birth or individual worth, which are relatively frequent in the period, from the treatise of the Florentine jurist Lapo da Castiglionchio (written before 1381) and Poggio Bracciolini's dialogue *On True Nobility* to the debate in Castiglione's *Courtier* (1528). This discussion needs to be placed in the context of political and social conflict in Florence and elsewhere, but it is also related to contemporary concern with the value of the individual (below, p. 203).

Renaissance Italy was also remarkable for a view of the past taken by some artists and humanists, a view which was possibly more widespread. With the idea of the malleability of institutions, already discussed, went an awareness of change over time, a sense of anachronism or historical

⁴⁶ Duby, Three Orders; Niccoli, Sacerdoti.

⁴⁷ Difficulties in the interpretation of the term *popolo minuto* and its synonyms are discussed by Cohn, *Laboring Classes*, p. 69n.

⁴⁸ Gilbert, Machiavelli and Guicciardini, pp. 19ff.; cf. Cohn, Laboring Classes, ch. 3.

distance. ⁴⁹ The term 'anachronism' is literally speaking an anachronism itself because the word did not yet exist, but, in his famous critique of the authenticity of the document known as the *Donation of Constantine*, the humanist Lorenzo Valla did point out that the text contained expressions from a later period. He was well aware that 'modes of speech' (*stilus loquendi*) were subject to change, that language had a history. ⁵⁰ Another fifteenth-century humanist, Flavio Biondo, argued that Italian and other romance languages had developed out of Latin. Biondo also wrote a book called *Rome Restored*, in which he tried to reconstruct classical Rome on the basis of literary evidence as well as the surviving remains. In another book he discussed the private life of the Romans, the clothes they wore and the way in which they brought up their children. ⁵¹

By the later fifteenth century, this antiquarian sensibility had become fashionable. The humanist condottiere Federigo da Montefeltro once asked the humanist pope Pius II, who recorded the question in his memoirs, whether the generals of antiquity wore the same kind of armour as he did (an prisci duces aeque ac nostri temporis armati fuissent). In the Dream of Polyphilus, the Venetian romance already mentioned, the lover searches for his beloved in a landscape of temples, tombs and obelisks, and even the language is a consciously archaic Latinate Italian.⁵² Among the artists whose work illustrates the growing interest in antiquarianism are Mantegna and Giulio Romano. Like his master and father-in-law Jacopo Bellini, Mantegna was extremely interested in copying ancient coins and inscriptions. He was a friend of humanists such as Felice Feliciano of Verona. His reconstructions of ancient Rome in the Triumphs of Caesar or the painting of Scipio introducing the cult of the Cybele are the pictorial equivalents of Biondo's patient work of historical reconstruction, even if they contain some 'fantastic' elements.⁵³ As for Giulio Romano, his painting of Constantine in battle draws heavily on the evidence of Trajan's Column, as Vasari pointed out in his life of the artist, 'for the costumes of the soldiers, the armour, ensigns, bastions, stockades, battering rams and all the other instruments of war'.

Vasari himself shared this sense of the past. His *Lives* are organized around the idea of development in time, from Cimabue to Michelangelo. He believed in progress in the arts, at least up to a point, but he also believed that individual artists ought to be judged by the standards of their own day, and he explained: 'my intention has always been to praise

⁴⁹ Burke, Renaissance Sense of the Past and 'Sense of anachronism'.

⁵⁰ Gaeta, Lorenzo Valla; Kelley, Foundations, ch. 1.

⁵¹ Weiss, Renaissance Discovery.

⁵² Mitchell, 'Archaeology and romance'; Brown, Venice and Antiquity.

⁵³ Saxl, Lectures, pp. 150-60; Greenstein, Mantegna and Painting, pp. 59-85.

not absolutely but, as the saying goes, relatively [non semplicemente ma, come s'usa dire, secondo ché], having regard to place, time, and other similar circumstances.'54

Another material sign of the awareness of the past is the fake antique, which seems to have been a fifteenth-century innovation. The young Michelangelo made a faun, a Cupid and a Bacchus in the classical style. He was essentially competing with antiquity rather than trying to deceive, but by the early sixteenth century the faking of classical sculptures and Roman coins was a flourishing industry in Venice and Padua in particular, so much so that the Italian engraver Enea Vico, in his *Discourses on Ancient Medals* (1555), told his readers how to distinguish genuine from faked artefacts. This response to two new trends, the fashion for ancient Rome and the rise of the art market, depended – like the detecting of the fakes – on a sense of period style. Texts too might be faked. Some humanists showed their skill by producing texts that they passed off as the work of Cicero and other classical writers, while others demonstrated the same kind of ability by identifying the fakes.⁵⁵

This new sense of the past is one of the most distinctive but also one of the most paradoxical features of the period. Classical antiquity was studied in order to imitate it more faithfully, but the closer it was studied, the less imitation seemed either possible or desirable. 'How mistaken are those', wrote Francesco Guicciardini, 'who quote the Romans at every step. One would have to have a city with exactly the same conditions as theirs and then act according to their example. That model is as unsuitable for those lacking the right qualities as it would be useless to expect an ass to run like a horse.' ⁵⁶ However, many people did quote the Romans at every step; Guicciardini's friend Machiavelli was one of them.

Another paradox was that, at a time when Italian culture was strongly marked by the propensity to innovate, innovation was generally considered a bad thing. In political debates in Florence, it was taken for granted that 'new ways' (modi nuovi) were undesirable, and that 'every change takes reputation from the city'.⁵⁷ In Guicciardini's History of Italy, the term 'change' (mutazione) seems to be used in a pejorative sense, and when a man is described, as is Pope Julius II, as 'desirous of new things' (desideroso di cose nuove), the overtones of disapproval are distinctly audible. Innovation in the arts was doubtless less dangerous, but it was rarely admitted to be innovation. It was generally perceived as a return to the past. When Filarete praises Renaissance architecture and condemns

⁵⁴ Panofsky, Meaning in the Visual Arts, pp. 169-225.

⁵⁵ Kurz, Fakes; Grafton, Forgers and Critics.

⁵⁶ Guicciardini, Maxims and Reflections, no. 110.

⁵⁷ Gilbert, 'Florentine political assumptions'.

the Gothic, it is the latter which he calls 'modern' (*moderno*). It is only at the end of the period that one can find someone (Vasari, for example) cheerfully admitting to being *moderno* himself (above p. 19).

VIEWS OF MAN

Classical views of the physical constitution of man, and the distinction between four personality types (choleric, sanguine, phlegmatic and melancholy), were taken seriously by writers in this period, which was an important one in the history of medicine. These views are not without relevance to the arts. Ficino, for example, joined the suggestion (which comes from a text attributed to Aristotle) that all great men are melancholies to Plato's concept of inspiration as divine frenzy, and argued that creative people (*ingeniosi*) were melancholic and even 'frantic' (*furiosi*). He was thinking of poets in particular, but Vasari applied his doctrine to artists and so helped create the modern myth of the bohemian (above, pp. 88–90). 59

However, the major theme of this section is inevitably one which contemporaries did not discuss in treatises but was discovered (or, as some critics would say, invented) by Jacob Burckhardt: Renaissance individualism. 'In the Middle Ages', wrote Burckhardt, in one of the most frequently quoted passages of his essay, '... Man was conscious of himself only as a member of a race, people, party, family or corporation, only through some general category. In Italy this veil first melted into air ... man became a spiritual *individual*, and recognized himself as such.'60 He went on to discuss the passion for fame and its corrective, the new sense of ridicule, all under the general rubric of 'the development of the individual'. For the use of this 'blanket term' he has been severely criticized. 61 Burckhardt himself came to be rather sceptical about the interpretation he had launched, and towards the end of his life he confessed to an acquaintance: 'You know, so far as individualism is concerned, I hardly believe in it anymore, but I don't say so; it gives people so much pleasure.'62

The objections are difficult to gainsay, since urban Italians of this period were very much conscious of themselves as members of families or

⁵⁸ Park, Doctors and Medicine; Siraisi, Clock and the Mirror.

⁵⁹ Klibansky, Saturn and Melancholy.

⁶⁰ Burckhardt, Civilization of the Renaissance in Italy, p. 81.

⁶¹ Nelson, 'Individualism as a criterion'.

⁶² Burckhardt's Swiss German, not often recorded, is worth repeating: 'Ach wisse Si, mit dem Individualismus, i glaub ganz nimmi dra, aber i sag nit; si han gar a Fraid' (Walser, *Gesammelte Studien*, xxxvii).

corporations.⁶³ And yet we need the idea of individualism, or something like it. The idea of the self, as the anthropologist Marcel Mauss pointed out more than half a century ago, is not natural. It is a social construct, and it has a social history.⁶⁴ Indeed, the concept of person that is current (indeed, taken for granted) in a particular culture needs to be understood if we are to comprehend that culture, and, as another anthropologist, Clifford Geertz, has suggested, it is a direct path into that culture for an outsider.⁶⁵

If we ask about the concept of person current – among elites, at least – in Renaissance Italy, we may find it useful to distinguish the self-consciousness with which Burckhardt was particularly concerned from self-assertiveness, and to distinguish both from the idea of the unique individual.⁶⁶

The idea of the uniqueness of the individual goes with that of a personal style in painting or writing, an idea which has been discussed already (above, p. 28). At the court of Urbino, the poet Bernardo Accolti went by the nickname 'L'unico Aretino'. The poet Vittoria Colonna described Michelangelo as *unico*. An anonymous Milanese poem declares that, just as there is only one God in Heaven, so there is only one 'Moro' (Ludovico Sforza) on earth. In his biographies, the bookseller Vespasiano da Bisticci often refers to men as 'singular' (*singolare*).

There is rather more to say about self-assertion. Burckhardt argued that the craving for fame was a new phenomenon in the Renaissance. The Dutch historian Huizinga retorted that, on the contrary, it was 'essentially the same as the chivalrous ambition of earlier times'. ⁶⁷ The romances of chivalry do indeed suggest that the desire for fame was one of the leading motives of medieval knights, so what Burckhardt noticed may have been no more than the demilitarization of glory. However, it is remarkable quite how often self-assertion words occur in the Italian literature of this period. Among them we find 'competition' (concertazione, concorrenza), 'emulation' (emulazione), 'glory' (gloria), 'envy' (invidia), 'honour' (onore), 'shame' (vergogna), 'valour' (valore) and, hardest of all to translate, virtù, a concept of great importance in the period referring to personal worth, which we have already met when discussing its com-

⁶³ Weissman, 'Reconstructing Renaissance sociology'; Burke, 'Anthropology of the Renaissance'.

⁶⁴ Mauss's lecture of 1938 is reprinted with a valuable commentary in Carrithers et al., *Category of the Person*, chs. 1–2.

⁶⁵ Geertz, Local Knowledge, pp. 59-70.

⁶⁶ Nelson, 'Individualism as a criterion', distinguishes five elements. Cf. Batkin, *L'idea di individualità*; Burke, 'The Renaissance, individualism and the portrait'.

⁶⁷ Burckhardt, Civilization of the Renaissance in Italy, ch. 2; Huizinga, Autumn of the Middle Ages, ch. 4.

plementary opposite, fortune.⁶⁸ Psychologists would say that, if words of this kind occur with unusual frequency in a particular text, as they do, for example, in the dialogue on the family by the humanist Leon Battista Alberti, then its author is likely to have had an above-average achievement drive, which in Alberti's case his career does nothing to refute. That the Florentines in general were unusually concerned with achievement is suggested by the *novelle* of the period, which often deal with the humiliation of a rival.⁶⁹ The suggestion is confirmed by the institutionalization of competitions between artists; by the sharp tongues and the envy in the artistic community, as recorded by Vasari, notably in his life of Castagno; and, not least, by the remarkable creative record of that city.

At any rate self-assertion was an important part of the Italian, and especially the Florentine, image of man. The humanists Bruni and Alberti both described life as a race. Bruni wrote that some 'do not run in the race, or when they start, become tired and give up half way'; Alberti, that life was a regatta in which there were only a few prizes: 'Thus in the race and competition for honour and glory in the life of man it seems to me very useful to provide oneself with a good ship and to give an opportunity to one's powers and ability (alle forze e ingegno tuo), and with this to sweat to be the first.'70 For a hostile account of the same kind of struggle, we may turn to the Sienese pope Pius II (who was not exactly backward in the race to the top), and his complaint that 'In the courts of princes the greatest effort is devoted to pushing others down and climbing up oneself.'71 Leonardo da Vinci recommended artists to draw in company because 'a sound envy' would act as a stimulus to do better.⁷² Rivalry between artists was not confined to Tuscans such as Leonardo and Michelangelo but involved Raphael and Titian as well, to mention only the most famous names.73

It is not unreasonable to suggest that competition encourages self-consciousness, and interesting to discover that the Tuscan evidence for this kind of individualism is once again richer than anything to be found elsewhere. The classic phrase of the Delphic oracle, 'know thyself', quoted by Marsilio Ficino among others, was taken seriously in the period, although it was sometimes given a more worldly interpretation than was originally intended.

The most direct evidence of self-awareness is that of autobiographies

⁶⁸ Gilbert, 'On Machiavelli's idea of virtù'.

⁶⁹ Rotunda, Motif-Index.

⁷⁰ Bruni, Epistolae populi Florentini, vol. 1, p. 137; Alberti, I libri della famiglia, p. 139.

⁷¹ Pius II, De curialium miseriis, p. 32.

⁷² Leonardo da Vinci, *Literary Works*, p. 307.

⁷³ Goffen, Renaissance Rivals.

or, more exactly (since the modern term 'autobiography' encourages an anachronistic view of the genre), of diaries and journals written in the first person, of which there are about a hundred surviving from Florence alone.⁷⁴ The local name for this kind of literature was *ricord*anze, which might be translated 'memoranda', a suitably vague word for a genre which had something of the account book and something of the city chronicle in it, and was focused on the family, but none the less reveals something about the individual who wrote it - the apothecary Luca Landucci, for example, who has been quoted more than once in these pages, or Machiavelli's father Bernardo, or the Florentine patrician Giovanni Rucellai, who left a notebook dealing with a variety of subjects, a 'mixed salad' as he called it. 75 Even if these memoranda were not intended to express self-awareness, they may have helped to create it. Rather more personal in style are the autobiographies of Pope Pius II (written, like Caesar's, in the third person, but none the less self-assertive for that), Guicciardini (a brief but revealing memoir), the physician Girolamo Cardano (a Lombard, for once, not a Florentine) and the goldsmith Benyenuto Cellini.

Autobiographies are not the only evidence for the self-consciousness of Renaissance Italians. There are also paintings. Portraits were often hung in family groups and commissioned for family reasons, but selfportraits are another matter. Most of them are not pictures in their own right but representations of the artist in the corner of a painting devoted to something else, such as the figure of Benozzo Gozzoli in his fresco of the procession of the Magi, Pinturicchio in the background to his Annunciation (Plate 8.2) or Raphael in his School of Athens. In the course of the sixteenth century, however, we find self-portraits in the strict sense by Parmigianino, for example, and Vasari, and more than one by Titian. They remind us of the importance of the mirrors manufactured in this period, in Venice in particular. Mirrors may well have encouraged self-awareness. As the Florentine writer Giambattista Gelli put it in a Carnival song he wrote for the mirror-makers of Florence, 'A mirror allows one to see one's own defects, which are not as easy to see as those of others.'76 Even letters from clients to patrons have been analysed as evidence of the gradual emergence of a new sense of self as 'an autonomous, discreet and elusive agent'.77

⁷⁴ Bec, Marchands écrivains; Brucker, Two Memoirs; Guglielminetti, Memoria e scrittura; Anselmi et al., 'Memoria' dei mercatores. Cf. Ciappelli and Rubin, Art, Memory, and Family.

⁷⁵ Rucellai, Giovanni Rucellai ed il suo Zibaldone.

Singleton, Canti carnascialeschi, pp. 357ff.
 McLean, Art of the Network, p. 228.

PLATE 8.2 PINTURICCHIO: SELF-PORTRAIT (DETAIL FROM THE ANNUNCIATION)

Evidence of self-awareness is also provided by the conduct books, of which the most famous are Castiglione's Courtier (1528), Giovanni Della Casa's Galateo (1558) and the Civil Conversation of Stefano Guazzo (1574). All three are manuals for the 'presentation of self in everyday life', as the sociologist Erving Goffman put it – instructions in the art of playing one's social role gracefully in public. They inculcate conformity to a code of good manners rather than the expression of a personal style of behaviour, but they are nothing if not self-conscious themselves, and they encourage self-consciousness in the reader. Castiglione recommends a certain 'negligence' (sprezzatura), to show that 'whatever is said or done has been done without pains and virtually without thought', but he admits that this kind of spontaneity has to be rehearsed. It is the art which conceals art, and he goes on to compare the courtier to a painter. The 'grace' (grazia) with which he was so much concerned was, as we have seen, a central concept in the art criticism of his time. It is hard to decide whether to call Castiglione a painter among courtiers or his friend Raphael a courtier among painters, but the connections between their two domains are clear enough. The parallel was clear to Giovanni Pico della Mirandola in his famous Oration on the Dignity of Man, in which he has God say to man that, 'as though the maker or moulder of thyself, thou mayest fashion thyself in whatever shape thou shalt prefer.'78

The dignity of man was a favourite topic for writers on the 'human condition' (the phrase is theirs: *humana conditio*). It is tempting to take Pico's treatise on the dignity of man to symbolize the Renaissance, and to contrast it with Pope Innocent III's treatise on the misery of man as a symbol of the Middle Ages. However, both the dignity and the misery of man were recognized by writers in both Middle Ages and Renaissance. Many of the arguments for the dignity of man (the beauty of the human body, its upright posture, and so on) are commonplaces of the medieval as well as the classical and Renaissance traditions. The themes of dignity and misery were considered as complementary rather than contradictory.⁷⁹

All the same, there does appear to have been a change of emphasis revealing an increasing confidence in man in intellectual circles in the period. Lorenzo Valla, with characteristic boldness, called the soul the 'man-God' (homo Deus) and wrote of the soul's ascent to heaven in the language of a Roman triumph. Pietro Pomponazzi declared that those (few) men who had managed to achieve almost complete rationality deserved to be numbered among the gods. Adjectives such as 'divine' and 'heroic' were increasingly used to describe painters, princes and other

⁷⁸ Cassirer et al., Renaissance Philosophy, p. 225.

⁷⁹ Trinkaus, In our Image; Craven, Giovanni Pico della Mirandola.

mortals. Alberti had called the ancients 'divine' and Poliziano had coupled Lorenzo de'Medici with Giovanni Pico as 'heroes rather than men', but it is only in the sixteenth century that this heroic language became commonplace. Vasari, for example, described Raphael as a 'mortal god' and wrote of the 'heroes' of the house of Medici. Matteo Bandello referred to the 'heroic house of Gonzaga' and to the 'glorious heroine' Isabella d'Este. Aretino, typically, called himself 'divine'. The famous references to the 'divine Michelangelo' were in danger of devaluation by this inflation of the language of praise.⁸⁰

These ideas of the dignity (indeed divinity) of man had their effect on the arts. Where Pope Innocent III, for example, found the human body disgusting, Renaissance writers admired it, and the humanist Agostino Nifo went so far as to defend the proposition that 'nothing ought to be called beautiful except man'. By 'man' he meant woman, and in particular Jeanne of Aragon. One might have expected paintings of the idealized human body in a society where such views were expressed. The derivation of architectural proportions from the human body (again, idealized) also depended on the assumption of human dignity. Again, at the same time that the term 'heroic' was being overworked in literature, we find the so-called grand manner dominant in art. If we wish to explain changes in artistic taste, we need to look at wider changes in worldviews.

Another image of man, common in the literature of the time, is that of a rational, calculating, prudent animal. 'Reason' (ragione) and 'reasonable' (ragionevole) are terms which recur, usually with overtones of approval. They are terms with a wide variety of meanings, but the idea of rationality is central. The verb ragionare meant 'to talk', but then speech was a sign of rationality which showed man's superiority to animals. One meaning of ragione was 'accounts': merchants called their account books libri della ragione. Another meaning was 'justice': the Palazzo della Ragione in Padua was not so much a 'Palace of Reason' as a court of law. Justice involved calculation, as the classical and Renaissance image of the scales should remind us. Ragione also meant 'proportion' or 'ratio'. A famous early definition of perspective, in the life of Brunelleschi attributed to Manetti, called it the science which sets down the differences of size in objects near and far con ragione, a phrase which can be (and has been) translated as either 'rationally' or 'in proportion'.

The habit of calculation was central to Italian urban life. Numeracy was relatively widespread, taught at special 'abacus schools' in Florence and elsewhere. A fascination with precise figures is revealed in some thirteenth-century texts, notably the chronicle of Fra Salimbene of Parma and Bonvesino della Riva's treatise on 'The Big Things of Milan', which

⁸⁰ Weise, L'ideale eroico del Rinascimento, pp. 79-119.

lists the city's fountains, shops and shrines and calculates the number of tons of corn the inhabitants of Milan demolished every day.⁸¹ The evidence for this numerate mentality is even richer in the fourteenth century, as the statistics in Giovanni Villani's chronicle of Florence bear eloquent witness, and richer still in the fifteenth and sixteenth century. In Florence and Venice in particular, an interest was taken in statistics of imports and exports, population and prices. Double-entry book-keeping was widespread. The great catasto of 1427, a household-to-household survey of a quarter of a million Tuscans who were then living under Florentine rule, both expressed and encouraged the rise of the numerate mentality.82 Time was seen as something 'precious', which must be 'spent' carefully and not 'wasted'; all these terms come from the third book of Alberti's dialogue on the family. In similar fashion, Giovanni Rucellai advised his family to 'be thrifty with time, for it is the most precious thing we have'.83 Time could be the object of rational planning. The humanist schoolmaster Vittorino da Feltre drew up a timetable for the students. The sculptor Pomponio Gaurico boasted that since he was a boy he had planned his life so as not to waste it in idleness.

With this emphasis on reason, thrift (masserizia) and calculation went the regular use of such words as 'prudent' (prudente), 'carefully' (pensatamente) and 'to foresee' (antevedere). The reasonable is often identified with the useful, and a utilitarian approach is characteristic of a number of writers in this period. In Valla's dialogue On Pleasure, for example, one of the speakers, the humanist Panormita, defends an ethic of utility (utilitas). All action – writes this fifteenth-century Jeremy Bentham – is based on calculations of pain and pleasure. Panormita may not represent the author's point of view. What is relevant here, however, is what was thinkable in the period rather than who exactly thought it. This emphasis on the useful can be found again and again in texts of the period, from Alberti's book on the family to Machiavelli's Prince, with its references to the 'utility of the subjects' (utilità de'sudditi), and the need to make 'good use' of liberality, compassion and even cruelty. Again, Filarete created in his ideal city of Sforzinda a utilitarian utopia that Bentham would have appreciated, in which the death penalty has been abolished because criminals are more useful to the community if they do hard labour for life, in conditions exactly harsh enough for this punishment to act as an adequate deterrent.84

⁸¹ Baxandall, *Painting and Experience*, pp. 86–108; Murray, *Reason and Society*, pp. 182ff.

⁸² Herlihy and Klapisch-Zuber, Toscans et leurs familles.
83 Rucellai, Giovanni Rucellai ed il suo Zibaldone, p. 8.

⁸⁴ Filarete, Treatise on Architecture, bk 20, pp. 282ff.

Calculation affected human relationships. The account-book view of man is particularly clear in the reflections of Guicciardini. He advised his family:

Be careful not to do anyone the sort of favour that cannot be done without at the same time displeasing others. For injured men do not forget offences; in fact, they exaggerate them. Whereas the favoured party will either forget or will deem the favour smaller than it was. Therefore, other things being equal, you lose a great deal more than you gain. 85

Italians (adult males of the upper classes, at any rate) admitted a concern (unusual for other parts of Europe in the period, whatever may be true of the 'age of capitalism') with controlling themselves and manipulating others. In Alberti's dialogue on the family, the humanist Lionardo suggests that it is good 'to rule and control the passions of the soul', while Guicciardini declared that there is greater pleasure in controlling one's desires (tenersi le voglie oneste) than in satisfying them. If self-control is civilization, as the sociologist Norbert Elias suggests in his famous book The Civilizing Process, then even without their art and literature the Italians of the Renaissance would still have a good claim to be described as the most civilized people in Europe. 86

TOWARDS THE MECHANIZATION OF THE WORLD PICTURE

It is time to end this necessarily incomplete catalogue of the beliefs of Renaissance Italians and to try to see their worldview as a whole. One striking feature of this view is the coexistence of many traditional attitudes with others which would seem to be incompatible with them, a point that was famously made by Aby Warburg in his discussion of the last will and testament of the Florentine merchant Francesco Sassetti.⁸⁷

Generally speaking, Renaissance Italians, including the elites who dominate this book, lived in a mental universe which, like that of their medieval ancestors, was animate rather than mechanical, moralized rather than neutral, and organized in terms of correspondences rather than causes.

A common phrase of the period was that the world is 'an animal'. Leonardo developed this idea in a traditional way when he wrote: 'We can say that the earth has a vegetative soul, and that its flesh is the land, its bones are the structure of the rocks . . . its blood is the pools of water . . .

⁸⁵ Guicciardini, Maxims and Reflections, no. 25.

⁸⁶ Elias, *Civilizing Process*, a book that does not place enough emphasis on the role of the Italians in the process of change he describes and analyses so well. Cf. Burke, 'Civilization, sex and violence'.

⁸⁷ Warburg, Renewal of Pagan Antiquity, pp. 247-9.

its breathing and its pulses are the ebb and flow of the sea.'88 The operations of the universe were personified. Dante's phrase about 'the love that moves the sun and the other stars' was still taken literally. Magnetism was described in similar terms. In the Dialogues on Love (1535) by the Jewish physician Leone Ebreo, a work in the neo-Platonic tradition of Ficino, one speaker explains that 'the magnet is loved so greatly by the iron, that notwithstanding the size and weight of the iron, it moves and goes to find it.'89 The discussions of the 'body politic' (above, p. 000) fit into this general picture. 'Every republic is like a natural body', as the Florentine theorist Donato Giannotti put it. Writers on architecture draw similar analogies between buildings and animate beings, analogies that are now generally misread as mere metaphors. Alberti wrote that a building is 'like an animal', and Filarete that 'A building . . . wants to be nourished and looked after, and through lack of this it sickens and dies like a man.' Michelangelo went so far as to say that whoever 'is not a good master of the figure and likewise of anatomy' cannot understand anything of architecture because the different parts of a building 'derive from human members'.90 Not even Frank Lloyd Wright in the twentieth century could match this organic theory of architecture.

The universe was 'moralized' in the sense that its different characteristics were not treated as neutral in the manner of modern scientists. Warmth, for example, was considered to be better in itself than cold, because the warm is 'active and productive'. It was better to be unchangeable (like the heavens) than mutable (like the earth); better to be at rest than to move; better to be a tree than a stone. Another way of making some of these points is to say that the universe was seen to be organized in a hierarchical manner, thus resembling (and also justifying or 'legitimating') the social structure. Filarete compared three social groups – the nobles, the citizens and the peasants - to three kinds of stone - precious, semi-precious and common. In this hierarchical universe it is hardly surprising to find that genres of writing and painting were also graded, with epics and 'histories' at the top and comedies and landscapes towards the bottom. However, more than hierarchy was involved on occasion. 'Prodigies' or 'monsters' – in other words, extraordinary phenomena – from the birth of deformed children to the appearance of comets in the sky, were interpreted as 'portents', as signs of coming disaster.⁹¹

⁸⁸ Leonardo da Vinci, Literary Works, no. 1000.

⁸⁹ Ebreo, Dialoghi d'amore, second dialogue, pt 1.

⁹⁰ Filarete, *Treatise on Architecture*, bk 1, pp. 8ff; Michelangelo, quoted in Ackerman, *Architecture of Michelangelo*, p. 37.

⁹¹ The discussion of 'the prose of the world' in Foucault, Order of Things, ch. 2, has become a classic. For a more thorough analysis, see Céard, Nature et les prodiges.

The different parts of the universe were related to one another not so much causally, as in the modern world picture, as symbolically, according to what were called 'correspondences'. The most famous of these correspondences was between the 'macrocosm', the universe in general, and the 'microcosm', the little world of man. Astrological medicine depended on these correspondences, between the right eye and the Sun, the left eye and the Moon, and so on. Numerology played a great part here. The fact that there were seven planets, seven metals and seven days of the week was taken to prove correspondences between them. This elaborate system of correspondences had great advantages for artists and writers. It meant that images and symbols were not 'mere' images and symbols but expressions of the language of the universe and of God its creator.

Historical events or individuals might also correspond to one another, since the historical process was often believed to move in cycles rather than to 'progress' steadily in one direction. Charles VIII of France was viewed by Savonarola as a 'Second Charlemagne' and as a 'New Cyrus' – more than the equivalent, almost the reincarnation, of the great ruler of Persia. ⁹² The emperor Charles V was also hailed as the 'Second Charlemagne'. The Florentine poets who wrote of the return of the golden age under Medici rule may well have been doing something more than turn a decoratively flattering or flatteringly decorative phrase. The idea of the Renaissance itself depends on the assumption that history moves in cycles and employs the organic language of 'birth'.

This 'organic mentality', as we may call it, so pervasive was it, met a direct challenge only in the seventeenth century from Descartes, Galileo, Newton and other 'natural philosophers'. The organic model of the cosmos remained dominant in the fifteenth and sixteenth centuries. All the same, a few individuals, at least on occasion, did make use of an alternative model – the mechanical one – which is hardly surprising in a culture which produced engineers such as Mariano Taccola, Francesco di Giorgio Martini and, of course, Leonardo. Giovanni Fontana, who wrote on water-clocks, among other subjects, once referred to the universe as this 'noble clock', an image that was to become commonplace in the seventeenth and eighteenth centuries.

Again, Leonardo da Vinci, whose comparison of the microscosm and the macrocosm has already been quoted, makes regular use of the mechanical model. He described the tendons of the human body as 'mechanical instruments' and the heart too as a 'marvellous instrument'. He also wrote that 'the bird is an instrument operating by mathematical

⁹² Weinstein, Savonarola and Florence, pp. 145, 166-7; Burke, 'History as allegory'.
⁹³ Gille, Engineers of the Renaissance.

law', a principle underlying his attempts to construct flying-machines. Machiavelli and Guicciardini saw politics in terms of the balance of power. In the twentieth chapter of *The Prince*, Machiavelli refers to the time when Italy was 'in a way in equilibrium' (in un certo modo bilanciata), while Guicciardini makes the same point at the beginning of his History of Italy, observing that, at the death of Lorenzo de'Medici, 'Italian affairs were in a sort of equilibrium' (le cose d'Italia in modo bilanciate si mantenessino). The widespread concern with the precise measurement of time and space, discussed earlier in this chapter, fits in better with this mechanical worldview than with the traditional organic one. The mechanization of the world picture was really the work of the seventeenth century, but in Italy, at least, the process had begun. 95

There would seem to be a case for talking about the pluralism of worldviews in Renaissance Italy, a pluralism which may well have been a stimulus to intellectual innovation. Such a coexistence of competing views naturally raises the question of their association with different social groups. The mechanical world picture has sometimes been described as 'bourgeois'. 'Mas it in fact associated with the bourgeoisie? It will be easier to answer this question after discussing both what the bourgeoisie were and the general shape of the social structure in Renaissance Italy. This is the task of the following chapter.

⁹⁴ On the coexistence of organic and mechanical modes of thought in Leonardo, Dijksterhuis, *Mechanization of the World Picture*, pp. 253–64.

⁹⁵ Delumeau, 'Réinterprétation de la Renaissance', stresses progress in the capacity for abstraction.

⁹⁶ Borkenau, Übergang.

THE SOCIAL FRAMEWORK

This chapter continues the process of moving outward from the art and literature of the Renaissance, the milieux in which they were produced and the worldviews they expressed. It is concerned essentially with organizations, formal and informal, and their relationship to Renaissance culture. It deals in the first place with an institution which existed to propagate a worldview, the Church; next with political institutions; then with the social structure; and, finally, at the very base of society, with the economy.

RELIGIOUS ORGANIZATION

If modern Christians could visit Renaissance Italy, they would probably be very much surprised, not to say shocked, by what they would find going on in church, and even an Italian Catholic might raise an eyebrow. The Venetian cardinal Gasparo Contarini described men walking through a church 'talking among themselves about trade, about wars, and very often even about love'. Walking through churches, especially during Mass, was frequently forbidden (at Modena in 1463, for example, and at Milan in 1530), frequently enough for us to conclude that it must have happened all the time. One might expect to find beggars in church, or horses, or gamblers, or a schoolmaster giving lessons, or a political meeting in progress. The parishioners ate, drank and danced in the church to celebrate major festivals such as that of the patron saint. Churches might be used as storehouses for grain or wood. A visitation of the diocese of Mantua in 1535 reported on a church in which 'the chaplain has a kitchen, beds and other things which are not very appropriate for a holy place; but . . . he may be excused because his dwelling is very small.'2 Valuables might be kept in the sacristy; there were, after all, few other safe places.

¹ A general survey in Hay, Church in Italy. Cf. Prodi and Johanek, Strutture ecclesiastiche.

The Dutch historian Johan Huizinga's remark that, in the Middle Ages, people were inclined 'to treat the sacred with a familiarity that did not exclude respect' remains true for the Renaissance, with the proviso that their familiarity did not necessarily include respect either.³ The distinction between the sacred and profane was not drawn in quite the same place and it was not drawn as sharply as it would be in the later sixteenth century after the Council of Trent. Nor was it drawn by everyone. As late as 1580, Montaigne, who was visiting Verona, was surprised to see men standing and talking during Mass, their hats on their heads and their backs to the altar.⁴

There was a similar lack of sharp distinction between clergy and laity. The Roman census of 1526 records a friar working as a mason (il frate muratore). The clergy lacked a special kind of education until seminaries were set up after the Council of Trent. 'How many', asked a participant in the Lateran Council of 1514, 'do not wear clothes laid down by the sacred canons, keep concubines, are simoniacal and ambitious? How many carry weapons like soldiers? How many go to the altar with their own children around them? How many hunt and shoot with crossbows and guns?'5 It does not seem possible to answer his rhetorical questions, or even to say how many clergy there were – a question complicated by the existence of marginal cases, men in minor orders, including such famous names as Poliziano and Ariosto. All that the evidence allows is an estimate of their number in particular cities in particular vears. In Florence in 1427, for example, a city of some 38,000 people, there were about 300 secular priests but over 1,100 monks, friars and nuns.⁶ By 1550 the total population had risen to nearly 60,000, but the proportion of clergy had climbed still more steeply, to just over 5,000, or nearly 9 per cent. In Venice in 1581, a city of about 135,000 people, there were nearly 600 secular priests, but the friars and nuns brought the clerical total to more than 4,000.7

The <u>clergy</u> were very far from being a homogeneous body, either culturally or socially. It is necessary to distinguish at least three groups: the bishops, the rank-and-file secular clergy and the members of religious orders.

Bishops, of whom there were nearly three hundred in Italy, were gener-

² Tacchi Venturi, Storia della Compagnia di Gesù, pp. 179ff.; Putelli, Vita, storia ed arte, p. 16.

³ Huizinga, Autumn of the Middle Ages, ch. 12.

⁴ Montaigne, Journal, p. 64.

⁵ Tacchi Venturi, Storia della Compagnia di Gesù, p. 36.

⁶ Herlihy and Klapisch-Zuber, Toscans et leurs familles, table 10.

⁷ Battara, Popolazione di Firenze, pp. 79–80; Beltrami, Storia della popolazione di Venezia, p. 79.

ally nobles. Some sees were virtually hereditary in particular families, the dynasty being perpetuated by the practice of uncles resigning in favour of their nephews. The other main avenue to a bishopric was the patronclient system. A young doctor of canon law would enter the household of a cardinal, serve him as secretary or in some other capacity, and obtain a bishopric through his influence. In Italy as elsewhere in Europe, bishops generally knew their law – better, in fact, than their theology.⁸

Parish priests also depended on patronage, since the right to appoint to a particular benefice often belonged to a particular family. Some rectors or holders of benefices did not do the work themselves but hired a deputy or 'vicar' to do it for them, often for a small proportion of the income. In the early sixteenth century, some chaplains in the diocese of Milan had an income of only 40 *lire* a year, less than that of an unskilled labourer. Some priests were active as horse or cattle dealers as a way of making ends meet. Whether rectors or vicars, parish priests had little formal training. They learned what they had to do by what has been called 'apprenticeship' – in other words, by helping and watching. Stories of their ignorance were common and may well have been exaggerated for effect, but diocesan visitations regularly revealed priests who lacked breviaries, or who could be described in laconic but devastating terms such as 'he knows nothing' or 'he is illiterate'. 9

Finally, there were the religious orders. There were monks, notably the Benedictines, among them the poet Teofilo Folengo, and the particularly strict Order of Camaldoli, one of whose members was the fifteenth-century humanist Ambrogio Traversari, a friend of Niccolò de Niccoli and Cosimo de'Medici and translator of some of the Greek Fathers of the Church.¹⁰ There were five mendicant orders. The Servites, devoted to the Blessed Virgin, had been founded at Florence. The Augustinians included Luigi Marsigli, a friend of Niccoli and the humanist Coluccio Salutati. Among the Carmelites, devoted to Our Lady of Mount Carmel, were Fra Lippo Lippi and the Latin poet Giovanni Battista Spagnolo, better known as 'the Mantuan'. The Dominicans included the painter Fra Angelico and the preacher Fra Girolamo Savonarola. The Franciscans had several leading preachers, among them San Bernardino of Siena. If they did not produce a major artist, they certainly had a great influence on the arts from the thirteenth century onwards.¹¹

⁸ Alberigo, *Vescovi italiani*; Prosperi, 'Figura del vescovo'. Cf. Hay, *Church in Italy*, pp. 18–20.

⁹ Hay, Church in Italy, pp. 49-57.

¹⁰ Collett, Italian Benedictine Scholars, ch. 1.

¹¹ Hay, *Church in Italy*, pp. 58–61; Zarri, 'Aspetti dello sviluppo degli ordini religiosi'; Francastel, 'Valeurs socio-psychologiques de l'espace–temps', pp. 305–15; Kempers, *Painting, Power and Patronage*, pp. 26–35.

It was the friars who made sermons important in Italian religious life, in the towns at least, at a time when many of the parish clergy seem to have been 'dumb dogs that will not bark', as reformers liked to describe their English equivalents. San Bernardino even told his congregation that, if they had a choice between Mass and a sermon, they should choose the sermon. Enthusiasts took his sermons down in shorthand, and legal proceedings were sometimes postponed so that everyone could go and listen. 12 Some preachers had little to learn from actors. One is said to have read to his congregation a letter from Christ, while another, Fra Roberto da Lecce, entered the pulpit to preach a crusade wearing a full suit of armour. If sermons receive no more than a brief mention in this study, it is not because they were unimportant in the cultural life of the time, but because they belong to late medieval tradition rather than to Renaissance innovation, and because the printed collections which survive are a highly abbreviated and incomplete record and no firm basis for the reconstruction of actual performances.¹³

Religious festivals were another kind of performance which it is hard to reconstruct but which meant a great deal to Italians in the fifteenth and sixteenth centuries. The feast of Corpus Christi, for example, was growing in importance in the fifteenth century. It was celebrated with special magnificence at Viterbo in 1462 by Pius II and his cardinals, as the pope records in his memoirs; the decorations included a fountain which ran with water and wine and 'a youth impersonating the Saviour, who sweated blood, and filled a cup with a healing stream from a wound in his side'. 14 A famous painting by Gentile Bellini represents the Corpus Christi procession in Venice as it went through Piazza San Marco. In the sixteenth century, tableaux vivants became an important element of Venetian Corpus Christi processions. 15 Religious plays were another important element in these festivals – performances within the performance. Corpus Christi was one great occasion for plays; another, in Florence at least, was the feast of the Epiphany, when the plays represented the three wise men, or kings, Jasper, Baltasar and Melchior, bringing their gifts to the infant Christ. In Rome, a Passion play was performed every year at the Colosseum. As a fifteenth-century German visitor recorded, 'This was acted by living people, even the scourging, the crucifixion, and how Judas hanged himself. They were all the children of wealthy people, and it was therefore done orderly and richly.'16

¹² Origo, World of San Bernardino; Bronzini, 'Pubblico e predicazione popolare'.

¹³ Rusconi, 'Predicatori e predicazione'; Nigro, Brache di San Griffone.

¹⁴ Pius II, Commentaries, bk 8.

¹⁵ Muir, Civic Ritual, pp. 223-30.

¹⁶ Harff, Pilgrimage, p. 40.

Among the most important festivals were those of the patron saints of cities: St Ambrose in Milan, St Mark in Venice, St John the Baptist in Florence, and so on. Such feasts were events on which civic prestige depended and on which communal values were solemnly reaffirmed. In Florence, for example, the feast of St John was celebrated with races, jousts and bull-fights. The subject towns of the Florentine empire sent deputations to the capital, there was a banquet for the Signoria (the town council), and there were the usual floats, races, cavalcades, hunts, jugglers, tight-rope walkers and giants (impersonated by men on stilts). Such as the patron saints of the patron saints of the patron saints and the patron saints of the patron sai

Central to the organization of these plays and festivals were religious fraternities (compagnie, scuole). These voluntary associations of the laity were widespread in the fourteenth and fifteenth centuries, when at least 420 of them were found in north and central Italy alone. Their main role may be described as the imitation of Christ: this underlay their frequent practice of flagellation, their banquets (a ritual of solidarity modelled on the Last Supper), their washing of the feet of the poor on special occasions, and their concern with what were known as the seven works of temporal mercy: visiting the sick, feeding the hungry, giving drink to the thirsty, clothing the naked, helping prisoners, burying the dead and giving lodging to pilgrims. Some specialized in a particular function. The fraternity of St Martin (Buonomini di San Martino) was founded in Florence in 1442 to aid the poor, especially the genteel poor, and named after the saint who had divided his cloak with a beggar. Others comforted condemned criminals, like the Roman fraternity of St John Beheaded (San Giovanni Decollato), of which Michelangelo was a member, 19

The significance of the fraternities as the patrons of art has already been discussed (above, p. 96). They played an important part in religious festivals, walking in procession and performing in pageants and plays. It was, for example, the Fraternity of the Magi in Florence which performed the pageant of the three kings.²⁰ The Fraternity of St John, also in Florence, performed Lorenzo de'Medici's play Saints John and Paul. The Fraternity of the Gonfalon in Rome staged the regular Good Friday Passion play at the Colosseum (the painter Antoniazzo Romano was a member and he painted the scenery). Fraternities often sang hymns in praise of the Virgin and the saints, in their processions and in church, and

¹⁷ Peyer, Stadt und Stadtpatron; Fiume, Santo patrono.

¹⁸ Guasti, Feste; Trexler, Public Life, pp. 240ff., 326ff., 406ff., 450ff.

¹⁹ Weissman, *Ritual Brotherhood*; Eisenbichler, *Crossing the Boundaries*. On St Martin, Trexler, 'Charity and the defence of urban elites'; Hughes-Johnson, 'Early Medici patronage'. On St John, Edgerton, *Pictures and Punishment*.

²⁰ Hatfield, 'Compagnia de'Magi'.

these hymns (*laude*) were sometimes distinguished examples of religious poetry and might be set to music by leading composers such as Guillaume Dufay.²¹ Fraternities also listened to special sermons, which might be delivered by laymen. It is curious to think of Machiavelli in the pulpit, but it is still possible to read the 'exhortation to penitence' he delivered to the Florentine Fraternity of Piety. It has been argued that the Platonic Academy of Florence owes as much to these fraternities as to Plato's original Academy.²²

POLITICAL ORGANIZATION

A distinctive feature of the political organization of Renaissance Italy was the importance of city-states and in particular of republics. Around the year 1200, 'some two or three hundred units existed which deserve to be described as city-states.'²³ By the fifteenth century, most of them had lost their independence, but not the Renaissance cities *par excellence*, Florence and Venice. Their constitutions make a study in contrasts.

If ever there were a state apparently well suited to the functional analysis which dominated sociology and social anthropology in the first half of the twentieth century, it is surely Venice. The Venetian constitution was celebrated for its stability and balance, thanks to the mixture of elements from the three main types of government, with the doge representing monarchy, the Senate aristocracy, and the Great Council democracy. In practice the monarchical element was a weak one. Despite the outward honours paid to the doge, whose head appeared on coins, he had little real power. The Venetians had already developed the distinction, best known from Walter Bagehot's famous description of the British constitution in the nineteenth century, between the 'dignified' and the 'efficient' parts of the political system. The Great Council, by contrast, did participate in decision-making, but this council of nobles was not exactly democratic. As for conflicts, they were not absent but hidden behind the fiction of consensus.

Like the idea of the mixed constitution, Venetian stability or 'harmony' was not a neutral descriptive term. It was part of an ideology, part of the 'myth of Venice', as historians call it today – in other words, the idealized view of Venice held by Venetians from the ruling class, such as Cardinal Gasparo Contarini, whose Commonwealth and Government of

²¹ Monti, Un laudario umbra and Confraternite medievali.

²² Kristeller, 'Lay religious traditions'.

²³ Waley, Italian City-Republics, p. 11.

Venice (1543) did much to propagate it.²⁴ Relatively speaking, however, there was a kernel of truth in the idea of Venetian stability. The political system did not change very much during the period. If Venice was ruled by the few, the few were unusually numerous. All adult patricians were members of the Great Council (Maggior Consiglio) – over 2,500 of them in the early sixteenth century²⁵ – hence the size of the Hall of the Great Council and the need for large paintings to fill it.

Florence, by contrast, had an unstable political system, compared by Dante in his *Divine Comedy* – which exile gave him the leisure to write – to a sick woman twisting and turning in bed, uncomfortable in every position (*Vedrai te simigliante a quella inferma / Che non può trovar pose in su le piume / Ma con dar volta suo dolore scherma*).²⁶ As a sixteenth-century Venetian observer put it, 'They have never been content with their constitution, they are never quiet, and it seems that this city always desires a change of constitution, so that no particular form of government has ever lasted more than fifteen years.' He commented, rather smugly, that this was God's punishment for the sins of the Florentines.²⁷ It may have had rather more to do with the fact that Florentines enjoyed political rights at the age of fourteen, while Venetians were not considered politically adult till they were twenty-five and had to be old men before their ideas were taken seriously. The average age of a doge of Venice on his election was seventy-two.²⁸

For whatever reason, change was the norm in Florence. In 1434, Cosimo de'Medici returned from exile and took over the state. In 1458, a Council of Two Hundred was set up. In 1480, this was replaced by a Council of Seventy. In 1494, the Medici were driven out, and a Great Council was set up on the Venetian model. In 1502, a kind of doge was created, the 'gonfaloniere for life'. In 1512, the Medici returned in the baggage of a foreign army. In 1527, they were driven out again, and in 1530 returned once more. It may not be too fanciful to suggest that there is some link, however difficult it may be to specify it, between the political culture and the artistic culture of the Florentines and the propensity to innovate in these two spheres. By contrast, the less unstable Venetians were slower to welcome the Renaissance. Apart from this tendency to structural change, Florence differed from Venice in that offices rotated more rapidly; the chief magistrates, or Signoria, were in office for only

²⁴ Gaeta, 'Alcuni considerazioni sul mito'; Logan, Culture and Society, ch. 1; Finlay, Politics in Renaissance Venice, ch. 1.

²⁵ Davis, Decline of the Venetian Nobility, ch. 3; Finlay, Politics in Renaissance Venice, ch. 2.

²⁶ Dante, *Purgatorio*, Canto 6.

²⁷ Segarizzi, Relazioni, p. 39.

²⁸ Finlay, 'Venetian republic as a gerontocracy'; Chojnacki, 'Political adulthood'.

two months at a time. The minority of Florentines involved in politics was much larger than that in Venice, with more than 6,000 citizens (craftsmen and shopkeepers as well as patricians) eligible for the chief magistracies alone.²⁹

The other three major powers in Italy were effectively monarchies, two hereditary (Milan and Naples) and one elective (the Papal States). Here, as in smaller states such as Ferrara, Mantua and Urbino, the key institution was the court. So many major works of Renaissance art and literature, from Mantegna's *Camera degli sposi* to Ariosto's *Orlando Furioso*, were produced in this milieu that it is important to understand what kind of place it was. This task has become easier thanks to a number of specialized studies produced in the wake of Norbert Elias's pioneering sociology (or anthropology) of court society.³⁰

Courts numbered hundreds of people. In 1527 the papal court, for example, was about seven hundred strong. From this point of view, the small circle surrounding Lorenzo de'Medici, the first citizen of a republic, does not qualify for the title of 'court' at all.³¹ This court population was extremely heterogeneous and ran from great nobles, holding offices such as constable, chamberlain, steward or master of the horse, through lesser courtiers such as gentlemen of the bedchamber, secretaries and pages, down to servants such as trumpeters, falconers, cooks, barbers and stable boys. Harder to place in the hierarchy (indeed, professional outsiders), but commonly in attendance to entertain the prince, were his fools and midgets. The position of his poets and musicians may not have been so very different.

A crucial feature of the court was that it served two functions which were becoming more and more divergent: the private and the public; the household of the prince and the administration of the state. The prince generally ate with his courtiers. When he moved, most of the court moved with him, despite the logistic problems of transporting, feeding and accommodating a group equivalent to the population of a small town. When Duke Ludovico Sforza decided to go from Milan to his favourite country residence, Vigevano, or to his other castles and hunting lodges, it took five hundred horses and mules to transport the court and its belongings.³² Alfonso of Aragon, king of Naples, was

²⁹ Molho, 'Politics and the ruling class'; Kent, 'Florentine Reggimento' and Rise of the Medici; Rubinstein, Government of Florence; Brucker, Civic World; Stephens, Fall of the Florentine Republic; and Butters, Governors and Government, ch. 1.

³⁰ Elias, Court Society; cf. Quondam, Corti farnesiane; Ossola, Corte e il cortegiano; Prosperi, Corte e il cortegiano; Fantoni, Corte del granduca; Rosenberg, Court Cities.

³¹ Contrast Pottinger, Court of the Medici.

³² Malaguzzi-Valeri, Corte di Lodovico il Moro, vol. 1, ch. 3.

similarly mobile much of the time, visiting different parts of an empire which included Catalonia, Sicily and Sardinia. His officials were forced to follow his example, indeed to follow him in a quite literal sense. In December 1451, for instance, Alfonso summoned his council to Capua, where he happened to be hunting, in order to decide his dispute with the city of Barcelona.³³

The cultural importance of the court as an institution was that it brought together a number of gentlemen - and ladies - of leisure. It was crucial to what Elias calls 'the civilizing process'. Like elegant manners, an interest in art and literature helped show the difference between the nobility and ordinary people. As in the salons of seventeenth-century Paris, the presence of ladies stimulated conversation, music and poetry. We must, of course, beware of idealizing the Renaissance court. Castiglione's famous Courtier must not be taken too literally. It was planned as a courtly equivalent of Plato's treatise on the ideal republic, and it should also be regarded (as the history of the revisions to the text demonstrates) as an exercise in public relations, from the defence of the threatened duchy of Urbino in the first draft to the censorship of anticlerical remarks in the final version, when the author was launching himself on a second, ecclesiastical career.³⁴ It is likely that courtiers often found time hanging heavily on their hands. Even in the pages of Castiglione we find them turning to practical jokes as well as to parlour games in order to alleviate boredom. One of the speakers in the dialogue describes courts where the nobles throw food at one another or make bets about eating the most revolting things: so much for 'civilization'.

A good corrective to the generally idealized portrait painted by Castiglione is the little book produced by the humanist Enea Silvio Piccolomini in 1444, fourteen years before he became pope as Pius II. The *Miseries of Courtiers*, as it is called, is doubtless something of a caricature, and it draws on a tradition of literary and moral commonplaces, but it adds a few sharp personal observations. If a man seeks pleasure at court, writes Enea, he will be disappointed. There is music at court, it is true, but it is when the prince wants it, not when you want it, and perhaps just when you had been hoping to sleep. In any case you cannot sleep comfortably because the bedclothes are dirty, there are several other people in the same bed (which was normal in the fifteenth century), your neighbour coughs all night and pulls the bedclothes off you, or perhaps you have to sleep in the stables. The servants never bring the food on time, and they whisk the plates away before you have finished. You never know when the court is going to move; you make ready to leave, only to

³³ Ryder, Kingdom of Naples.

³⁴ Guidi, 'Jeu de cour'.

find that the prince has changed his mind. Solitude and quiet are impossible. Whether the prince stands or sits, the courtier always has to be on his feet. These do not sound like the conditions most likely to stimulate creativity, but they are the conditions in which poets such as Ariosto, to take only the most famous example, must have worked.

Courts existed all over Europe, and there were city-states, in practice if not always in strict political theory, in the Netherlands, in Switzerland and in Germany. It is worth asking whether Italian forms of political organization were distinctive in this period and, if so, whether this distinctiveness encouraged the cultural movement we call the Renaissance. As the Italian historian Federico Chabod asked, 'Was there a Renaissance state?'

Chabod's answer was a qualified 'yes', not so much on the grounds of the political consciousness of which Jacob Burckhardt made so much as of the rise of bureaucracy.³⁵ 'Bureaucracy' is a term with many meanings. It will make for clarity if we follow the precise definitions of the German sociologist Max Weber and distinguish two political systems, the patrimonial and the bureaucratic, on six criteria in particular.

Patrimonial government is essentially personal, but bureaucratic government is impersonal (the public sphere is separated from the private, and it is the holder of the office rather than the individual whom one obeys). Patrimonial government is carried out by amateurs, bureaucratic government by professionals, trained for the job, with appointment by merit rather than favour, a fixed salary, and an ethos of their own. Patrimonial government is informal, while bureaucrats put everything on record in writing. Patrimonial government is unspecialized, but in the bureaucratic system the officials practise an elaborate division of labour and are careful to define the frontiers of their political territories. Patrimonial government appeals to tradition, bureaucratic government to reason and to the law.³⁶

There is certainly a case for arguing that some at least of the states of Renaissance Italy were precociously bureaucratic, thanks to Italian urbanization and the consequent spread of literacy and numeracy, discussed above; thanks to the existence of republics, where loyalty was focused not on the ruler but the impersonal state; and thanks to the existence in Italy of the capital of a huge international organization, the Catholic Church. The distinction between public and private was certainly drawn quite explicitly by some contemporaries, such as the speaker in Alberti's dialogue on the family who rejected the idea of treat-

³⁵ Chabod, 'Was there a Renaissance state?'. Cf. Gamberini, *Italian Renaissance State*.

³⁶ Weber, Economy and Society, pt 2, chs 10-14.

ing the former in any way as if it were the latter (*ch*'io in modo alcuno facessi del publico privato).³⁷ There was an institutional means of preventing officials confusing public and private to their own advantage: the sindacato. When an official's term of office expired in Florence, Milan and Naples, he had to remain behind until his activities had been investigated by special commissioners or 'syndics'. The pope's dual role as head of the Church and ruler of the Papal States also encouraged awareness of the distinction between an individual and his office.³⁸

Again, full-time officials were relatively numerous, especially in Rome, and a doctorate in law was something of a professional training for them. Some had tenure and developed a corporate ethos. Fixed money salaries were not uncommon, and some of them were relatively high. In Venice at the beginning of the sixteenth century, secretaries in the chancery averaged 125 ducats a year, about the salary of branch managers of the Medici Bank. Attempts were made to ensure appointment by merit rather than by purchase, favour or neighbourhood. In Rome, too, the role of secretaries increased in importance in the period.³⁹

In the greater Italian states, there was considerable demarcation of function between officials. In Milan under Ludovico Sforza, for example, there was a secretary for ecclesiastical affairs, a secretary for justice and a secretary for foreign affairs, who was in turn served by subordinates who specialized in the affairs of different states.⁴⁰ In Florence and Venice specialist committees were set up, concerned with trade, naval affairs, defence, and so on. In Rome in the later sixteenth century, Pope Sixtus V set up 'congregations' or standing committees of cardinals with specialized functions ranging from ritual to the navy. It was in Renaissance Italy that diplomacy first became specialized and professionalized.⁴¹

The importance of written records in administration was increasing. In the fifteenth century, a bishop of Modena was already declaring that he did not want to be a chancellor or ambassador and live in 'a world of paper' (un mundo de carta). The most striking examples of the collection of information come from the censuses, notably the Florentine catasto of 1427, dealing with every individual under the rule of the Florentine Signoria. It was, of course, less difficult to undertake a census of a small state like Florence than of a large one like France. As for the filing and retrieval of information, some sixteenth-century rulers such

³⁸ Prodi, Papal Prince, pp. 50ff.

⁴² Quoted in Senatore, *Mundo de carta*, p. 25.

³⁷ Alberti, I libri della famiglia, p. 221.

³⁹ Kraus, 'Secretarius und Sekretariat'; Partner, Pope's Men.

Santoro, Uffici del domino sforzesco.
 Mattingly, Renaissance Diplomacy.

⁴³ Herlihy and Klapisch-Zuber, Toscans et leurs familles.

as Cosimo de'Medici, grand duke of Tuscany, and popes Sixtus V and Gregory XIII, took a particular interest in the setting up of archives.⁴⁴ There was also increasing awareness, in Rome in particular, of the need for budgeting – in other words, for calculating income and expenditure in advance.⁴⁵

One is left with an impression of Italian self-consciousness and innovation in the political field as in that of the arts. In so far as a bureaucratic mode of domination had developed, it is useful to speak of a 'Renaissance state'. All the same, the extent and speed of change must not be exaggerated. Italy had no lack of courts, and at court, as we have seen, public administration was not separated from the private household of the ruler; loyalty was focused on a man, not an institution, and the ruler by-passed the system whenever he wished to grant a favour to a suitor. In appointments and promotions, the prime necessity was the prince's favour. As Pius II remarked in his complaint of the miseries of courtiers, 'at the courts of princes, what matters is not what you do but who you are' (non enim servitia in curiis principum sed personae ponderantur).⁴⁶

At the court of Rome, official positions were regularly sold, especially in the reign of Leo X, and the department of the Datary grew up to deal with this business.⁴⁷ Offices were also sold in the states of Milan and Naples.⁴⁸ The buyer of the office might not exercise it in person but 'farm' it – in other words, pay a substitute to perform the duties for the fraction of the proceeds, like the 'vicar' in a parish. Offices were seen as investments and were expected to bring in an income. However, official salaries were often inadequate. In Milan in the middle of the fifteenth century, the chancellor of the duke's council was paid little more than an unskilled labourer. Administrators relied on presents, fees and other perquisites, such as the right to a proportion of confiscated goods.

Even the administration of republics was in many ways far removed from Max Weber's model of an impersonally efficient bureaucracy. Indeed, in some respects, such as the corporate ethos of officials, Florence seems to have been less bureaucratic than Milan.⁴⁹ The official system may have stressed equality and merit, but one also has to take into account what Italians today call the *sottogoverno*, the underbelly of the administration. In Venice, for example, some offices were bought, sold and given as dowries. In any Italian state of this period it is difficult to

⁴⁴ Prodi, Papal Prince, p. 117.

⁴⁵ Partner, 'Papal financial policy'.

⁴⁶ Pius II, De curialium miseriis, p. 35.

⁴⁷ Partner, Renaissance Rome, pp. 60ff.; D'Amico, Renaissance Humanism, pp. 27ff.

⁴⁸ Chabod, 'Usi ed abusi'.

⁴⁹ Witt, Hercules at the Cross-Roads, pp. 112ff.

overestimate the importance of family connections and also of what was known euphemistically as 'friendship' (*amicizia*) – in other words, the links between powerful patrons and their dependents or 'clients'. The many surviving letters addressed to members of the Medici family in the years immediately before Cosimo came to power in 1434 give a vivid impression of the importance of *amicizia* to both parties. These letters give substance to the contemporary complaint by Giovanni Cavalcanti that the Florentine commune 'was governed at dinners and in private studies [*alle cene e negli scrittoi*] rather than in the Palace'. ⁵⁰

Many of the political conflicts of the time were struggles between rival 'factions' – in other words, between groups of patrons and clients. Perugia, where the Oddi fought the Baglioni, and Pistoia, where the Panciatichi fought the Cancellieri, were notorious for their factionalism. As Machiavelli put it in the twentieth chapter of his *The Prince*, it was necessary 'to control Pistoia by means of factions' (tenere Pistoia con le parti). Local rivalries continued to give some substance to the venerable party terms 'Guelf' (originally a supporter of the pope) and 'Ghibelline' (a supporter of the emperor) as late as the sixteenth century. The importance of patronage in political and social life gave its force to the Italian proverb 'You can't get to heaven without saints' (Senza santi non si va in Paradiso), picturing the next world in the image of this one. The patronage of artists and writers formed part of this wider system.

At this point we may return to the links between politics and culture. Following Norbert Elias, it has been argued that Renaissance Italy illustrates the links between 'state formation' and 'civilization'.⁵¹ More precisely, we might say that the organization of both political and artistic life was taking increasingly complex and sophisticated forms in Italy, which was in these ways ahead of many other parts of Europe. Given the contrast between different Italian regimes, a more precise question is also worth asking. Which was the better form of government for the arts, the republic or the principality?⁵² Contemporaries discussed the question, but their opinions were divided. Leonardo Bruni argued, as we have seen (p. 32), that Roman culture flourished and died with the republic, and Pius II suggested that 'The study of letters flourished most of all at Athens, while it was a free city, and at Rome, while the consuls ruled the commonwealth.'⁵³ On the other hand, the fifteenth-century humanist Giovanni Conversino da Ravenna complained bitterly: 'Where

⁵⁰ Kent, *Rise of the Medici*, pp. 83ff. Cf. Weissman, 'Taking patronage seriously'; Cavalcanti, *Istorie fiorentine*, bk 2, ch. 1.

⁵¹ Elias, Civilizing Process; Kempers, Painting, Power and Patronage, pp. 209–16.

⁵² Warnke, *Court Artist*; Kemp, *Behind the Picture*, pp. 153–8.
⁵³ Pius II, *De curialium miseriis*, p. 39.

the multitude rules, there is no respect for any accomplishment that does not yield a profit ... everybody has as much contempt for the poets as he is ignorant of them, and will rather keep dogs than maintain scholars or teachers.'54

The fact that the two great republics, Florence and Venice, were the cities where most artists and writers originated is an obvious point in favour of the Bruni thesis. However, it is not enough to record a correlation; we have to try to explain it. Although it is impossible to measure the achievement drive, it is reasonable to expect it to be greater in republics because they are organized on the principle of competition, so that parents are more likely to bring up their children to try to excel over others. One might also expect this drive to be stronger in Florence, where the system was more open, than in Venice, where the major public offices were virtually monopolized by the nobility. So it was better for artists and writers to be born in a republic; they had a better chance of developing their talents.

After these talents had been developed, however, patronage was needed, and in this case it is less easy to say which political system benefited artists and writers most. In republics there was civic patronage, at its most vigorous in Florence in the early fifteenth century, when artisans still participated in the government, while Brunelleschi was elected to one of the highest offices, that of 'prior', in 1425. It was helped by campanilismo, a sense of local patriotism fuelled by rivalry with the neighbouring commune and expressed architecturally in the magnificent town halls of the period (the Sienese deliberately built their tower higher than that of Florence). Civic patronage was weaker in the later fifteenth century and weaker in Venice than in Florence, despite the official and quasi-official positions of Bembo, Titian and others. It is not surprising to find artists who had been born and trained in republics attracted to courts - Leonardo to Milan, Michelangelo to Rome, and so on. An enterprising prince who was willing to spend the money could make his court an artistic centre fairly quickly, by buying up artists who were already in practice. What he could not do was to produce artists. Whether young men chose to follow the career of artist or not depended, as we have seen, on the social structure.

THE SOCIAL STRUCTURE

One reason for the trend towards bureaucratic government not going further was that impersonal administration was impossible in what was still essentially a face-to-face society. Only two cities, Naples and

⁵⁴ Quoted in Baron, Crisis of the Early Italian Renaissance, p. 139.

Venice, had populations over 100,000. Loyalty to one's quarter of town. or ward, or rione (as in Rome), or sestiere (as in Venice) was strong, a lovalty which has survived - whatever the reason - among the contrade of Siena today and is symbolized in the famous annual race, the palio.55 Within the quarter, the neighbourhood (vicinanza) was a meaningful unit, a stage for local dramas of solidarity and enmity. In Florence, the neighbourhood, or more exactly the gonfalone (a quarter within the quarter, or a sixteenth of the city), was a focus for political activity, as has been shown by studies of the 'Red Lion' and 'Green Dragon'.56 The parish was often a community, and so was the street, which was frequently dominated by a particular trade, such as the goldsmiths in Via del Pellegrino in Rome. Cities were small enough for the sound of a particular bell, such as the marangone in Venice or the bell in the Torre del Mangia in Siena, to announce the opening of the gates, or the beginning of the working day, or to call the citizens to arms or to a council.⁵⁷ Official impersonality was hindered by the fact that citizens might know officials in their private roles.

Renaissance Florence seems in some ways more like a village than a city, in the sense that so many of the artists and writers with whom we are concerned knew one another, often intimately. A vivid illustration of relationships in this face-to-face society is the meeting of experts called by the *Opera del Duomo* of Florence in 1503 to decide where to display Michelangelo's *David*. Present were thirty men, mainly artists, including Leonardo, Botticelli, Perugino, Piero di Cosimo, Cosimo Rosselli, the Sangallos and Andrea Sansovino, all recorded in the minutes as discussing one another's suggestions. 'Cosimo has said exactly where I think it should go', says Botticelli, and so on.⁵⁸

However, Italian society was certainly complicated enough to need an elaborate system of classification. The range of occupations was expanding, especially what we now call 'professions' – not only lawyers and physicians, but professors, managers and secretaries.⁵⁹ A simple way of illustrating this complexity is to quote a few examples of annual income, in lire, in order to show the range in variation, which works out at 3,500 to 1.60

⁵⁵ Dundes and Falassi, Terra in piazza.

⁵⁶ Kent and Kent, *Neighbours and Neighbourhood*; Eckstein, *District of the Green Dragon* and 'Neighbourhood as microcosm'.

⁵⁷ Hook, Siena, pp. 96ff.

⁵⁸ Gaye, Carteggio inedito d'artisti, vol. 2, pp. 454–63; Klein and Zerner, Italian Art, pp. 39–44.

⁵⁹ Biow, Doctors, Ambassadors, Secretaries.

⁶⁰ Different currencies (florins, ducats, etc.) have been converted into lire because this was the standard 'money of account' of the period. The annual figures are

L140,000	the richest Venetian cardinal, c.1500
L77,000	great merchant, Venice, c.1500
L21,000	doge of Venice, c.1500
L12,500	ambassador, Venice, c.1500
L3,750	captain of infantry, Milan, c.1520
L900	secretary in the Chancery, Venice, c.1500
L900	master shipwright, Venice, c.1500
L600	branch manager, Medici Bank, Florence, c.1450
L400	silkweaver, Florence, c.1450
L250	soldier, Milan, c.1520
L250	court trumpeter, Milan, c.1470
L200	young bank clerk, Florence, c.1450
L150	soldier, Venice, c.1500
L120	mason or carpenter, Milan, c.1450
L70	shop-boy, Florence, c.1450
L60	labourer, Milan, c.1450
L50	servant, Venice, c.1500
L50	apprentice shipwright, Venice, c.1500
L40	chaplain, Milan, c.1500
L40	servant, Florence, c.1450

As we have seen (above, p. 200) contemporaries were conscious of these complexities. There is no need to repeat their descriptions of society. What is required by the general argument of this study is a discussion of the extent to which Renaissance Italy was distinctive in its social structure, as it certainly was in its culture. This discussion will be focused on two questions. Was Italian society open? Was it bourgeois?

The first question can be rephrased more precisely. Was social mobility higher in Italy than elsewhere in the fifteenth and sixteenth centuries? In this formulation, the difficulty of giving it a straight answer will become more obvious. Individual cases of upward mobility are striking. Giovanni Antonio Campano, for example, a shepherd boy who became a university lecturer in Perugia and was made a bishop by Pius II, illustrates the traditional function of the Church as an avenue for advancement. Nicholas V, the so-called humanist pope, lived in poverty in his student days, although he was the son of a professional man, a physician.

sometimes conversions of daily rates, multiplied by 250 rather than 365. No allowance is made for changes in prices because Italy was struck by serious inflation only in the mid-sixteenth century. The sources used are Fossati, 'Lavoro e lavoratori'; Lane, Venetian Ships and Shipbuilders; Barbieri, Economia e politica; Sardella, Nouvelles et spéculations; Chabod, L'epoca di Carlo V; Roover, Rise and Decline of the Medici Bank. On workers' wages, cf. Goldthwaite, Building of Renaissance Florence, appendix 3.

Bartolommeo della Scala was a miller's son who became chancellor of Florence. Scala's coat of arms featured a ladder, with the motto 'step by step' (*gradatim*). These were obvious heraldic puns on his name but also an appropriate symbol of his social mobility. His Apologia discusses great men of humble birth.⁶¹ Less impressive to contemporaries, but of greater interest to posterity, are the cases of peasants turned artists, from Giotto to Beccafumi (above, pp. 53–4).

The literature of Renaissance Italy suggests a society which was unusually concerned with social mobility. Some of the literary references are hostile, such as the sixteenth Canto of Dante's *Inferno*, with its critique of Florence for 'the upstart people and the sudden gains' (*La gente nuova e i subiti guadagni*). Others are more favourable, such as Poggio's dialogue *On True Nobility*, which fits in better with the image of life as a race which the best man wins (above, p. 205). There was considerable interest in ancient Greek and Roman examples of men of humble origins rising to high place. The dominant value system (in Tuscany at least) favoured social mobility. However, a famous study of America in the mid-twentieth century revealed serious discrepancies between the theory and the practice of social mobility, discrepancies which cannot be discounted for earlier periods.⁶²

It is unfortunately impossible to measure the rate of social mobility in Renaissance Italy. The evidence is too fragmentary and the different systems of taxation, and so on, in different states make precise comparison virtually impossible. ⁶³ This is particularly unfortunate in a field where the historian who does not make a statement about quantities says virtually nothing, for there is virtually no society without some measure of social mobility and no society where mobility is 'perfect' – in other words, where the status of individuals has a purely random relation to that of their parents. All societies are somewhere in between these two extremes; what matters is the precise position.

All the same there are good reasons for asserting that social mobility was relatively high in the cities of fifteenth-century Italy, and above all in early fifteenth-century Florence, with 'new men' (*gente nuova*) coming in from the countryside and becoming citizens and holding office in number sufficient to alarm patricians such as Rinaldo degli Albizzi, who, according to a contemporary chronicle, launched a violent attack on these new men in a meeting held in 1426.⁶⁴ The competitiveness, the envy and the

⁶¹ Brown, Bartolommeo Scala.

⁶² Lipset and Bendix, Social Mobility.

⁶³ Delumeau, 'Mobilité sociale'; Herlihy, 'Three patterns'.

⁶⁴ Cavalcanti, *Istorie fiorentine*, bk 3, ch. 2. Cf. Kent, 'Florentine *Reggimento*'; Brucker, *Civic World*, pp. 256ff., 472ff.

stress on achievement of the Florentines (discussed above, p. 204) look very much like characteristics of a mobile society.

By the later fifteenth century, however, the ranks had closed. In Padua, Verona, Bergamo and Brescia, the change came earlier, perhaps as a result of their incorporation into the Venetian empire. In Venice itself there was little opportunity for new men to enter the patriciate throughout the period, whatever mobility there may have been at lower levels.⁶⁵

The second question which this section attempts to answer is whether Italian society of this period may reasonably be described as 'bourgeois'. That it was bourgeois has been the assumption of many historians of the Renaissance, as we have seen, but this bold statement needs to be hedged about with at least a few qualifications and distinctions.⁶⁶

In the fifteenth and sixteenth centuries, Italy was one of the most highly urban societies in Europe. In 1550, about forty Italian towns had a population of 10,000 or more. Of these, about twenty had a population of 25,000 or more, as follows (figures have been rounded to the nearest 5,000).⁶⁷

210,000	Naples
160,000	Venice
70,000	Milan, Palermo
60,000	Bologna (1570), Florence, Genoa (1530)
50,000	Verona
45,000	Rome (55,000 in 1526)
40,000	Mantua, Brescia
35,000	Lecce, Cremona
30,000	Padua, Vicenza
25,000	Lucca, Messina (1505), Piacenza, Siena
20,000	Perugia, Bergamo, Parma, Taranto, Trapani

In the rest of Europe, from Lisbon to Moscow, there were probably no more than another twenty towns of this size. About a quarter of the population of Tuscany and the Veneto was urban; in all the regions of Europe, only Flanders is likely to have had a higher proportion of townspeople.

It must not be assumed that all these townspeople were bourgeois. Renaissance Florence and other cities rested on the backs of what contemporaries called the *popolo minuto*, the 'labouring classes'.⁶⁸

⁶⁵ Ventura, Nobiltà e popolo, ch. 2; Lane, Venice, pp. 111ff., 151ff., 252ff.

⁶⁶ Jones, 'Economia e societa'.

⁶⁷ Beloch, Bevölkerungsgeschichte, pp. 327ff.

⁶⁸ Cohn, Laboring Classes.

Florence has been described as 'two cities' of rich and poor, even if the potential conflict between these two groups was reduced by patron–client relations, solidarity between neighbours and opportunities for social mobility. ⁶⁹ All the same, the relative importance of Italian towns is obviously linked with the relative importance of merchants, professional men, craftsmen and shop-keepers. All these groups are sometimes called 'bourgeois'; none of them fits the traditional model of a society divided into clergy, nobles and peasants. However, it is necessary to distinguish between them. Rich merchants were sometimes important as patrons. The craftsmen sired the artists, while the professional men sired the writers and humanists, whether they were lawyers (Machiavelli's father), physicians (Ficino's father), notaries (Brunelleschi's father) or professors (Pomponazzi's father).

To go beyond these relatively precise points requires speculation. Was there an affinity between Renaissance values, notably the concern with abstraction, measurement and the individual, and the values of one or more groups within the bourgeoisie? The analogies are obvious enough, but the point must not be made too crudely. Machiavelli was a master of political calculation, but he expressed contempt for Florence as a city governed by shop-keepers (*uomini nutricati nella mercanzia*), and he described himself as 'unable to talk about gains and losses, about the silk-guild or the wool-guild'.⁷⁰

There are other links between the social structure of Renaissance Italy and its art and literature. The importance of the lineage and the value set upon its cohesion, in noble and patrician circles at least, helps explain the importance of the family chapel and its tombs, the focus of a kind of ancestor worship. No ancestors, no lineage. Large sums of money were spent on palaces partly because they were a symbol of the greatness of the 'house' in the sense of the family. Loggias might be built (as, in the most famous case, that of the Rucellai in fifteenth-century Florence) as a setting for feasts and other rituals involving a large group of kinsmen. On the other hand, a breakdown of the cohesiveness of the extended family may well have encouraged Renaissance 'individualism' (the self-consciousness no less than the competition).⁷¹

Finally, this brief survey of Italian society suggests that the ambiguous

⁶⁹ Kent, 'Be rather loved than feared'.

⁷⁰ Letter to Vettori, 9 April 1513. Hence it is likely that the Niccolò Machiavelli who worked in a bank was a different man, despite Maffei, *Giovane Machiavelli banchiere*.

⁷¹ Goldthwaite, *Private Wealth*, and Kent, *Household and Lineage*, offer important and to some extent contradictory studies of Florentine patrician families. On loggias and ancestors, Kent, *Household and Lineage*, ch. 5. On society and individuals, Connell, *Society and Individual*.

status of the painter, the musician and even, to some extent, the humanist are special cases of a more general problem: that of finding a place in the social structure for everyone who was not a priest, warrior or peasant (above, p. 200). If the status of the artist was ambiguous, so was that of the merchant. It is probably no mere coincidence that it was in cities of shop-keepers, Florence in particular, that the artist was accepted most easily. It was probably easier for achievement-oriented merchant cultures to recognize the worth of artists and writers than it was for birth-oriented military cultures such as France, Spain and Naples. It is no surprise to find a relatively mobile society like Florence associated with respect for achievement and also with a high degree of creativity.

THE ECONOMY⁷²

The fact that towns were larger and more numerous in Italy than elsewhere does a good deal to explain the importance in the social structure of the different 'middle classes', such as the craftsmen, merchants and lawyers. But this explanation leads to a further question: why were towns so important in Italy?

Once established, towns were able to maintain their position by their economic policies. Cities generally controlled the countryside around them, their *contado*, and they might enforce at the expense of the countryside a policy of cheap food for their own inhabitants, as a study of Pavia, for instance, has demonstrated.⁷³ The *contado* was also forced to pay more than its share of tax, which must have been an incentive for the more prosperous peasants to migrate to the city. Revolts against cities by their rural subjects were not uncommon; Tuscan highlanders rebelled in 1401 and again in 1426 against their domination by Florence.⁷⁴ Citizens also enjoyed legal and political privileges which inhabitants of the countryside lacked. In the sixteenth century, pregnant women used to come into Lucca from the *contado* to give their children the advantages of birth within the city walls.⁷⁵ No wonder that there was an Italian proverb to the effect that the countryside is for animals and the city for men.

These policies do not, of course, explain how the cities came to grow up where they did in the first place. The siting of the major urban centres of Renaissance Italy owed a good deal to the communication system inherited partly from nature and partly from ancient Rome. Genoa,

⁷² For the Mediterranean context, Braudel, Mediterranean and the Mediterranean World, pts 1 and 2.

⁷³ Zanetti, Problemi alimentari.

⁷⁴ Cohn, Creating the Florentine State.

⁷⁵ Berengo, Nobili e mercanti, p. 298.

Venice, Rimini, Pesaro, Naples and Palermo are all seaside towns, while Rome and Pisa are not far from the coast. Pavia and Cremona are on the Po, Pisa and Florence on the Arno, and so on. The Roman Via Emilia, still followed by the railway, links Piacenza, Parma, Modena, Bologna, Imola, Faenza, Forli and Rimini.⁷⁶

These advantages are still insufficient to explain the importance of the towns of Renaissance Italy. Towns develop in response to demands from other places, either their immediate hinterland or more distant areas, because they perform services for these other places. In the case of pre-industrial Europe, it is useful to distinguish three types of service and three types of city.

First, there was the commercial city, usually a port, such as Venice and its rival Genoa. The hinterland they served was much more than the Veneto or Liguria. Genoa was no longer so great a commercial power as it had been in the thirteenth century, especially after the Turks took Caffa, its trading post on the Black Sea, but its role in the grain and the wool trade involved economic relations with France, Spain and North America.⁷⁷ As for Venice, in a sense its economic hinterland was the whole of Europe because Venetian merchants were the principal middlemen in the trade between Europe and the East (Aleppo, Alexandria, Beirut, Caffa, Constantinople, Damascus, etc.), without serious competitors before the Portuguese began to use the Cape route at the end of the fifteenth century. In the early fifteenth century, Venice was one of the greatest merchant cities in the world (after Cairo, Guangzhou and Suzhou) and exported 10 million ducats' worth of goods a year. The Venetians imported cotton, silk and spices (especially pepper), for which they paid partly in woollen cloth (English as well as Italian) and partly in silver coins minted specially for the purpose. At the beginning of the sixteenth century, 2.5 million pounds of spices came to Venice every year from Alexandria, and 300,000 ducats, besides merchandise, went back in return. The spices were resold to the merchants of Augsburg, Nuremberg and Bruges.78

Secondly, there was the craft-industrial town such as Milan or Florence. Florence was the industrial town *par excellence*, and cloth-making the chief industry; a late fifteenth-century description of the city lists 270 cloth-making workshops, compared with 84 for woodcarving and inlay, 83 for silk, 74 for goldsmiths and 54 for stonedressers. Through cloth-making the Florentines became involved in trade. Their

 $^{^{76}}$ Gambi and Bollati, *Storia d'Italia*, offer a well-illustrated introduction to the historical geography of Italy.

⁷⁷ Lopez, 'Quattrocento genovese'.

⁷⁸ Lane, Venice.

Calimala guild (discussed earlier as a patron of the arts) imported cloth from France and Flanders, arranged for it to be 'finished' (sheared, dyed, and so on), and re-exported it.⁷⁹ Cloth-making was also important in Milan, but the city was best known for its armourers and other metalworkers.⁸⁰ Genoese silks had an international reputation, while Venice was famous for its glass, its ship-building and, from the 1490s or thereabouts, its printing industry; Aldo Manuzio was the most scholarly and the most famous but far from the only Venetian printer of the sixteenth century. In the sixteenth century, Venice was the most important centre of printing in Europe.⁸¹

Thirdly, there was the service city. One of the most profitable services to offer was financial. From the fourteenth century to the sixteenth, the Italians dominated European banking. The leading firms included the Bardi and the Peruzzi of Florence (till Edward III and other rulers bankrupted them), the Medici, and, at the end of the period, the Pallavicini and the Spinola of Genoa, who lent vast sums to King Philip of Spain. Capital cities offered other kinds of service - Naples and Rome, for example, were cities of officials and centres of power. In the case of Naples, the hinterland for the 'services' provided by judges, advocates, tax collectors, and so on, was the Kingdom of Naples or, in the reign of Alfonso of Aragon, his entire Mediterranean Empire. In the case of Rome, the hinterland was sometimes the Papal States, but for some functions it was the whole Catholic world. Rome was, as a contemporary critic remarked, 'a shop for religion' (una bottega delle cose di Cristo). Among its invisible exports were indulgences and dispensations. This huge business required management, and an important role was played by the pope's bankers, from the Medici to Agostino Chigi of Siena, remembered today for his patronage of Raphael.82

Despite the growing importance of grain imports, this elaborate urban structure rested on the foundation of Italian agriculture. Particularly fertile was the Po valley, one of the great plains of Europe. It owed this fertility partly to nature – a well-distributed rainfall – and partly to human activity. In the course of the fifteenth century several canals were dug in Lombardy, and irrigation schemes allowed formerly waste land to be brought under the plough. By the year 1500, some 85 per cent of the

⁷⁹ Doren, Florentiner Wollentuchindustrie.

⁸⁰ Barbieri, Economia e politica.

⁸¹ Lowry, World of Aldus Manutius and Nicholas Jenson; Zeidberg and Superbi, Aldus Manutius and Renaissance Culture; Nuovo, Commercio librario.

⁸² Roover, Rise and Decline of the Medici Bank; Gilbert, Pope, his Banker, and Venice, ch. 4.

⁸³ Sereni, *Storia del paesaggio* and 'Agricoltura e mondo rurale'; Jones, 'Agrarian development' and 'Italy'.

land between Pavia and Cremona was under cultivation, an extremely high proportion for the period when marshes and woods were much more widespread than they are today. Dairy farming was becoming important.⁸⁴

South of the Po valley the picture was less rosy. In Tuscany, although the hilly terrain restricted agriculture, the interior valleys were fertile. The Valdarno was best known for grain, the Valdichiana for wine, the Mugello for fruit, and the area around Lucca for olives. However, in the fourteenth and fifteenth century land was going out of cultivation in Tuscany, and 10 per cent of the villages disappeared altogether. Further south, the rocky terrain and the low rainfall in the growing season have always been obstacles to cultivation, and, despite pockets of prosperity around Naples and elsewhere, southern agriculture was in decline. There was a gradual shift from arable to pasture, accompanied by a fall in population. As in Thomas More's England, the sheep were eating up the men.

To maintain Italy's high urban population, it was necessary for many farmers to produce for the market. For example, the concentration in Venice of some 160,000 people who did not grow their own food led to the commercialization of agriculture not only in the Veneto but as far afield as Mantua, the Marches and even, perhaps, Apulia. The Italian cloth industry encouraged the growing of woad in Lombardy and the keeping of sheep in the Roman Campagna and in the south, as well as in Tuscany.

This brief description of the Italian economy is intended as no more than an introduction to the question of its links with the Renaissance. Before discussing these links, however, it is necessary to tackle one major problem. Was the economy 'capitalist'? Capitalism has been defined in many different ways, but it may be useful to emphasize two features of this mode of production: the concentration of capital in the hands of a few entrepreneurs and the institutionalization of a rational, calculating approach to economic problems. It may also be useful to draw distinctions between commercial, financial and industrial capitalism.⁸⁶

It is not difficult to find spectacular examples in this period of rich entrepreneurs, such as Averardo di Bicci de'Medici (the grandfather of Cosimo), who left a fortune of 180,000 florins in 1428. It was possible for entrepreneurs to accumulate capital in this way because in some leading industries many of the workers were no longer independent

85 Klapisch-Zuber and Day, 'Villages désertés en Italie'.

⁸⁴ Dowd, 'Economic expansion of Lombardy'.

⁸⁶ Gras, 'Capitalism, concepts and history'. Cf. Braudel, Wheels of Commerce, ch. 3.

craftsmen. Cloth-making was the industry in which the division of labour was most highly developed; contemporaries distinguished some twentyfive or more steps in the process of turning a fleece into a piece of finished cloth, and most of these stages involved a specialized occupation. In Florence, several of these jobs, such as beating, sorting and combing the wool, were carried out in large workshops, which it is tempting to regard as 'factories', by men who were paid by the day. Much of the spinning was done by women living at home, but they might still be dependent on the entrepreneur who supplied them with the raw material. In Genoa and Lucca, the silk merchants provided not only the raw material but also spinning machines and workshops, which they hired out to spinners who worked for them, as they hired looms out to weavers.⁸⁷ This system is very different from industrial capitalism in the nineteenth-century sense of large-scale organization and direct control by the manufacturer, but it is clear that the entrepreneur played a central role and that he exercised considerable control by indirect means.

The numerate mentality of Italian townsmen has already been discussed (above, p. 209). What needs emphasis here is the existence of institutions which both expressed and encouraged this mode of thought and the existence of a complex credit structure which depended on abstraction and calculation and included banks, a public debt, commercial companies and even maritime insurance. As we have seen, banking was something of an Italian speciality in this period. Besides banks, there were also communal pawnshops (Monti di Pietà), which spread in the later fifteenth century with the encouragement of the Church. These Monti borrowed money as well as lending it, and paid regular interest. They were modelled on the public debt, the Monte commune, which had been set up in Florence in the middle of the fourteenth century, thus making the citizens into investors in the state. Florence also had a 'Dowry fund' (Monte delle doti), in which the investor received his money back with interest at the marriage of his daughter.88 Commercial companies existed, and it was possible to invest in them without taking part in their management and with only a limited liability in the case of the company's failure. It was also possible to insure against the loss of ships - Venice was the great centre of marine insurance - while, in Genoa, husbands could even insure against the risk of their wives dying in childbirth.⁸⁹

In many ways, economic organization remained traditional. The

⁸⁷ Doren, *Florentiner Wollentuchindustri*e, criticized by Hermes, 'Kapitalismus', and Roover, 'Florentine firm'. On the silk industry at Lucca, Berengo, *Nobili e mercanti*, pp. 66ff.

⁸⁸ Kirshner and Molho, 'Dowry fund'.

⁸⁹ Tenenti, Naufrages.

small workshop and the family business were the most common forms of industry and trade. Many peasants paid their rent in kind. However, the new forms of organization were unusually well developed in Italy, particularly in large cities such as Florence, Rome and Venice, where so much of what we call the Renaissance was taking place. It is natural to look for links between the state of economy and the state of the culture, more particularly the material culture, the visual arts.

These links are not difficult to find, but they are not easy to describe without falling into a narrow precision or its opposite, a grandiose vagueness. To begin with the detail, we may observe that art and ideas often followed the trade routes. 90 Books followed the route from Venice to Vienna, for example. Venice imported decorative motifs as well as spices from Damascus and Aleppo, and exported art and artists as well as spices to Central Europe. Titian and Paris Bordone went to Augsburg and Jacopo de'Barbari to Nuremberg (just as Dürer arrived in Venice from Nuremberg). Sebastiano del Piombo left Venice for Rome at the invitation of the banker Agostino Chigi; thanks to his business connections, Chigi had come to be well acquainted with the Venetian artistic scene. Tuscan artists also followed the trade routes - Rosso and Leonardo to France and Torrigiani to England (in his case, it is known that Florentine merchants with English contacts arranged this visit). Pictures travelled in both directions. Florentine paintings were shipped to France for the collection of Francis I, but the famous Portinari altarpiece now in the Uffizi was brought to Florence by the manager of the Bruges branch of the Medici Bank.

Precise information of this kind has its interest, but it does not take us very far towards a historical explanation of the Renaissance – why the movement took place in this particular society at this time. Was wealth the key factor? Did Italy have a Renaissance because she could afford it? The problem here is that the dates do not fit. An economic recession followed the devastating plague of 1348–9, and recovery was slow. As we have seen, the economic historian Roberto Lopez has argued that this recession was just what was needed for the Renaissance, that merchants spent their money on the arts at times when there were fewer profitable ways of placing their money than usual – 'hard times and investment in culture'. However, the study of patronage (above, pp. 133ff.) suggests that merchants did not think in terms of investment when they commissioned works of art but rather of piety, pride or pleasure.

⁹⁰ Examples in Bologna, Napoli e le rotte mediterranee; Nuovo, Commercio librario, p. 48.

⁹¹ Lopez, 'Hard times and investment'. Cf. Esch, 'Sul rapporto fra arte ed economia'.

A social factor, style of life, has to be inserted between trends in the economy and trends in culture. In the fifteenth and sixteenth centuries, Florentines and Venetians were coming to value conspicuous consumption more than before. It may be that this change in lifestyle can itself be explained in economic terms, that the shift from entrepreneurs to rentiers was an adaptation to economic recession – a case of 'hard times and contempt for trade', a kind of sour grapes effect. It has also been suggested that the Italian economic structure was unusually favourable to the development of a luxury market, thanks not only to the accumulation of wealth but also to its wide distribution among a constantly changing group of urban consumers.⁹²

In these circumstances, competition for status thrived so that building magnificently became a strategy for distinguishing some families from others. ⁹³ It would be unhistorical to treat Renaissance art as no more than a set of status symbols, forgetting the piety that underlay the patronage of sacred images or the pleasures of a private collection. Yet it would be equally unhistorical to treat the art of this period as if it had no connections with conspicuous consumption at all. The strength of the connections was subject to change over time. To examine the links between cultural and social change is the purpose of the following chapter.

⁹² Goldthwaite, 'Renaissance economy', 'Empire of things', Wealth and the Demand for Art and Economy of Renaissance Florence.

⁹³ Bourdieu, Distinction. On Italy, Burke, Historical Anthropology, pp. 132-49.

-DOD-

CULTURAL AND SOCIAL CHANGE

The natural changes in worldly affairs make poverty succeed riches . . . the man who first acquires a fortune takes a greater care of it, having known how to make his money, he also knows how to keep it . . . his heirs are less attached to a fortune they have made no effort to acquire. They have been brought up to riches and have never learned the art of earning them. Is it any wonder that they let it slip through their fingers?

Guicciardini, Maxims and Reflections, no. 33

The focus of this book has been the description and analysis of social and cultural 'structures' – that is, factors which remain fairly constant over a century or two. They were not static, but it makes for clarity to treat them as if they were. Artistic, ideological, political and economic factors have so far been treated in relative isolation. Such a procedure has its advantages if the aim is to analyse as well as describe. It is obvious, however, that what contemporaries experienced was the combination or conjuncture of all these factors, and that this conjuncture was constantly changing. It may be useful at this point, therefore, to draw together the themes of different sections and to concentrate on the historian's traditional business – the study of change over time.

It is in practice useful to distinguish different kinds of change, as Braudel did in his famous study of the Mediterranean. There is short-term change, the time of events, of which contemporaries are well aware, and there is long-term change, almost impossible to notice at the time but visible to historical hindsight. There are times when it is useful to distinguish the long term from the very long term, as Braudel does, but not in the case of a study concerned, as this one is, with a mere two centuries.

¹ Braudel, Mediterranean and the Mediterranean World.

GENERATIONS

In the study of short-term changes, a useful and attractive concept is that of 'generation'. The concept is attractive because it seems to grow out of experience, that of identifying oneself with one group and distancing oneself from others. It helps in finding links between the history of events and the history of structures, the area where Braudel's study is at its weakest. The concept of generation would seem to be particularly useful in the case of a group as self-conscious as the artists and writers of the Renaissance. It was in fact when discussing Mannerism that the art historian Walter Friedländer formulated his 'grandfather law', arguing that 'A generation with deliberate disregard for the views and feelings of the generation of its fathers and direct teachers skips back to the preceding period and takes up the very tendencies against which its fathers had so zealously struggled, albeit in a new sense.'²

It is often said that a generation lasts about thirty years, the period between maturity and retirement. However, the average length of adult life varies over time, and so does the age distance between parents and children.³ In any case, generations are not objective facts; they are cultural constructs. As in the case of social classes, the consciousness of belonging to a generation is a crucial part of the experience. Characteristic of generations as of social classes is what the sociologist Karl Mannheim called 'a common location in the social and historical process', which encourages certain kinds of behaviour and inhibits others.⁴

If generation-consciousness is created by the historical process itself, generations will not be equally long or divided equally sharply from their predecessors. Momentous events are likely to bind the members of an age-group together more closely than is normal. The Spanish writers known as the 'generation of 1898', for example, from Miguel de Unamuno to José Ortega y Gasset, were bound together by the realization, following the loss of the colonies of Cuba, Puerto Rico and the Philippines, that Spain was no longer a great power.⁵ It may well be that such acute generation-consciousness is a nineteenth- and twentieth-century phenomenon (the result of accelerating political, social and cultural change after 1789), a phenomenon that we must beware of projecting onto an earlier past. It is, however, at least worth attempting to see whether major events in Renaissance Italy made certain age-groups

² Friedländer, Mannerism and Anti-Mannerism, p. 56. Cf. Pinder, Problem der Generation; Peyre, Générations littéraires.

³ Herlihy, 'Generation in medieval history'.

⁴ Mannheim, Essays, pp. 276-320, commenting on Pinder.

⁵ Ramsden, 1898 Movement.

aware of their common location in history, and whether this awareness affected the arts.

The importance of political events in the early fifteenth century in creating a generation has been emphasized by a number of scholars, notably Hans Baron (above, p. 41), in his study of what he calls the 'crisis of the early Italian Renaissance'. Giangaleazzo Visconti, duke of Milan from 1395 to 1402, built up an empire by seizing Verona, Vicenza, Padua, and then Pisa, Perugia, Siena and Bologna. The Florentines, virtually encircled, might well have thought that their turn was next. However, they were able to defend themselves until the duke was carried off by the plague.

Leonardo Bruni, chancellor of Florence, presented the war between Florence and Milan as a struggle between liberty and tyranny. He identified Florence with the Roman Republic under which the city was supposed to have been founded; this is the point of his remark (quoted above, p. 32) that the brilliant minds of Rome vanished under the tyranny of the emperors. In his oration on the death of the patrician Nanni Strozzi, Bruni also identified Florence with classical Athens and the values expressed in the funeral speech of Pericles, which he took as his model.

In the early fifteenth century, there came a relatively sudden change of style in the visual arts in Florence, a move towards the art of ancient Rome. The artists responsible had generally been at an impressionable age when the threat from Giangaleazzo Visconti was removed from their city. Brunelleschi, for example, was twenty-five in 1402; Ghiberti was twenty-four; Masolino was nineteen; Donatello was sixteen or thereabouts.

The 'Baron thesis' provides an elegantly economical explanation for a wide variety of phenomena. It is relevant to the humanism of Bruni and his circle and also to the visual arts. In the arts, it is relevant to form, to the creation of a more 'antique' style, as well as to iconography; as we have seen (above, p. 181), the representations of David and St George had political overtones. The thesis applies to both patrons and artists. Brunelleschi and Donatello were stimulated by civic patronage, and civic patronage was stimulated by the crisis.

Yet this interpretation of the relation between politics and culture is a little more ambiguous than it may look. It is possible to argue either that the events of the year 1402 were decisive in forming the new generation or that this formation was the work of a longer period, extending from the 1390s to the 1420s. To argue, as Baron himself has tended to do, that one year was crucial, involves controversial questions such as the dating

⁶ Baron, Crisis of the Early Italian Renaissance. Cf. Fubini, 'Renaissance historian'; Hankins, 'Baron thesis'; Molho, 'Hans Baron's crisis'.

of certain works by Bruni and also the omission of figures as important as Coluccio Salutati (1331–1406), who expressed similar ideas too early, and Masaccio (1401–*c*.1428), who was born too late.⁷

It seems more plausible to argue that the whole struggle with Milan, and possibly the earlier War of the Eight Saints between Florence and the papacy (1375–8) as well, were the decisive events; but that, of course, spreads the events too thinly for the creation of a generation. It must also be admitted that we know very little of the political attitudes of leading artists such as Brunelleschi and Donatello, or even whether Bruni's stress on liberty was a heartfelt conviction or the expression of an official attitude required by his administrative position. In any case, the argument applies only to Florence. The Florentines were the leaders in innovation, but there were other important humanists, such as Vittorino da Feltre and Guarino da Verona, and other important painters, from Pisanello to Jacopo Bellini. The two humanists did not show any distaste for princes: Vittorino was employed at the court of Mantua, Guarino at that of Ferrara.

Another political event which was supposed to have had a profound impact on culture took place in 1453: the fall of Constantinople to the Turks.8 Long embedded in textbooks as the explanation of the Renaissance, this thesis goes back to the period itself, to the Lombard humanist Pier Candido Decembrio. The fall of the city, so the argument goes, forced Greek scholars to migrate to Italy, bringing with them their knowledge of the Greek language and literature and so stimulating the revival of ancient learning. The obvious objection to this thesis is that Greek scholars were working in Italy before 1453. Gemistos Plethon and Bessarion attended the Council of Florence in 1439, and Bessarion remained in Italy. Demetrios Chalcondylas and Theodore Gaza arrived in Italy in the 1440s. As in the case of the year 1402, however, it is perhaps a mistake to focus attention too narrowly on a particular date. The crucial political event was the westward advance of the Turks, which was clear enough before 1453. Indeed, it was the Turkish threat which underlay the rapprochement between Latin and Greek Christians at the Council of Florence. The humanist Theodore Gaza went to Italy after his native city of Salonika had been taken by the Turks in 1430. After the fall of Constantinople, more Greek scholars, such as Janos Argyropoulos and Janos Lascaris, arrived in Italy.

These immigrants had an important effect on the Italian world of learning, not unlike that of scholars from Central Europe – including spe-

⁷ Critiques of Baron in Seigel, 'Civic humanism'; Larner, Culture and Society, pp. 244ff.

⁸ Burke, 'Myth of 1453'.

cialists on the Renaissance – on the English-speaking world after 1933. They stimulated Greek studies. However, their importance was that they satisfied a demand which already existed. The fall of Constantinople shocked the Christian world, but it does not seem to have bound together a generation. Indeed, the artists and writers born between 1420 and 1450 (Ficino, for example, or Ghirlandaio) seem a much less politically minded group than their predecessors, whether because they reacted against them or because the age in which they were in their prime was an age of relative peace in the peninsula, the age of the balance of power within Italy.

After two essentially Florentine generations came one which was genuinely Italian. Of the eighty-five members of the creative elite born between 1460 and 1479, only twenty-one were Tuscans. In any case, political events made the generation of 1460-90 (which includes Machiavelli and Guicciardini, Ariosto and Bembo, Michelangelo, Titian and Raphael) aware of their common destiny as Italians. Their formative years were marked by the French invasion of 1494 and the long wars which followed, a struggle for mastery between the French (Charles VIII, Louis XII, Francis I) and the forces of Spain (under Ferdinand the Catholic) and the Empire (under Maximilian and Charles V). Many Italians were killed, whether fighting with or against the invaders. Many cities were captured and some were sacked. 'Crisis' is a term which is overworked by historians. Indeed, it ought to be obligatory on anyone who uses the term about a particular period to show that it was preceded and followed by years of non-crisis. All the same, it is clear that Italy was passing through a 'time of troubles'.

The year 1494 has been taken as a turning point in the history of Italy – indeed, of Europe – from that day to this. Francesco Guicciardini and Leopold von Ranke are only two of the distinguished historians who began their narratives with that year. So, still closer to 1494, did Bernardo Rucellai. It cannot be assumed that 1494 marks a break in the history of Italian culture, but it is not difficult to find evidence which supports this suggestion.

The dispersal of artists and writers in this time of troubles is relatively easy to chart. In Florence, for example, the musician Heinrich Isaac left in 1494, when the Medici, his patrons, were driven out. In Naples, plans for improving the city were brought to an end by the French invasion, and the architect Fra Giocondo went back to France with Charles VIII. In Milan, the black year was 1499, when Ludovico Sforza fled from the French and the artists at his court were dispersed. The architect Bramante, the sculptor Cristoforo Solari, and the musician Gaspar van

⁹ Bec, *Italie* 1500–1550, extends the notion of crisis to the whole period 1500–50. ¹⁰ Gilbert, 'Bernardo Rucellai'; Bec, *Italie* 1500–1550.

Weerbecke all went to Rome, while the historian Bernardino Corio retired to his country villa. In 1509, it was the turn of Venice to be attacked. Although the city was not captured, its mainland possessions were overrun. The University of Padua closed for some years, while the printer Aldo Manuzio left Venice for three years, whether for economic or political reasons.¹¹

Two very different conscious responses to the time of troubles were given by Machiavelli and Savonarola. For Savonarola, the French invasion was the fulfilment of his prophecy of a new flood. He described Charles VIII as God's instrument to reform the Church, who had been able to invade Italy because of her sins. Some humanists, such as Giovanni Nesi, joined Savonarola in expecting an immediate 'new age'. 12 For Machiavelli, too, Charles VIII's easy conquest of Italy was a lesson, but what he learned from it was something rather different from Savonarola. Machiavelli learned that men are 'ungrateful, fickle, liars and deceivers', and that force, not reason, was decisive in politics. His work, like Guicciardini's, reflects what has been called a 'crisis of assumptions'. 13 Events had called into question the conventional wisdom, the ideas of the perfectibility of man and the place of reason in politics held by fifteenth-century humanists. Like the Spanish generation of 1898, the Italian generation of 1494, from Machiavelli to Savonarola, however diverse their responses, seems to have been driven by the same need to explain the disaster which had struck them. The Venetians were spared this crisis, only to encounter one of their own in 1509, when the League of Cambrai was formed against them and the independence of the city-state was threatened.¹⁴

It is more difficult to say how far this disaster affected styles of art as well as styles of thought. The example of Botticelli suggests that it did. Although Botticelli was in his late forties when the invasion occurred, his style changed dramatically after 1494. The security of his earlier paintings was replaced by the much more unquiet quality of his *Lamentation*, for example, or his *Mystic Nativity*. The inscription on the latter painting is an unusually direct piece of evidence of a painter's reaction to the time of troubles, which Botticelli, like Savonarola, interpreted in millenarian terms:

I Sandro painted this picture at the end of the year 1500 in the troubles of Italy in the half time after the time according to the eleventh chapter of St John in the second woe of the Apocalypse in the loosing of the devil for

¹¹ Lowry, World of Aldus Manutius, pp. 159-61.

¹² Weinstein, Savonarola and Florence, pp. 194ff., and Savonarola: Renaissance Prophet; Fontes et al., Savonarole.

¹³ Gilbert, Machiavelli and Guicciardini.

¹⁴ Gilbert, 'Venice in the crisis'.

three and a half years. Then he will be chained in the twelfth chapter and we will see him trodden down as in this picture. 15

Generally speaking, however, the evidence does not allow us to establish close connections between political events and pictorial style in this period. One Florentine painter, Baccio della Porta, an ardent supporter of Savonarola, became a Dominican in 1500, known as Fra Bartolommeo, but his style did not change. Leonardo's drawings of the destruction of the world date from the early sixteenth century, when the destruction of Italy was taking place around him, but his notebooks do not suggest any connection. Leonardo's style did not change at this time. He did not even leave Milan when the French invaded.

Thirty-three years after 1494 came another black year which has sometimes been taken to mark the end of a period: 1527, when Rome was sacked by the troops of the emperor Charles V. This was doubtless the greatest disaster to happen to the city since its sack by Alaric and the Visigoths over 1,100 years earlier. It was viewed by contemporaries as a cataclysm, and it can be shown, like the invasion of 1494, to have had tangible if limited effects upon the arts.

In the years immediately before 1527, Rome had been an especially magnificent centre of patronage. Artists and writers had flocked to this 'centre of the world' (caput mundi), making their dispersal all the more spectacular. Aretino, Sebastiano del Piombo and Jacopo Sansovino all went to Venice, and Michele Sammicheli entered Venetian service in the following year. Parmigianino (who had been captured by German soldiers) and the engraver Marcantonio Raimondi went to Bologna. Cellini, after the exploits he boasts about in his memoirs, went back to Florence. The painter Giovanni da Udine, a pupil of Raphael's, returned to Udine, while his colleagues Perino del Vaga and Polidoro da Caravaggio went to Genoa and Naples respectively. Those who stayed on suffered unpleasant experiences. The painter-architect Baldassare Peruzzi, for example, was imprisoned until he paid a ransom. The humanist Jacopo Sadoleto lost his library, while another humanist, Angelo Colocci, lost both his manuscripts and his statues. It is no wonder that Colocci's friend Pierio Valeriano was moved to write a book on the miseries of the *litterati*. 'especially at this time' - 'Some killed by pestilence, others driven into exile and oppressed with want; these butchered by the sword, those assailed with daily torments.'16

The sack put an end to the cultural predominance of Rome. Whether

¹⁵ Weinstein, 'Myth of Florence', p. 15; cf. Ettlinger and Ettlinger, *Botticelli*, pp. 96ff.

¹⁶ Valeriano, De litteratorum infelicitate; Chastel, Sack of Rome, pp. 123ff.

it created a generation, or stimulated changes in style, is more difficult to decide. As in the case of the years 1402 and 1494, it would be a mistake to concentrate on 1527 to the exclusion of the years immediately before and after. The 1520s were terrible years for Italians - years of famine, years of plague, years of the siege and sack of cities such as Genoa, Milan, Naples and Florence as well as Rome. The 1520s were also years of spiritual crisis or, if that sounds too vague, of severe criticisms of the Church, leading to the foundation of new, strict religious orders (such as the Theatines and the Capuchins) and also to an interest in the ideas of Luther. The diffusion of prophecies in chapbook form suggests that ordinary townspeople were involved in this movement of crisis, criticism and the expectation of renewal.¹⁷ The ecclesiastical reaction to the crisis was to lead to the establishment of the Holy Office, a centralized inquisition, in 1542, and of the Index of Prohibited Books a few years later. The increasing effectiveness of ecclesiastical censorship was a crucial factor in the development of the arts in Italy after 1550.18

The 1520s were also the time when the style art historians now call 'Mannerism' emerged, breaking with the rules of perspective, proportion, the combination of architectural motifs, and so on. A famous example of rule-breaking is to be found in the Palazzo del Te in Mantua, designed by Giulio Romano (1527-34), with its frieze in which every third triglyph is out of place and seems to be coming loose (above, p. 92: Plate 3.9). This was a kind of architectural joke, but it is worth asking whether the rejection of rules and reason, whether joking or serious, may not be a response to this time of troubles, which helped create a new generation, including the writers Aretino, Berni and Folengo and the artists Pontormo, Rosso, Giulio Romano, Cellini, Parmigianino and Vasari (all born between 1492 and 1511). The mood of this generation was an unstable one, veering between a violent rejection of the world and a cynical acceptance of it. A possible account of the movement would describe the changes in style as expressing changes in worldview and the changes in worldview as responses to changes in the world. Some writers would go so far as to talk of this as an 'alienated' generation.¹⁹

Such an account is too simple because it ignores the possibility of changes in style being – in part at least – reactions to art rather than to the world outside it. In any case, corroborative evidence is lacking yet again about the inner lives of most artists and their responses to the world around them. The one exception, Michelangelo, comes from an

¹⁷ Niccoli, Prophecy and People.

¹⁸ Rochon, Le pouvoir et la plume.

¹⁹ Hauser, Mannerism, called alienation 'the key' to that style.

earlier generation (he was born in 1475). He was involved in the religious movements of his time, sympathetic to Savonarola in his youth and to Ignatius Loyola in his old age. His letters and poems do communicate a sense of spiritual anguish. However, the little we know about the lives and personalities of such artists as Giulio Romano and Parmigianino suggests that they were very different from Michelangelo. The most that could be safely said would be that the Mannerists responded in different ways to similar experiences, of which the sack of 1527 was the most important.²⁰

STRUCTURAL CHANGES

At the same time as these dramatic events, other cultural and social changes were taking place in Italy, which were no less significant for passing virtually unnoticed at the time. If we compare the situation in the later sixteenth century with that in 1400, certain major differences will become apparent. In 1400, for example, what we now call the Renaissance was a movement restricted to a small group of Florentines, who made important innovations in the arts and criticized some traditional assumptions and values. They were surrounded, even in Florence, by colleagues with traditional attitudes, patrons who made the usual demands, and craftsmen who went on working in the customary manner. The new ideas and the new style gradually spread from Florence to the rest of Tuscany and from Tuscany to the rest of Italy.²¹

The invention of printing helped spread the ideals of the movement more quickly than had ever been possible before. Grammars and anthologies of poems and letters familiarized literate men and women all over Italy with Tuscan usage. The illustrated architectural treatises of Vitruvius, Serlio and Palladio made the classical language of architecture equally familiar. The new art gradually created a market for itself. Patrons became aware that it was possible to commission statuettes or scenes from classical mythology, while the knowledge of the differences between the Doric, Ionic and Corinthian orders became part of a gentleman's education.

The growth of a public interested in the new ideals was itself a force for change, encouraging the development of a more allusive art and literature. Aretino and Berni were among the writers who parodied the love

²⁰ Chastel, Sack of Rome, pp. 169ff.

²¹ Fifty members of the creative elite were born between 1360 and 1399 – 23 in Tuscany, 14 in the Veneto, only 13 from the rest of Italy. But 176 members of the elite were born between 1480 and 1519: 50 in Tuscany, 49 in the Veneto, 77 from other parts of Italy.

lyrics of Petrarch. To enjoy their poems the reader needs to have some familiarity with Petrarch and his fifteenth-century imitators, a familiarity which breeds boredom if not exactly contempt.²² In a similar way the deliberate mistakes or solecisms in Giulio Romano's frieze at Mantua imply spectators who are educated enough to know the rules, to entertain certain visual expectations, to receive a shock when those expectations are falsified, and finally to enjoy being shocked because familiarity with the rules has made them rather blasé.

Another unintended consequence of the spread of the new ideals was the gradual diminution of regional diversities, which had been enormously important in earlier centuries and remained visible even in the sixteenth century in Lombardy, in Naples and especially in Venice.²³ Domenico Beccafumi, for example, was not as distinctively Sienese a painter as (say) Neroccio de' Landi had been. From Milan to Naples, literature composed in dialect was giving way to literature composed in Tuscan.²⁴

Other cultural changes have been discussed more than once in this study. Individual style in art and literature was becoming more noticeable, and was indeed attracting more notice in the sixteenth century than before (above, pp. 230ff.). There was a slow but steady secularization of the arts – for example a rise in the proportion of paintings with secular subjects.²⁵ There was an increasing concern with gravity, elegance, grace, grandeur and majesty in art and literature alike.²⁶ As a result, many words had to be eliminated from literature (dialect terms, technical terms, 'vulgar' terms, and so on) and many gestures had to be eliminated from art. Wölfflin's example is a striking one: 'St Peter, in Ghirlandaio's Last Supper of 1480, gestures with his thumb towards Christ, a gesture of the people, which High Art forthwith rejected as inadmissible.'27 In the course of the sixteenth century, the upper classes gradually withdrew from participation in popular festivals. They did not give up Carnival, but they created a Carnival of their own, parallel to popular festivities rather than a part of it. In short, the cultural differences between regions were replaced by cultural differences between classes. As the gap between

²² Borsellino, Anticlassicisti; Battisti, L'antirinascimento; Grendler, Critics of the Italian World.

²³ Castelnuovo and Ginzburg, 'Centre and periphery'; Schofield, 'Avoiding Rome'; Humfrey, *Venice and the Veneto*; Michalsky, 'Local eye'.

²⁴ Binni and Sapegno, Storia letteraria.

Taking dated paintings as a sample, we find 5 per cent of secular paintings 1480–9; 9 per cent 1490–9; 10 per cent 1500–9; 11 per cent 1510–19; 13 per cent 1520–9; and 22 per cent 1530–9.

²⁶ Weise, L'ideale eroico del Rinascimento.

²⁷ Wölfflin, Classic Art, pp. 213ff.

Lombard culture and Tuscan culture narrowed, the gap between high culture and low culture widened.²⁸

Why did these changes take place? It would be presumptuous even to attempt to explain them down to the last detail, but it would also be absurd to ignore obvious connections with social changes that were taking place both in the milieu of the arts and in Italy as a whole.

There was, for example, a gradual rise in the social status of artists and also in their social origin. Such leading artists of the early fifteenth century as Fra Angelico, Jacopo Bellini (son of a tinsmith), Andrea Castagno (son of a peasant), Donatello, Fra Lippo Lippi, Masolino and Michelozzo all had humble social origins. On the other hand, a number of leading artists born in the first twenty years of the sixteenth century were of relatively high status: Paris Bordone, for example (whose mother was noble), Angelo Bronzino, Benvenuto Cellini, Leone Leoni (who was knighted) and Pirro Ligorio (a nobleman). Most cases of ennobled painters are later than 1480 or thereabouts, as are most cases of painters with a splendid style of life, such as Raphael (whom some expected to be made a cardinal) and Baldassare Peruzzi, who was taken for a nobleman when he was captured during the sack of Rome. In his life of Dello Delli, Vasari noted that, in the fifteenth century, unlike 'today', artists were not ashamed to paint and gild furniture. The obvious reason for this increase in shame is a rise in social status. Another sign of the separation of artists from the main body of craftsmen was the foundation of academies, such as the Accademia di Disegno in Florence (founded in the 1560s) and the Accademia di San Luca in Rome (founded in the 1590s); the models for these institutions were the literary academies, which were clubs of noble amateurs. In 1400, the social status of art was low, and so were the social origins of artists; each factor helps explain the other. By 1600, however, the status of art and the origins of artists had risen together.

There were also significant changes in patronage during the period. By the sixteenth century, it is possible to find a significant number of collectors who, like the well-documented Isabella d'Este or the Venetian patrons of Giorgione, bought works of art for their own sake, were interested in the style and the iconographic details, and were concerned to acquire a Raphael or a Titian rather than a Madonna or a St Sebastian. Artistic individualism was now profitable, and, although artists are rarely named in inventories before 1600, there is other evidence of a shift in certain circles from 'cult images' in the religious sense to the 'cult of images' for their own sake.²⁹ There was also a shift in the balance of power

²⁸ Burke, Popular Culture, pp. 366-81.

²⁹ Ferino Pagden, 'From cult images to the cult of images'. Cf. Kemp, *Behind the Picture*, pp. 149–54.

between the patron and the artist. Their rising status perhaps improved the bargaining position of artists. Michelangelo, who stood up to patrons in a manner which most of his colleagues could not emulate, was the son not of a craftsman but of a Florentine magistrate. On the other hand, the increasing independence of artists, who were becoming more like poets and less like carpenters, doubtless enhanced their status. The roles of artist and patron were mutually dependent and they changed together. They were also part of a much larger network of social roles and were affected by changes in the social structure.

These changes in the social structure may be summed up in two words, standing for two conflicting trends: 'commercialization' and 'refeudalization'.

A certain amount of evidence for commercialization has been offered in earlier chapters. Towns were growing in the fifteenth and still more rapidly in the sixteenth century. The population of Florence, for example, grew from about 40,000 in 1427 to about 70,000 in the early to midsixteenth century. Naples contained about 40,000 people in 1450 but more than 200,000 a century later. The growth of these and other towns involved the commercialization of agriculture. Share-cropping spread in Tuscany, for example, a system which implies that landlords were increasingly inclined to think like businessmen about profits rather than a steady income from a fixed rent. At the same time, the book market was becoming important, thanks to the invention of printing. So, as we have seen, was the market in works of art, ancient and modern, originals and reproductions alike.

Yet this trend was to some degree offset by another, which historians describe as 'refeudalization' (in the wide, Marxist sense of the term 'feudal') or, as Braudel does, as the 'treason of the bourgeoisie'. A number of wealthy merchants (how many in any given decade it is unfortunately impossible to say) shifted their investments from trade to land. The trend is most noticeable in the two cities that have concerned us most in this study, Florence and Venice, where the patricians, poised for a long time between bourgeoisie and nobility, opted by their changing style of life for the latter. In Florence, the movement was gradual, almost imperceptible in any one generation, though obvious enough if one compares the patriciate of 1600 with its equivalent in 1400 or the better-documented year 1427. In Venice, the movement was more sudden. It was after the year 1570 or thereabouts that the patricians began to switch their investments from trade to landed estates on the

³⁰ Romano, Tra due crisi. Cf. Braudel, Mediterranean and the Mediterranean World, pt 2, ch. 5, section 2.

mainland, from neighbouring Padua to distant Friuli.³¹ They changed from being entrepreneurs to rentiers; from having a dominant interest in profit to a dominant interest in consumption. The elegant gestures in Florentine portraits by Bronzino and others reflect the attitudes of the sitters, who were no longer prepared to get their hands dirty as their fathers and grandfathers had done (good merchants, as Giovanni Rucellai had observed in the later fifteenth century, always have inky fingers).³² The most splendid Venetian villas, starting with Villa Maser, built by Palladio and decorated by Veronese in the early 1560s for the Barbaro family, belong to this period of the return to the land.

Why did this change take place? It looks like an example of the shirt-sleeves-to-shirtsleeves cycle, the third-generation syndrome which the American economist W. W. Rostow called 'the pattern of Buddenbrooks dynamics', after the Lübeck family described in a famous novel by Thomas Mann.³³ As in Mann's novel, so in Renaissance Italy one can point to examples (most obviously that of the Medici) of families ruined for trade by a humanist education; Lorenzo the Magnificent composed poems while the family bank went into decline. However, the significant change is the one that affected not only some families but a whole social group. Families had withdrawn from trade before; what was new, in Florence, Venice and elsewhere, was the lack of new families to replace them.

Why? The fundamental explanation was probably an economic one. As a result of the discovery of America, the centre of gravity of European trade was shifting away from the Mediterranean and towards the Atlantic. The Italians were losing their traditional role as middlemen in international trade, which was being taken over by the Portuguese, the English and, above all, in the seventeenth century, the Dutch. We have returned to the theme of 'hard times and contempt for trade' (above, p. 239). At the same time food prices were rising, so that, to wealthy urban Italians, land appeared an increasingly attractive investment.

This change in the style of life of the patriciate was good for the arts in the short term but not so beneficial in the long run. The ruling class was more inclined to patronize the arts because this was part of their new aristocratic lifestyle, but in the long term the wealth which permitted them to build palaces and buy works of art dried up. The change in values – especially the emphasis on birth and the contempt for manual labour – worked against the newly risen status of the artist. There was a kind of 'brain drain' (brains being what an artist mixes his colours with)

³¹ Woolf, 'Venice and the terraferma'.

³² Rucellai, Giovanni Rucellai ed il suo Zibaldone, p. 6.

³³ Rostow, Stages of Economic Growth.

thanks to the diffusion of Renaissance ideals abroad and the consequent demand for Italian artists in Hungary, France, Spain, England and elsewhere. In the fourteenth and fifteenth centuries, Italy, a country of merchant republics, had been as distinctive socially as she was culturally. As she came to resemble other European societies, Italy lost her cultural lead. There was also a shift of creativity from the visual arts into music, which has been explained by the decline of the city-state as well as increasing ecclesiastical control of the media.³⁴ All the same, Italian art remained the envy of Europe until the death of Bernini in 1680.

³⁴ Koenigsberger, 'Decadence or shift?'.

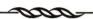

Comparisons and Conclusions

The explanations offered by historians – whether they admit this or not – depend on implicit comparisons, contrasts and even generalizations. The explanations advanced in this study are no exception, and it may be useful to make a few of these implied comparisons and contrasts more explicit.

The culture of the Italian Renaissance described and analysed here has many features in common with the culture of other societies, near and remote. For example, artistic achievement and innovation was linked to civic patronage and civic pride in sixteenth-century Nuremberg as in Florence and Venice. Albrecht Dürer was asked to paint murals in the Town Hall of Nuremberg in 1521, and the post of city painter was created ten years later. The idea that a 'crisis of liberty' successfully surmounted is a stimulus to the arts can be illustrated not only from Florence in the early fifteenth century but from ancient Greece in the age of Aeschylus, Sophocles and Euripides and from England in the age of Shakespeare. As Florence beat off the threat posed by Milan, so the English defeated the superior forces of Spain and the Greeks the Persian Empire. Although Vasari was the first European to devote a book to the lives of artists (Pliny's anecdotes about Greek artists being part of his enormous Natural History), Chang Yen-Yuan had preceded him in China with biographies of 370 painters. On the other hand, the apparent lack of concern with individual creativity shown in the organization of workshops and in some large-scale projects in Renaissance Italy has parallels with some tribal societies, such as the Tiv of Nigeria, where different people may take turns carving the same object.¹

The danger of isolating cultural traits lies in exaggerating apparent similarities and in ignoring the context in which their meaning resides. It is more illuminating, although obviously more difficult, to compare entire cultural configurations or systems. Joseph Alsop, for example, argued that the rise of the art market and of art history have occurred

¹ Bohannan, 'Artist and critic', p. 89.

together in several cultures, including ancient Rome and traditional China as well as Renaissance Italy.² The great French historian Marc Bloch made a useful distinction between two kinds of comparative history: comparisons between societies which are fundamentally alike (such as medieval France and England) and comparisons between the fundamentally unlike (such as France and Japan).³ Each is instructive, but in different ways. In the pages which follow I shall sketch two comparisons with Renaissance Italy, one of each kind: with the Netherlands in the fifteenth and sixteenth centuries and with Japan in the late seventeenth and early eighteenth centuries (or, rather less Eurocentrically, in the Genroku period of the Tokugawa era).

THE NETHERLANDS

In the fifteenth and sixteenth centuries, the Netherlands was a centre of cultural innovation which (so far as Europe was concerned) was equalled or surpassed only by Italy. As in Italy, there was a whole cluster of outstanding painters, among them Ian van Evck, Rogier van der Weyden, Gerard David, Hans Memlinc, Quentin Massys, Lucas van Leyden and Pieter Brueghel the elder. As in Italy, there was conscious innovation, a nouvelle pratique as it was called. One of the chief aims of painters was verisimilitude, and one of their chief means to this end was the employment of perspective. Again, as in Italy, the subject matter of painting was becoming more secular, and a differentiation of genres was taking place. These genres included the portrait, even more popular than in Italy; the still-life, a sixteenth-century development; the landscape, from the miniatures in fifteenth-century manuscripts to the work of Joachim Patenir of Antwerp, described by Dürer as a 'good landscape painter'; and scenes from everyday life, such as the card-players and chess-players of Lucas van Levden or the markets painted by Pieter Aertsen.

In other respects, however, Italian and 'Flemish' culture, as it is convenient to call it (although Flanders was technically only a part of the Netherlands), were rather dissimilar. As the art historian Erwin Panofsky pointed out, a comparison of cultural innovation in the two regions reveals a 'chiastic pattern'. In Italy, innovation was greatest in architecture; then came sculpture, then painting and, finally, music. In the Netherlands, by contrast, innovation was greatest of all in music in the age of Dufay, Binchois, Busnois, Ockeghem and Josquin des Près. In the second place came painting. Sculpture was a long way behind;

³ Bloch, Land and Work, pp. 44-81.

² A concern with the whole is the strength of Alsop, *Rare Art Traditions*, as of Kroeber, Configurations of Culture Growth.

no major figure succeeded Claus Sluter, who died in 1406 (the rivals of the Italian sculptors came from southern Germany and worked in wood). Architecture was relatively traditional in manner; a typical example is the Town Hall at Louvain, built in 1448 in ornate Gothic style.⁴

To focus more sharply on painting is to reveal other differences between the two regions. Frescoes were less important in the Netherlands (where large windows left little wall space in churches) and miniatures in manuscripts more important. The most famous contrast between the painters of Italy and the Netherlands was made at the time, by Michelangelo:

They paint in Flanders only to deceive the outward eye [vista exterior] ... Their painting is of textiles, bricks and mortar, the grass of the fields, the shadows of trees, and bridges and rivers, which they call landscapes, and little figures here and there; and all this, although it may appear good to some eyes, is in truth done without reason or art, without symmetry or proportion, without care in selecting or rejecting, and finally without any substance or nerve.⁵

The criticism is unfair but revealing – in its very unfairness – of the values of Michelangelo and of Florentine visual culture, in which idealization and the heroic were central, while the illusion of solidity mattered more than the illusion of space. The contrast did not prevent Italians of the period from admiring and buying works by painters such as Hans Memlinc, Hugo van der Goes or Rogier van der Weyden.

There were economic and social as well as cultural parallels between Italy and the Netherlands. As a fifteenth-century Spanish traveller put it, 'two cities compete with each other for commercial supremacy, Bruges in Flanders in the West and Venice in the East.' These cities were set in the most highly urbanized parts of Europe. Around the year 1500, in the provinces of Flanders and Brabant, as much as two-thirds of the population lived in towns. As in Italy, the commercialization of agriculture consequent on the growth of towns led to the disappearance of serfdom earlier than elsewhere. As in Italy, the textile industry was of great importance for export-led growth, and within the industry there was a shift towards production for the luxury market, as in the case of the tapestries made in Arras, Lille and Tournai. In the Netherlands, too, the peak

⁴ Panofsky, Early Netherlandish Painting. Cf. Chipps Smith, Northern Renaissance; Nash, Northern Renaissance Art; Belozerskaya, Rethinking the Renaissance.

⁵ Hollanda, Da pintura antigua, first dialogue, p. 63.

⁶ This topic has interested scholars since the time of Aby Warburg. A recent study is Nuttall, *From Flanders to Florence*.

period for the visual arts coincided with the peak in the development of the luxury industries.⁷

In Flanders, as in Italy, artists were often the sons of craftsmen. Out of seventeen leading painters whose father's occupation is known, fourteen were the sons of craftsmen: a cutler, a weaver, a smith, an artist, and so on. Painting was a family business and there were well-known dynasties of artists, such as the Bouts, Brueghel, Floris and Massys families. However, female artists are more visible, 'and must have made up a significant part of the workforce in many towns'. The painters tended to be born in sizeable towns and to gravitate towards Bruges and Antwerp, the greatest commercial cities of the Netherlands. Bruges lost its economic dominance around the year 1500 owing to the silting up of the River Zwijn, and its place was taken by Antwerp, where the population rose to about 100,000 by 1550. In painting, too, the centre shifted from Bruges to Antwerp, which is not surprising, since merchants were among the most important patrons. As in Italy, an art market developed in the sixteenth century.

In the Netherlands, as in Italy, artists generally had the status of craftsmen, unless their patrons were rulers such as Philip the Good, duke of Burgundy, who appointed Jan van Eyck his official painter and valet de chambre, sent him on diplomatic missions, visited his studio at Bruges and gave him six silver cups for the christening of the painter's son. However, the painters of the Netherlands seem to have lacked the self-awareness of some of their Italian colleagues. Self-portraits are more rare, and the Dutch Vasari, Karel van Mander, did not publish his collection of artists' biographies until 1604.

The relation of the music of the period to the society in which it was composed is rather more indirect and elusive. Most of this music is church music (possibly because church music had a better chance of survival). The great composers usually owed their musical training (as we have seen, p. 61) to cathedral choir schools. Some of them held benefices. However, the increasing size of church choirs in this period was made possible only by the generosity of the laity. The money was used in part to bring laymen into the choirs; for example, the cathedral chapter at Antwerp diverted income from some benefices to pay the salaries of professional singers, who did not have to be clerics. As in Italy, townspeople founded fraternities, and some, such as the Fraternity of Our Lady at Antwerp (whose members included bankers, merchants and craftsmen),

⁷ Lestocquoy, Aux origines de la bourgeoisie; Prevenier and Blockmans, Burgundian Netherlands.

⁸ Nash, Northern Renaissance Art, p. 77.

⁹ Floerke, Studien.

financed a daily service with singers. In other words, the ecclesiastical culture of the Netherlands in the fifteenth century was founded on urban wealth.

Music was also written for the court. Duke Philip the Good made Binchois his chaplain and appointed Dufay music tutor to his son Charles the Bold, who learned to sing, play the harp and compose chansons and motets. When he became duke he employed Busnois, and he took his musicians with him even on campaign. The importance of this court patronage is suggested by the fact that, after Charles's death in 1477, the leading composers Isaac and Josquin left the Netherlands.

The court had, of course, to be paid for. The Feast of the Pheasant, a Burgundian banquet held in 1454 at which musicians played a prominent part, cost so much that even a courtier who took part in it, Olivier de la Marche, commented in his chronicle on what he called the 'outrageous and unreasonable expense'. It was the good fortune of Philip the Good and Charles the Bold that their dominions took in towns such as Ghent and Bruges, Brussels and Antwerp, with rich merchants who could provide large sums in taxation. The court, like the Church, depended ultimately on trade.

JAPAN

In Japan over a century later, there was a cluster of cultural achievements and innovations at least as remarkable as the cases of Renaissance Italy and the Netherlands. The height of the period was the Genroku era, from 1688 to 1703. The great figures include the poet Matsuo Basho (best known for his *haiku*), Ihara Saikaku, a writer of prose fiction, the playwright Chikamatsu Monzaemon, the philosopher Ogyu Sorai and the artist Moronobu. Among the new genres were the coloured woodblock print; 'kana books', written not in Chinese characters but in a simple syllabic script; and two new kinds of drama, the *kabuki* and the *jōruri* (in which the roles were taken by puppets). It was at this time that the samisen was introduced into Japanese music and used to accompany dramatic performances.

As in the case of Italy and the Netherlands, one important trend in the arts in Japan at this period was their secularization. In philosophy, the Japanese Confucians of the period, like the humanists of the fifteenth century, shifted their emphasis from knowing heaven to knowing man. ¹¹ The dominant form of drama before 1600, the $N\bar{o}$, was religious, but

Hibbett, Floating World; Keene, World within Walls; Lane, Masters of the Japanese Print.

¹¹ Bellah, Tokugawa Religion; Maruyama, Studies in the Intellectual History.

jōruri and kabuki theatres played historical dramas or scenes from domestic life. Traditional Japanese painting, like sculpture, was mainly Buddhist in inspiration, but after 1600 secular works become more common, among them painted screens, statues to ornament private houses, and woodblock prints, which usually represented landscapes, actors or scenes from everyday life.

At once an illustration and a symbol of this process of secularization is the term ukivo, 'floating world'. Originally a Buddhist term for the transience of all worldly things, it took on hedonist overtones in the seventeenth century and came to mean 'living for the moment', particularly if that kind of living took place in the pleasure-quarters of the three great cities of Edō (now Tokyo), Kyōto and Ōsaka. The 'floating trade' was prostitution. The entertainment industry (actors, courtesans, wrestlers, etc.) was often represented in the woodblock prints, which came to be called 'pictures of the floating world' (ukiyo-e). The secularization of Buddhist values had its parallel in the fiction of the period, which was sometimes known as 'notes from the floating world' (ukiyo-zōshi). Iharu Saikaku's most famous story, The Life of an Amorous Woman, is an adaptation to secular purposes of a religious genre, Buddhist confession literature. It resembles that genre about as closely in form and about as little in spirit as Defoe's Moll Flanders resembles Bunyan's Grace Abounding.

Another characteristic to be found in several arts and genres in Genroku Japan was realism, particularly domestic realism (above, p. 23). The equivalent Japanese term, sewamono, was applied to kabuki plays about contemporary life as opposed to historical events. Just as Hishikawa Moronobu made prints of street scenes in the Yoshiwara (the pleasure-quarter of Edo), so Monzaemon Chikamatsu and Iharu Saikaku took scenes from everyday life and turned them into literature, without even changing the names and addresses. There is a story that Chikamatsu was in a restaurant when he was told that there had been a love suicide at Amijima, and was asked to write a puppet-play on the subject immediately. What he produced for performance two days later is one of his most famous pieces. Saikaku was fascinated, like Defoe, by true-to-life details of clothes and prices, and incorporated them into his stories to give them a greater air of verisimilitude.

Whether or not this is an illusion on the part of a European observing from a distance and missing the finer detail, I have the impression that these changes in Japanese culture were more obviously and more closely related to social changes than their equivalents in Italy or the Netherlands.

The sixteenth century had been a period of civil war in Japan. Towards the end of the century, peace was established by a succession

of three strong rulers, the third of whom, Tokugawa Ieyasu, founded a dynasty of effective rulers or *shōguns*. Peace was followed by a rise in population, an improvement in communications and a rapid growth of towns. Three cities in particular expanded: the old capital, Kyōto, which had 410,000 inhabitants in 1634; Ōsaka, which had 280,000 in 1625; and Edō, which was no more than a village before Tokugawa Ieyasu chose it for his capital, but rose to half a million people by 1721.¹²

The Tokugawa regime was not sympathetic to artisans and merchants (the *chōnin*), which it regarded as inferior to peasants as well as to *samurai*. However, these *chōnin* prospered as never before, while many *samurai*, whose contempt for trade equalled that of seventeenth-century Spanish noblemen, found themselves in economic difficulties.¹³ As for the values of the period, they seem to be reflected in Saikaku's *Family Storehouse*, a series of success stories in business which would be reminiscent of Samuel Smiles if they did not antedate him by a century and a half (Smiles's *Self-Help* (1859) was in fact translated into Japanese only a few years after publication).

It seems plausible to argue that the rise of the chōnin - not to say 'middle class' – and the cultural innovations of the period are connected. Of the major writers and artists, Moronobu was the son of an embroiderer; Saikaku the son of an Osaka merchant; Kiseki, the best-known of Saikaku's followers, the son of a Kyōto shop-keeper. The No plays had been for samurai only. On the other hand, samurai were forbidden to go to performances of kabuki and joruri, which were for the chonin, and not infrequently dealt with their lives. As for the stories of Saikaku and others, they were printed in the simple kana script and so reached an audience (female as well as male) that was much wider than that of traditional literati. In the seventeenth century, bookselling was good business: there were fifty bookshops in Osaka in 1626. Adapting Defoe's remark about England, we may say that writing was becoming 'a very considerable part of the Japanese commerce'. So were images. Woodblock prints could be mass-produced cheaply, so that they were within the means of craftsmen. One of their functions was commercial - to advertise the skills and charms of the actors and courtesans they so frequently portrayed. In Iapan as in Europe we see the rise of what we might call an art market and the commercialization of art and literature.

There are two qualifications to make to this picture of townspeople's culture. The first is to point out that it was associated with merchants who were no longer accumulating but indulging in conspicuous consumption.

¹² Hall and Jansen, Studies in the Institutional History.

¹³ Sheldon, Rise of the Merchant Class; cf. Crawcour, 'Changes in Japanese commerce'.

The second is to emphasize that Genroku culture was not for merchants and craftsmen alone. Edō was a capital with a court and a traditional culture associated with it. All that is being argued here is that new genres were created primarily for new social groups (or groups that were newly rich, numerous or literate). Even these new genres drew on aristocratic traditions, from $N\bar{o}$ plays to the eleventh-century $Tale\ of\ Genji$, though it is not easy to say whether they are examples of imitation, of parody or of an ambiguous and unstable mixture of the two.

This brief comparison of Italy with the Netherlands and Japan contains obvious gaps. The available secondary literature does not permit a discussion of the merchant ethos in Flanders or the milieu of Japanese artists. In any case, these examples are not the only ones that could have been chosen. Yet they do suggest the existence of recurrent patterns of cultural and social change, and they bring us back to a problem which has appeared many times in this study (sometimes in the foreground, sometimes in the background): the problem of the cultural role of the bourgeoisie.

I began work on this book, in the later 1960s, with the idea of juxtaposing the ideas of Jacob Burckhardt and those of Karl Marx, criticizing and rejecting where criticism and rejection were needed and attempting a synthesis. Burckhardt is not, of course, the only interesting interpreter of the Renaissance, and a good many of his successors - Baron, Baxandall, Gombrich, Lopez, etc. - have contributed ideas as well as information to this study. Nor is Marx the only important social theorist, or the only one whose ideas are relevant to this period and this problem. It is a stimulating intellectual exercise (but more than just an exercise) to imagine how Max Weber might have discussed the Renaissance (emphasizing secularization, calculation, abstraction); how Emile Durkheim might have discussed it (stressing the division of labour and its effect on collective representations); how Norbert Elias might view it (as part of the civilizing process); Erving Goffman (focusing on the presentation of self); Pierre Bourdieu (attending to 'cultural capital', 'distinction' and strategies for 'symbolic dominance'); or Clifford Geertz (considering the relation between order and meaning). I have learned something from each of these thinkers, and others, and made use of them all in this book.

The central problem of this study, however, remains that of the relationship between cultural and social structures and change, and the apparent detour via the Netherlands and Japan has revealed this centrality even more clearly. The link between realism and the bourgeoisie, for example, is not as simple as some Marxists (Antal, for instance) have argued or assumed, because (as we have seen) there is more than one

type of realism, more than one kind of bourgeoisie and more than one possible relationship between society and culture.

Refining the concepts, however, does not dissolve the problem. There do seem to be affinities between social groups and artistic genres (if not styles). If bourgeoisies are divided into merchants and craftsmen, their contributions to the arts may be distinguished as follows. The milieu from which most artists come is urban and dominated by craftsmen, so that it can be argued (above, p. 52) that it is in craft-industrial towns that the abilities of potential artists are least likely to be frustrated. Merchants, on the other hand, are especially important as patrons, and often quick to take up new genres. They are, after all, professionally adaptable and need to be able to adapt to new situations if they are to survive economically. The emphasis on novelty is important here. The argument is not that rulers, nobility (mandarins, samurai) and the Church (or its Hindu, Buddhist or Muslim equivalents) are unimportant patrons; this is clearly false. The focus of this study, however, has been on cultural innovation, and the Flemish and Japanese examples, no less than the Italian ones, suggest that innovations need the support, initially at least, of new kinds of patron. In culture as in economic life, there are rentiers and there are entrepreneurs.

APPENDIX: THE CREATIVE ELITE

The six hundred painters, sculptors, architects, writers, humanists, scientists and musicians whose lives form the basis of chapter 3, in particular,

were selected as follows:

- 1 314 painters and sculptors from the article on Italian Art in the *Encyclopaedia of World Art* (organized by region, this list seemed to counter the Tuscan bias of Vasari).
- 2 88 writers from E. H. Wilkins, *A History of Italian Literature* (Cambridge, MA, and London: Harvard University Press, 1954).
- 3 74 humanists from E. Garin, *Italian Humanism* (Eng. trans., Oxford: Blackwell, 1965).
- 4 55 'scientists' from R. Taton (ed.), A General History of the Sciences, vol. 2 (London: Thames & Hudson, 1965), revised with the help of Professor Marshall Clagett.
- 5 50 musicians selected from G. Reese, *Music in the Renaissance* (New York and London: W. W. Norton, 1959).
- 6 19 writers and humanists not in Wilkins or Garin, added to round the number up to 600 and chosen because I thought them important: J. Aconcio, G. B. Adriani, Aldo Manuzio, G. Aurispa, F. Barbaro, G. Barzizza, G. Benivieni, F. Beroaldo, B. Bibbiena, A. Bonfini, V. Calmeta, J. Caviceo, B. Corio, L. Domenichi, F. Nerli, B. Rucellai, M. A. Sabellico, B. della Scala and B. Segni.

The complete list can be found in the index to this book, with asterisks against the names.

Such a list is inevitably arbitrary, at least at the edges. Contemporaries, however much in sympathy with the idea of a collection of biographies, might have found the criterion of selection, 'creativity', hard to understand, and the learned would have expected to find canon lawyers or theologians rather than artists. The object of the exercise was to conduct something like a social survey of the dead: to look for patterns or tendencies. Hence the need to ask precise questions, as follows:

- 1 Region of birth: nine possible answers (Lombardy; Veneto; Tuscany; States of the Church; south Italy; Liguria; Piedmont; outside Italy; not known).
- 2 Size of birthplace: four possible answers (large; medium; small; not known).
- 3 Father's occupation: nine possible answers (cleric; noble; humanist; professional or merchant; artist; artisan or shop-keeper connected with the arts; artisan or shop-keeper unconnected with the arts; peasant; not known).
- 4 Training: six possible answers (University of Padua; other universities; other humanist education; apprenticeship; musical education; not known).
- 5 Main discipline practised: seven possible answers (painting; sculpture; architecture; literature; humanism; science; music).
- 6 Specialization: three possible answers (one discipline; two disciplines; three or more).
- 7 Relatives practising these disciplines: five possible answers (no known relatives; one; two; three; four or more).
- 8 Geographical mobility: five possible answers (extremely sedentary; fairly sedentary; fairly mobile; extremely mobile; not known).
- 9 Patronage: two possible answers (Medici patronage; other).
- 10 Period of birth: ten possible answers (dividing the years 1340–1519 into nine periods of twenty years each, and adding a 'not known').

REFERENCES AND BIBLIOGRAPHY

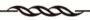

This bibliography contains all works to which reference is made in the notes, together with a few other studies of relevance to the field. *IWCI* = *Journal of the Warburg and Courtauld Institute*.

- Ackerman, J. S., 'Architectural practice in the Italian Renaissance', *Journal of the Society for Architectural History* 13 (1954), pp. 3–10.
- —The Architecture of Michelangelo. 2nd edn, Harmondsworth: Penguin, 1970.
- 'Ars sine scientia nihil est', Art Bulletin 12 (1949), pp. 84-108.
- -Palladio. Harmondsworth: Penguin, 1966.
- —'Sources of the Renaissance villa', in *Studies in Western Art*, Vol. 2: *The Renaissance and Mannerism*, ed. I. E. Rubin, pp. 6–18. Princeton, NJ: Princeton University Press, 1963.
- Ady, C. M., *The Bentivoglio of Bologna*. Oxford: Oxford University Press, 1937.
- Ago, R., Gusto for Things: A History of Objects in Seventeenth-Century Rome. Eng. trans., Chicago: University of Chicago Press, 2013.
- Ajmar, M., 'Talking pots', in *The Art Market in Italy*, ed. M. Fantoni et al., pp. 55–64. Modena: Panini, 2003.
- Ajmar-Wollheim, M., and F. Dennis (eds), *At Home in Renaissance Italy*. London: V&A, 2006.
- Ajmar-Wollheim, M., F. Dennis and A. Matchette, *Approaching the Italian Renaissance Interior*. Oxford: Blackwell, 2007.
- Alberici, C. (ed.), Leonardo e l'incisione. Milan: Electa, 1984.
- Alberigo, G., I vescovi italiani al concilio di Trento. Florence: Sansoni, 1959.
- Alberti, L. B., *De re aedificatoria*, ed. P. Portoghesi, 2 vols. Milan: Il Polifilo, 1966.
- —I libri della famiglia, ed. R. Romano and A. Tenenti. Eng. trans. R. N. Watkins. Columbia: University of South Carolina Press, 1969.
- —On Painting, Eng. trans. J. R. Spencer. London: Routledge & Kegan Paul, 1956.

- —On Painting; and On Sculpture, Eng. trans. C. Grayson. London: Phaidon Press, 1972.
- Albertini, R. von, Das florentinisch Staatsbewusstsein im Ubergang von der Republik zum Prinzipat. Bern: Franke, 1955.
- Alpers, S., *The Art of Describing*. Chicago: University of Chicago Press, 1983.
- Alsop, J., The Rare Art Traditions. London: Thames & Hudson, 1982.
- Ames-Lewis, F., 'Donatello's bronze *David* and the Palazzo Medici courtyard', *Renaissance Studies* 3 (1989), pp. 235–51.
- —Drawing in Early Renaissance Italy. New Haven, CT, and London: Yale University Press, 1981.
- —(ed.), Florence. Cambridge: Cambridge University Press, 2012.
- —The Intellectual Life of the Early Renaissance Artist. New Haven, CT, and London: Yale University Press, 2000.
- —Isabella and Leonardo. New Haven, CT, and London: Yale University Press, 2012.
- Ames-Lewis, F., and Wright, J. (eds) *Drawing in the Italian Renaissance Workshop*. New Haven and London: Yale University Press, 1983.
- Anderson, J., 'Rewriting the history of art patronage', *Renaissance Studies* 10 (1996), pp. 129–38.
- Anselmi, G. M., F. Pezzarassa and L. Avellini, La 'memoria' dei mercatores. Bologna: Pàtron, 1980.
- Antal, F., Florentine Painting and its Social Background. London: Kegan Paul, 1947.
- Anthon, C., 'Social status of Italian musicians during the sixteenth century', *Journal of Renaissance and Baroque Music* 1 (1946), pp. 111–23, 222–34.
- Antoni, C., From History to Sociology. Eng. trans., Detroit: Wayne State University Press, 1959.
- Archambault, P., 'The analogy of the body in Renaissance political literature', *Bibliothèque d'Humanisme et Renaissance* 29 (1967), pp. 21–53.
- Aretino, P., Sei giornate (1534-6), ed. G. Aquilecchia. Bari: Einaudi, 1975.
- Arnaldi, G., and M. Pastore Stocchi (eds), Storia della cultura veneta, 3: Dal primo quattrocento al concilio di Trento, 2 vols. Vicenza: Neri Pozza, 1980-1.
- Aron, P., Toscanello. Venice, 1523.
- Asor Rosa, A. (ed.), Letteratura italiana, 2: Produzione e consumo. Turin: Einaudi, 1983.
- Atlas, A. W., *Music at the Aragonese Court of Naples*. Cambridge: Cambridge University Press, 1985.

Auerbach, E., 'Figura', in Auerbach, *Scenes from the Drama of European Literature*, pp. 11–76. New York, 1959.

—Literary Language and its Public in Late Latin Antiquity and in the Middle Ages. Eng. trans., London: Routledge & Kegan Paul, 1965.

—Mimesis. Eng. trans., Princeton, NJ: Princeton University Press, 1954. Avery, C., Florentine Renaissance Sculpture. London: John Murray, 1970.

Bandello, M., Novelle (1554), ed. G. G. Ferrero. Turin, 1974.

Barbieri, G., Economia e politica nel ducato di Milano. Milan: Vita e pensiero, 1938.

Bareggi, C., Il mestiere di scrivere: lavoro intellettuale e mercato librario a Venezia nel cinquecento. Rome: Bulzoni, 1988.

Barkan, L., Unearthing the Past: Archaeology and Aesthetics in the Making of Renaissance Culture. New Haven, CT: Yale University Press, 1999.

Barnes, B., Michelangelo's Last Judgement: the Renaissance Response. Berkeley: University of California Press, 1998.

Barolsky, P., *Infinite Jest: Wit and Humor in Italian Renaissance Art.* London: University of Missouri Press, 1978.

—Why Mona Lisa Smiles. University Park: Pennsylvania State University Press, 1991.

Baron, H., 'Burckhardt's Civilisation of the Renaissance a century after its publication', Renaissance News 13 (1960), pp. 207–22.

—The Crisis of the Early Italian Renaissance. Rev. edn, Princeton, NJ: Princeton University Press, 1966.

—'The historical background of the Florentine Renaissance', *History* 23 (1938), pp. 315–27.

Barzman, K.-E., 'Gender, religious representation and cultural production in early modern Italy', in *Gender and Society in Renaissance Italy*, ed. J. C. Brown and R. C. Davis, pp. 213–33. London: Longman, 1998.

Baskins, C., Cassone Painting, Humanism and Gender in Early Modern Italy. Cambridge: Cambridge University Press, 1998.

Batkin, L. M., L'idea di individualità nel Rinascimento italiano. Italian trans. from Russian. Rome: Laterza, 1992.

—Die italienische Renaissance. German trans. from Russian, Dresden: Verlag der Kunst, 1979.

Battara, P., La popolazione di Firenze alla metà del '500. Florence: Rinascimento del libro, 1935.

Battisti, E., L'antirinascimento. Milan: Feltrinelli, 1962.

Bauer, H., Kunst und Utopie. Berlin: De Gruyter, 1965.

Baxandall, M., 'Art, society and the Bouguer principle', *Representations* 12 (1985), pp. 32–43.

- 'Bartholomaeus Facius on painting', JWCI 27 (1964), pp. 90-107.
- —'A dialogue on art from the court of Leonello d'Este', *JWCI* 26 (1963), pp. 304–26.
- -Giotto and the Orators. Oxford: Clarendon Press, 1971.
- —'Guarino, Pisanello and Manuel Chrysoloras', JWCI 28 (1965), pp. 183-201.
- —Painting and Experience in Fifteenth-Century Italy. Oxford: Clarendon Press, 1972.
- Bayer, A. (ed.), *Art and Love in Renaissance Italy*. New Haven, CT: Yale University Press, 2008.
- Bec, C., Cultura e società a Firenze nell'età della Rinascenza. Rome: Salerno editrice 1981.
- —(ed.), Italie 1500–1550: une situation de crise? Lyons: Hermès, 1975.
- —Les livres des florentins (1413-1608). Florence: Olschki, 1984.
- -Les marchands écrivains. Paris and The Hague: Mouton, 1967.
- 'Lo statuto socio-professionale degli scrittori', in *Letteratura italiana*, 2: *Produzione e consumo*, ed. A. Asor Rosa. Turin: Einaudi, 1983.
- Bellah, R., Tokugawa Religion. Glencoe, IL: Free Press, 1957.
- Belloni, G., and R. Drusi (eds), *Umanesimo ed educazione*. Vicenza: Costabissara, 2007.
- Beloch, K. J., *Bevölkerungsgeschichte Italiens*, vol. 3. Berlin: De Gruyter, 1961.
- Belozerskaya, M., *Luxury Arts of the Renaissance*. Los Angeles: J. Paul Getty Museum, 2005.
- —Rethinking the Renaissance: Burgundian Arts across Europe. Cambridge: Cambridge University Press, 2002.
- Belting, H., Florence and Baghdad: Renaissance Art and Arab Science. Eng. trans. D. L. Schneider. Cambridge, MA: Belknap Press, 2011.
- —Likeness and Presence: A History of the Image before the Era of Art. Eng. trans. E. Jephcott. Chicago: University of Chicago Press, 1994.
- Beltrami, D., Storia della popolazione di Venezia. Padua: Cedam, 1954.
- Bembo, P., *Prose della volgar lingua* (1525), in Bembo, *Prose e rime*, ed. C. Dionisotti. Turin: Unione Tipografico, 1960.
- Benjamin, W., 'The work of art in the age of mechanical reproduction', Eng. trans. in Benjamin, *Illuminations*, pp. 219–44. London: Jonathan Cape, 1970.
- Benson, P. J., *The Invention of the Renaissance Woman*. University Park: Pennsylvania State University Press, 1992.
- Bentley, J., *Politics and Culture in Renaissance Naples*. Princeton, NJ: Princeton University Press, 1987.
- Berengo, M., Nobili e mercanti nella Lucca del cinquecento. Turin: Einaudi, 1965.
- Berlin, I., Vico and Herder. London: Hogarth Press, 1976.

Bertelli, S., 'L'egemonia linguistica come egemonia culturale', *Bibliothèque d'humanisme et Renaissance* 38 (1976), pp. 249–81.

Bing, G., 'A. M. Warburg', JWCI 28 (1965), pp. 299-313.

Binni, W., and N. Sapegno (eds), Storia letteraria delle regioni d'Italia. Florence: Sansoni, 1968.

Biow, D., *The Culture of Cleanliness in Renaissance Italy*. Ithaca, NY: Cornell University Press, 2006.

—Doctors, Ambassadors, Secretaries: Humanism and Professions in Renaissance Italy. Chicago: University of Chicago Press, 2002.

—In your Face: Professional Improprieties and the Art of Being Conspicuous in Sixteenth-Century Italy. Stanford, CA: Stanford University Press, 2010.

Biringuccio, V., *Pirotechnia* (1540). Eng. trans., new edn, Cambridge, MA: MIT Press, 1966.

Black, R., 'Italian Renaissance education', *Journal of the History of Ideas* 52 (1991), pp. 315–34.

Bloch, M., Land and Work in Medieval Europe. Berkeley and London: University of California Press, 1967.

Blunt, A., Artistic Theory in Italy 1450–1600. Oxford: Clarendon Press, 1940.

Boase, T. S. R., *Giorgio Vasari: The Man and the Book*. Princeton, NJ: Princeton University Press, 1979.

Bock, N., 'Patronage standards and *transfert culturel*: Naples between art history and social science', *Art History* 31 (2008), pp. 574–97.

Bodart, D. H., Tiziano e Federico II Gonzaga: storia di un rapporto di committenza. Rome: Bulzoni, 1998.

Bohannan, P., 'Artist and critic in an African society', in *The Artist in Tribal Society*, ed. M. W. Smith, pp. 85–94. London: Routledge & Kegan Paul, 1961.

Bolland, A., 'From the workshop to the academy: the emergence of the artist in Renaissance Florence', in *Renaissance Florence: A Social History*, ed. R. J. Crum and J. T. Paoletti, pp. 454–78. Cambridge: Cambridge University Press, 2007.

Bologna, F., Napoli e le rotte mediterranee della pittura: da Alfonso il Magnanimo a Ferdinando il Cattolico. Naples: Società Napoletana di Storia Patria, 1977.

Bombe, W. (ed.), Nachlass-Inventare des Angelo da Uzzano und des Lodovico di Gino Capponi. Leipzig and Berlin: Teubner, 1928.

—'Die Tafelbilder, Gonfaloni und Fresken des Benedetto Bonfigli', Repertorium für Kunstwissenschaft 32 (1909), pp. 97–146.

Bonfil, R., 'The historian's perception of the Jews in the Italian Renaissance', *Revue des Etudes Juives* 143 (1984), pp. 59–82.

- —Rabbis and Jewish Communities in Renaissance Italy. Oxford: Oxford University Press, 1990.
- Bonomo, G., Caccia alle streghe. Palermo: Pulumbo, 1959.
- Borkenau, F., Der Übergang vom feudalen zum bürgerlichen Weltbild. Paris: Alcan, 1934.
- Borsellino, N., Gli anticlassicisti del cinquecento. Rome and Bari: Laterza, 1973.
- Bottari, G. G., Raccolta di lettere sulla pittura, scultura ed architettura, 8 vols. Milan: Silvestri, 1822–5.
- Bourdieu, P., *Distinction*. Eng. trans. R. Nice. London: Routledge & Kegan Paul, 1984.
- Bouwsma, W. J., 'The Renaissance and the drama of European history', *American Historical Review* 84 (1979), pp. 1–15.
- Braghirolli, W., 'Carteggio di Isabella d'Este intorno ad un quadro di Giambellino', *Archivio Veneto* 13 (1877), pp. 376–83.
- Branca, V., Poliziano e l'umanesimo della parola. Turin: Einaudi, 1983.
- —(ed.), *Umanesimo europeo ed umanesimo veneziano*. Florence: Sansoni, 1964.
- Braudel, F., *The Mediterranean and the Mediterranean World in the Age of Philip II*. Eng. trans. S. Reynolds, 2 vols. Berkeley and London: University of California Press, 1972–3.
- —The Wheels of Commerce. Eng. trans. S. Reynolds. London: Collins, 1982.
- Bredekamp, H., M. Diers and C. Schoell-Glass (eds), *Aby Warburg*. Hamburg: VCH, 1991.
- Bridgman, N., La vie musicale au quattrocento et jusqu'à la naissance du madrigal. Paris: Gallimard, 1964.
- Bronzini, G., 'Pubblico e predicazione popolare di Bernardino di Siena', *Lares* 44 (1978), pp. 3–31.
- -Tradizione di stile aedico dai cantari al 'Furioso'. Florence: Olschki, 1966.
- Brotton, J., *The Renaissance Bazaar: from the Silk Road to Michelangelo*. Oxford: Oxford University Press, 2002.
- Brown, A., *Bartolommeo Scala*, 1430–1497, *Chancellor of Florence*. Princeton, NJ: Princeton University Press, 1979.
- —'The humanist portrait of Cosimo de'Medici', JWCI 24 (1961), pp. 186–221.
- —(ed.), Language and Images of Renaissance Italy. Oxford: Oxford University Press, 1995.
- Brown, C. M., 'A Ferrarese lady and a Mantuan marchesa: the art and antiquities collections of Isabella d'Este Gonzaga', in *Women and Art in Early Modern Europe*, ed. C. Lawrence, pp. 53–71. University Park: Pennsylvania State University Press, 1997.

- Brown, J. C., and R. C. Davis (eds), Gender and Society in Renaissance Italy. London: Longman, 1998.
- Brown, P. F., *Private Lives in Renaissance Venice*. New Haven, CT: Yale University Press, 2004.
- —Venetian Narrative Painting in the age of Carpaccio. New Haven, CT: Yale University Press, 1988.
- -Venice and Antiquity. New Haven, CT: Yale University Press, 1996.
- Brucker, G., *The Civic World of Early Renaissance Florence*. Princeton, NJ: Princeton University Press, 1977.
- —(ed.), Two Memoirs of Renaissance Florence. New York: Harper & Row, 1967.
- Bruni, L., *Epistolae populi Florentini nomine scriptae*, ed. L. Mehus, 2 vols. Florence, 1741.
- —'Panegyric to the city of Florence', in *The Earthly Republic*, ed. B. Kohl and R. Witt, pp. 135–75. Philadelphia: University of Pennsylvania Press, 1978.
- Bryson, N., Word and Image. Cambridge: Cambridge University Press, 1981.
- Bullen, J. B., The Myth of the Renaissance in Nineteenth-Century Writing. Oxford: Clarendon Press, 1994.
- Burckhardt, J., *The Architecture of the Italian Renaissance* (1867). Eng. trans., London: Secker & Warburg, 1985.
- -Beiträge zur Kunstgeschichte von Italien. Basel: Lendorff, 1898.
- —The Civilization of the Renaissance in Italy (1860). Eng. trans., London: Phaidon Press, 1944.
- —Reflections on History (1906). Eng. trans., London: Allen & Unwin, 1943.
- Burke, J., Changing Patrons: Social Identity and the Visual Arts in Renaissance Florence. University Park: Pennsylvania State University Press, 2004.
- Burke, P., 'Anthropology of the Renaissance', *Journal of the Institute for Romance Studies* 1 (1992), 207–15.
- —'L'art de la propagande à l'époque de Pisanello', in *Pisanello*, pp. 253–62. Paris: La documentation française, 1998.
- —'Civilization, sex and violence in early modern Italy: reflections on the theories of Norbert Elias', *Journal of the Institute of Romance Studies* 5 (1997), pp. 71–80.
- —'Decentering the Renaissance: the challenge of postmodernism', in *At the Margins: Minority Groups in Premodern Italy*, ed. S. Milner, pp. 36–49. Minneapolis: University of Minnesota Press, 2005.
- 'Gianfrancesco Pico and his *Strix*', in *The Damned Art*, ed. S. Anglo, pp. 32–52. London: Routledge & Kegan Paul, 1977.
- -Historical Anthropology of Early Modern Italy: Essays on Perception

- and Communication. Cambridge: Cambridge University Press, 1987.
- —'History as allegory', Inti 45 (1997), pp. 337-51.
- —'Investment and culture in three seventeenth-century cities', *Journal of European Economic History* 7 (1978), pp. 311–36.
- —'The Italian artist and his roles', in *History of Italian Art*, ed. Burke, 2 vols, vol. 1, pp. 1–28. Cambridge: Polity, 1994.
- —'Jack Goody and the comparative history of Renaissances', *Theory*, *Culture and Society* 26 (2009), pp. 1–17.
- Learned culture and popular culture in Renaissance Italy', *Pauvres et riches: mélanges offerts à Bronislaw Geremek*, ed. M. Aymard, S. Bylina et al., pp. 341–9. Warsaw: Wydawnictwo Naukowe PWN, 1992.
- —'The myth of 1453: notes and reflections', in Querdenken: Dissens und Toleranz im Wandel der Geschichte: Festschrift zum 65. Geburtstag Hans R. Guggisberg, ed. M. Erbe et al., pp. 23-30. Mannheim: Palatium, 1996.
- —'Oral culture and print culture in Renaissance Italy', ARV: Nordic Yearbook of Folklore (1998), pp. 79–90.
- —Popular Culture in Early Modern Europe. 3rd edn, Farnham: Ashgate, 2009.
- 'Prosopografie van der Renaissance', Millennium 7 (1993), pp. 14-22.
- —'Renaissance Europe and the world', in *Palgrave Advances in Renaissance Historiography*, ed. J. Woolfson, pp. 52–70. Basingstoke: Palgrave Macmillan, 2005.
- —'The Renaissance, individualism and the portrait', *History of European Ideas* 21 (1995), pp. 393–400.
- —The Renaissance Sense of the Past. London: Edward Arnold, 1969.
- —'Il ritratto veneziano nel cinquecento', in *La pittura nel Veneto: il cinquecento*, vol. 3, ed. Mauro Lucco, pp. 1079–118. Milan: Electa, 1999.
- —'The sense of anachronism from Petrarch to Poussin', in *Time in the Medieval World*, ed. C. Humphrey and W. M. Ormrod, pp. 157–73. Woodbridge: York Medieval Press, 2001.
- —'Strengths and weaknesses of the history of mentalities', *History of European Ideas* 7 (1986), pp. 439–51.
- -Varieties of Cultural History. Cambridge: Polity, 1997.
- Burney, C., A General History of Music, 4 vols (1776–89). New York: Dover, 1969.
- Burroughs, C., *The Italian Renaissance Palace Façade*. Cambridge: Cambridge University Press, 2002.
- Butters, H., Governors and Government in Early Sixteenth-Century Florence. Oxford: Clarendon Press, 1986.
- Callmann, E., Apollonio di Giovanni. Oxford: Clarendon Press, 1974.

Campbell, L., Renaissance Portraits, New Haven, CT: Yale University Press, 1990.

Campbell, S., The Cabinet of Eros: Renaissance Mythological Painting and the studiolo of Isabella d'Este. New Haven, CT: Yale University Press, 2004.

Caplan, H., 'The four senses of scriptural interpretation', *Speculum* 4 (1929), pp. 282–94.

Caplow, H. N., 'Sculptors' partnerships', *Studies in the Renaissance* 21 (1974), pp. 145–75.

Carboni Baiardi, G., et al. (eds), Federico di Montefeltro: lo stato/le arti/la cultura, 3 vols. Rome: Bulzoni, 1986.

Cardano, G., *The Book of My Life* (1575). Eng. trans., New York: Dover, 1962.

—De rerum varietate. Basel, 1557.

Carew-Reid, N., Les fêtes florentines au temps de Lorenzo il Magnifico. Florence: Olschki, 1995.

Carrithers, M., S. Collins and S. Lukes (eds), *The Category of the Person*. Cambridge: Cambridge University Press, 1985.

Cartwright, J., Isabella d'Este. 2nd edn., 2 vols. London: John Murray, 1903.

Casotti, G. B., Memorie istoriche della miracolosa immagine di Maria vergine dell'Impruneta, 2 vols. Florence, 1714.

Cassirer, E., P. Kristeller and J. H. Randall (eds), *The Renaissance Philosophy of Man*. Chicago: University of Chicago Press, 1948.

Cast, D., *The Calumny of Apelles*. New Haven, CT, and London: Yale University Press, 1981.

Castelnuovo, E., 'Per una storia sociale de l'arte', in Castelnuovo, *Arte, industria, rivoluzioni*. Turin: Einaudi, 1985.

—'Il significato del ritratto pittorico nella società', *Storia d'Italia 5*, pp. 1035–94. Turin: Einaudi, 1973.

Castelnuovo, E., and C. Ginzburg, 'Centre and periphery', Eng. trans. in *History of Italian Art*, ed. P. Burke, 2 vols, vol. 1, pp. 29–112. Cambridge: Polity, 1994.

Castiglione, B., *Il cortegiano* (1528), ed. B. Maier. 2nd edn, Eng. trans., New York: Ungar, 1959.

Castiglione, S. di, Ricordi (1549). 2nd edn, Venice, 1554.

Cavalcanti, G., Istorie fiorentine. Milan: Aldo Martello, 1944.

Céard, J., La nature et les prodiges. Geneva: Droz, 1977.

Cellini, B., Vita, ed. E. Camesasca. Eng. trans., Harmondsworth: Penguin, 1956.

Cèndali, L., Giuliano e Benedetto da Maiano. Florence: Società editrice Toscana, 1936.

- Cennini, C., *Il libro dell'arte*. Eng. trans., ed. D. V. Thompson, 2 vols. New Haven, CT: Yale University Press, 1932–3.
- Chabod, F., L'epoca di Carlo V. Milan: Treccani, 1961.
- —'Usi ed abusi nell'amministrazione dello stato di Milano', in *Studi storici in onore di Gioacchino Volpe*, pp. 95–194. Florence: Sansoni, 1958.
- —'Was there a Renaissance state?', in *The Development of the Modern State*, ed. H. Lubasz. New York: Macmillan, 1964.
- Chakrabarty, D., *Provincializing Europe*. Princeton, NJ: Princeton University Press, 2000.
- Chambers, D. S. (ed.), *Patrons and Artists in the Italian Renaissance*. London: Macmillan, 1970.
- Chambers, D. S., and Quiviger, F. (eds), *Italian Academies of the Sixteenth Century*. London: Warburg Institute, 1995.
- Chastel, A., Art et humanisme à Florence au temps de Laurent le Magnifique. Paris: Presses Universitaires de France, 1961.
- —'Art et humanisme au quattrocento', in *Umanesimo europeo ed umanesimo veneziano*, ed. V. Branca, pp. 395–406. Florence: Sansoni, 1964.
- —The Sack of Rome. Princeton, NJ: Princeton University Press, 1983.
- Chipps Smith, J., *The Northern Renaissance*. London: Phaidon Press. 2004.
- Chojnacki, S., 'Political adulthood in fifteenth-century Venice', *American Historical Review* 91 (1986), pp. 791–810.
- Christian, K. W., and D. J. Drogin (eds), Patronage and Italian Renaissance Sculpture. Farnham: Ashgate, 2010.
- Christiansen, K., and S. Weppelmann (eds), *The Renaissance Portrait:* From Donatello to Bellini. New York: Metropolitan Museum of Art, 2011.
- Ciammitti, L., S. Ostrow and S. Settis (eds), *Dosso's Fate: Painting and Court Culture in Renaissance Italy*. Los Angeles: Getty Research Institute, 1998.
- Ciappelli, G., and P. Rubin (eds), *Art, Memory, and Family in Renaissance Florence*. Cambridge: Cambridge University Press, 2000.
- Cipolla, C. M., Clocks and Culture. London: Collins, 1967.
- 'Economic depression of the Renaissance?', Economic History Review 16 (1963-4), pp. 519-24.
- Clark, S., Thinking with Demons: The Idea of Witchcraft in Early Modern Europe. Oxford: Clarendon Press, 1997.
- Clark, T., Image of the People. London: Thames & Hudson, 1973.
- Clements, R. J. (ed.), *Michelangelo: A Self-Portrait*. Englewood Cliffs, NJ: Prentice-Hall, 1963.

- Clough, C. H., 'Federigo da Montefeltre's patronage of the arts', *JWCI* 36 (1973), pp. 129–44.
- Cocchiara, G., Le origini della poesia popolare. Turin: Boringhieri, 1966.
- Coffin, D. R. (ed.), *The Italian Garden*. Washington, DC: Dumbarton Oaks, 1972.
- —The Villa in the Life of Renaissance Rome. Princeton, NJ: Princeton University Press, 1979.
- Cohn, S. K., Creating the Florentine State: Peasants and Rebellion, 1348–1434. Cambridge: Cambridge University Press, 1999.
- —The Laboring Classes in Renaissance Florence. New York: Academic Press, 1980.
- —'Renaissance attachment to things', *Economic History Review* 65 (2011), pp. 984–1004.
- Cole, B., The Renaissance Artist at Work: From Pisano to Titian. London: John Murray, 1983.
- -Sienese Painting. New York: Harper & Row, 1980.
- Collett, B., Italian Benedictine Scholars and the Reformation. Oxford: Clarendon Press, 1985.
- Comanducci, R. M., 'Il concetto di "artista" e la pratica di lavoro nella bottega quattrocentesca', in *Arti fiorentine*, ed. G. Fossi and F. Franceschi, vol.2, pp. 149–65. Florence: Giunti, 1999.
- —'L'organizzazione produttiva della bottega d'arte fiorentina', in *Economia ed arte*, ed. S. Cavaciocchi, pp. 751–9. Florence: Le Monnier, 2002.
- —'Produzione seriale e mercato dell'arte a Firenze tra quattro e cinquecento', in *The Art Market in Italy*, 15th–17th Century, ed. M. Fantoni et al., pp. 105–13. Modena: F. C. Panini, 2003.
- Concina, E., L'Arsenale della Repubblica di Venezia. Milan: Electa, 1984.
- —Dell'arabico: a Venezia tra Rinascimento e Oriente. Venice: Marsilio, 1994.
- Condivi, A., Vita di Michelangelo Buonarroti, ed. E. S. Barelli. Milan: Rizzoli, 1964.
- Coniglio, G., II regno di Napoli al tempo di Carlo V. Naples: Edizioni scientifiche italiane, 1951.
- Connell, S., The Employment of Sculptors and Stonemasons in Venice in the Fifteenth Century. New York: Garland, 1988.
- Connell, W. J. (ed.), Society and Individual in Renaissance Florence. Berkeley: University of California Press, 2002.
- Contadini, A., 'Middle Eastern objects', in *At Home in Renaissance Italy*, ed. M. Ajmar-Wollheim and F. Dennis, pp. 308–21. London: V&A, 2006.

- Contarini, G., Commonwealth and Government of Venice (1543). Eng. trans., London, 1598.
- Conti, A., 'L'evoluzione dell'artista', *Storia dell'arte italiana*, 2, pp. 117–263. Turin: Einaud, 1979.
- Coor, G., Neroccio de'Landi. Princeton, NJ: Princeton University Press, 1961.
- Copenhaver, B. P., and C. Schmitt, *Renaissance Philosophy*. Oxford: Oxford University Press, 1992.
- Corti, G., and F. Hartt, 'New documents concerning Donatello', *Art Bulletin* 44 (1962), pp. 155–67.
- Cosenza, M., Biographical and Bibliographical Dictionary of the Italian Humanists. New York, 1952.
- Cox, V., The Renaissance Dialogue: Literary Dialogue in its Social and Political Contexts, Castiglione to Galileo. Cambridge: Cambridge University Press, 1992.
- —Women's Writing in Italy, 1400–1650. Baltimore: Johns Hopkins University Press, 2008.
- Cox-Rearick, J., *Dynasty and Destiny in Medici Art*. Princeton, NJ: Princeton University Press, 1984.
- Cozzi, G., 'Cultura, politica e religione nella pubblica storiografia veneziana', *Studi Veneziani* 5 (1963), pp. 215–94.
- Cranston, J., *The Poetics of Portraiture in the Italian Renaissance*. Cambridge: Cambridge University Press, 2000.
- Craven, W. G., Giovanni Pico della Mirandola, Symbol of his Age. Geneva: Droz, 1981.
- Crawcour, E. S., 'Changes in Japanese commerce in the Tokugawa period', in *Studies in the Institutional History of Early Modern Japan*, ed. J. W. Hall and M. B. Jansen, pp. 189–202. Princeton, NJ: Princeton University Press, 1968.
- Crouzet-Pavan, E., Renaissances italiennes 1380-1500. Paris: Albin Michel, 2007.
- Crowe, J. A., and G. B. Cavalcaselle, *The Life and Times of Titian*. London: John Murray, 1881.
- Crum, R. J., and J. T. Paoletti (eds), *Renaissance Florence: A Social History*. Cambridge: Cambridge University Press, 2006.
- Currie, E., Inside the Renaissance House. London: V&A, 2006.
- Dacos, N., 'Italian art and the art of antiquity', in *History of Italian Art*, ed. P. Burke, 2 vols, vol. 1, pp. 113–213. Cambridge: Polity, 1994.
- D'Amico, J. F., *Renaissance Humanism in Papal Rome*. Baltimore: Johns Hopkins University Press, 1983.
- D'Ancona, A. (ed.), Sacre rappresentazioni dei secoli xiv, xv, e xvi. Florence: Le Monnier, 1872.
- Daniello, B., Poetica. Venice, 1536.

- D'Arco, C., Giulio Pippi Romano, 2nd edn. Mantua: Fratelli Negretti, 1842.
- Darnton, R., The Great Cat Massacre and other Episodes in French Cultural History. New York: Basic Books, 1984.
- Davis, J. C., The Decline of the Venetian Nobility as a Ruling Class. Baltimore: Johns Hopkins University Press, 1962.
- Davis, N. Z., Trickster Travels: A Sixteenth-Century Muslim between Worlds. London: Faber, 2006.
- De Caprio, V., 'Aristocrazia e clero da la crisi dell'umanesimo alla Controriforma', *Letteratura italiana*, 2: *Produzione e consumo*, ed. A. Asor Rosa, pp. 299–361. Turin: Einaudi, 1983.
- —'Intellettuali e mercato del lavoro nella Roma medicea', *Studi romani* 29 (1981), pp. 29–46.
- De la Mare, A., 'Vespasiano da Bisticci', PhD thesis, University of London, 1965.
- Della Casa, G., *Galateo* (1558), ed. D. Provenzal. Eng. trans., Harmondsworth: Penguin, 1958.
- Delumeau, J., 'Mobilité sociale: riches et pauvres à l'époque de la Renaissance', in *Ordres et classes*, ed. E. Labrousse, pp. 125–34. Paris and The Hague: Mouton, 1973.
- 'Réinterprétation de la Renaissance', Revue d'histoire moderne et contemporaine 14 (1967), pp. 296-314.
- De Maio, R., Michelangelo e la Controriforma. Rome: Laterza, 1978.
- Dempsey, C., 'Mercurius Ver: the sources of Botticelli's *Primavera*', *JWCI* 31 (1968), pp. 251–69.
- —The Portrayal of Love: Botticelli's Primavera and Humanist Culture at the Time of Lorenzo the Magnificent. Princeton, NJ: Princeton University Press, 1992.
- —'Some observations on the education of artists at Florence and Bologna during the later sixteenth century', *Art Bulletin* 62 (1980), pp. 552–6.
- Denley, P., 'Recent studies on Italian universities of the Middle Ages and Renaissance', *History of Universities* 1 (1981), pp. 193–206.
- —'The social function of Italian Renaissance universities', CRE Information 62 (1983), pp. 47–58.
- Dijksterhuis, E. J., *The Mechanization of the World Picture*. Eng. trans., Oxford: Clarendon Press, 1961.
- Dionisotti, C., Geografia e storia della letterature italiana. Turin: Einaudi, 1967.
- Dolce, L., *Aretino* (1557). Eng. trans., ed. M. W. Roskill. New York: New York University Press, 1968.
- Dominici, G., Regola del governo di cura familiare (1860). Eng. trans., Washington, DC: Catholic University of America, 1927.

- Doren, A., 'Aby Warburg und sein Werk', Archiv für Kulturgeschichte 21 (1931), pp. 1–23.
- —Die florentiner Wollentuchindustrie vom 14. bis zum 16. Jahrhundert. Stuttgart, 1901.
- -Fortuna im Mittelalter und in der Renaissance. Hamburg: Teubner, 1922.
- Doria, G., 'Una città senza corte: economia e committenza a Genova nel '400-'500', in *Arte, committenza ed economia a Roma e nelle corti del Rinascimento*, 1420-1530, ed. A. Esch and C. L. Frommel, pp. 243-54. Turin: Einaudi, 1995.
- Dowd, D. F., 'The economic expansion of Lombardy, 1300–1500', *Journal of Economic History* 21 (1961), pp. 143–60.
- Duby, G., *The Three Orders*. Eng. trans., Chicago: University of Chicago Press, 1980.
- Dundes, A., and A. Falassi, *La terra in piazza: An Interpretation of the Palio of Siena*. Berkeley: University of California Press, 1975.
- Dürer, A., Schriftlicher Nachlass, ed. H. Rupprich, 3 vols. Berlin: Deutscher Verein für Kunstwissenschaft, 1956–69.
- Ebreo, L., Dialoghi d'amore (1535). Bari: Laterza, 1929.
- Eckstein, N. A., The District of the Green Dragon: Neighbourhood Life and Social Change in Renaissance Florence. Florence: Olschki, 1995.
- 'Neighbourhood as microcosm', in *Renaissance Florence: A Social History*, ed. R. J. Crum and J. T. Paoletti, pp. 219–39. Cambridge: Cambridge University Press, 2006.
- Edgerton, S. Y., *Pictures and Punishment: Art and Criminal Prosecution during the Florentine Renaissance*. Ithaca, NY, and London: Cornell University Press, 1985.
- —The Renaissance Rediscovery of Linear Perspective. New York: Basic Books, 1975.
- Edwards, J. M. B., 'Creativity: social aspects', *International Encyclopaedia* of the Social Sciences, ed. D. L. Sills, vol. 3, pp. 442–55. New York: Macmillan, 1968.
- Einstein, A., Essays on Music. London: Faber & Faber, 1958.
- —The Italian Madrigal, 3 vols. Princeton, NJ: Princeton University Press, 1949.
- Eisenbichler, K. (ed.), Crossing the Boundaries: Christian Piety and the Arts in Italian Medieval and Renaissance Confraternities. Kalamazoo: Western Michigan University Press, 1991.
- Elam, C., 'Battista della Palla', I Tatti Studies 5 (1993), pp. 33-109.
- 'Lorenzo de'Medici and the urban development of Renaissance Florence', Art History 1 (1978), pp. 43–56.
- 'Lorenzo de' Medici's sculpture garden', Mitteilungen des Kunsthistorischen Instituts in Florenz 36 (1992), pp. 41–84.

- Elias, N., *The Civilizing Process*. Eng. trans., 2 vols. Oxford: Blackwell, 1978–82.
- -The Court Society. Eng. trans., Oxford: Blackwell, 1983.
- Elsner, J., and Cardinal, R. (eds), *The Cultures of Collecting*. London: Reaktion, 1994.
- Emison, P., 'The replicated image in Florence, 1300–1600', in *Renaissance Florence: A Social History*, ed. R. J. Crum and J. T. Paoletti, pp. 431–53. Cambridge: Cambridge University Press, 2006.
- Encyclopaedia of World Art, 15 vols. New York: McGraw-Hill, 1959–68. Errera, I., Répertoire des peintures datées. Brussels: Librairie nationale

d'art et d'histoire, 1920.

- Esch, A., 'Sul rapporto fra arte ed economia nel Rinascimento italiano', in *Arte, committenza ed economia a Roma e nelle corti del Rinascimento*, 1420–1530, ed. A. Esch and C. L. Frommel, pp. 3–49. Turin: Einaudi, 1995.
- Esch, A., and Frommel, C. L. (eds), Arte, committenza ed economia a Roma e nelle corti del Rinascimento, 1420–1530. Turin: Einaudi, 1995.
- Esposito, A., 'Le confraternite romane tra arte e divozione', in *Arte, committenza ed economia a Roma e nelle corti del Rinascimento*, 1420–1530, ed. A. Esch and C. L. Frommel, pp. 107–20. Turin: Einaudi, 1995.
- Ettlinger, L. D., 'The emergence of the Italian architect during the fifteenth century', in *The Architect*, ed. S. Kostof, pp. 96–121. New York: Oxford University Press, 1977.
- —The Sistine Chapel before Michelangelo. Oxford: Clarendon Press, 1965.
- Ettlinger, L. D., and H. S. Ettlinger, *Botticelli*. London: Thames & Hudson, 1976.
- Evans-Pritchard, E. E., The Nuer. Oxford: Clarendon Press, 1940.
- Fagiolo Dell'Arco, M., Il Parmigianino: un saggio sull'ermetismo nel cinquecento. Rome: Bulzoni, 1970.
- Fahy, E., 'The marriage portrait in the Renaissance', in *Art and Love in Renaissance Italy*, ed. A. Bayer, pp. 17–27. New Haven, CT: Yale University Press, 2008.
- Fantoni, M., La corte del granduca. Rome: Bulzoni, 1994.
- Fantoni, M., et al. (eds), *The Art Market in Italy*, 15th–17th Century. Modena: F. C. Panini, 2003.
- Farago, C. (ed.), Reframing the Renaissance: Visual Culture in Europe and Latin America, 1450–1650. New Haven, CT: Yale University Press, 1995.
- Febvre, L., The Problem of Unbelief in the Sixteenth Century. Eng. trans., Cambridge, MA: Harvard University Press, 1983.

- Feldman, M., City Culture and the Madrigal at Venice. Berkeley: University of California Press, 1995.
- Fenlon, I. *The Ceremonial City*. New Haven, CT: Yale University Press, 2007.
- -Music and Culture in Late Renaissance Italy. Oxford: Oxford University Press, 2002.
- —Music and Patronage in Sixteenth-Century Mantua. Cambridge: Cambridge University Press, 1980.
- Ferguson, W. K., *The Renaissance in Historical Thought*. Boston: Houghton Mifflin, 1948.
- Ferino Pagden, S., 'From cult images to the cult of images: the case of Raphael's altarpieces', in *The Altarpiece in the Renaissance*, ed. P. Humfrey and M. Kemp, pp. 165–89. Cambridge: Cambridge University Press, 1990.
- ffoulkes, C. J., and R. Maiocchi, Vincenzo Foppa. London: J. Lane, 1909.
- Ficino, M., De vita. Venice, c. 1525.
- Field, A., *The Origins of the Platonic Academy of Florence*. Princeton, NJ: Princeton University Press, 1988.
- Filarete, A., *Treatise on Architecture*. Eng. trans., with facsimile, ed. J. R. Spencer, 2 vols. New Haven, CT: Yale University Press, 1965.
- Findlen, P., 'Possessing the past: the material culture of the Italian Renaissance', *American Historical Review* 103 (1998), pp. 83–114.
- Finlay, R., Politics in Renaissance Venice. London: Ernest Benn, 1980.
- —'The Venetian Republic as a gerontocracy', *Journal of Medieval and Renaissance Studies* 8 (1978), pp. 157–78.
- Finucci, V., 'La donna di corte: discorso istituzionale e realtà nel *Libro* del Cortegiano', Annali d'Italianistica 7 (1989), pp. 88–103.
- Firenzuola, A., Prose. Florence, 1548.
- Fishman, J. A., 'Who speaks what language to whom and when', in *The Sociology of Language*, ed. J. B. Pride and J. Holmes, pp. 15–31. Harmondsworth: Penguin, 1971.
- Fiume, G., Il santo patrono e la città. Venice: Marsilio, 2000.
- Flaten, A. R., 'Portrait medals and assembly-line art in late '400 Florence', in *The Art Market in Italy*, 15th–17th Century, ed. M. Fantoni et al., pp.127–39. Modena: F. C. Panini, 2003.
- Fletcher, J., 'Isabella d'Este and Giovanni Bellini's *Presepio'*, *Burlington Magazine* 113 (1971), pp. 703–12.
- Floerke, H., Studien zu niederländische Kunst- und Kulturgeschichte. Munich and Leipzig, 1905.
- Folena, G. F., 'La cultura volgare e l'umanesimo cavalleresco nel Veneto', in *Umanesimo europeo ed umanesimo veneziano*, ed. V. Branca, pp. 141–57. Florence: Sansoni, 1964.

Fontes, A., et al. (eds), *Savonarole: enjeux, débats, questions*. Paris: Université de la Sorbonne nouvelle, 1997.

Forcellino, A., *Michelangelo: A Tormented Life*. Eng. trans. A. Cameron. Cambridge: Polity, 2011.

Forster, K., 'Introduction' to A. Warburg, *The Renewal of Pagan Antiquity*. Eng. trans., Los Angeles: Getty Center, 1999.

Foscari, A., and M. Tafuri, L'armonia e i conflitti: la chiesa di San Francesco della Vigna nella Venezia del '500. Turin: Einaudi, 1983.

Fossati, F., 'Lavoro e lavoratori a Milano nel 1438', *Archivio storico lombardo 55* (1928), pp. 225–58, 496–525; 56 (1929), pp. 71–95.

Foucault, M., The Order of Things. Eng. trans., London: Vintage, 1973.

Fraenkel, B., La signature, genèse d'un signe. Paris: Gallimard, 1992.

Fragnito, G. (ed.), Church, Censorship and Culture in Early Modern Italy. Cambridge: Cambridge University Press, 2001.

Frajese, V., Nascita dell'Indice: la censura ecclesiastica dal Rinascimento alla Controriforma. Brescia: Morcelliana, 2006.

Francastel, G., 'De Giorgione à Titien: l'artiste, le public et le commercialisation de l'oeuvre d'art', *Annales ESC* 15 (1960), pp. 1060–75.

Francastel, P., Peinture et société. 2nd edn., Paris: Gallimard, 1965.

— 'Valeurs socio-psychologiques de l'espace-temps figuratif de la Renaissance', L'Annee Sociologique (1965), pp. 3-68.

Frangenberg, T., 'Bartoli, Giambullari and the prefaces to Vasari's *Lives*', *JWCI* 65 (2002), pp. 244–58.

Frey, C. (ed.), Il libro de Antonio Billi. Berlin: Grote, 1892.

Friedländer, W., Mannerism and Anti-Mannerism in Italian Painting. New York: Schocken, 1965.

Frommel, C. L., *Architettura e committenza da Alberti a Bramante*. Florence: Olschki, 2006.

Fubini, R., Humanism and Secularization: From Petrarch to Valla. Durham, NC: Duke University Press, 2003.

—'Renaissance historian: the career of Hans Baron', *Journal of Modern History* 64 (1992), pp. 541–74.

Fumagalli, G., Leonardo: omo sanza lettere. Florence: Sansoni, 1952.

Fumaroli, M., L'âge de l'éloquence. Geneva: Droz, 1980.

Gabrieli, F., Testimonianze arabe ed europee. Bari: Dedalo libri, 1976.

Gaeta, F., Lorenzo Valla: filologia e storia nell'umanesimo italiano. Naples: Nella Sede dell'Istituto, 1955.

Gaeta, F., 'Alcuni considerazioni sul mito di Venezia', *Bibliothèque d'Humanisme et Renaissance* 23 (1961), pp. 58-75.

Galitz, R., and B. Reimers (eds), Aby M. Warburg: Portrait eines Gelehrten. Hamburg: Dölling & Galitz, 1995.

Galton, F., Hereditary Genius. London: Macmillan, 1869.

- Gamberini, A. (ed.), *The Italian Renaissance State*. Cambridge: Cambridge University Press, 2012.
- Gambi, L., and G. Bollati (eds), Storia d'Italia, 6: Atlante. Turin: Einaudi, 1976.
- Garin, E., Astrology in the Renaissance. Eng. trans., London: Routledge & Kegan Paul, 1983.
- —'I cancellieri umanisti della repubblica fiorentina', *Rivista storica italiana* 71 (1959), pp. 185–208.
- 'La cité idéale de la Renaissance italienne', in *Les utopies à la Renaissance*, ed. J. Lameere, pp. 13–37. Brussels: Presses universitaires de Bruxelles, 1963.
- Gauricus, P., *De sculptura* (1504), ed. A. Chastel and R. Klein. Geneva: Droz, 1969.
- Gaye, G. (ed.), Carteggio inedito d'artisti dei secoli xiv, xv, xvi, 3 vols. Florence: Molini, 1839–40.
- Geanakoplos, D. J., Interaction of the 'Sibling' Byzantine and Western Cultures in the Middle Ages and Italian Renaissance (330–1600). New Haven, CT: Yale University Press, 1976.
- Geertz, C., Local Knowledge. New York: Basic Books, 1983.
- Gelli, G. B., 'Vite d'artisti', Archivio Storico Italiano 17 (1896), pp. 32-62.
- Ghelardi, M., La scoperta del Rinascimento: l'Età di Raffaello' di Jacob Burckhardt. Turin: Einaudi, 1991.
- Ghiberti, L., *I commentari*, ed. O. Morisani. Naples: Riccardo Ricciardi, 1947.
- Giard, L., 'Histoire de l'université et histoire du savoir: Padoue (xiv^e-xvi^e siècles', *Revue de Synthèse* 104-6 (1983-5), pp. 139-69, 259-98, 419-42.
- Gilbert, C. E., 'The archbishop on the painters of Florence', *Art Bulletin* 41 (1959), pp. 75–87.
- —'On subject and not-subject in Italian Renaissance pictures', *Art Bulletin* 34 (1952), pp. 202–16.
- —'What did the Renaissance patron buy?' Renaissance Quarterly 51 (1998), pp. 392–450.
- Gilbert, F., 'Bernardo Rucellai and the Orti Oricellari', *JWCI* 12 (1949), pp. 101–31.
- 'Biondo, Sabellico and the beginnings of Venetian official historiography', in *Florilegium historiale*, ed. J. G. Rowe and W. H. Stockdale, pp. 276–87. Toronto: University of Toronto Press, 1970.
- —'Florentine political assumptions in the period of Savonarola and Soderini', *JWCI* 20 (1957), pp. 187–214.
- -Machiavelli and Guicciardini. Princeton, NJ: Princeton University Press, 1965.

- -- 'On Machiavelli's idea of *virtù*', *Renaissance News* 4 (1951), pp. 53-55.
- —The Pope, his Banker, and Venice. Cambridge, MA, and London: Harvard University Press, 1980.
- 'Venice in the crisis of the League of Cambrai', in Gilbert, *History: Choice and Commitment*, ch. 11. Cambridge, MA: Belknap Press, 1977.
- Gille, B., *Engineers of the Renaissance*. Eng. trans., Cambridge, MA: MIT Press, 1966.
- Ginzburg, C., Cheese and Worms. Eng. trans., London: Routledge & Kegan Paul, 1981.
- -- 'Da A. Warburg a E. H. Gombrich', Studi medievali 7 (1966), pp. 1015-65.
- —The Enigma of Piero. Eng. trans., London: Verso, 1985.
- —The Night Battles. Eng. trans., London: Routledge & Kegan Paul, 1983.
- -- 'Stregoneria e pietà popolare', Annali Scuola Normale di Pisa 30 (1961), pp. 269-87.
- Gnoli, D., La Roma di Leon X. Milan: Ulrico Hoepli, 1938.
- Goffen, R., *Piety and Patronage in Renaissance Venice*. New Haven, CT, and London: Yale University Press, 1986.
- -Renaissance Rivals: Michelangelo, Leonardo, Raphael, Titian. New Haven, CT: Yale University Press, 2002.
- Goffman E., *The Presentation of Self in Everyday Life*. Rev. edn, New York: Doubleday, 1959.
- Goldthwaite, R. A., *The Building of Renaissance Florence*. Baltimore: Johns Hopkins University Press, 1980.
- —'The economic and social world of Italian Renaissance maiolica', Renaissance Quarterly 42 (1989), pp. 1–32.
- —The Economy of Renaissance Florence. Baltimore: Johns Hopkins University Press, 2009.
- —'The empire of things: consumer demand in Renaissance Italy', in *Patronage, Art and Society in Renaissance Italy*, ed. F. W. Kent and P. Simons, pp. 153–75. Oxford: Oxford University Press, 1987.
- —Private Wealth in Renaissance Florence. Princeton, NJ: Princeton University Press, 1968.
- —'The Renaissance economy: the preconditions for luxury consumption', in *Aspetti della vita economica medievale*, pp. 659–75. Florence: Olschki, 1985.
- 'Schools and teachers of commercial arithmetic in Renaissance Florence', *Journal of European Economic History* 1 (1972), pp. 418–33.
- —Wealth and the Demand for Art in Italy, 1300–1600. Baltimore: Johns Hopkins University Press, 1993.

- Gombrich, E. H., Aby Warburg: An Intellectual Biography. London: Warburg Institute, 1970.
- -Art and Illusion. London: Phaidon Press, 1960.
- —The Heritage of Apelles. Oxford: Phaidon Press, 1976.
- -In Search of Cultural History. Oxford: Clarendon Press, 1969.
- -Meditations on a Hobby Horse. London: Phaidon Press, 1963.
- -Norm and Form. London: Phaidon Press, 1966.
- 'The social history of art', Art Bulletin 35 (1953), pp. 79-84.
- -Symbolic Images. London: Phaidon Press, 1972.
- -The Uses of Images. London: Phaidon Press, 1999.
- 'Vasari's Lives and Cicero's Brutus', JWCI 23 (1960), pp. 309-11.
- González García, J., La diosa fortuna: metamorfosis de una metáfora política. Madrid: A. Machado, 2006.
- Goody, J., *Renaissances: The One or the Many?* Cambridge: Cambridge University Press, 2009.
- Gossman, L., Basel in the Age of Burckhardt. Chicago: University of Chicago Press, 2000.
- Graf, A., Attraversa il '500. Turin, 1888.
- Grafton, A., *The Culture of Correction in Renaissance Europe*. London: British Library, 2011.
- —Forgers and Critics: Creativity and Duplicity in Western Scholarship. London: Collins & Brown, 1990.
- —Leon Battista Alberti: Master Builder of the Italian Renaissance. New York: Hill & Wang, 2001.
- Grafton, A., and L. Jardine, 'Humanism and the school of Guarino', *Past and Present* 96 (1982), pp. 51–80.
- Gras, N. S. B., 'Capitalism, concepts and history', in *Enterprise and Secular Change*, ed. F. C. Lane and J. Riemersma, pp. 66–79. London: Allen & Unwin, 1953.
- Greene, T., The Light in Troy: Imitation and Discovery in Renaissance Poetry. New Haven, CT, and London: Yale University Press, 1982.
- Greenstein, J. M., *Mantegna and Painting as Historical Narrative*. Chicago: University of Chicago Press, 1992.
- Greer, G., The Obstacle Race. London: Secker & Warburg, 1979.
- Grendler, P. F., *Critics of the Italian World 1530–60*. Madison: University of Wisconsin Press, 1969.
- —'Francesco Sansovino and Italian popular history', *Studies in the Renaissance* 16 (1969), pp. 139–80.
- —'Printing and censorship', in *The Cambridge History of Renaissance Philosophy*, ed. C. B. Schmitt et al. Cambridge: Cambridge University Press, pp. 25–54.
- —Schooling in Renaissance Italy: Literacy and Learning 1300–1600. Baltimore: Johns Hopkins University Press, 1989.

- —The Universities of the Italian Renaissance. Baltimore: Johns Hopkins University Press, 2002.
- Grove, G., *New Dictionary of Music and Musicians*, ed. S. Sadie, 2nd edn, 29 vols. London: Macmillan, 2001; online version accessible via Oxford Music Online.
- Guasti, C. (ed.), Le feste di S. Giovanni Batista in Firenze. Florence: G. Cirri, 1884.
- Guerri, D., La corrente popolare nel Rinascimento. Florence: Sansoni, 1931.
- Guerzoni, G., *Apollo and Vulcan: The Art Markets in Italy 1400–1700*. East Lansing: Michigan State University Press, 2011.
- Guglielminetti, M., Memoria e scrittura: l'autobiografia da Dante a Cellini. Turin: Einaudi, 1977.
- Guicciardini, F., Maxims and Reflections of a Renaissance Statesman. Eng. trans., New York: Harper & Row, 1965.
- -Storia d'Italia (1561), ed. C. Panigada, 5 vols. Bari: Laterza, 1929.
- Guidi, J., 'Le jeu de cour et sa codification dans les différentes rédactions du Courtisan', Centre de Recherches sur la Renaissance Italienne 10 (1982), pp. 97–115.
- Gundersheimer, W., 'Patronage in the Renaissance', in *Patronage in the Renaissance*, ed. G. F. Lytle and S. Orgel, pp. 3–23. Princeton, NJ: Princeton University Press, 1981.
- Gutas, D., Greek Thought, Arabic Culture: The Graeco-Arabic Translation Movement in Baghdad and Early 'Abbāsid Society. London: Routledge, 1998.
- Haines, M., 'Brunelleschi and bureaucracy: the tradition of public patronage at the Florentine cathedral', *I Tatti Studies* 3 (1989), pp. 89–125.
- —'The market for public sculpture in Renaissance Florence', in *The Art Market in Italy, 15th–17th Century*, ed. M. Fantoni et al., pp. 75–93. Modena: F. C. Panini, 2003.
- Hale, J. R., England and the Italian Renaissance. London: Faber & Faber, 1954.
- Hall, J. W., and M. B. Jansen (eds), Studies in the Institutional History of Early Modern Japan. Princeton, NJ: Princeton University Press, 1968.
- Hall, M. (ed.), Rome. Cambridge: Cambridge University Press, 2005.
- Hall, P., Cities in Civilization. London: Weidenfeld & Nicolson, 1998.
- Hankins, J., 'The "Baron thesis" after forty years and some recent studies of Leonardo Bruni', *Journal of the History of Ideas* 56 (1995), 309–30.
- -Plato in the Italian Renaissance, 2 vols. Leiden: E. J. Brill, 1990.
- —(ed.), Renaissance Civic Humanism: Reappraisals and Reflections. Cambridge: Cambridge University Press, 2000.

- Hansen, J. (ed.), Quellen zur Geschichte des Hexenwahns. Bonn: C. Georgi, 1901.
- Harff, A. von, *The Pilgrimage of Arnold von Harff, Knight* (1496). Eng. trans., London: Hakluyt Society, 1946.
- Harprath, R., Papst Paul III. als Alexander der Grosse. Berlin: De Gruyter, 1981.
- Hartt, F., 'Art and freedom in quattrocento Florence', in *Essays in Memory of Karl Lehmann*, ed. L. F. Sandler, pp. 114–31. New York: New York University Press, 1964.
- -Giulio Romano. New Haven, CT: Yale University Press, 1958.
- Haskell, F., Patrons and Painters. London: Chatto & Windus, 1963.
- Hatfield, R., 'The Compagnia de'Magi', JWCI 33 (1970), pp. 107-44.
- —'The funds of the façade of S. Maria Novella', JWCI 67 (2004), pp. 81–127.
- —'Review of Burke, *Tradition and Innovation*', *Art Bulletin* 55 (1973), pp. 630–3.
- Hauser, A., Mannerism, 2 vols. London: Routledge & Kegan Paul, 1965.
- —A Social History of Art, 2 vols. London: Routledge & Kegan Paul, 1951.
- Hay, D., The Church in Italy in the Fifteenth Century. Cambridge: Cambridge University Press, 1977.
- Hegel, G. W. F., *Philosophy of History* (1837). Eng. trans., New York: Dover, 1956.
- Heikamp, D., Mexico and the Medici. Florence: EDAM, 1972.
- Heller, A., Renaissance Man. London: Routledge & Kegan Paul, 1979.
- Herder, J. G., *Ideen zur Philosophie der Geschichte der Menschheit*, 4 vols. Berlin, 1784–91.
- Herlihy, D., 'The generation in medieval history', *Viator* 5 (1974), pp. 347–64.
- —'Three patterns of social mobility in medieval history', *Journal of Interdisciplinary History* 3 (1973), pp. 633–47.
- Herlihy, D., and C. Klapisch-Zuber, *Les Toscans et leurs familles*. Paris: Presses de la Fondation nationale des sciences politiques, 1978.
- Hermes, G., 'Der Kapitalismus in der Florentiner Wollentuchindustrie', Zeitschrift für die gesamte Staatswissenschaft 72 (1916), pp. 367–400.
- Herrick, M. T., *Italian Comedy in the Renaissance*. Urbana: University of Illinois Press, 1960.
- —Italian Tragedy in the Renaissance. Urbana: University of Illinois Press, 1965.
- Hersey, G. L., *Alfonso II and the Artistic Renewal of Naples*. New Haven, CT, and London: Yale University Press, 1969.
- Hexter, J., *The Vision of Politics on the Eve of the Reformation*. London: Allen Lane, 1973.

Heydenreich, L. H., 'Federico da Montefeltre as a building patron', in Studies in Renaissance and Baroque Art presented to Anthony Blunt on his 60th Birthday, pp. 1–6. London: Phaidon Press, 1967.

Heydenreich, L. H., and W. Lotz, *Architecture in Italy* 1400–1600. Harmondsworth: Penguin, 1974.

Hibbett, H., *The Floating World in Japanese Fiction*. London: Oxford University Press, 1959.

Hill, G. F., A Corpus of Italian Medals of the Renaissance before Cellini, 2 vols. London: British Museum, 1930.

Hills, P., 'Piety and patronage in '500 Venice: Tintoretto and the Scuole del Sacramento', *Art History* 6 (1983), pp. 30–43.

Hind, A. M., Early Italian Engraving. London: H. Milford, 1930.

Hollanda, F. de, *Da pintura antigua* (1548). Eng. trans. as *Four Dialogues on Painting*, London: Oxford University Press, 1928.

Hollingsworth, M., *Patronage in Renaissance Italy*, 2 vols. London: John Murray, 1993–6.

Holly, M. A., *Panofsky and the Foundations of Art History*. Ithaca, NY, and London: Cornell University Press, 1984.

Hook, J., Siena: A City and its History. London: Hamish Hamilton, 1979.

Hope, C., 'Artists, patrons and advisers in the Italian Renaissance', in *Patronage in the Renaissance*, ed. G. F. Lytle and S. Orgel, pp. 293–343. Princeton, NJ: Princeton University Press, 1981.

- 'The eyewitness style', New York Review of Books, 22 December 1988.

-Titian. London: Jupiter, 1980.

—'Le *Vite* vasariane: un esempio di autore multiplo', in *L'autore multi- plo*, ed. A. Santoni, pp. 59–74. Pisa: Scuola normale superior, 2005.

Hope, C., and E. McGrath, 'Artists and humanists', in *The Cambridge Companion to Renaissance Humanism*, ed. J. Kraye, pp. 161–88. Cambridge: Cambridge University Press, 1996.

Howard, D., The Architectural History of Venice. London: Batsford, 1980.

- 'Architectural politics in Renaissance Venice', *Proceedings of the British Academy* 154 (2008), pp. 29-67.

—Jacopo Sansovino: Architecture and Patronage in Renaissance Venice. New Haven, CT: Yale University Press, 1975.

—'The status of the oriental traveller in Renaissance Venice', in Re-orienting the Renaissance: Cultural Exchanges with the East, ed. G. MacLean, pp. 29–49. Basingstoke: Palgrave Macmillan, 2005.

—Venice and the East: The Impact of the Islamic World on Venetian Architecture 1100–1500. New Haven, CT: Yale University Press, 2000.

- Hughes-Johnson, S., 'Early Medici patronage and the confraternity of the Buonomini di San Martino', Confraternitas 22 (2012), pp. 3–25.
- Huizinga, J., *Autumn of the Middle Ages* (1919). Eng. trans., Chicago: University of Chicago Press, 1995.
- —'Renaissance and realism' (1920), Eng. trans. in Huizinga, Men and Ideas, pp. 288–309. New York: Meridian Books, 1959.
- —'The task of cultural history' (1929), Eng. trans. in Huizinga, Men and Ideas, pp. 17–76. New York: Meridian Books, 1959.
- Humfrey, P. (ed.), *Venice and the Veneto*. Cambridge: Cambridge University Press, 2007.
- Humfrey, P., and M. Kemp (eds), *The Altarpiece in the Renaissance*. Cambridge: Cambridge University Press, 1990.
- Humfrey, P., and R. MacKenney, 'The Venetian trade guilds as patrons of art in the Renaissance', *Burlington Magazine* 128 (1986), pp. 317–30.
- Huse, N., and W. Wolters, *The Art of Renaissance Venice: Architecture, Sculpture and Painting*, 1460–1590. Chicago: University of Chicago Press, 1990.
- Hymes, D., Foundations in Sociolinguistics: An Ethnographic Approach. London: Tavistock, 1977.
- Ianziti, G., Humanistic Historiography under the Sforzas. Oxford: Clarendon Press, 1988.
- Jacobs, F. H., Defining the Renaissance Virtuosa: Women Artists and the Language of Art History and Criticism. Cambridge: Cambridge University Press, 1997.
- Janson, H. W., 'The equestrian monument from Cangrande della Scala to Peter the Great', in *Aspects of the Renaissance*, ed. A. R. Lewis. Austin: University of Texas Press, 1967.
- Jardine, L., 'Isotta Nogarola: women humanists education for what?', *History of Education* 12 (1983), pp. 231–44.
- —'The myth of the learned lady in the Renaissance', *Historical Journal* 28 (1985), pp. 799–820.
- -Worldly Goods. London: W. W. Norton, 1996.
- Javitch, D., Proclaiming a Classic: The Canonization of Orlando Furioso. Princeton, NJ: Princeton University Press, 1991.
- Jenkins, C. H., 'Cosimo de'Medici's patronage of architecture and the theory of magnificence', *JWCI* 33 (1970), pp. 162–70.
- Jones, P. J., 'The agrarian development of medieval Italy', Second International Conference of Economic History, 2, pp. 69–86. Paris and The Hague: Mouton, 1965.
- 'Economia e societa nell'Italia medievale: la leggenda della borghesia', *Storia d'Italia: Annali 1*, pp. 185–372. Turin: Einaudi, 1978.
- 'Italy', in The Cambridge Economic History of Europe, vol. 1, ed.

- M. M. Postan, pp. 340–431. Cambridge: Cambridge University Press, 1966.
- Jones, R., and N. Penny, *Raphael*. New Haven, CT, and London: Yale University Press, 1983.
- Jordan, C., Renaissance Feminism. Ithaca, NY: Cornell University Press, 1990.
- Kaegi, W., *Jacob Burckhardt: eine Biographie*, 7 vols. Basel: B. Schwabe, 1947–82.
- —'Das Werk Aby Warburgs', Neue Schweize Rundschau 1 (1933), pp. 283-93.
- Kagan, R., 'Universities in Italy, 1500–1700', in *Histoire sociale des populations étudiantes*, ed. D. Julia, J. Revel and R. Chartier, 2 vols., vol. 1, pp. 153–86. Paris: Ecole des hautes études en sciences sociales, 1986.
- Kasl, R. (ed.), *Giovanni Bellini and the Art of Devotion*. Indianapolis: Indianapolis Museum of Art, 2004.
- Kearney, H. F., Scholars and Gentlemen. London: Faber, 1970.
- Keene, D., World within Walls: Japanese Literature of the Premodern Era, 1600–1867. London: Secker & Warburg, 1976.
- Kelley, D., Foundations of Modern Historical Scholarship. New York: Columbia University Press, 1970.
- Kelly, J., 'Did women have a Renaissance?', in *Becoming Visible*, ed. R. Bridenthal and C. Koonz, pp. 137–61. Boston: Houghton Mifflin, 1977.
- Kemp, M., Behind the Picture: Art and Evidence in the Italian Renaissance. New Haven, CT: Yale University Press, 1997.
- —'From "mimesis" to "fantasia": the quattrocento vocabulary of creation, inspiration and genius in the visual arts', *Viator* 8 (1977), pp. 347–98.
- —Leonardo da Vinci: The Marvellous Works of Nature and of Man. London: Dent, 1981.
- Kempers, B., *Painting*, *Power and Patronage*. Eng. trans., London: Allen Lane, 1992.
- Kent, D. V., Cosimo de' Medici and the Florentine Renaissance: The Patron's Oeuvre. New Haven, CT: Yale University Press, 2000.
- —'The Florentine Reggimento in the fifteenth century', Renaissance Quarterly 28 (1975), pp. 575-620.
- —The Rise of the Medici: Faction in Florence, 1426–1434. Oxford: Oxford University Press, 1978.
- Kent, D. V., and F. W. Kent, Neighbours and Neighbourhood in Renaissance Florence. Locust Valley, NY: J. J. Augustin, 1982.
- Kent, F. W., 'Be rather loved than feared: class relations in quattrocento Florence', in *Society and Individual in Renaissance Florence*, ed. W.

- J. Connell, pp. 13-50. Berkeley: University of California Press, 2002.
- —Household and Lineage in Renaissance Florence. Princeton, NJ: Princeton University Press, 1977.
- —Lorenzo de' Medici and the Art of Magnificence. Baltimore: Johns Hopkins University Press, 2004.
- —'Palaces, politics and society in fifteenth-century Florence', *I Tatti Studies* 2 (1987), pp. 41–70.
- Kent, F. W., and P. Simons (eds), *Patronage, Art and Society in Renaissance Italy*. Oxford: Oxford University Press, 1987.
- Kernodle, G. F., From Art to Theatre: Form and Convention in the Renaissance. Chicago: University of Chicago Press, 1944.
- King, C., Renaissance Women Patrons: Wives and Widows in Italy, c.1300-c.1550. Manchester: Manchester University Press, 1998.
- King, M. L., 'Thwarted ambitions: six learned women of the Italian Renaissance', *Soundings* 59 (1976), pp. 280–300.
- —Venetian Humanism in an Age of Patrician Dominance. Princeton, NJ: Princeton University Press, 1986.
- Kirshner, J., and A. Molho, 'The dowry fund and the marriage market in early fifteenth-century Florence', *Journal of Modern History* 50 (1978), pp. 403–38.
- Klapisch-Zuber, C., Les maîtres du marbre. Paris: SEVPEN, 1969.
- —Women, Family and Ritual in Renaissance Italy. Chicago and London: University of Chicago Press, 1985.
- Klapisch-Zuber, C., and J. Day, 'Villages désertés en Italie', in *Villages désertés et histoire économique*, ed. F. Braudel, pp. 420–59. Paris: SEVPEN, 1965.
- Klein, R., and R. Zerner, *Italian Art* 1500–1600. Englewood Cliffs, NJ: Prentice-Hall, 1966.
- Klibansky, R., E. Panofsky and F. Saxl, *Saturn and Melancholy*. London: Nelson, 1964.
- Koch, G. F., Die Kunstausstellung. Berlin: De Gruyter, 1967.
- Koenigsberger, H. G., 'Decadence or shift? Changes in the civilization of Italy and Europe', *Transactions of the Royal Historical Society* 10 (1960), pp. 1–18.
- Kraus, A., 'Secretarius und Sekretariat', Romische Quartalschrift 55 (1960), pp. 43–84.
- Krautheimer, R., and T. Krautheimer-Hess, *Lorenzo Ghiberti*. Princeton, NJ: Princeton University Press, 1956.
- Kraye, J. (ed.), *The Cambridge Companion to Renaissance Humanism*. Cambridge: Cambridge University Press, 1996.
- Kris, E., and O. Kurz, Legend, Myth and Magic in the Image of the Artist. Eng. trans., New Haven, CT: Yale University Press, 1979.
- Kristeller, P. O., 'Italian humanism and Byzantium', in Kristeller,

Renaissance Thought and its Sources, ch. 7. New York: Columbia University Press, 1964.

—'Lay religious traditions and Florentine Platonism', in Kristeller, *Studies in Renaissance Thought and Letters*, pp. 99–123. Rome: Edizione di storia e letteratura, 1956.

-Renaissance Thought. New edn, New York: Harper & Row, 1961.

Kroeber, A. L., Configurations of Culture Growth. Berkeley and Los Angeles: University of California Press, 1944.

Kubersky-Piredda, S., 'Immagini devozionali nel rinascimento fiorentino', in *The Art Market in Italy*, 15th–17th Century, ed. M. Fantoni et al., pp. 115–25. Modena: F. C. Panini, 2003.

Kurczewski, J., 'Społeczny mechanizm odrodzenia', *Znak* 35 (1983), pp. 1333–40.

Kurz, O., Fakes. Rev. edn, New York: Dover, 1967.

Labalme, P. (ed.), Beyond their Sex: Learned Women of the European Past. New York: New York University Press, 1980.

La-Coste-Messelière, M. G. de, 'Giovanni Battista della Palla', in *Il se rendit en Italie: études offertes à André Chastel*, pp.195–208. Rome: Elefante, 1987.

Ladis, A., and C. Wood (eds), The Craft of Art: Originality and Industry in the Italian Renaissance and Baroque Workshop. Athens: University of Georgia Press, 1995.

Ladis, A., and S. Zuraw (eds), Visions of Holiness: Art and Devotion in Renaissance Italy. Athens: Georgia Museum of Art, 2001.

Land, N. E., *The Viewer as Poet: The Renaissance Response to Art.* University Park: Pennsylvania State University Press, 1994.

Landau, D., and P. Parshall, *The Renaissance Print*, 1470–1550. New Haven, CT: Yale University Press, 1994.

Landes, D., Revolution in Time. Cambridge, MA: Belknap Press, 1983.

Landino, C., Commento sopra la Comedia di Dante. Venice, 1507.

Landucci, L., A Florentine Diary. Eng. trans., London: Dent, 1927.

Lane, F. C., Venetian Ships and Shipbuilders of the Renaissance. Baltimore: Johns Hopkins University Press, 1934.

—Venice: A Maritime Republic. Baltimore: Johns Hopkins University Press, 1973.

Lane, R., Masters of the Japanese Print. London: Thames & Hudson, 1962.

Langdale, A., 'Aspects of the critical reception and intellectual history of Baxandall's concept of the period eye', *Art History* 21 (1998), pp.479–97.

Larivaille, P., Pietro Aretino fra Rinascimento e Manierismo. Rome: Bulzoni, 1980.

- Larner, J., Culture and Society in Italy, 1290-1420. London: Batsford, 1971.
- —Italy in the Age of Dante and Petrarch. London: Longman, 1980.
- Lazzaro, C., *The Italian Renaissance Garden*. New Haven, CT: Yale University Press, 1990.
- Lee, R. W., 'Ut pictura poesis: the humanistic theory of painting', Art Bulletin 3 (1940); repr. New York: W. W. Norton, 1967.
- Lenzi, M. L. (ed.), Donne e madonne: l'educazione femminile nel primo rinascimento italiano. Turin: Loescher, 1982.
- Leonardo da Vinci, *Literary Works*, ed. J. P. Richter. Oxford: Oxford University Press, 1939.
- Lerner-Lehmkuhl, H., Zur Struktur und Geschichte des florentinischen Kunstmarktes im 15. Jahrhundert. Wattenscheid: K. Busch, 1936.
- Lestocquoy, J., Aux origines de la bourgeoisie: les villes de Flandre et d'Italie sous le gouvernement des patriciens. Paris: Presses universitaires de France, 1952.
- Levey, M., Painting at Court. London: Weidenfeld & Nicolson, 1971.
- Lewis, C. S., *The Discarded Image*. Cambridge: Cambridge University Press, 1964.
- Lillie, A., Florentine Villas in the Fifteenth Century: An Architectural and Social History. Cambridge: Cambridge University Press, 2005.
- Lindow, J. R., The Renaissance Palace in Florence: Magnificence and Splendour in Fifteenth-Century Italy. Aldershot: Ashgate, 2007.
- Lipset, S. M., and R. Bendix, *Social Mobility in Industrial Society*. Berkeley: University of California Press, 1959.
- Lockwood, L., *Music in Renaissance Ferrara*, 1400–1505. Cambridge, MA: Harvard University Press, 1984.
- Logan, O., Culture and Society in Venice 1470–1790. London: Batsford, 1972.
- Lopez, R. S., 'Économie et architecture médiévales', *Annales ESC* (1952), pp. 433–8.
- —'Hard times and investment in culture', in W. K. Ferguson et al., *The Renaissance: Six Essays*. New York: Harper & Row, 1953.
- —'Quattrocento genovese', Rivista Storica Italiana 75 (1963), pp. 709-27.
- —The Three Ages of the Italian Renaissance. Charlottesville: University Press of Virginia, 1970.
- Lord, A. B., *The Singer of Tales*. Cambridge, MA: Harvard University Press, 1960.
- Lorenzi, G., Monumenti per servire alla storia de Palazzo Ducale. Venice: Visentini, 1868.
- Lotto, L., *Libro delle spese diverse (1538–1556)*, ed. P. Zampetti. Rome and Venice: Olschki, 1969.

- Lovejoy, A. O., *The Great Chain of Being*. Cambridge, MA: Harvard University Press, 1936.
- Lowe, K. J. P., Nuns' Chronicles and Convent Culture: Women and History Writing in Renaissance and Counter-Reformation Italy. Cambridge: Cambridge University Press, 2003.
- Lowinsky, E. E., 'Music in the culture of the Renaissance', *Journal of the History of Ideas* 15 (1954), pp. 509–53.
- —'Music of the Renaissance as viewed by Renaissance musicians', in *The Renaissance Image of Man and the World*, ed. B. O'Kelly, pp. 129–64. Columbus: Ohio State University Press, 1966.
- Lowry, M., Nicholas Jenson and the Rise of Venetian Publishing in Renaissance Europe. Oxford: Blackwell, 1991.
- —The World of Aldus Manutius. Oxford: Blackwell, 1979.
- Lydecker, J. K., The Domestic Setting of the Arts in Renaissance Florence. Ann Arbor, MI: UMI, 2001.
- Lyotard, J.-F., *The Postmodern Condition*. Eng. trans., Minneapolis: University of Minnesota Press, 1984.
- Machiavelli, N., *Istorie fiorentine* (1523). Eng. trans., New York: AMS Press, 1967.
- —*The Prince* (1532). Eng. trans. ed. Q. Skinner and R. Price. Cambridge: Cambridge University Press, 1988.
- McIver, K., Women, Art and Architecture in Northern Italy, 1520–1580. Aldershot: Ashgate, 2006.
- Mack, R. E., Bazaar to Piazza: Islamic Trade and Italian Art, 1300–1600. Berkeley: University of California Press, 2002.
- MacKenney, R., 'Arti e stato a Venezia tra tardo medioevo e '600', *Studi veneziani* 5 (1981), pp. 127–43.
- —'Guilds and guildsmen in sixteenth-century Venice', Bulletin of the Society for Renaissance Studies 2/2 (1984), pp. 7–18.
- —Tradesmen and Traders: The World of the Guilds in Venice and Europe, c.1250-c.1650. London: Croom Helm, 1987.
- McLean, P. D., The Art of the Network: Strategic Interaction and Patronage in Renaissance Florence. Durham, NC: Duke University Press, 2007.
- Maffei, D., Il giovane Machiavelli banchiere con Berto Berti a Roma. Florence: Giunti, G. Barbera, 1973.
- -Gli inizi dell'umanesimo giuridico. 2nd edn, Milan: Giuffrè, 1972.
- Maikuma, Y., Der Begriff der Kultur bei Warburg, Nietzsche und Burckhardt. Königstein: Hain bei Athenäum, 1985.
- Makdisi, G., The Rise of Humanism in Classical Islam and the Christian West. Edinburgh: Edinburgh University Press, 1990.
- Malaguzzi-Valeri, F., La corte di Lodovico il Moro, 4 vols. Milan: Hoepli, 1913–23.

-Pittori Lombardi del quattrocento. Milan: L. F. Cogliati, 1902.

Mâle, E., L'art religieux après le concile de Trente. Paris: Colin, 1951.

-L'art religieux du 13e siècle en France. Paris: Colin, 1925.

Manetti, A., *Vita di Brunelleschi*, text and Eng. trans. ed. H. Saalman. University Park: Pennsylvania State University Press, 1970.

Mann, N., and L. Syson (eds), *The Image of the Individual: Portraits in the Renaissance*. London: British Museum, 1998.

Mannheim, K., Essays on the Sociology of Knowledge. London: Oxford University Press, 1952.

Marabottini, A., 'I collaboratori', in Raffaello: l'opera, le fonti, la fortuna, ed. M. Salmi, 2 vols, 1, pp. 199–203. Novara: Agostini, 1968.

Marchant, E., and A. Wright (eds) With and Without the Medici: Studies in Tuscan Art and Patronage, 1434–1530. Aldershot: Ashgate, 1998.

Martin, A. von, *The Sociology of the Renaissance*. Eng. trans., new edn, New York, 1963.

Martines, L., Power and Imagination: City-States in Renaissance Italy. New York: Knopf, 1979.

—The Social World of the Florentine Humanists, 1390–1460. London: Princeton University Press, 1963.

Martini, G. S., La bottega di un cartolaio fiorentino della seconda metà del quattrocento. Florence: Olschki, 1956.

Maruyama, M., Studies in the Intellectual History of Tokugawa Japan. Princeton, NJ, and Tokyo: Princeton University Press, 1974.

Marx, K., and F. Engels, F., *The German Ideology* (1846). Eng. trans., Moscow: Progress, 1964.

Massing, J.-M., *Du texte à l'image: la Calomnie d'Apelle et son iconographie.* Strasbourg: Presses universitaires de Strasbourg, 1990.

Mather, R., 'Documents relating to Florentine painters and sculptors', *Art Bulletin* 30 (1948), pp. 20-65.

Matthew, L. C., 'The painter's presence: signatures in Venetian Renaissance pictures', *Art Bulletin* 80, pp. 616–48.

—'Were there open markets for pictures in Renaissance Venice?' in Fantoni, M., et al. (eds), *The Art Market in Italy*, 15th–17th Century, ed. M. Fantoni et al., pp. 253–61. Modena: F. C. Panini, 2003.

Matthews-Greco, S., and G. Zarri, 'Committenza artistica feminile', *Quaderni Storici* 104 (2000), pp. 283–95.

Mattingly, G., Renaissance Diplomacy. London: Penguin, 1955.

Medcalf, S., 'On reading books from a half-alien culture', in *The Later Middle Ages*, ed. S. Medcalf, pp. 1–55. London: Holmes & Meier, 1981.

Medin, A., and L. Frati (eds), *Lamenti storici* 3. Bologna: Romagnoli, 1890.

Meiss, M., 'Masaccio and the early Renaissance', in Renaissance and

- *Mannerism*, ed. I. E. Rubin, pp. 123–43. Princeton, NJ: Princeton University Press, 1963.
- —Painting in Florence and Siena after the Black Death. Princeton, NJ: Princeton University Press, 1951.
- —Review of Antal, Florentine Painting and its Social Background, Art Bulletin 30 (1948), pp. 143–50.
- Menocal, M. R., *The Arabic Role in Medieval Literary History: A Forgotten Heritage*. Philadelphia: University of Pennsylvania Press, 1987.
- Michalsky, T., 'The local eye: formal and social distinctions in late quattrocento Neapolitan tombs', *Art History* 31 (2008), pp. 484–504.
- Michelacci, L., Giovio in Parnasso. Bologna: Il Mulino, 2004.
- Michelangelo, *Carteggio*, ed. G. Poggi, 5 vols. Florence, 1965–83. Eng. trans. E. H. Ramsden as *The Letters of Michelangelo*. London: Peter Owen, 1963.
- Migiel, M., and J. Schiesari (eds), Refiguring Woman: Perspectives on Gender and the Italian Renaissance. Ithaca, NY: Cornell University Press, 1991.
- Millon, H. (ed.), *Italian Renaissance Architecture: From Brunelleschi to Michelangelo*. London: Thames & Hudson, 1994.
- Mills, C. Wright, *The Sociological Imagination*. Oxford: Oxford University Press, 1959.
- Milner, S., and S. Campbell (eds), Artistic Exchange and Cultural Translation in the Italian Renaissance City. Cambridge: Cambridge University Press, 2004.
- Mitchell, C., 'Archaeology and romance in Renaissance Italy', in *Italian Renaissance Studies*, ed. E. F. Jacob, pp. 455–83. London: Faber & Faber, 1960.
- Molho, A., 'The Brancacci Chapel: studies in its iconography and history', *JWCI* 40 (1977), pp. 50–85.
- —'Hans Baron's crisis', in *Florence and Beyond: Culture, Society and Politics in Renaissance Italy*, ed. D. S. Peterson and D. E. Bornstein, pp. 61–90. Toronto: Centre for Reformation and Renaissance Studies, 2008.
- —'The Italian Renaissance: made in the USA', in *Imagined Histories: American Historians Interpret the Past*, ed. Molho and G. S. Wood, pp. 263–94. Princeton, NJ: Princeton University Press, 1998.
- —'Politics and the ruling class in early Renaissance Florence', *Nuova Rivista Storica* 52 (1968), pp. 401–20.
- Molmenti, P., and G. Ludwig, Vittore Carpaccio et la confrérie de Sainte Ursule à Venise. Florence: R. Bemporad, 1903.
- Mondolfo, R., 'The Greek attitude to manual labour', *Past and Present* 6 (1954), pp. 1–5.

- Montaigne, M. de, Journal de voyage en Italie, ed. F. Rigolot. Paris, 1992.
- Monti, G. M., Le confraternite medievali dell'alta e media Italia, 2 vols. Venice: La Nuova Italia, 1927.
- —(ed.), Un laudario umbra quattrocentista dei Bianchi. Todi: Atanòr, 1920.
- Morisani, O., 'Cristoforo Landino', *Burlington Magazine* 95 (1953), pp. 267–70.
- Morison, S., Venice and the Arabesque. London: Morison, 1955.
- Morse, M. A., 'Creating sacred space: the religious visual culture of the Renaissance Venetian *casa*', *Renaisance Studies* 21 (2007), pp. 151–84.
- Mortier, A., Etudes italiennes. Paris: Albert Messein, 1930.
- Mosher, F. J., 'The fourth catalogue of the Aldine Press', *La Bibliofilia* 80 (1978), pp. 229–35.
- Motta, E., 'Musici alla corte degli Sforza', Archivio Storico Lombardo 14 (1887), pp. 29-64, 278-340, 514-57.
- 'L'università dei pittori milanesi nel 1481', *Archivio Storico Lombardo* 22 (1895), pp. 408-33.
- Motture, P., and M. O'Malley, 'Introduction' to Re-Thinking Renaissance Objects: Design, Function and Meaning, Renaissance Studies 24/1 (2010), pp. 1–8 [special issue].
- Muir, E., Civic Ritual in Renaissance Venice. Princeton, NJ: Princeton University Press, 1981.
- —'The idea of community in Renaissance Italy', *Renaissance Quarterly* 55 (2002), pp. 1–18.
- —'In some neighbours we trust: on the exclusion of women from the public in Renaissance Italy', in *Florence and Beyond: Culture, Society and Politics in Renaissance Italy*, ed. D. S. Peterson and D. E. Bornstein, pp. 271–89. Toronto: Centre for Reformation and Renaissance Studies, 2008.
- Müntz, E., Les collections des Médicis au XVe siècle. Paris: Librairie de l'art, 1888.
- Muraro, M. A., 'The statutes of the Venetian *Arti* and the mosaics of the Mascoli Chapel', *Art Bulletin* 43 (1961), pp. 263–74.
- Murray, A., Reason and Society in the Middle Ages. Oxford: Clarendon Press, 1978.
- Murray, P., 'The Italian Renaissance architect', Journal of the Royal Society of Arts 144 (1966), pp. 589-607.
- Musacchio, J. M., Art, Marriage and Family in the Florentine Renaissance Palace. New Haven, CT: Yale University Press, 2008.
- —The Ritual of Childbirth in Renaissance Italy. New Haven, CT: Yale University Press, 1999.

- Nagel, A., Michelangelo and the Reform of Art. Cambridge: Cambridge University Press, 2000.
- Nagel, A., and C. Wood, *Anachronic Renaissance*. New York: Zone Books, 2010.
- Najemy, J. M., Between Friends: Discourses of Power and Desire in the Machiavelli-Vettori Letters of 1513-1515. Princeton, NJ: Princeton University Press, 1993.
- —A History of Florence, 1200-1575. Oxford: Blackwell, 2006.
- Nash, S., Northern Renaissance Art. Oxford: Oxford University Press, 2008.
- Neher, G., and R. Shepherd (eds), *Revaluing Renaissance Art*. Aldershot: Ashgate, 2000.
- Nelson, J. K., and R. Zeckhauser (eds), *The Patron's Payoff: Conspicuous Commissions in Italian Renaissance Art.* Princeton, NJ: Princeton University Press, 2008.
- Nelson, N., 'Individualism as a criterion of the Renaissance', *Journal of English and Germanic Philology* 32 (1933), pp. 316–34.
- Niccoli, O., *Prophecy and People in Renaissance Italy*. Eng. Trans., Princeton, NJ: Princeton University Press, 1990.
- —(ed.), Rinascimento al femminile. Rome: Laterza, 1991.
- —I sacerdoti, i guerrieri, i contadini. Turin: Einaudi, 1979.
- —Vedere con gli occhi del cuore: alle origini del potere delle imagini. Rome: Laterza, 2011.
- Nigro, S., Le brache di San Griffone: novellistica e predicazione tra quattrocento e cinquecento. Bari: Laterza, 1985.
- Nochlin, L., 'Why have there been no great women artists?' *ARTnews* (January 1971), pp. 22–39, 67–71.
- Novelli, L., and M. Massaccesi, Ex voto del santuario della Madonna del Monte di Cesena. Forli: Santa Maria del Monte, 1961.
- Nuovo, A., *Il commercio librario nell'Italia del Rinascimento*. Rev. edn, Milan: F. Angeli, 2003.
- Nuttall, P., From Flanders to Florence: The Impact of Netherlandish Painting, 1400–1500. New Haven, CT: Yale University Press, 2004.
- Oberhuber, K., 'Raffaello e l'incisione', in Fabrizio Mancinelli et al., Raffaello in Vaticano, pp. 333–42. Milan: Electa, 1984.
- O'Kelly, B. (ed.), *The Renaissance Image of Man and the World*. Columbus: Ohio State University Press, 1966.
- O'Malley, M., The Business of Art: Contracts and the Commissioning Process in Renaissance Italy. New Haven, CT: Yale University Press, 2005.
- O'Malley, M., and E. Welch (eds), *The Material Renaissance*. Manchester: Manchester University Press, 2007.
- Origo, I., The Merchant of Prato. London: Jonathan Cape, 1957.

- -The World of San Bernardino. London: Reprint Society, 1963.
- Ortalli, G., La pittura infamante nei secoli xiii-xvi. Rome: Jouvence, 1979.
- Ossola, C. (ed.), La corte e il cortegiano, vol. 1. Rome: Bulzoni, 1980.
- Ostrow, S. F., Art and Spirituality in Counter-Reformation Rome: The Sistine and Pauline Chapels in S. Maria Maggiore. Cambridge: Cambridge University Press, 1996.
- Owens, J. A., 'Was there a Renaissance in music?' in Language and Images of Renaissance Italy, ed. A. Brown, pp. 111–26. Oxford: Clarendon Press, 1995.
- Palisca, C., Humanism in Renaissance Italian Musical Thought. New Haven, CT: Yale University Press, 1985.
- Palladio, A., I quattro libri dell'architettura (1570). Eng. trans. as The Four Books of Architecture. New York: Dover, 1965.
- Palmieri, M., Vita civile, ed. G. Belloni. Florence: Sansoni, 1982.
- Palumbo Fossati Casa, I., 'La casa veneziana', in *Da Bellini a Veronese*, ed. G. Toscano and F. Valcanover, pp. 443–92. Venice: Istituto Veneto di scienze, lettere ed arti, 2004.
- -Intérieurs vénitiens à la Renaissance. Paris: Maule, 2012.
- Panizza, L. (ed.), Women in Italian Renaissance Culture and Society. Oxford: European Humanities Research Centre, 2000.
- Panofsky, E., 'Artist, scientist, genius', in W. K. Ferguson et al., *The Renaissance: Six Essays*. New edn, New York: Harper & Row, 1962.
- -Early Netherlandish Painting. Cambridge, MA: Harvard University Press, 1953.
- —Idea: A Concept in Art Theory (1924). Eng. trans., New York: Harper & Row, 1968.
- -Meaning in the Visual Arts. Garden City, NY: Doubleday, 1955.
- —Perspective as Symbolic Form (1924–5). Eng. trans., New York: Zone Books, 1991.
- -Studies in Iconology. New York: Oxford University Press, 1939.
- Paoletti, J. T., and G. M. Radke, Art in Renaissance Italy. London: Laurence King, 1997.
- Park, K., *Doctors and Medicine in Early Renaissance Florence*. Princeton, NJ: Princeton University Press, 1985.
- Parker, R., and G. Pollock, Old Mistresses: Women, Art and Ideology. London: Pandora, 1981.
- Partner, P., 'Papal financial policy in the Renaissance and the Counter-Reformation', *Past and Present* 88 (1980), pp. 17–62.
- —The Pope's Men: The Papal Civil Service in the Renaissance. Oxford: Clarendon Press, 1990.
- —Renaissance Rome 1500–1559. Berkeley: University of California Press, 1976.

Partridge, L., and R. Starn, A Renaissance Likeness: Art and Culture in Raphael's Julius II. Berkeley: University of California Press, 1980.

Pesenti, G., 'Alessandra Scala: una figura della Rinascenza fiorentina', Giornale Storico della Letteratura Italiana 85 (1925), pp. 241–67.

Petrucci, A., 'Le biblioteche antiche', in *Letteratura italiana 2: Produzione e Consumo*, ed. A. Asor Rosa, pp. 499–524. Turin: Einaudi, 1983.

—'Il libro manoscritto', in *Letteratura italiana 2: Produzione e Consumo*, ed. A. Asor Rosa, pp. 499–524. Turin: Einaudi, 1983.

—(ed.), 'Per la storia dell'alfabetismo e della culture scritta', *Quaderni Storici* 38 (1978), pp. 437–50.

—La scrittura: ideologia e rappresentazione. Turin: Einaudi, 1986.

Pevsner, N., Academies of Art. Cambridge: Cambridge University Press, 1940.

—'The term "architect" in the Middle Ages', *Speculum* 17 (1942), pp. 549–62.

Peyer, H. C., Stadt und Stadtpatron im mittelalterlichen Italien. Zurich: Europa, 1955.

Peyre, H., Les générations littéraires. Paris: Boivin, 1948.

Phillips-Court, K., *The Perfect Genre: Drama and Painting in Renaissance Italy*. Farnham: Ashgate, 2011.

Pignatti, T. (ed.), Le scuole di Venezia. Milan: Electa, 1981.

Pinder, W., *Das Problem der Generation in der Kunstgeschichte Europas*. Berlin: Frankfurter Verlags-Anstalt, 1926.

Pine, M. L., *Pietro Pomponazzi: Radical Philosopher of the Renaissance*. Padua: Antenore, 1986.

Pino, P., Dialoghi di pittura (1548). New edn, Milan, 1954.

Pitkin, H. F., Fortune is a Woman: Gender and Politics in the Thought of Machiavelli. Berkeley: University of California Press, 1984.

Pius II, Commentaries (1614). Eng. trans., 5 vols. Northampton, MA, 1959.

—De curialium miseriis epistola. Baltimore: Johns Hopkins University Press, 1928.

Plaisance, M., 'Culture et politique à Florence de 1542 à 1551', in *Les écrivains et le pouvoir en Italie à l'époque de la Renaissance*, ed. A. Rochon, pp. 149–228. Paris: Université de al Sorbonne nouvelle, 1973.

—Florence: fêtes, spectacles et politique à l'époque de la Renaissance. Rome: Vecchiarelli, 2008.

— La politique culturelle de Côme Ier et les fêtes annuelles à Florence de 1541 à 1550', in *Les fêtes de la Renaissance*, 3, ed. J. Jacquot, pp. 133–48. Paris: Centre national de la recherché scientifique, 1975.

—'Une première affirmation de la politique culturelle de Côme I', in *Les écrivains et le pouvoir en Italie à l'époque de la Renaissance*, ed. A. Rochon, pp. 361–433. Paris: Université de al Sorbonne nouvelle, 1973.

Plekhanov, G., *The Role of the Individual in History* (1898). Eng. trans., New York: International, 1940.

Pocock, J. G. A., *The Machiavellian Moment*. Princeton, NJ: Princeton University Press, 1975.

Podro, M., The Critical Historians of Art. New Haven, CT: Yale University Press, 1982.

Poggi, G. (ed.), Il duomo di Firenze. Berlin: Cassirer, 1909.

Poliziano, A., Panepistemon. Venice, 1495.

Pomian, K., Collectors and Curiosities. Eng. trans., Cambridge: Polity, 1990.

Pomponazzi, P., *De incantationibus* (1556). Hildesheim and New York: G. Olms, 1970.

Pope-Hennessy, J., *Italian Renaissance Sculpture*. London: Phaidon Press, 1958.

—The Portrait in the Renaissance. London: Phaidon Press, 1966.

Pottinger, G., The Court of the Medici. London: Croom Helm, 1978.

Prager, F. D., and G. Scaglia, *Brunelleschi: Studies of his Technology and Inventions*. Cambridge, MA: MIT Press, 1970.

Prevenier, W., and W. Blockmans, *The Burgundian Netherlands*. Eng. trans., Cambridge: Cambridge University Press, 1986.

Procacci, U., 'Compagnie di pittori', *Rivista d'Arte* X (1960), pp. 3–37. Prodi, P., *The Papal Prince*. Eng. trans., Cambridge: Cambridge University Press, 1987.

Prodi, P., and P. Johanek (eds), Strutture ecclesiastiche in Italia e in Germania prima della Riforma. Bologna: Il Mulino, 1984.

Prosperi, A. (ed.), La corte e il cortegiano, vol. 2. Rome: Bulzoni, 1980.

—'La figura del vescovo fra '400 e '500', *Storia d'Italia*, *Annali* 9, ed. G. Chittolini and G. Miccoli, pp. 221–62. Turin: Einaudi, 1986.

Pullan, B., 'Nature e carattere delle scuole', in *Le scuole di Venezia*, ed. T. Pignatti, pp. 9–26. Milan: Electa, 1981.

-Rich and Poor in Renaissance Venice. Oxford: Blackwell, 1971.

Puppi, L., Andrea Palladio. Eng. trans., London: Phaidon Press, 1975.

Putelli, R., Vita, storia ed arte mantovana nel cinquecento, vol. 2. Mantua: Peroni, 1935.

Pyle, C., Milan and Lombardy in the Renaissance. Rome: La Fenice, 1997.

Quadflieg, R., Filaretes Ospedale maggiore in Mailand: zur Rezeption islamischen Hospitalwesens in der italienischen Frührenaissance. Cologne: Abteilung Architektur des Kunsthistorischen Instituts, 1981.

Quondam, A. (ed.), *Le corti farnesiane di Parma e Piacenza*, 1545–1622. Rome: Bulzoni, 1978.

—'La letteratura in tipografia', in Letteratura italiana 2: Produzione e Consumo, ed. A. Asor Rosa, pp. 555-686. Turin: Einaudi, 1983.

- —'Mercanzia d'honore, mercanzia d'utile: produzione libraria e lavoro intellettuale a Venezia nel '500', in *Libri editori e pubblico nell'Europa moderna*, ed. A. Petrucci, pp. 53–104. Bari: Laterza, 1977.
- Raby, J., Venice, Dürer and the Oriental Mode. London: Islamic Art, 1982.
- Radcliffe, A., and N. Penny, *Art of the Renaissance Bronze*, 1500–1650. London: Philip Wilson, 2004.
- Ramsden, H., *The 1898 Movement in Spain*. Manchester: Manchester University Press, 1974.
- Randolph, A., Engaging Symbols: Gender, Politics and Public Art in Fifteenth-Century Florence. New Haven, CT: Yale University Press, 2002.
- —'Gendering the period eye: *Deschi di parto* and Renaissance visual culture', *Art History* 27 (2004), pp. 538–62.
- Rashdall, H., *The Universities of Europe in the Middle Ages*. Oxford: Oxford University Press, 1936.
- Regan, L. K., 'Ariosto's threshold patron: Isabella d'Este in the Orlando Furioso', *Modern Language Notes* 20 (2005), pp. 50–69.
- Reiss, S. E., and D. G. Wilkins (eds), Beyond Isabella: Secular Women Patrons of Art in Renaissance Italy. Kirksville, MO: Truman State University Press, 2001.
- Renouard, Y., 'L'artiste ou le client?' *Annales ESC 5* (1950), pp. 361–5. Reti, L., 'The two unpublished manuscripts of Leonardo', *Burlington Magazine* 110 (1968), pp. 10–22.
- Ricci, C., *Il tempio malatestiano*. Milan and Rome: Bestetti & Tumminelli, 1924.
- Rice, E., *St Jerome in the Renaissance*. Baltimore and London: Johns Hopkins University Press, 1985.
- Richardson, B., *Manuscript Culture in Renaissance Italy*. Cambridge: Cambridge University Press, 2009.
- —Print Culture in Renaissance Italy: The Editor and the Vernacular Text, 1470–1600. Cambridge: Cambridge University Press, 1994.
- —Printing, Writers and Readers in Renaissance Italy. Cambridge: Cambridge University Press, 1999.
- Richardson, C. M. (ed.), *Locating Renaissance Art.* New Haven, CT: Yale University Press, 2007.
- —Reclaiming Rome: Cardinals in the Fifteenth Century. Leiden: E. J. Brill, 2009.
- Ringbom, S., Icon to Narrative: The Rise of the Dramatic Close-Up Fifteenth-Century Devotional Painting. Åbo: Åbo Akademi, 1965.
- Roberts, A., Dominican Women and Renaissance Art: The Convent of San Domenico of Pisa. Farnham: Ashgate, 2008.

- Robertson, C., 'Annibal Caro as iconographer', JWCI 45 (1982), pp. 160-75.
- —'Il gran cardinale': Alessandro Farnese, Patron of the Arts. New Haven, CT: Yale University Press, 1992.
- Robin, D., Filelfo in Milan. Princeton, NJ: Princeton University Press, 1991.
- Rochon, A. (ed.), Les écrivains et le pouvoir en Italie à l'époque de la Renaissance, 1. Paris: Université de la Sorbonne nouvelle, 1973.
- —(ed.), Formes et significations de la beffa dans la littérature italienne de la Renaissance. Paris: Université de la Sorbonne nouvelle, 1972.
- —La jeunesse de Laurent de Médicis (1449–1478). Clermont-Ferrand: Université de Paris, 1963.
- —(ed.), Le pouvoir et la plume: incitation, contrôle et répression dans l'Italie du 16e siècle. Paris: Université de la Sorbonne nouvelle, 1982.
- Roeck, B., Der junge Aby Warburg. Munich: Beck, 1997.
- Rogers, M. (ed.), Fashioning Identities in Renaissance Art. Aldershot: Ashgate, 2000.
- Romano, R., Tra due crisi: l'Italia del Rinascimento. Turin: Einaudi, 1971.
- Roover, R. de, 'A Florentine firm of cloth manufacturers', *Speculum* 16 (1941), pp. 3–30.
- —The Rise and Decline of the Medici Bank. Rev. edn, Cambridge, MA: Harvard University Press, 1963.
- Rosand, D., *Painting in Cinquecento Venice: Titian*, *Veronese*, *Tintoretto*. Rev. edn, Cambridge: Cambridge University Press, 1997.
- Roscoe, W., The Life of Lorenzo de'Medici. London, 1795.
- Rose, P. L., The Italian Renaissance of Mathematics. Geneva: Droz, 1975.
- Rosenberg, C. (ed.), *The Court Cities of Northern Italy*. Cambridge: Cambridge University Press, 2010.
- Rossi, S., Dalle botteghe alle accademie: realtà sociale e teorie artistiche a Firenze dal xiv al xvi secolo. Milan: Feltrinelli, 1980.
- Rostow, W. W., *The Stages of Economic Growth*. Cambridge: Cambridge University Press, 1960.
- Rotunda, D. P., *Motif-Index of the Italian Novella in Prose*. Bloomington: Indiana University Press, 1942.
- Rowe, J. G., and W. H. Stockdale (eds), *Florilegium historiale*. Toronto: University of Toronto Press, 1971.
- Rowland, I., The Culture of the High Renaissance: Ancients and Moderns in Sixteenth-Century Rome. Cambridge: Cambridge University Press, 1998.
- —From Heaven to Arcadia: The Sacred and the Profane in the Renaissance. New York: New York Review of Books, 2005.

Rubin, I. E., *The Renaissance and Mannerism*. Princeton, NJ: Princeton University Press, 1963.

Rubin, P. L., Giorgio Vasari: Art and History. New Haven, CT: Yale University Press, 1995.

—Images and Identity in Fifteenth-Century Florence. New Haven, CT: Yale University Press, 2007.

Rubinstein, N. (ed.), Florentine Studies. London: Faber, 1968.

—The Government of Florence under the Medici. 2nd edn, Oxford: Clarendon Press, 1997.

—'Notes on the word *stato* in Florence before Machiavelli', in *Florilegium historiale*, ed. J. G. Rowe and W. H. Stockdale, pp. 314–21. Toronto: University of Toronto Press, 1971.

Rucellai, B., Giovanni Rucellai ed il suo Zibaldone. London: Warburg Institute, 1960.

Ruda, J., Fra Filippo Lippi. London: Phaidon Press, 1993.

Rupprecht, B., 'Villa: Geschichte eines Ideals', in *Probleme der Kunstwissenschaft* 2, pp. 210–50. Berlin: De Gruyter, 1966.

Rusconi, R., 'Dal pulpito alla confessione: modelli di comportamento religioso', in *Strutture ecclesiastiche in Italia e in Germania prima della Riforma*, ed. P. Prodi and P. Johanek, pp. 259–315. Bologna: Il Mulino, 1984.

—'Predicatori e predicazione (secoli ix-xviii)', *Storia d'Italia*, *Annali 4*, pp. 951–1053. Turin: Einaudi, 1981.

Ryder, A. F., 'Antonio Beccadelli', in *Cultural Aspects of the Italian Renaissance*, ed. C. H. Clough, ch. 7. Manchester: Manchester University Press, 1976.

—The Kingdom of Naples under Alfonso the Magnanimous. Oxford: Clarendon Press, 1976.

Saalman, H., 'Antonio Filarete', Art Bulletin 41 (1959), pp. 89-106.

- 'Filippo Brunelleschi', Art Bulletin 40 (1958), pp. 113-37.

Sabbadini, R., 'Come il Panormita diventò poeta aulico', *Archivio Storico Lombardo* 43 (1916), pp. 5–28.

Salomon, X. F., 'Cardinal Pietro Barbo's collection and its inventory', *Journal of the History of Collections* 15 (2003), pp. 1–18.

Sannazzaro, J., L'Arcadia. Venice, 1504.

Santangelo, G. (ed.), Le epistole 'De imitatione' di Giovanfrancesco Pico della Mirandola e di Pietro Bembo. Florence: Olschki, 1954.

Santillana, G. de, 'Paolo Toscanelli and his friends', in *The Renaissance Image of Man and the World*, ed. B. O'Kelly, pp. 105–28. Columbus: Ohio State University Press, 1966.

Santoro, C., Gli uffici del dominio sforzesco (1450–1500). Milan: Fondazione Treccani, 1948.

Sardella, P., Nouvelles et spéculations à Venise au début du XVIe siècle. Paris: Colin, 1948.

Savonarola, G., Prediche e scritti. Florence: Olschki, 1952.

Saxl, F., La fede astrologica di Agostino Chigi. Rome: Reale accademia d'Italia, 1934.

-Lectures. London: Warburg Institute, 1957.

Schaffran, E., 'Die Inquisitionsprozesse gegen Paolo Veronese', *Archiv fur Kulturgeschichte* 42 (1960), pp. 17–93.

Schiaparelli, A., La casa fiorentina e i suoi arredi nei secoli XIV e XV. Florence: Sansoni, 1908.

Schmarsow, A., Gotik in der Renaissance. Stuttgart: F. Enke, 1921.

Schmitt, C., (ed.), *The Cambridge History of Renaissance Philosophy*. Cambridge: Cambridge University Press, 1988.

—'Philosophy and science in sixteenth-century universities', in *The Cultural Context of Medieval Learning*, ed. J. E. Murdoch and E. D. Sylla. Dordrech: D. Reidel, 1975.

Schofield, R., 'Avoiding Rome: an introduction to Lombard sculptors and the antique', *Arte Lombarda* 100 (1992), pp. 29–44.

Scholderer, V., *Printers and Readers in Italy in the Fifteenth Century*. London: G. Cumberlege, 1949.

Schubring, P., Cassoni. Leipzig: Hiersemann, 1915.

Schulz, A. M., *The Sculpture of Bernardo Rossellino and his Workshop*. Princeton, NJ: Princeton University Press, 1977.

Schutte, A. J., 'Printing, piety and the people in Italy: the first thirty years', Archiv für Reformationsgeschichte 71 (1980), pp. 5-20.

Segarizzi, A. (ed.), Relazioni degli ambasciatori veneti, vol. 3. Bari: Laterza, 1916.

Seigel, J., 'Civic humanism or Ciceronian rhetoric?', *Past and Present* 34 (1966), pp. 3–48.

Senatore, F., Uno mundo de carta: forme et strutture della diplomazia sforzesca. Naples: Liguori, 1998.

Serafino dell'Aquila, Opere. Venice, 1505.

Sereni, E., 'Agricoltura e mondo rurale', *Storia d'Italia* 1, pp. 136–252. Turin: Einaudi, 1973.

-Storia del paesaggio agrario italiano. Bari: Laterza, 1961.

Serra Desfilis, A., 'Classical language and imperial ideal in the early Renaissance: the artistic patronage of Alfonso V the Magnanimous', in *Europe and its Empires*, ed. N. Harris and C. Lévai, pp. 17–29. Pisa, PLUS-Pisa University Press, 2008.

Settis, S., 'Artisti e committenti fra quattro e cinquecento', *Storia d'Italia*, *Annali 4*, pp. 791–64. Turin: Einaudi, 1981.

—Giorgione's Tempest: Interpreting the Hidden Subject. Eng. trans., Cambridge: Polity, 1990.

- —'The iconography of Italian art, 1100–1500', Eng. trans. in *History of Italian Art*, ed. P. Burke, 2 vols, vol. 2, pp. 119–259. Cambridge: Polity, 1994.
- —(ed.), Memoria dell'antico nell'arte italiana, 2 vols. Turin: Einaudi, 1984-5.
- Seymour, C., *Michelangelo's David: A Search for Identity*. 2nd edn, New York: W. W. Norton, 1974.
- -Sculpture in Italy, 1400 to 1500. Harmondsworth: Penguin, 1966.
- Seznec, J., The Survival of the Pagan Gods. Eng. trans., New York: Pantheon Books, 1953.
- Shaftesbury, Lord, Second Characters, or, The Language of Forms. Cambridge: Cambridge University Press, 1914.
- Sheard, W. S., and J. T. Paoletti (eds), *Collaboration in Italian Renaissance Art.* New Haven, CT: Yale University Press, 1978.
- Shearman, J., Andrea del Sarto, 2 vols. New Haven, CT: Yale University Press, 1965.
- —'The collections of the younger branch of the Medici', *Burlington Magazine* 117 (1975), pp. 12–27.
- —'The Florentine entrata of Leo X, 1515', JWCI 38 (1975), pp. 136–44.
- -Mannerism. Harmondsworth: Penguin, 1967.
- —'Il mecenatismo di Giulio II e Leone X', in *Arte, committenza ed economia a Roma e nelle corti del Rinascimento*, 1420–1530, ed. A. Esch and C. L. Frommel, pp. 213–42.Turin: Einaudi, 1995.
- —Only Connect: Art and the Spectator in the Italian Renaissance. Princeton, NJ: Princeton University Press, 1992.
- —'The Vatican stanze: functions and decoration', *Proceedings of the British Academy 57* (1971), pp. 369–424.
- Sheldon, C. D., The Rise of the Merchant Class in Tokugawa Japan. Locust Valley, NY: Association for Asian Studies, 1958.
- Shepherd, R., 'Republican anxiety and courtly confidence: the politics of magnificence and fifteenth-century Italian architecture', in *The Material Renaissance*, ed. M. O'Malley and E. Welch, pp. 47–70. Manchester: Manchester University Press, 2007.
- Simeoni, L., 'Una vendetta signorile nel '400', Nuovo Archivio Veneto 5 (1903), pp. 252-8.
- Simons, P., 'Women in frames', *History Workshop* 25 (1988), pp. 4–30. Singleton, C. (ed.), *Canti carnascialeschi*. Bari: Laterza, 1936.
- Siraisi, N., Avicenna in Renaissance Italy. Princeton, NJ: Princeton University Press, 1987.
- —The Clock and the Mirror: Girolamo Cardano and Renaissance Medicine. Princeton, NJ: Princeton University Press, 1997.
- Skinner, Q., Foundations of Modern Political Thought, 2 vols. Cambridge: Cambridge University Press, 1978.

—'The vocabulary of Renaissance republicanism: a cultural *longue durée*?', in *Language and Images of Renaissance Italy*, ed. A. Brown, pp. 87–110. Oxford: Clarendon Press, 1995.

Smith, C., Architecture in the Culture of Early Humanism. New York: Oxford University Press, 1992.

Smith, W., 'On the original location of the *Primavera*', *Art Bulletin* 57 (1975), pp. 31–40.

Smyth, C. H., Mannerism and Maniera. Locust Valley, NY: J. J. Augustin, 1962.

Snow-Smith, J., The Primavera of Sandro Botticelli: A Neoplatonic Interpretation. New York: Peter Lang, 1993.

Solum, S. (2008) 'The problem of female patronage in fifteenth-century Florence', *Art Bulletin* 90, pp. 76–100.

Soria, A., Los humanistas de la corte de Alfonso el Magnanimo. Granada: Universidad de Granada, 1956.

Sorrentino, A., La letteratura italiana e il Sant'Uffizio. Naples: Francesco Perrella, 1935.

Spencer, J. R., 'Ut rhetorica pictura', JWCI 20 (1957), pp. 26-44.

Starn, R., 'A postmodern Renaissance?', Renaissance Quarterly 60 (2007), pp.1–24.

Steinberg, R. M., Fra Girolamo Savonarola, Florentine Art, and Renaissance Historiography. Athens: Ohio University Press, 1977.

Steinmann, E., Die Sixtinische Kapelle, 2 vols. Munich: F. Bruckmann, 1905.

Stephens, J. N., *The Fall of the Florentine Republic*, 1512–1530. Oxford: Clarendon Press, 1983.

Sterling, C., Still Life Painting: From Antiquity to the Present Time. Paris: Pierre Tisné, 1959.

Stone, L., 'Prosopography', Daedalus (Winter 1971), pp. 46-73.

Straeten, E. van der (ed.), La musique aux Pays-Bas, vol. 6: Les musiciens néerlandais en Italie (1882). New York: Dover, 1969.

Strocchia, S., 'Learning the virtues: convent schools and female culture in Renaissance Florence', in *Women's Education in Early Modern Europe*, ed. B. J. Whitehead, pp. 3–46. New York: Garland, 1999.

Strozzi, A. Macinghi negli, Lettere di una gentildonna fiorentina del secolo xv ai figliuoli esuli. Florence: Sansoni, 1877.

Summers, D., Michelangelo and the Language of Art. Princeton, NJ: Princeton University Press, 1981.

Syson, L., and D. Thornton, Objects of Virtue: Art in Renaissance Italy. London: British Museum, 2001.

Tacchi Venturi, P., Storia della Compagnia di Gesù in Italia, 1. Rome: Segati, 1910.

Tafuri, M., Venice and the Renaissance. Eng. trans., Cambridge, MA: MIT Press, 1989.

Tagliaferro, G., and B. Aikema, *Le botteghe di Tiziano*. Florence: Alinare 24 ore, 2009.

Talvacchia, B., 'Raphael's workshop and the development of a managerial style', in *The Cambridge Companion to Raphael*, ed. M. Hall, pp. 167–85. Cambridge: Cambridge University Press, 2005.

-Taking Positions: On the Erotic in Renaissance Culture. Princeton,

NJ: Princeton University Press, 1999.

Tavernor, R., On Alberti and the Art of Building. New Haven, CT: Yale University Press, 1999.

-Palladio and Palladianism. London: Thames & Hudson, 1990.

Tenenti, A., 'Luc'Antonio Giunti il giovane, stampatore e mercante', in *Studi in onore di Armando Sapori*, pp. 1023-60. Milan: Cisalpino, 1957.

—Naufrages, corsaires et assurances maritimes à Venise, 1592–1609. Paris: SEVPEN, 1959.

Testa, F., Winckelmann e l'invenzione della storia dell'arte. Bologna: Minerva, 1999.

Thieme, U., and F. Becker, *Allgemeines Lexikon der bildenden Künstler*, 37 vols. Leipzig: Seemann, 1907–50.

Thomas, A., *The Painter's Practice in Renaissance Tuscany*. Cambridge: Cambridge University Press, 1995.

—'The workshop as the space of collaborative artistic production', in *Renaissance Florence: A Social History*, ed. R. J. Crum and J. T. Paoletti, pp. 415–30. Cambridge: Cambridge University Press, 2006.

Thomas, K. V., Religion and the Decline of Magic. London: Weidenfeld & Nicolson, 1971.

Thorndike, L., *History of Magic and Experimental Science*, 8 vols. New York: Macmillan, 1930–58.

Thornton, D., *The Scholar in his Study*. New Haven, CT: Yale University Press, 1998.

Thornton, P., *The Italian Renaissance Interior*, 1400–1600. London: Weidenfeld & Nicolson, 1991.

Tietze, H., 'Master and workshop in the Venetian Renaissance', *Parnassus* 11 (1939), pp. 34–45.

Tietze-Conrat, E., 'Marietta, fille du Tintoret', Gazette des Beaux Arts 76 (1934), pp. 258-62.

Tillyard, E. M. W., The Elizabethan World Picture. London: Chatto & Windus, 1943.

Tinagli, P., Women in Italian Renaissance Art: Gender, Representation, Identity. Manchester: Manchester University Press, 1997.

- Tinctoris, J., De arte contrapuncti (1477). Eng. trans. in Musicological Studies and Documents 5. Rome, 1961.
- Tirosh-Rothschild, H., 'Jewish culture in Renaissance Italy', *Italia* 9 (1990), pp. 63–96.
- Tolnay, C., Michelangelo, 5 vols. Princeton, NJ: Princeton University Press, 1943-60.
- Tomlinson, G., Music in Renaissance Magic: Toward a Historiography of Others. Chicago: University of Chicago Press, 1993.
- Toscano, B., 'The history of art and the forms of the religious life', Eng. trans. in *History of Italian Art*, ed. P. Burke, 2 vols, vol. 2, pp. 260–325. Cambridge: Polity, 1994.
- Toynbee, A., A Study of History, vol. 9: Contacts between Civilizations in Time. Oxford: Oxford University Press, 1954.
- Trachtenberg, M., Dominion of the Eye: Urbanism, Art and Power in Early Modern Florence. Cambridge: Cambridge University Press, 1997.
- Trexler, R., 'Charity and the defence of urban elites in the Italian communes', in *The Rich*, the Well Born and the Powerful, ed. F. C. Jaher, pp. 64–105. Urbana: University of Illinois Press, 1973.
- —'Florentine religious experience: the sacred image', Studies in the Renaissance 19 (1972), pp. 7–41.
- —Public Life in Renaissance Florence. New York: Academic Press, 1980. Trinkaus, C., In our Image and Likeness, 2 vols. London: Constable, 1970.
- Trovato, P., Con ogni diligenza corretto: la stampa e le revisioni editoriali dei testi letterari italiani (1470–1570). Bologna: Il Mulino, 1991.
- Turner, A. R., *The Vision of Landscape in Renaissance Italy*. Princeton, NJ: Princeton University Press, 1966.
- Turner, J. (ed.), The Dictionary of Art, 34 vols. London: Macmillan, 1990.
- Urquizar Herrera, A., Coleccionismo y nobleza: signos de distinción social en la Andalucía del Renacimiento. Madrid: Marcial Pons, 2007.
- Usmiani, M. A., 'Marko Marulić', *Harvard Slavic Studies* 3 (1957), pp. 1–48.
- Valeriano, G. P., De litteratorum infelicitate (1620). Eng. trans. as Pierio Valeriano on the Ill Fortune of Learned Men. Ann Arbor: University of Michigan Press, 1999.
- Varchi, B., Due lezioni. Florence, 1549.
- Vasari, G., Der Literarische Nachlass, 2 vols. Munich: Müller, 1923.
- —Vite, ed. P. Barocchi and R. Bettarini, 6 vols. Florence, 1966–87.
 Eng. trans. as Lives of the Most Eminent Painters, Sculptors, and Architects. London: Macmillan, 1912–15.
- Veen, H. T. van, Cosimo I de' Medici and his Self-Representation in

Florentine Art and Culture. Eng. trans., Cambridge: Cambridge University Press, 2006.

Venezian, S. (1921) Olimpo da Sassoferrato. Bologna: Zanichelli, 1921. Ventura, A., Nobiltà e popolo nella società veneta del quattrocento e cinqueento. Bari: Laterza, 1964.

Verde, A., Lo studio fiorentino, 3 vols. Florence: Istituto nazionale di studi sul Rinascimento, 1973.

Verdon, T., and J. Henderson (eds), Christianity and the Renaissance: Image and Religious Imagination in the Quattrocento. Syracuse, NY: Syracuse University Press, 1990.

Vespasiano da Bisticci, Vite di uomini illustri. Eng. trans., as Lives of Illustrious Men of the 15th Century. London: Routledge, 1926.

Vicentino, N., L'antica musica. Venice, 1555.

Vida, M. G., *The De arte poetica* (1527). Eng. trans., New York: Columbia University Press, 1976.

Voltaire, Essai sur les moeurs (1756), 2 vols. Paris: Garnier, 1963.

Wackernagel, M., The World of the Florentine Renaissance Artist. Eng. trans. Alison Luchs. Princeton, NJ: Princeton University Press, 1981.

Waley, D., The Italian City-Republics. 2nd edn, London: Longman, 1978.

Walker, D. P., Spiritual and Demonic Magic from Ficino to Campanella. London: Warburg Institute, 1958.

Wallace, W. E., *Michelangelo at San Lorenzo: The Genius as Entrepreneur*. Cambridge: Cambridge University Press, 1994.

—'Michelangelo's assistants in the Sistine Chapel', Gazette des Beaux-Arts 110 (1987), pp. 203-16.

Walser, E., Gesammelte Studien zur Geistesgeschichte der Renaissance. Basel: B. Schwabe, 1932.

Warburg, A., *The Renewal of Pagan Antiquity*. Eng. trans., Los Angeles: Getty Center, 1999.

Warkentin, G., and C. Podruchny (eds), Decentring the Renaissance: Canada and Europe in Multidisciplinary Perspective, 1500–1700. Toronto: University of Toronto Press, 2001.

Warnke, M., *The Court Artist*. Eng. trans., Cambridge: Cambridge University Press, 1993.

Warren, J., 'Bronzes', in *At Home in Renaissance Italy*, ed. M. Ajmar-Wollheim and F. Dennis, pp. 294–305. London: V&A, 2006.

Weber, M., *Economy and Society*. Eng. trans., New York: Bedminster Press, 1968.

Weinberg, B., A History of Literary Criticism in the Italian Renaissance, 2 vols. Chicago: University of Chicago Press, 1961.

Weinstein, D., 'The myth of Florence', in *Florentine Studies*, ed. N. Rubinstein, pp. 15–44. London: Faber, 1968.

- —Savonarola and Florence. Princeton, NJ: Princeton University Press, 1970.
- —Savonarola: The Rise and Fall of a Renaissance Prophet. New Haven, CT: Yale University Press, 2011.
- Weise, G., L'ideale eroico del Rinascimento, 2 vols. Naples: Edizioni scientifiche italiane, 1961–5.
- 'Maniera und Pellegrino', Romanistisches Jahrbuch 3 (1950), pp. 321-403.
- Weisinger, H., 'The English origins of the sociological interpretation of the Renaissance', *Journal of the History of Ideas* 11 (1950), pp. 321–38.
- Weiss, R., The Renaissance Discovery of Classical Antiquity. Oxford: Blackwell, 1969.
- Weissman, R., 'Reconstructing Renaissance sociology', in *Persons in Groups*, ed. R. Trexler, pp. 39–46. Binghamton, NY: Center for Medieval and Early Renaissance Studies, 1985.
- —Ritual Brotherhood in Renaissance Florence. New York: Academic Press, 1982.
- —'Taking patronage seriously: Mediterranean values and Renaissance society', in *Patronage, Art and Society in Renaissance Italy*, ed. F. W. Kent and P. Simons, pp. 25–45. Oxford: Oxford University Press, 1987.
- Welch, E. S., Art and Authority in Renaissance Milan. New Haven, CT: Yale University Press, 1995.
- —Art and Society in Italy 1350–1500. Oxford: Oxford University Press, 1997.
- —'The process of Sforza patronage', Renaissance Studies 3 (1989), pp. 370-86.
- —Shopping in the Renaissance: Consumer Culture in Italy, 1300–1550. New Haven, CT: Yale University Press, 2005.
- —'Women as patrons and clients in the courts of quattrocento Italy', in *Women in Italian Renaissance Culture and Society*, ed. L. Panizza, pp. 18–34. Oxford: European Humanities Research Centre, 2000.
- Wellek, R., Concepts of Criticism. New Haven, CT: Yale University Press, 1963.
- Wendorff, R., Zeit und Kultur. 2nd edn, Opladen: Westdeutscher Verlag, 1980.
- Westfall, C. W., In this Most Perfect Paradise: Alberti, Nicholas V and the Invention of Conscious Urban Planning in Rome, 1447–55. University Park: Pennsylvania State University Press, 1974.
- Wilde, J., 'The hall of the Great Council of Florence', in *Renaissance Art*, ed. C. Gilbert, pp. 92–132. New York: Harper & Row, 1970.

- Williams, R., Culture and Society, 1780-1950. London: Chatto & Windus, 1958.
- -Keywords: A Vocabulary of Culture and Society. London: Croom Helm, 1976.
- —The Long Revolution. 2nd edn, Harmondsworth: Penguin 1965.
- -Marxism and Literature. Oxford: Oxford University Press, 1977.
- Williamson, G. C. (ed. and trans.), *The Anonimo: Notes on Pictures and Works of Art in Italy*. London: Bell, 1903.
- Wilson, N. G., From Byzantium to Italy: Greek Studies in the Italian Renaissance. London: Duckworth, 1992.
- Winckelmann, J. J., Geschichte der Kunst des Altertums (1764). Eng. trans., London: Low, 1881.
- Wind, E., Bellini's Feast of the Gods. Cambridge, MA: Harvard University Press, 1948.
- -Giorgione's Tempestà. Oxford: Clarendon Press, 1969.
- —Pagan Mysteries in the Renaissance. Rev. edn, Oxford: Oxford University Press, 1980.
- Wisch, B., and D. C. Ahl (eds), Confraternities and the Visual Arts in Renaissance Italy: Ritual, Spectacle, Image. Cambridge: Cambridge University Press, 2000.
- Witt, R. G., Hercules at the Cross-Roads: The Life, Work and Thought of Coluccio Salutati. Durham, NC: Duke University Press, 1983.
- —'In the Footsteps of the Ancients': The Origins of Humanism from Lovato to Bruni. Leiden: E. J. Brill, 2000.
- Witt, R. G., J. M. Najemy, C. Kallendorf and W. Gundersheimer, 'Hans Baron's Renaissance humanism', *American Historical Review* 101 (1996), 107–44.
- Wittkower, R., Architectural Principles in the Age of Humanism. 3rd edn, London: Alec Tiranti, 1962.
- —'Individualism in art and artists', *Journal of the History of Ideas* 22 (1961), pp. 291–302.
- Wittkower, R., and M. Wittkower, Born under Saturn. London: Weidenfeld & Nicolson, 1963.
- Wohl, H., The Aesthetics of Italian Renaissance Art: A Reconsideration of Style. Cambridge: Cambridge University Press, 1999.
- Wölfflin, H., Classic Art (1898). Eng. trans., London: Phaidon Press, 1952.
- -Principles of Art History (1915). Eng. trans., New York: Dover, 1950.
- —Renaissance and Baroque (1888). Eng. trans., London: Cornell University Press, 1964.
- Woods-Marsden, J., The Gonzaga of Mantua and Pisanello's Arthurian Frescoes. Princeton, NJ: Princeton University Press, 1988.

- —Renaissance Self-Portraiture. New Haven, CT: Yale University Press, 1998.
- —Toward a History of Art Patronage in the Renaissance: The Case of Pietro Aretino. Durham, NC: Duke University Press, 1994.
- Woolf, S., 'Venice and the terraferma', in Crisis and Change in the Venetian Economy, ed. B. Pullan, pp. 175–203. London: Methuen, 1968.
- Woolfson, J. (ed.), *Palgrave Advances in Renaissance Historiography*. Basingstoke: Macmillan, 2004.
- Wright, A., 'Between the patron and the market: production strategies in the Pollaiuolo workshop', in *The Art Market in Italy*, 15th–17th Century, ed. M. Fantoni et al., pp. 225–36. Modena: F. C. Panini, 2003.
- Wyrobisz, A., 'L'attività edilizia a Venezia', *Studi Veneziani* 7 (1965), pp. 307–43.
- Yates, F., Giordano Bruno and the Hermetic Tradition. London: Routledge & Kegan Paul, 1964.
- Zancan, M., 'La donna e il cerchio nel Cortegiano', in Nel cerchio della luna, ed. Zancan, pp. 13–56. Venice: Marsilio, 1983.
- Zanetti, D., Problemi alimentari di una economia preindustriale: cereali a Pavia dal 1338 al 1700. Turin: Boringhieri, 1964.
- Zanrè, D., Cultural Non-Conformity in Early Modern Florence. Aldershot: Ashgate, 2004.
- Zappella, G., Il ritratto nel libro italiano del cinquecento, 2 vols. Milan: Bibliografica, 1988.
- Zarlino, G., Istitutioni harmoniche (1558). Eng. trans. as The Art of Counterpoint. New York, W. W. Norton, 2011.
- Zarri, G., 'Aspetti dello sviluppo degli ordini religiosi', in *Strutture ecclesiastiche in Italia e in Germania prima della Riforma*, ed. P. Prodi and P. Johanek, pp. 207–57. Bologna: Il Mulino, 1984.
- —Le sante vive: profezie di corte e devozione femminile tra '400 e '500. Turin: Rosenberg & Sellier, 1990.
- Zeidberg, D., and F. Superbi, *Aldus Manutius and Renaissance Culture*. Florence: Olschki, 1998.
- Zhiri, O., L'Afrique au miroir de l'Europe: fortunes de Jean Léon L'Africain à la Renaissance. Geneva: Droz, 1991.
- Zilsel, E., Die Entstehung des Geniebegriffes. Tübingen: Mohr, 1926.
- Zimmermann, T. C. P., 'Paolo Giovio and the evolution of Renaissance art criticism', in *Cultural Aspects of the Italian Renaissance*, ed. C. H. Clough, pp. 406–24. Manchester: Manchester University Press, 1976.
- —Paolo Giovio: The Historian and the Crisis of Sixteenth-Century Italy. Princeton, NJ: Princeton University Press, 1995.

INDEX

'An asterisk denotes membership of the creative elite, not all of whom are included in the text of this book'

*Abbate, Niccolò dell', of Modena, painter, 79

'Abd Allah Ibn Qutayba, 13

Abu Ma'asar (Albumazar), Arab scholar, 12

*Accolti, Benedetto, Tuscan humanist Accolti, Bernardo, Tuscan poet, 74, 204

*Aconcio, Jacopo, from Trent, humanist, 87

Adrian VI (of Utrecht), pope, 170 Aertsen, Pieter, Flemish painter, 256

*Agricola, Alexander, Flemish musician, 62

Albert of Saxony, medieval

philosopher, 23 Albert the Great, medieval philosopher, 23

*Alberti, Leon Battista, universal man, 29–30, 61–2, 67, 71–2, 81–2, 118, 124, 154–5, 157–8, 190, 199, 205, 209–11, 224–5

*Albertinelli, Mariotto, Florentine painter, 79

Albizzi, Rinaldo degli, Florentine patrician, 231

*Alciati, Andrea, Lombard legal humanist, 85, 198

*Aldo Manuzio, humanist printer, 79, 126–7, 236, 246

Alexander VI (Borgia), pope, 146

Alexander the Great, 81 Alfonso of Aragon, 'the

Magnanimous', King of Naples, 85, 87, 118, 119, 123, 127, 131,

139-40, 222-3

Alfonso of Calabria, prince and patron, 103

Alhazen, see Ibn al-Haytham Alsop, Joseph, American journalist, 255

*Amadeo, Giovanni, of Pavia, painter, 82

Ambrose, St, 65

*Ammannati, Bartolommeo, of Settignano, sculptor, 50

anachronism, 201

*Andrea del Sarto, painter, 56–7, 66, 99, 107, 109–10, 113, 129, 141, 145

*Angelico, fra, Tuscan painter, 51, 53, 79, 217, 251

Anguissciola, Sofonisba, Italian painter, 48

Antal, Frederick, Hungarian art historian, 39, 167

anthropology, 5–6

'Antico' (Pier Jacopo Alari Bonacolsi), Mantuan sculptor, 128

*Antoniazzo, Romano, artist, 50, 219 *Antonino, St (Pierozzi), archbishop

*Antonino, St (Pierozzi), archbishop of Florence, writer, 81, 90, 194

Antonio da Murano, painter, 69 Apelles, ancient Greek painter, 22

applied art, 10-11

Aquila, Serafino d', poet, see Serafino of Aquila

arabesques, 14

*Aragona, Tullia d', Roman courtesan and poet, 48 INDEX 315

- *Arcadelt, Jacques, Flemish musician, 164
- *Aretino, Pietro, Tuscan writer, 55, 77, 124–5, 147–8, 168, 170, 175, 209, 247–9
- * Argyropoulos, Janos, Greek humanist, 50, 87, 244
- *Ariosto, Ludovico, from Emilia, writer, 18, 23, 81, 122–4, 146, 165, 168–9, 177, 181, 195–6, 216
- Aristotle, 22–3, 85, 168, 189, 198, 203
- *Aron, Pietro, Florentine musician, 30, 161–2
- Attavante degli Attavanti, illuminator, 127
- Augurello, Giovanni, poet and alchemist, 194
- Augustine, St, 65
- *Aurispa, Giovanni, Sicilian humanist, 78
- Averroes, see Ibn Rushd Avicenna, see Ibn Sina
- *Baçó, Jacomart, Valencian painter, 51 Bagehot, Walter, English political theorist, 220
- *Baldovinetti, Alesso, Florentine painter, 52
- *Bandello, Matteo, Lombard writer, 79, 89, 126, 209
- *Bandinelli, Baccio, Florentine sculptor, 64–6, 82, 102, 129
- *Barbari, Jacopo de', painter and engraver, 77–8, 239
- Barbaro, Daniele, Venetian patrician and humanist, 82, 253
- Barbaro, Ermolao, Venetian patrician and humanist, 85, 105
- *Barbaro, Francesco, Venetian patrician and humanist, 78, 124
- Baron, Hans, German-American historian, 41–3, 243
- *Bartolommeo, fra (Baccio della Porta), Florentine painter, 79, 129, 169, 247
- Bash, Matsuo, Japanese poet, 259
- *Bassano, Jacopo, painter from the Veneto, 81, 129
- Bassano, Leandro, painter from the Veneto, 98, 129

Battiferri, Laura, Tuscan writer, 48
*Beccafumi, Domenico, Sienese
painter, 51, 54, 58, 109, 250
Becchi, Gentile, humanist tutor, 105
Beck, James, American art historian,
8

*Bellini, Gentile, Venetian painter, 13, 52, 57, 68, 81, 96, 218

*Bellini, Giovanni, Venetian painter, 13, 52, 57, 68, 98, 109, 114, 116, 127, 129, 151

*Bellini, Jacopo, Venetian painter, 52, 57, 68, 201, 251

Belliniano, Vittore, painter, 64, 68 Bembo, Bernardo, Venetian patrician humanist, 105, 124

*Bembo, Pietro, Venetian patrician, writer and critic, 79, 114, 117, 120, 123–4, 165–6, 168–9

*Benaglio, Francesco, of Verona, painter, 149

Benjamin, Walter, German critic, 130 Bentivoglio family, of Bologna, 23,

Benvenuto di Giovanni, Sienese painter, 86

Bernardino da Feltre, preacher, 191
*Bernardino of Siena, St, preacher,
134, 169, 173–4, 191, 195,
217–18

- *Berni, Francesco, Tuscan poet, 170, 248–9
- *Beroaldo, il vecchio, Filippo, of Bologna, humanist, 84
- *Bertoldo di Giovanni, Florentine sculptor, 29, 64
- *Bessarion, Cardinal Basilios, Greek humanist, 50, 122, 244
- *Betussi, Giuseppe, of Bassano, writer and editor, 77

Bevilaqua, Simon, printer, 78 Bicci di Lorenzo, painter, 57

Bidon of Asti, singer, 162

Binchois, Gilles, Flemish musician, 256, 259

Bindoni family, Venetian printers,

- *Biondo, Flavio, of Forli, humanist, 122, 201
- *Biringuccio, Vannoccio, Sienese engineer, 123, 194

*Bisticci, Vespasiano da, Florentine bookseller and biographer, 75–6, 105, 127, 204

Bloch, Marc, French historian, 4, 256 Boccaccio, Giovanni, Florentine writer, 64, 127, 138, 165–6, 169,

176

Bohannan, Paul, American anthropologist, 4

*Boiardo, Matteo, of Ferrara, writer,

*Boltraffio, Giovanni, of Milan, painter, 86

Bonaventura, St, Italian friar, 191

*Bonfigli, Benedetto, painter, 133 Bono, Piero, lutenist, 84

Bonsignore, Giovanni de,

commentator on Ovid, 177

Bonvesino della Riva, chronicler of Milan, 209

*Bordone, Paris, of Treviso, painter, 66, 239, 251

Borghini, Vicenzo, Florentine humanist, 32

Borgia, Cesare, 146

*Botticelli, Sandro, Florentine painter, 2, 11, 22, 37, 57, 65, 67, 73–4, 87, 95, 117, 134, 137–8, 141, 152, 180, 229, 246

Botticini, Francesco, Florentine painter, 57

Bourdieu, Pierre, French social theorist, 5, 104, 262

Bracciolini, see Poggio Bracciolini

*Bramante, Donato, of Urbino, architect, 57, 61, 66, 245

Bramantino, painter, 153

Brancacci, Felice, Florentine patrician and patron, 39

Braudel, Fernand, French historian, 3–5, 241–2, 252

*Bronzino, Angelo, from Monticelli, Tuscan painter, 57, 66, 68, 108, 141, 251

Brueghel, Peter, the elder, 256

*Brumel, Antoine, Flemish musician, 62

*Brunelleschi, Filippo, Florentine architect, 13–14, 27, 29, 53, 55, 57, 61, 64, 67, 72, 82, 103, 157, 189, 228, 233, 243

*Bruni, Leonardo, Tuscan humanist,

32, 51, 79, 84, 117, 122, 156, 205, 227, 243

*Burchiello, Domenico, Florentine comic writer, 55, 66, 80

Burckhardt, Jacob, Swiss art historian, 1, 4, 8, 18, 35–7, 166, 193–4, 199, 203–4, 224, 262

Buridan, Jean, medieval philosopher, 23

Burney, Charles, English writer on music, 34

*Busnois, Antoine, Flemish musician, 83, 256

*Calcagnini, Celio, of Ferrara, natural philosopher, 79

*Campagnola, Domenico, painter, 57, 130

*Campagnola, Giulio, of Padua, painter, 56, 66, 127, 130

*Campano, Giovanni, Piedmontese humanist, 51, 53, 230

Canossa, Lodovico da, count, 77

*Cara, Marchetto, of Verona, musician, 84, 119, 162

*Caravaggio, Polidoro (Caldara) da, Lombard painter, 57, 247

*Cardano, Girolamo, Lombard physician and autobiographer, 198, 206

*Caro, Annibale, from the Marches, writer, 79, 116, 118

*Caroto, Giovanni Francesco, of Verona, painter, 7, 80

*Carpaccio, Vittore, Venetian painter, 25, 96, 103, 128, 136, 150

*Casa, Giovanni della, Tuscan writer, 208

*Castagno, Andrea del, Tuscan painter, 51, 53–4, 74, 101, 115, 141, 251

*Castiglione, Baldassare, writer and courtier, 28, 66–7, 82, 88, 124, 162, 198, 208, 223

Castiglione, Sabba di, Lombard nobleman, 151

*Catena, Vincenzo, Venetian painter, 68, 80, 82

Caterina da Bologna, miniaturist, 48 *Cavalcanti, Giovanni, Florentine chronicler, 227 *Cavazzoni, Marc'Antonio, of Urbino, organist, 29, 120

*Cecchi, Giovanni Maria, Florentine playwright, 80

*Cellini, Benvenuto, artist and writer, 14, 66, 88, 143, 206, 247–8, 251

*Cennini, Cennino, Tuscan writer on art, 28, 66, 80

Ceresara, Paride da, Lombard humanist, 117

Cereta, Laura, Brescian humanist, 49 Chabod, Federico, Italian historian, 224

Chakrabarty, Dipesh, Indian historian, 12

Chalcondylas, Demetrios, Greek humanist, 244

Chang Yen-Yuan, Chinese biographer of artists, 255

Chariteo, see Gareth, Benedetto Charles V, emperor, 81–2, 85, 213, 247

Charles VIII, king of France, 213, 245–6

Charles the Bold, duke of Burgundy, 259

Chigi, Agostino, Sienese banker and patron, 124, 149, 190, 236, 239

Chikamatsu, Monzaemon, Japanese playwright, 259–60

Chinese culture, 12–13, 255 chivalric humanism, 23

Cicero, 166

Cimabue, Tuscan painter, 53, 155, 201

Cino da Pistoia, poet, 164

Clement VII (Medici), pope, 102, 123–4

collaboration, 69–72 collecting, 8, 105, 251

Colocci, Angelo, Roman humanist, 247

*Colonna, Vittoria, Roman noblewoman and poet, 48, 204 *Compère, Loyset, Flemish musician, 62

competitions, 103, 118

Condivi, Ascanio, from the Marches, artist and writer, 117

conspicuous consumption, 8 *Contarini, Gasparo, Venetian

humanist and cardinal, 215, 220–1

Contarini, Taddeo, Venetian collector, 105

Conti, Sigismondo de', historian, 136 Conversino da Ravenna, Giovanni, humanist, 227–8

*Corio, Bernardino, Milanese historian, 123, 246

*Cornaro, Alvise, Venetian patrician and writer, 124

*Correggio, Antonio, of Parma, painter, 99, 152

Cortese, Paolo, Roman humanist, 166

*Cossa, Francesco del, of Ferrara, painter, 117, 133

*Costa, Lorenzo, of Ferrara, painter, 115

*Costanzo, Angelo di, Neapolitan writer, 16

Courbet, Gustave, French painter, 23
*Credi, Lorenzo di, Florentine painter, 57

Cristoforo Altissimo, improvising poet, 74

Cristoforo da Feltre, musician, 120 *Crivelli, Carlo, Venetian painter, 25, 81, 99

Crivelli, Taddeo, scribe and printer, 76
*Cronaca, Simone, Florentine
architect, 82

*Cyriac of Ancona, humanist, 79

*Dalmata, Giovanni, see Duknovic, Ivan

Dalmatinac, Juraj (Giorgio da Sebenico), Dalmatian sculptor, 50

Dante, 64, 127, 165, 169, 189, 212, 221, 231

Dario da Udine, painter, 78 Darnton, Robert, American historian,

Darnton, Robert, American historian,

Datini, Francesco, merchant of Prato, 127

David, Gerard, Flemish painter, 256 *Decembrio, Angelo, Lombard humanist, 85, 87, 131

Decembrio, Pier Candido, Lombard humanist, 79, 131, 244

Dee, John, English magus, 195 Delli, Dello, Florentine artist, 251 *Desiderio da Settignano, Tuscan sculptor, 50, 127

*Diana, Benedetto, Venetian painter, 103

Dionisotti, Carlo, Italian literary scholar, 41

distinction, social, 104, 240, 262

*Dolce, Lodovico, Venetian writereditor, 77, 126, 151–2, 167, 177

Domenichi, Ludovico, Venetian writer, 77

Domenico de'Lapi, scribe and printer, 76

domestic turn, 10–12, 148–9

Dominici, fra Giovanni, Florentine moralist, 135

*Donatello, Florentine sculptor, 57, 69, 90, 95–6, 98, 127, 139, 142, 151, 153, 190, 243, 251

Dondi, Giovanni, Paduan astrologer, 189

*Doni, Antonfrancesco, Florentine writer, 55, 77

Doren, Alfred, German historian, 38 Dossi, Battista, of Trento, painter, 100 *Dossi, Dosso, of Trento, painter, 96, 175–6, 196–7

*Dufay, Guillaume, Flemish musician, 50, 62, 133, 220, 259

*Duknovic, Ivan (Giovanni Dalmata), Dalmatian sculptor, 50, 82

Dürer, Albrecht, German artist, 73, 82, 98, 155, 239, 255–6

Durkheim, Emile, French social theorist, 5, 262

Eleonora of Toledo, wife of Grand Duke Cosimo de'Medici, 120, 147

Elias, Norbert, German social theorist, 211, 222–3, 227, 262

Engels, Friedrich, German social theorist, 30

*Equicola, Mario, South Italian humanist, 85

Erasmus, Dutch humanist, 28, 170 Este, Alfonso d', duke of Ferrara, 107, 109–10, 123

Este, Beatrice d', 152

Este, Borso d', duke of Ferrara, 115,

Este, Ercole d', duke of Ferrara, 84, 119–20

Este, Isabella d', marchioness of Mantua, 8, 10, 84, 105–6, 111–12, 114–17, 119, 122, 126, 128–30, 151, 176–7, 209

Este, Leonello d', marquis of Ferrara, 117

Eugenius IV (Condulmer), pope, 138, 169

Evans-Pritchard, Edward, British anthropologist, 5, 188 exhibitions, 129

Eyck, Jan van, Flemish painter, 153, 158, 256, 258

*Fabriano, Gentile da, painter, 39, 57, 69, 95

fakes, 202

Fancelli, Luca, assistant to Alberti, 71

Farnese family, 79, 116

Fausto, Vettor, Venetian humanist, 72

*Fazio, Bartolommeo, Ligurian humanist, 87, 123, 131, 153, 157–8, 164

Febvre, Lucien, French historian, 3–5, 188

Fedele, Cassandra, Venetian humanist, 49

Federigo of Urbino, see Montefeltro, Federigo da

Feliciano, Felice, Veronese humanist, 201

feminine turn, 9-10, 99

Ferdinand, prince of Capua, 81 Ferguson, Adam, Scottish social

erguson, Adam, Scottish social theorist, 34

*Festa, Costanzo, of Savoy, musician, 120, 164

*Ficino, Marsilio, philosopher, 23, 28, 37, 51, 84, 117, 123, 134, 190, 203, 205

*Fiesole, Mino da, Tuscan sculptor,

*Filarete, Antonio (Averlino), architectural writer, 21, 62, 66, 70–1, 94, 104–5, 107, 118, 157, 168, 190, 199, 202–3, 210, 212

*Filelfo, Francesco, from the Marches, humanist, 78, 85, 87, 123 *Firenzuola, Agnolo, Tuscan writer, 156

Fishman, Joshua, American sociolinguist, 6

Fogolino brothers, painters from Friuli, 80

*Folengo, Teofilo, Mantuan writer, 217, 248

*Fontana, Giovanni, Venetian natural philosopher, 195, 213

Fontana, Lavinia, Italian painter, 48 Foppa, Vincenzo, of Brescia, painter, 109, 111

Foscari, Francesco, doge of Venice, 120

*Fossis, Pierre de, Flemish musician, 119

*Fracastoro, Girolamo, of Verona, humanist physician, 190

Francastel, Pierre, French art historian, 27

Francis I, king of France, 129, 239

*Franco, Niccolò, south Italian writer, 77

Frederick III, emperor, 81 Friedländer, Walter, German art historian, 242

*Gabrieli, Andrea, Venetian musician, 29, 62

Gabrieli, Giovanni, Venetian musician, 16, 57, 62

*Gaffurio, Franchino, Lombard musical theorist, 161

*Gaggini, Domenico, Lombard sculptor, 50, 70

Gallerani, Cecilia, mistress of Lodovico Sforza, 115

Galton, Francis, English geneticist, 52

*Gambara, Veronica, of Brescia, poet, 48, 152

*Gareth, Benedetto (il Chariteo), Catalan poet, 51, 79

Gattamelata (Erasmo da Narni), Italian condottiere, 139

Gaurico, Luca, Roman astrologer, 190 *Gaurico, Pomponio, south Italian

writer on sculpture, 62, 210 *Gaza, Theodore, Greek humanist, 244 Geertz, Clifford, American anthropologist, 5, 204, 262

*Gelli, Giambattista, Florentine writer, 153, 159, 206

Gemistus Plethon, Georgius, Greek scholar, 244

*Genet, Elzéar, French musician, 120 Ghiberti, Lorenzo, Florentine sculptor, 56–8, 62, 66–7, 82, 96, 103, 117, 154, 156–7, 243

*Ghirlandaio, Domenico, Florentine painter, 18, 25, 56–7, 111, 152, 176

Giacomo da Piacenza, astrologer, 189 *Giambono, Michele, Venetian artist, 74

*Gian Cristoforo Romano, sculptor, 50, 88, 139

*Giannotti, Donato, Florentine political theorist, 212

Gibbon, Edward, English historian, 33

Ginzburg, Carlo, Italian historian, 5 *Giocondo, fra Giovanni, of Verona, architect, 66, 79, 245

Giolito family, Venetian publishers, 77, 126, 181

*Giorgi (Zorzi), fra Francesco, Venetian philosopher, 161

*Giorgio (Martini), Francesco de', of Siena, architect, 118, 130, 213

Giorgio da Sebenico, *see* Dalmatinac, Juraj

*Giorgione, Venetian painter, 51, 57, 68, 88, 105, 127–8, 183

Giotto di Bondone, Florentine painter, 53

Giovanni d'Allemagna, painter, 69 *Giovio, Paolo, of Como, writer, 8, 117, 176

Giudeo, Gian Maria, lutenist, 84, 120 Giuliano, Andrea, Venetian humanist, 78

*Giulio (Pippi) Romano, painter and architect, 50, 57, 61, 81, 83, 92, 110, 201, 248–50

Giunti, Lucantonio, Venetian printer, 76, 126

*Giustinian, Leonardo, Venetian patrician and poet, 174 global turn, 12–14 Goes, Hugo van der, Flemish painter, Goffman, Erving, American anthropologist, 148, 208, 262 Goldthwaite, Richard, American economic historian, 19 Gombrich, Sir Ernst, Anglo-Austrian art historian, 6, 39, 41 Gonzaga, Elisabetta, duchess of Urbino, 10 Gonzaga, Federico II, marquis of Mantua, 110, 124, 129, 151, 174 Gonzaga, Gianfrancesco II, marquis of Mantua, 105, 128, 136, 176 *Gozzoli, Benozzo, Florentine painter, 113, 173, 206 Gramsci, Antonio, Italian social theorist, 7 *Grazzini (il Lasca), Anton Francesco, Florentine writer, 80 Greer, Germaine, Australian feminist, Gregory XIII (Boncompagni), pope, Gregory the Great, pope, 136 Grimani family, Venetian patricians, 76, 176 Gritti, Andrea, doge of Venice, 119, 124 *Guarino da Verona, humanist, 55, 79, 81, 84–5, 105, 117, 122, 244 Guazzo, Stefano, Lombard writer, 208

*Guicciardini, Francesco, Florentine patrician and historian, 60-1, 147, 193, 199, 202, 206, 211, 214, 241 Hale, John, British historian, 8 Hauser, Arnold, Hungarian art historian, 39 Hawkwood, Sir John, English condottiere, 108 Hegel, Georg Wilhelm Friedrich, German philosopher, 34-6 Held, Julius, German-American art historian, 8 Herder, Johann Gottfried, German writer, 34 Hollanda, Francisco de, Portuguese writer on art, 28-9, 90-1 Homer, 196

Hooch, Pieter de, Dutch painter, 23 Horace, 22, 164 *Hothby, John, English musician, 60 - 1Huizinga, Johan, Dutch historian, 4, 191, 204, 216 hybridity, 13-14, 22-3 Hymes, Dell, American ethnographer of communication, 6 Ibn al-Haytham (Alhazen), 14 Ibn Qutayba, see 'Abd Allah Ibn Qutayba Ibn Rushd (Averroes), 13 Ibn Sina (Avicenna), 13 individualism, 28-9, 36, 58, 68-9, 116, 131, 166, 203-8, 250 Innocent III, pope, 208 Innocent VIII (Cybo), pope, 81 innovation, 19-21, 37, 72, 202, 256 *Isaac, Heinrich, Flemish musician, 50, 89, 120, 164, 245, 259 *Isaia de Pisa, sculptor, 50 Islamic culture, 12–13 'Italia', 17

Jewish culture, 12–13
John VII Palaeologus, Byzantine
emperor, 182
*Josquin des Près, Flemish musician,
18, 50, 61–2, 89, 113, 119–20,
161–2, 256, 259
Julius II (della Payera), page 86, 95

Julius II (della Rovere), pope, 86, 95, 114, 138–9, 146–7, 149, 182, 202

*Justus of Ghent, painter, 96, 130

Kelly, Joan, American historian, 9 Kristeller, Paul, German-American scholar, 79

*Landi, Neroccio de', Sienese painter, 8, 64, 87, 250

*Landino, Cristoforo, Florentine humanist, 122, 153, 155, 176 Landucci, Luca, Florentine diarist,

133, 191, 206

*Lapo da Castiglionchio, Tuscan humanist, 200

*Lascaris, Janos, Greek humanist, 122, 244

321 INDEX

*Laurana, Francesco, from Dalmatia, sculptor, 50, 131

*Laurana, Luciano, from Dalmatia, architect, 50, 82, 130

Leo X (Medici), pope, 81, 84–5, 102, 119-21, 147, 182, 194, 226

Leo Africanus (al-Hasan ibn Muhammad al-Wazzan), 13

Leombruno, Lorenzo, of Mantua, painter, 131

*Leonardo da Vinci, Florentine universal man, 23, 51, 55, 57, 65, 67, 80–1, 85–6, 88–9, 96, 98, 106-7, 109, 115-16, 123, 127, 134, 141, 154, 158, 178–9, 192, 199, 205, 211, 213-14, 229, 239, 247

*Leone Ebreo, Portuguese philosopher, 212

Leoni, Leone, Lombard sculptor, 82, 88, 251

*Leto, Pomponio, south Italian humanist, 87

Leyden, Lucas van, Dutch painter,

*Ligorio, Piero, humanist architect, 251

*Lippi, Filippino, of Prato, Tuscan painter, 88, 132, 152

*Lippi, fra Lippo, Florentine painter, 109–10, 127, 217

Livy, ancient Roman historian, 64 *Lombardo, Antonio, of Venice,

architect and sculptor, 52 *Lombardo, Pietro, sculptor, 52

*Lombardo, Tullio, sculptor, 52, 61 Lopez, Roberto, Genoese-American historian, 41-2, 239

*Loschi, Antonio, of Vicenza, humanist, 79, 85

*Lotti, Lorenzo, Florentine sculptor, 57

*Lotto, Lorenzo, Venetian painter, 78, 87, 99, 129

Lucretius, 175

Lukács, Georg, Hungarian philosopher and critic, 39-40

Machiavelli, Bernardo, father of Niccolò, 206, 233

*Machiavelli, Niccolò, 30, 32, 104,

123, 181, 191, 193, 198–9, 210, 214, 220, 246

*Maiano, Benedetto da, Tuscan sculptor, 64, 82

*Maiano, Giuliano da, Tuscan sculptor, 64, 82, 103

Malatesta, Sigismondo, ruler of Rimini, 71–2

Mâle, Emile, French art historian, 171 Mander, Karel van, Dutch artist and writer, 258

Manetti, Antonio, presumed biographer of Brunelleschi, 209

*Manetti, Giannozzo, Florentine humanist, 84, 192

Mann, Thomas, German novelist,

Mannheim, Karl, Hungarian sociologist, 5, 38, 242

*Mantegna, Andrea, Paduan painter, 52, 56, 68–9, 81, 89, 113, 115-16, 127, 135-6, 149, 201

Marche, Olivier de la, Burgundian court chronicler, 259

*Marliani, Giovanni, of Milan, 79

Marsigli, Luigi, Florentine monk and humanist, 217

*Marsuppini, Carlo, Tuscan humanist,

Martin, Alfred von, German sociologist, 38

Marx, Karl, German social theorist, 35, 262

*Masaccio, Florentine painter, 18, 39, 52, 55, 89–90, 141, 144, 157,

*Masolino, Florentine painter, 57, 243, 251

Massys, Quentin, Flemish painter,

*Masuccio Salernitano, writer, 66, 79, 170

Matthias Corvinus (Mátyás Hunyadi), king of Hungary, 81-2, 127

Mauss, Marcel, French anthropologist,

Medici, Alessandro de', 102, 115

Medici, Averardo de', 237

Medici, Cosimo de', the elder, 75, 102, 105, 107, 118, 122–3, 139, 217, 221, 227

Medici, Cosimo I de', grand duke of Tuscany, 13, 102, 120, 141, 143, 146 - 7,226Medici, Giovanni de', see Leo X Medici, Giovanni de', condottiere, 124 Medici, Giuliano de', 102, 123, 154 Medici, Giulio de', see Clement VII Medici, Ippolito de', 102 *Medici, Lorenzo de', 'the Magnificent', ruler and writer, 13, 23, 79, 84, 102–3, 105, 118, 120, 122, 124, 128, 131, 139, 168, 179–81, 190, 192, 199, 209, 219, 222, 253 Medici, Lorenzo de Pierfrancesco de', Medici, Ottaviano de', 129 Medici, Piero de', father of Lorenzo, 101, 104, 113 Medici, Piero de', son of Lorenzo, 79 Meiss, Millard, American art historian, 8 Memlinc, Hans, Flemish painter, 256 - 7mentalities, 166, 187, 213, 238 *Merula, Giorgio, Piedmontese humanist, 51, 77 *Michelangelo (Buonarroti), sculptor, 18, 22, 47, 50, 53, 55–8, 66–7, 69-70, 86, 88, 94-5, 98, 104, 107, 109–10, 112–14, 117, 129, 138-9, 141, 151, 154-8, 161, 190, 202, 204, 209, 212, 229, 248-9, 252, 257 *Michelozzo di Bartolommeo, Florentine architect, 57, 61, 69, 72,251Michiel, Marcantonio, Venetian patrician, 43, 176 Milano, Carlo da, painter, 56 Millar, John, Scottish political economist, 34 Montaigne, Michel de, French essayist, 216 Montefeltro, Federigo da, ruler of Urbino, 82, 105, 118, 123, 127, 130, 181, 201 Moroni, Giovanni Battista, painter from Bergamo, 99

Moronobu, Hishikawa, Japanese

artist, 259-61

*Mouton, Jean, French musician, 62

naturalism, see realism

*Navagero, Andrea, Venetian
patrician and writer, 76, 85, 123

Neri di Bicci, painter, 57

Neroccio de'Landi, see Landi,
Neroccio de'

*Nesi, Giovanni, Florentine humanist,

*Nesi, Giovanni, Florentine numanis 246 *Niccoli, Niccolò de', Florentine

humanist, 217 Nicholas V (Parentucelli), pope, 76,

230 Nicola Pisano, sculptor, 14 *Nifo, Agostino, south Italian

*Nifo, Agostino, south Italian humanist, 85, 195, 209 Nochlin, Linda, American art

historian, 9 Nogarola, Isotta, Veronese humanist,

9, 49 Novellara, fra Pietro da, 177–8

*Obrecht, Jacob, Flemish musician, 84

*Ockeghem, Joannes, Flemish musician, 62, 83, 256 Organi, Antonio degli, musician, 77 Ortega y Gasset, José, Spanish

intellectual, 242 Orto, Mambriano da, Flemish singer,

Ovid, 64, 76, 175, 177, 180, 183

*Pacioli, fra Luca, of Borgo S. Sepolcro, mathematician, 123 Palla, Gian Battista della, art dealer,

*Palladio, Andrea, of Vicenza, architect, 54, 56, 61, 66, 82, 151, 253

Palma Vecchio, Jacopo, Venetian painter, 91

*Palmieri, Matteo, Florentine humanist, 66, 84

Pannartz, Arnold, German printer, 75, 77

Panofsky, Erwin, German-American art historian, 27, 171, 256 *Panormita, Antonio (Beccadelli), INDEX 323

Sicilian humanist, 78, 122, 131, 169, 210

*Parmigianino, Francesco, painter, 156, 194, 206, 247–8

Passerini, Silvio, Tuscan cardinal, 102 Pasti, Matteo de', assistant to Alberti, 71, 161

Patenir, Joachim, Flemish painter, 256 Paul II (Barbo), pope, 8

Paul III (Farnese), pope, 190

Paul IV (Caraffa), pope, 170

*Paul of Venice, scientist, 60, 79

*Penni, Gianfrancesco, Florentine painter, 57

perspective, 27

*Perugino, Pietro, painter, 57, 81–2, 95, 111–12, 152, 229

*Peruzzi, Baldassare, Sienese architect, 61, 247, 251

Petrarch, Francesco, Tuscan poet and scholar, 13, 127, 169, 176, 250

Petrucci, Pandolfo, ruler of Siena, 123 Philip the Good, duke of Burgundy, 258–9

Philip the Handsome (Philippe le Bel), duke of Burgundy, 84

Philostratus of Lemnos, ancient Greek writer, 175

*Pico, Gianfrancesco, of Mirandola, philosopher, 166, 196

*Pico, Giovanni, of Mirandola, humanist, 13, 79, 191, 194–5, 208–9

Piccolomini, Alessandro, 67

*Piero della Francesca, of Borgo S. Sepolcro, painter, 81, 130, 182, 189

*Piero di Cosimo, Florentine painter, 57, 90, 113–14, 175, 229

Pino, Paolo, Venetian critic, 167, 171 *Pinturicchio, Bernardino, of Perugia,

painter, 206–7
*Piombo, Sebastiano (Luciani) del,
painter, 81, 174, 239, 247

painter, 81, 174, 239, 247 Pirckheimer, Willibald, German

patrician and humanist, 82
*Pisanello, Antonio, of Pisa, painter,
69, 81, 131, 139, 157

*Pius II (Piccolomini), pope, Tuscan humanist, 201, 205–6, 218, 223–4, 230 *Pizzolo, Nicolò, from near Vicenza, painter, 69

*Platina, Bartolommeo, Lombard humanist, 76–7, 79, 87, 122

Plato, 22, 123, 203, 220, 223

Plautus, ancient Roman playwright, 18

Pliny, ancient Roman writer, 255 Plekhanov, Georgi, Russian Marxist, 35

*Plethon, Georgios Gemistos, Greek humanist, 50

Plutarch, Greek moralist, 85

*Poggio Bracciolini, Florentine humanist, 8, 75, 79, 84, 122, 170, 200, 231

*Poliziano, Angelo, Tuscan humanist and poet, 29, 37, 51, 66, 76, 79, 84, 113, 116–17, 120, 122–4, 149, 164, 166, 168, 192, 209, 216

*Pollaiuolo, Antonio, Florentine painter, 57

*Pollaiuolo, Piero, Florentine painter, 103

*Pomponazzi, Pietro, Lombard philosopher, 85, 192, 198, 208, 233

*Pontano, Giovanni, Umbrian humanist and poet, 85, 168

*Pontormo, Jacopo, Tuscan painter, 57, 66, 69, 89, 93, 99, 129, 248 popular culture, 168–9, 250–1

*Pordenone, Giovanni da, painter, 81 Prisciani, Pellegrino, from Ferrara,

humanist, 117

prosopography, 7, 47 Ptolemy, Greek geographer and

astronomer, 22, 189

*Pulci, Luigi, Florentine poet, 66, 146, 170

quantitative methods, 7-8, 209-10

*Raimondi, Marcantonio, from Bologna, engraver, 127, 130, 247 Ram, Zuan, Catalan art dealer, 129

*Ramos de Pareja, Bartolomé, Spanish musician, 51

Ranke, Leopold von, German historian, 245

*Raphael (Raffaello Sanzio), painter, 12, 18, 51, 57, 61, 66, 68–9, 81–3, 88, 95, 109–11, 121, 127–8, 134, 136, 138, 149, 156, 158, 160, 182, 205–6, 209, 251

realism, 23–7, 153–4, 260 reproductions, 127–8, 139

Riccio, Andrea il (Briosco), of Padua, sculptor, 11, 82

Riegl, Alois, Austrian art historian,

*Robbia, Luca della, Florentine sculptor, 57, 127

Roberto da Lecce, preacher, 218 Roscoe, William, English banker and historian, 33

*Rosselli, Cosimo, Florentine painter, 57, 229

*Rossellino, Antonio, Tuscan sculptor, 50

*Rossellino, Bernardo, Tuscan sculptor, 50, 70–1

Rossi, Properzia de', Italian sculptress, 48

*Rosso, Giovanni Battista, Florentine painter, 88, 239, 248

Rosso, Zoare, Venetian printer, 71 Rostow, W. W., American economist,

*Rucellai, Giovanni, Florentine diarist, 206, 210, 253

Rucellai family, 193, 233

*Ruscelli, Girolamo, of Viterbo, writer, 77

Ruskin, John, art critic, 22

*Ruzzante, Angelo (Beolco), of Padua, playwright, 25, 124

*Sabellico, Marcantonio, Roman humanist, 51, 123, 146

*Sadoleto, Jacopo, of Modena, humanist, 247

Saikaku, Ihara, Japanese writer, 259–61

Salimbene of Parma, fra, chronicler, 209

Salutati, Coluccio, Florentine humanist, 75, 122, 170, 176, 217, 244

Salviati, cardinal, Florentine patrician and patron, 12

*Sammicheli, Michele, architect, 61, 247

*Sangallo, Antonio de, architect, 61, 229

*Sangallo, Giuliano, architect, 229

*Sannazzaro, Jacopo, Neapolitan poet, 22, 155

Sanseverino, Roberto, prince, 79

*Sansovino, Andrea (Contucci), Tuscan painter, 51, 54, 229

Sansovino, Francesco, Venetian writer and publisher, 77

*Sansovino, Jacopo, architect, 57, 98, 247

Sassetti, Francesco, Florentine merchant, 211

*Savonarola, Girolamo, of Ferrara, preacher, 134, 153, 165, 169, 181–2, 191, 195, 213, 217, 246

*Savonarola, Michele, of Padua, physician, 55

Scala, Alessandra della, Tuscan humanist, 49

*Scala, Bartolommeo della, Tuscan humanist, 51, 53, 79, 231

*Schiavone, Giorgio, Dalmatian painter, 80

Schütz, Heinrich, German musician, 62

secularization, 27-8, 250

Seneca, ancient Roman philosopher and playwright, 22

*Serafino of Aquila, poet, 124

*Seregni, Vincenzo, Lombard architect, 52

*Serlio, Sebastiano, of Bologna, architect, 66

Serragli, Bartolommeo, Florentine merchant, 127

Sforza, Ascanio, cardinal, 117, 124 Sforza, Galeazzo Maria, duke of Milan, 119

Sforza, Lodovico, 'il Moro', duke of Milan, 103, 115, 123, 152, 204, 222, 225, 245

Shaftesbury, Lord, English philosopher, 33

signatures, 68

*Signorelli, Luca, Tuscan painter, 81, 88, 109, 111

INDEX 325

Simmel, Georg, German sociologist, 38

Sismondi, J. C. L. S. de, Swiss historian, 34

Sixtus IV (della Rovere), pope, 138 Sixtus V (Peretti), pope, 173, 226

Sluter, Claus, Flemish sculptor, 257

Smith, Adam, Scottish political economist, 34

Soderini, cardinal, 86

*Sodoma, Giovanni, Piedmontese painter, 52, 56–7, 81, 88, 149

*Solari, Cristoforo, Milanese sculptor, 245

Solari family, 52, 70

Sorai, Ogyu, Japanese philosopher, 259

*Spagnolo, Giovanni Battista ('Mantuano'), poet, 217

*Spataro, Giovanni, of Bologna, musician, 119

*Speroni, Sperone, of Padua, critic, 85

Speyer, Johan and Windelin, German printers, 77

Spinola family, Genoese patricians,

*Squarcialupi, Antonio, Florentine

musician, 80, 84 Stampa, Gaspara, Paduan poet, 48

*Steuco, Agostino, of Gubbio, philosopher, 76

Strozzi family, Florentine patricians, 39, 95, 132, 190–1, 243

Sweynheym, Konrad, German printer, 75, 77

Taccola, Mariano, Sienese engineer, 51, 80, 213

Tacitus, 32

*Tasso, Bernardo, Venetian poet, 123 Tebaldeo, 67

Terence, ancient Roman playwright, 22

Terracina, Laura, Neapolitan poet, 48

Thompson, Edward, English historian,

*Tinctoris, Johannes de, Flemish writer on music, 20–1, 62, 83, 161–2, 164 *Tintoretto, Jacopo, Venetian painter, 48, 52, 96

Tintoretto, Marietta, Venetian painter, 48

*Titian (Tiziano Vecellio), from the Veneto, painter, 51–2, 56–7, 66, 68, 81–3, 88, 98, 107, 109–10, 125, 129, 136, 151, 175, 205–6, 239

*Torbido, Francesco, Venetian painter, 88

Tornabuoni, Giovanni, Florentine patrician, 104, 111, 176

*Torni, Bernardo, professor at Pisa, 74

*Torrigiani, Pietro, Florentine sculptor, 69, 88, 239

*Tortelli, Giovanni, Tuscan humanist, 76

*Toscanelli, Paolo, Florentine mathematician and geographer, 67

Toynbee, Arnold, British historian, 12

*Traversari, Ambrogio, from the Romagna, monk and humanist, 217

*Trissino, Gian Giorgio, of Vicenza, patrician and poet, 53

*Tromboncino, Bartolommeo, of Verona, musician, 84, 119

*Tura, Cosimo, of Ferrara, painter, 58, 68, 81, 112, 115

*Uccello, Paolo, Florentine painter, 27, 48, 56–7, 89, 96, 113, 135, 189

*Udine, Giovanni da, painter, 68–9, 81, 247

'universal man', 62, 66–7 universities, 58–61, 74

*Vaga, Perino del, Florentine painter, 57, 86, 247

Valeriano, Giovanni Pietro (Pierio), humanist, 66, 247

*Valla, Giorgio, humanist, 51

*Valla, Lorenzo, Roman humanist, 50, 78, 122–3, 131, 146, 201, 208, 210

*Varchi, Benedetto, Florentine writer, 146, 156

*Vasari, Giorgio, Tuscan artist and art historian, 6, 11–12, 20, 27, 32–3, 48, 53–4, 58, 66–7, 86, 88–90, 93, 99, 102, 113–16, 129, 134, 141, 153–4, 156–9, 167, 169, 179–80, 183, 190, 192, 194, 201, 203, 205–6, 209, 248, 251, 255

*Vecchietta, Lorenzo, Tuscan painter, 91, 96–7

Vendramin, Gabriele, Venetian patrician, 105

*Veneziano, Domenico, Venetian painter, 102

Veronese, Paolo, artist, 138, 253

*Verrocchio, Andrea, Florentine artist, 57, 87, 103

*Vicentino, Nicolò, musician, 161, 164, 168

Vico, Enea, from Parma, engraver, 202

*Vida, Marco Girolamo, of Cremona, poet, 22, 168

Villani, Giovanni, Florentine chronicler, 210

*Viola, Alfonso della, of Ferrara, musician, 77

Virgil, 22, 126, 146, 162, 181, 196

Visconti, Giangaleazzo, ruler of Milan, 42, 243

Vitruvius Pollio, Marcus, ancient Roman writer on architecture, 21, 118

*Vittorino da Feltre, humanist, 79, 85, 105, 210, 244

*Vivarini, Alvise, Venetian painter, 98, 102

Voltaire, French *philosophe* and historian, 33

Wackernagel, Martin, German art historian, 38

Warburg, Aby, German cultural historian, 5, 12, 37–8, 117, 133–4, 171, 190, 211

Weber, Max, German sociologist, 5, 224, 226, 262

*Weerbecke, Gaspar van, Flemish musician, 62, 245–6

Weyden, Roger van der, Flemish painter, 157, 256–7

Whistler, James A. M., American painter, 90

*Willaert, Adriaan, Flemish musician, 62–3, 84, 119, 164

Williams, Raymond, British critic, 4, 187

Winckelmann, Johann Joachim, German art historian, 34

Wittkower, Margot, 41

Wittkower, Rudolf, German-American art historian, 41

Wölfflin, Heinrich, Swiss art historian, 25–6, 37, 39, 250

*Zarlino, Gioseffe, writer on music, 84, 164

*Zenale, Bernardino, of Treviso, painter, 82

Zhu Xi, Chinese philosopher, 12